Archaic and Classical Greek Art

Oxford History of Art

Robin Osborne is Professor of Ancient History in the University of Oxford and Fellow and Tutor of Corpus Christi College. He has written *Demos: the Discovery of Classical Attika* (Cambridge, 1985), *Classical Landscape with Figures: the Ancient Greek City and its Countryside* (London, 1987), and *Greece in the Making 1200–479 BC* (London, 1996), and has edited (with Simon Goldhill) *Art and Text in Ancient Greek Culture* (Cambridge, 1994), (with Susan Alcock) *Placing the Gods: Sanctuaries and Sacred Space in Ancient Greece* (Oxford, 1994), and (with Simon Hornblower) *Ritual, Finance, Politics: Athenian Democratic Accounts presented to David Lewis* (Oxford, 1994).

Oxford History of Art

Archaic and Classical Greek Art

Robin Osborne

Oxford New York

OXFORD UNIVERSITY PRESS

1998

For EGO and AMO

Oxford University Press, Great Clarendon Street, Oxford OX2 6DP

Oxford New York
Athens Auckland Bangkok Bogota Bombay
Buenos Aires Calcutta Cape Town Dar es Salaam
Delhi Florence Hong Kong Istanbul Karachi
Kuala Lumpur Madras Madrid Melbourne
Mexico City Nairobi Paris Singapore
Taipei Tokyo Toronto Warsaw
and associated companies in Berlin Ibadan

Oxford is a trade mark of Oxford University Press

First Published 1998 by Oxford University Press

British Library Cataloguing in Publication Data
Data available

Library of Congress Cataloging in Publication Data
Data available

0–19–284202–1 Pbk
0–19–284264–1 Hb

10 9 8 7 6 5 4 3 2

Picture Research by Virginia Stroud-Lewis
Designed by Esterson Lackersteen
Printed in Hong Kong
on acid-free paper by
C&C Offset Printing Co., Ltd

Contents

Introduction

Greek art occupies a unique place in the history of western art. It stands at the head not only of the western tradition of figurative art but also of the tradition of writing the history of art. That Greek sculpture, in particular, has become exemplary is dependent not simply on the way in which Greek sculptors pioneered a new relationship between the image and the observed world but also on the way in which, from the Renaissance on, Greek and Roman writers' accounts of what those sculptors were doing have served as the framework for understanding the artistic enterprise.

The story of Greek art has often been told, and has inspired some of the most influential modern discussions of the nature of art. This book tells the story again, but although it draws attention to ancient writing on art, as well as to Greek sculpture and painting itself, it attempts to break out of the mould which that ancient writing created. Greek and Roman writers on art began the tradition of treating art as having its own history, quite independent of the political, social, cultural, or economic history of the people by whom and for whom the art is produced. Like other volumes in this series, this book attempts to reveal the limitations of that view. In particular I am concerned to uncover the ways in which the changing nature of artistic expression was linked to the way in which the objects which artists created were employed and deployed, whether those objects were cheap offerings made at sanctuaries, everyday pots, items of costly jewellery, or major state monuments. Although I offer only a very selective picture of the wider history of Greece in the five hundred years covered by my story, I try to reveal something of the interaction between the pot painter or sculptor and the customer.

The history of scholarship on Greek art is a fascinating one, which is only just now beginning to be studied. But this book is not concerned with that history, and I make no attempt in my text to outline the previous scholarship to which my work is indebted, or to summarize the variety of interpretations that have been offered of particular works of art. I hope that readers will find adequate guidance to past scholarship in the Bibliographic Essay which covers topics in the order in which they appear in each chapter.

I am grateful to Catherine Clarke who commissioned and initially encouraged this book, and to Jaś Elsner and Simon Mason for reading and commenting on the whole text.

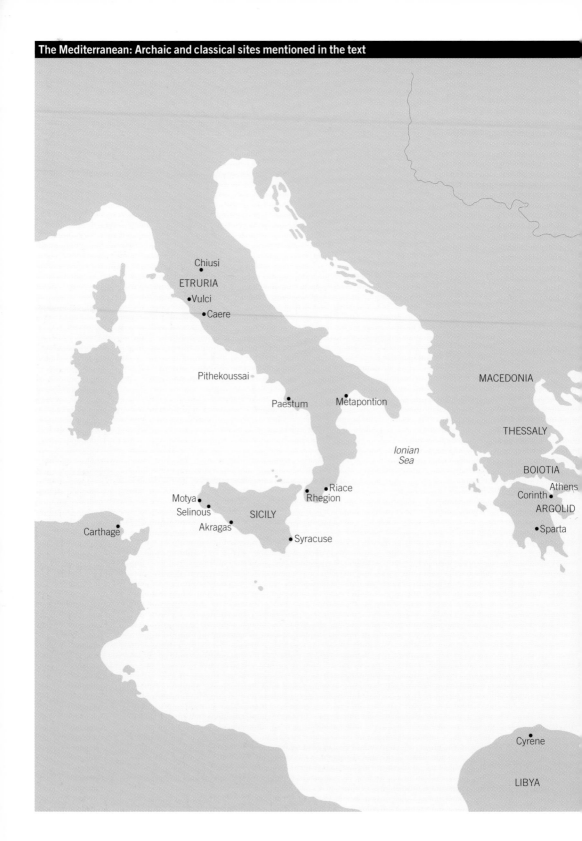

Chiusi

ETRURIA

Vulci

Caere

Pithekoussai

Paestum

Metapontion

MACEDONIA

THESSALY

Ionian
Sea

BOIOTIA

Athens

Corinth

ARGOLID

Motya

Selinous

SICILY

Riace

Rhegion

Sparta

Carthage

Akragas

Syracuse

Cyrene

LIBYA

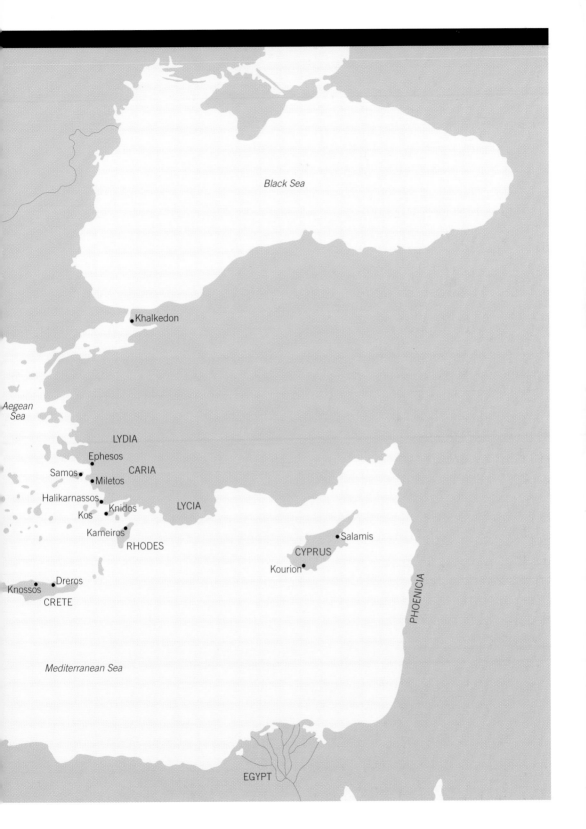

Black Sea

Khalkedon

Aegean
Sea

LYDIA

Ephesos

Samos

CARIA

Miletos

Halikarnassos

Knidos

Kos

LYCIA

Kameiros

RHODES

CYPRUS

Salamis

Kourion

Dreros

Knossos

PHOENICIA

CRETE

Mediterranean Sea

EGYPT

MAP 5

CORFU

Ionian
Sea

• Derveni

• Vergina

AITOLIA

• Thermon

• Delphi

EUBOIA

Khalkis • • Lefkandi
• Eretria
• Oropos

BOIOTIA

Thebes •
• Plataia

• Rhamnous

Perakhora •

Athens •

• Marathon

Isthmia •
Corinth •

ATTICA

Salamis

• Myrrhinous

Elis •

• Lousoi

Olympia •

• Orkomenos

Aigina

• Anavyssos

Mazi •

ARKADIA

Argos • Epidauros •

Phigaleia • • Bassai

• Tegea

MESSENIA

• Sparta

LAKONIA

Siphn•

Melos

Antikythera •

CRETE

LESBOS

Aegean
Sea

Pergamon

'YCLADES

Mykonos

Delos

Paros

Naxos

Ephesos

SAMOS •Samos

•Miletos

•Halikarnassos

•Kos

•Knidos

• Kameiros

RHODES

Mediterranean Sea

Knossos• •Dreros

•Prinias

MAP 7

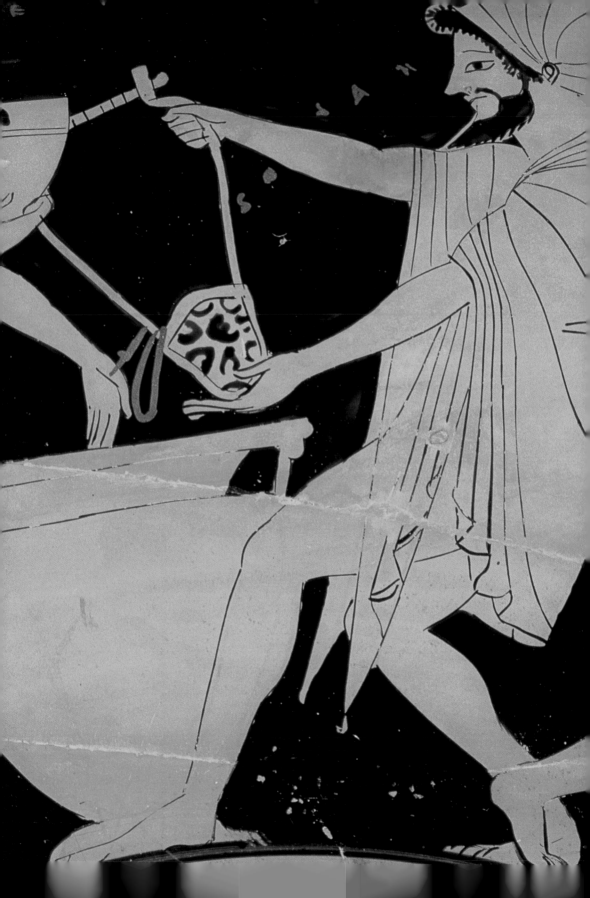

A History of Art Without Artists

1

A study of archaic and classical Greek art rightly stands at the head of a series of books on the history of western art, for it was precisely in Greece between 800 and 300 BC that the tradition began which has dominated western art ever since. During this period Greece moved from being recognizably part of the art world of the Near East to pioneering an approach to the representation of the human body which not only set it apart from the east but which has made it a reference point for naturalistic figurative art in the west ever since. That transformation of visual representation in Greece and laying of the foundations of western art is the topic of this book.

The place of Greek art, and particularly Greek sculpture, at the head of the artistic tradition in which the western world still operates, and the more or less tendentious use made of the Greek example to justify the representation of the male and female nude [1], obscure the difficulties of writing a history of Greek art and often lead to Greek art being treated in isolation from its historical setting. For a long time scholars of classical archaeology sought to establish the claims of the often humble material they studied by structuring their histories of the painting of clay pots around the different artists' hands they detected and the workshops they hypothesized. At the same time both classical specialists and historians of later art adopted the Renaissance and its transformation of medieval art as the model for understanding the difference between the classical style, which was the ultimate model for Renaissance artists, and the earlier art of archaic Greece. This book tries to show how the art of archaic and classical Greece can be understood in terms not derived from the Renaissance and the study of Renaissance art. In this introductory chapter I explore the ways in which studying Greek art has to be different from the study of western art since the Renaissance, and illustrate the rich possibilities for understanding the place of art in society which studying the private and public art of Greece in its context affords.

The lost history of Greek art

Wealthy private individuals throughout Greece commissioned paintings and hung them in their town and their country houses. Painters

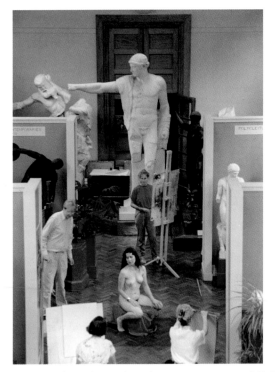

1

A life class in the Cast Gallery of the Ashmolean Museum at Oxford in 1994.

Such galleries have played an important part in artistic education in Europe since the eighteenth century, as students have been encouraged to copy the antique. To hold a life class in a cast gallery is to suggest that art is comparable to life and that what the Greek sculptor was doing is precisely comparable to what the modern artist does.

competed with each other to attract publicity, and their studios attracted admiring visitors. Stories about artists' aims, rivalries, private lives, quarrels with patrons, passions for their models, and the like, came to circulate freely. But for us the history of Greek painting has to be a history of painting where the artists have no lives, and where private patrons play no role. Not a single panel painting survives from archaic or classical Greece, and none of the few surviving wall paintings can be confidently attributed to an artist known from ancient writers. The only history of painting which we can write is the history of painting on pottery, where most of the painters are anonymous and where even when we can name an artist that name gives us no further information.

We are little better off when it comes to sculpture. Here we can sometimes match up the stories of sculpture and sculptors among the Greeks, which were handed down by writers from the third century BC on, with copies of Greek sculptures made in the Roman period (see **88**, **140**, **141**, and see below, p. 163). But the sculptures on which that ancient history of sculpture focused were largely free-standing sculptures in bronze. Bronze statues were always vulnerable, being relatively easy to transport and easy also to melt down. The creation by Hellenistic and Roman scholars of a canon of artists and their works only further encouraged the acquisition of Greek art by wealthy Romans, and it is not entirely by chance that not one of the bronze sculptures which figure in ancient writings survives, or that most surviving bronzes have

been recovered from the seabed. The marble copies of famous classical bronzes vary greatly in quality and fidelity to the original, and although they afford some sense of the famous lost works (see **88**), it is the surviving original monuments which must dominate any history of Greek sculpture which we write, and those monuments are largely architectural and funerary works which attracted little ancient critical attention.

The story of archaic and classical Greek art which later Greek and Roman scholars told is the story of an art which is lost to us. Much can be done to analyse the tradition of art-historical writing which ancient authors, largely working during the Roman period, handed down to us. Fruitful too is the exploration of the terms with which ancient writers themselves assess art, and of the more or less overtly philosophical debate about the aims, nature, and effects of art which those writers sustain. But to discover what later Greeks and Romans came to think of the art of their past and how some Greek contemporaries analysed works of art is not to discover the history of Greek art. The self-consciousness to which ancient discussions of artists' aims draws attention is indeed important for our understanding of what sorts of factors might be involved in the creation of an extant work of art, but just because it is the philosophical discussion which survives does not mean that it was the philosophical issues alone that artists addressed. At best ancient writers are telling us but a small part of the story: they tell us *a* story about lost art, and although scholars in the past have often been keen to do so, we cannot turn that into *the* story about surviving art.

The history of art at work

If we cannot write a history of private patronage, or relate art to the lives of individual artists, what sort of a history of Greek art can we write? The loss of the personal context for the production of works of art in the Greek world actually has some positive advantages. Very little Greek art of the archaic and classical period was created for the admiring gaze of the art connoisseur. Works of art worked: they worked in public, conveying messages about the dead, helping to construct relations between humanity and the gods, marking sporting or political achievements; and they worked in private, entering into the discourse of the highly discursive private gatherings to compete in wit, wisdom, self-control, singing, and sexual conquest known as *symposia*. For most works of art surviving from Greek antiquity, we have a pretty good idea about the general context in which they were displayed.

This history of Greek art is a history of art at work, of the way in which a group of closely linked small-scale societies communicated in images, of the way in which such visual communications related to oral and written communications, and of the connections between art and social and political life. That we must write about painting on tens of thousands of pots, rather than merely hundreds of panels, liberates as well as constrains: we are able to observe the trends in choice of scene, nature of composition, style of draughtsmanship, use of colour, and technique at more than just an individual level, and can be confident that we observe the changing tastes of purchasers, rather than the quirky demands of a particular patron or the battle of an avant-garde individual against an unenlightened market. That we must write of sculptures from temples and cemeteries forces us to appreciate how the sculptures related to their cultural setting, both in general (death, the gods) and in particular (programmatic relations with other sculptures on the same building or in the same cemetery). The social history of art

is not something other than the formal history of art: the rich contextual information which we have for archaic and classical Greek art enables us to see how form and content interact, as members of a community negotiate places for themselves among their peers and before the gods. Two case studies, one of a set of monuments put up in a public context and the other of art for use in a private context, will show how studying Greek art in its context brings out the social and political importance of what art represents and how it represents it.

The status of art in classical Athens

In the year 394–393 BC the Athenians erected a public monument to those who died fighting for the city during that year [2]. Above an inscription, which listed the dead by name, was carved a relief, the left-hand third of which is lost, showing a cavalryman on a rearing horse aiming his spear at a collapsing naked, infantryman, behind whom advances another foot-soldier (hoplite). A fine demonstration of the difference between a naturalistic and a realistic art, this relief in no way represents real-life battle: none of the participants is properly armed, the cavalry charger is a mere pony, and cavalry and infantry

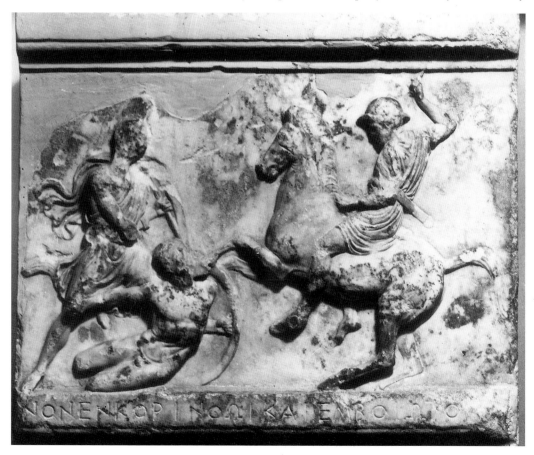

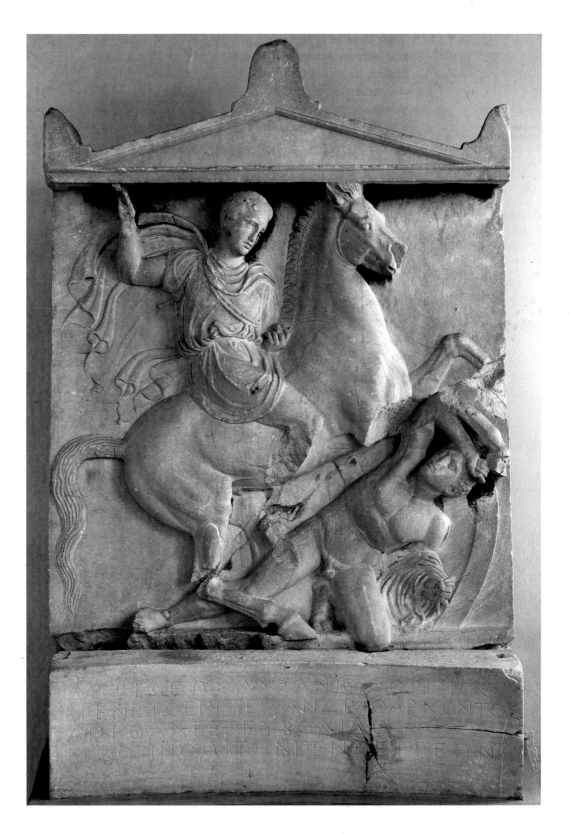

Everything about this large monument is of exceptionally high quality—the sculpture, the architectural detailing of the *stele*, the cutting of the letters. Dexileos' family seem to have spared no expense to impress their loss and their son's youthful achievements upon fellow Athenians who visited the main Athenian cemetery of the Kerameikos.

did not meet head on in battle. Rather, the combination of glorious cavalryman and dashing hoplite give credit to both the divisions of the Athenian army, while the awkward and vulnerable body of the naked victim of war gives this monument to war dead the necessary pathetic charge.

Such a commemoration, however, was evidently not sufficient in the eyes of some relatives or friends, and we possess two further monuments also erected to war dead of 394–393 BC. One commemorates twelve members of the cavalry who died in this year, once more listing them by name; it too included a relief, although the relief is now lost. The other commemorates just one of those cavalrymen, a certain Dexileos, recording the name of his father and of his *deme* (village), together with the year of his birth and the year of his death. Beyond the information given here, from which we can tell that he was aged nineteen or twenty when he died, we know very little about Dexileos. The inscription is overshadowed by a relief [3] showing a mounted warrior on a rearing horse triumphing over a naked infantryman who raises his right, spear-carrying arm, not in attack but to shield himself. Although the body of Dexileos must have been included in the public burial of the war dead, his monument dominated an imposing funerary enclosure which included also two sculpted sirens and two further gravestones, although these lacked sculpture.

Dexileos' is the only grave monument from classical Athens which gives the date of birth of the deceased, and it must surely do so for good reason. The date of birth demonstrates, in a very official way, how old, or rather how young, this cavalryman was at the time of his death. To show that might be simply to make a point about the waste of young life, but it is not unlikely that in this case there is a more precise political point. In the last dozen years of the fifth century, as Athens lost her long war against Sparta, there were two attempts to subvert the democracy and establish a more narrowly based regime in which only the wealthy would have a say in politics. Both coups were short-lived and violent—different ancient sources say that 1,500 or 2,500 were killed during the second coup. The cavalry were more or less closely associated with both coups, and when democracy was restored a contemporary historian, Xenophon, tells us that the Athenians took the opportunity offered by a Spartan request for support for a foreign expedition to send off three hundred cavalrymen 'considering that it would be a gain for them if they went and died abroad'. By showing that Dexileos was only twenty when he died, and so only ten at the time of the second coup, this memorial disassociates him from responsibility for those events. By erecting this monument to Dexileos in their funerary enclosure the family could bask in his glory and his innocence.

If the text of Dexileos' monument attempts to show that he was, by

the criteria of democrats, politically sound, the relief sculpture carries a more brazen message. In the archaic period (see below, p. 89) wealthy Athenians had commemorated men who died young with images of them as athletes or soldiers, but in the fifth century such images had disappeared. Late-fifth-century grave reliefs were dominated by domestic scenes, and when soldiers appeared they were generally shown taking leave of their families as they went to war. Dexileos' relief is different. It takes up the iconography of the state monument, and transforms it. Where the warriors of the state monument stand indifferently for hoplites and cavalrymen, officers and men, and offer recognition of both the glory and the pathos of war, the cavalryman on Dexileos' monument cannot but stand for Dexileos himself. The compact and finely balanced composition shows Dexileos' horse, identifiable as a stallion, framing and towering over the cowering infantryman, a still vigorous naked warrior but one entirely at Dexileos' mercy. The relaxed Dexileos, rendered flamboyant by his flying cloak, contrasts sharply both with the excited horse, with its throbbing veins and flanks, and the tense infantryman, and he exudes an effortless superiority which recognizes as difficult only the moral pain of the killing of brave young men in war—a moral pain enhanced by the fact that this is a funerary monument, and that Dexileos himself has been killed.

Dexileos' monument belongs clearly in the tradition of late-fifth-century relief sculpture. His head can be compared with the heads of the young cavalrymen of the Parthenon frieze [**108**], the composition owes something to the tradition of temple metopes [**105–7**], and the drapery treatment comes close to that on the frieze of the temple of Apollo at Bassai [**125, 126**]. But to identify the position of this relief purely in stylistic terms is to miss what this monument does. This monument takes the language in which the glorious achievements of heroes have been presented in temple sculptures, and takes the self-representation which the Parthenon frieze (see below, p. 180) had offered to the democratic Athenians, and marries them to create a new image which can claim to stay within the idealizing non-portrait tradition of the frieze while arrogating to itself, and to a particular individual, the glory of heroic achievements. The contrast between Dexileos' relief and the relief commemorating all the war dead of that year shows nicely how, within the same stylistic tradition, differing composition and greater delicacy of execution can combine to enable quite different political and social work to be done.

Art and private life

Towards the end of the sixth century a painter, whose name and status we do not know, painted a wine cup in the then relatively novel red-figure technique [**5–7**]. Although the cup ended up in a tomb at Vulci

Red-figure cup thought to
be an early work by Douris,
c.500 BC.

This scene shows the
characteristic activities of the
symposion: of the three
bearded men who recline and
party one drinks, holding the
cup by its foot, one plays a
game with his drinking cup in
which drops of wine are
thrown at another person by
spinning the cup round the
finger, and one sings and
accompanies himself on the
lyre (see **69** below). For the
pot shapes shown below the
diners see below, p. 114–15.

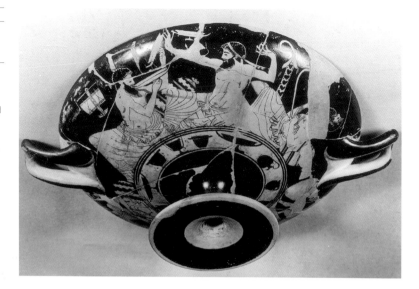

in Etruria, the inscriptions on it naming a number of young men as
beautiful strongly suggest that it was made with an Athenian market
primarily in mind. It is from the name of one of those boys, dubbed
'beautiful' on this and on four other cups attributable to the same hand,
that the painter has been given a name by modern scholars: the
Epeleios Painter.

Shallow cups like this, with a flaring foot on a short stem and two
handles, were part of the equipment of those more or less exclusive
symposia at which men reclined on couches arranged round the edges
of a small room, in the centre of which would stand a mixing bowl from
which young serving boys or women would refill the cups [**4**] (compare
69, 72, 92). With music provided by their own playing of the lyre, or by
young men or women playing the pipes, participants would sing songs
or compete in story-telling or argument on a set theme (as in the works
entitled *Symposion* by Plato and by Xenophon), while a master of cere-
monies regulated the quantity of wine and the proportion of water to
be mixed with it.

Like many cups painted at this period, this cup reflects the proceed-
ings in which it was used. The interior of the cup [**5**] shows a satyr
struggling to squeeze the contents of a wine skin into a garlanded mix-
ing bowl. Satyrs play almost no part in Greek mythology, but from his
first appearance in Greek art they are the customary followers of
Dionysos, the god most closely associated with wine. Their modified
human form (they have the tail and the ears of a horse) and mixture of
human and bestial behaviour made them a favourite means of reflect-
ing on the limits of acceptable human social and sexual behaviour, both
on painted pottery and in drama. It was precisely at this period that the
convention grew up of concluding the performance of three tragedies

5

Interior of cup attributed to the
Epeleios Painter, *c.*510 BC.
The satyr of this cup cele-
brates the 'sweet wine' in
words which pour out of his
mouth, and is labelled 'Terpon
the Silen' or 'a Silen enjoying
himself'. Behind his back and
between his legs are the words
kalos Epeleios (Epeleios is a
beauty).

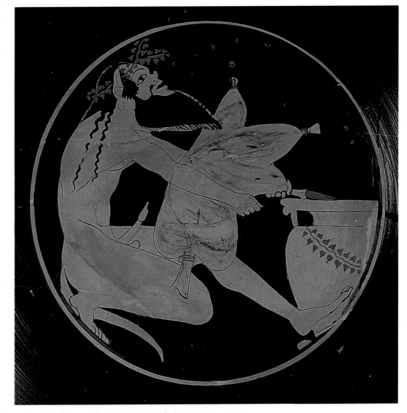

by a single author with a satyr play by the same author in which a famil-
iar myth was humorously set in a world of satyrs. The painter makes
the satyr here brace his tipsy self against the round field of the cup inte-
rior, and uses the sensuous bursting out of the wine from the manipu-
lated skin, which is emphasized by the upturned head of the satyr, to
reinforce the sexual charge of the occasion as indicated by the satyr's
customary sexual excitement and the homoerotic greeting of Epeleios.

A somewhat gentler eroticism pervades the scenes on the exterior of
the cup. On one side [**6**] we see continued revelling around a centrally
placed mixing bowl. Beside the mixing bowl a bearded man holding a
lyre and wearing a turban, which has exotic and perhaps effeminate
overtones (compare **69**), and a younger man with a *skyphos* evoke the
ordered and cultured activities of the *symposion*. But the figures further
away have moved into another stage of proceedings: to the right
the bearded man with a drinking horn and the younger man with a
wine skin belong to the world in which the god Dionysos is celebrated
neat; to the left drinking has been abandoned and bodily display and
gestures of seduction materialize the homoerotic intentions conveyed
by yet more 'x is (very) beautiful' inscriptions. On the other side [**7**] no
wine is in evidence, and the seduction is heterosexual: a bearded figure
wrestles with a woman whose companions brandish fish and make

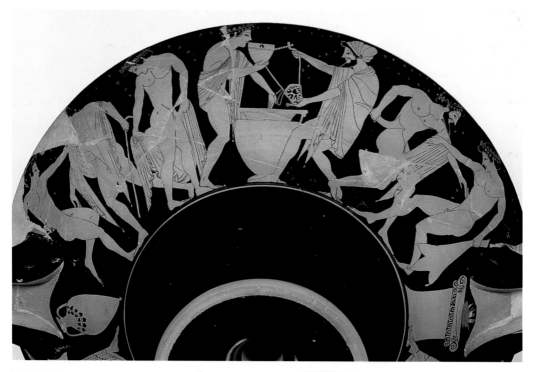

6

One side of the exterior of the same cup by the Epeleios Painter.

The mixing bowl occupies centre stage here, as at a *symposion*, but the symposiasts have got up from their couches and begun the homoerotic seductions and excesses of the revel.

gestures of alarm. This is a mythological scene much in favour in the late sixth and early fifth century: Peleus wrestles to gain the marine goddess Thetis whose ability to turn into animals (hence the lion on Peleus' shoulder here), and even into fire, demanded that he be a determined suitor. Fated to give birth to a son greater than his father, Thetis was shunned by fearful gods, but they came to her wedding to Peleus, an occasion much represented as the ideal wedding [**41–3**], and Peleus and Thetis became the parents of the hero Achilles.

The scenes on this pot, as on the vast majority of pots, are not themselves original: each scene can be more or less closely paralleled on other vases. The discourse about drink and sex to which this vase contributes is one in which the scenes on a very large number of drinking vessels engage, and the easy movement from social rituals to religious behaviour, from myth to contemporary Athenian life is a feature of much painted pottery of this date. But no other cup presents these scenes in quite this way, and no other cup chooses to combine this set of scenes. What the combination does is to suggest links between facets of Athenian life normally kept separate: the excess of the satyr and the revels of citizens; the party drinking and the worship of Dionysos; the homoeroticism of the *symposion* and marriage. By turning the wine skin into an object of sexual delight, which nevertheless has to be wrestled with, the painter humorously likens the satyr to Peleus, Thetis to a wineskin. By abundant use of inscriptions the painter throws his scene into the contemporary life of the actual

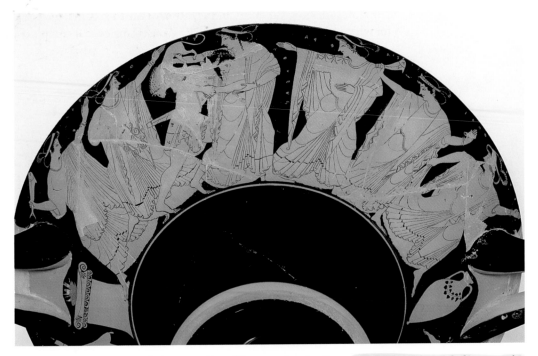

The other side of the exterior of the same cup by the Epeleios Painter.

To the homoerotic courtship on the other side of the cup this side juxtaposes Peleus' courtship of Thetis, alarming her sea-nymph companions. Greek texts often refer to marriage as 'taming', and Thetis' ability to turn into animals highlights women's potential wildness.

Athenian élite. The turning bodies, which the new red-figure technique had given the painters greater scope to explore (see below pp. 136–9), emphasize bodily display and enable relations between figures to be rendered with delicacy.

Individual pots like this only rarely proved to be influential even in the history of ceramic art. While a case can be made for Dexileos' relief establishing the classic form for a cavalryman's monument, which would be much repeated throughout the Greek and Roman world and beyond, no case can be made for the Epeleios Painter's pot exercising any influence. Its importance lies in what it tells us about the uses of art in classical Greece, about the place of art in private social discourse, and about the contents of that discourse. By seeing what painters did with their developing abilities to evoke bodily forms and to render textures and poses, we can see how the technical developments on which the history of painting traditionally concentrates are intimately linked with iconographic developments, and can highlight the contribution which artists made to the way Athenians viewed their own social actions and constructed their own identity.

The contextual information which archaeology provides for works of archaic and classical Greek art will never enable us to re-enter the artist's studio or recreate the webs of private patronage. But it does give us an opportunity to see art being consumed, and so to see the mutual interaction of artworks and society. By doing so it uncovers the complex relationship between the way sculptures are carved or pictures drawn, the choice of object or scene to depict, and the political, social,

moral, and theological values and activities of the society in which, and for which, the depiction takes place. It is something of that complexity which the following pages attempt systematically to expose.

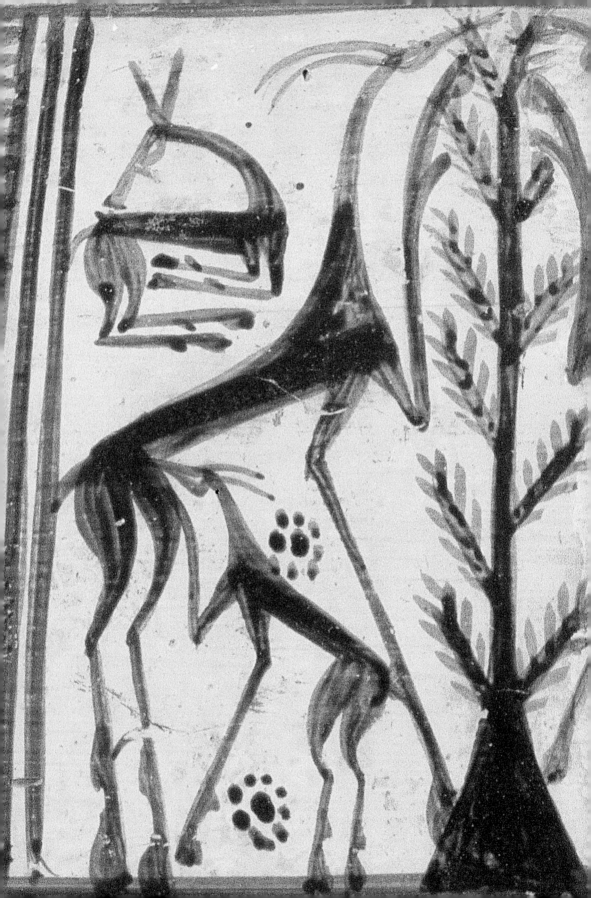

From Praying to Playing: Art in the Eighth Century BC

2

Writing, monumental architecture, wall-painting, figurative art of any kind, specialist metal-working techniques, all these were lost with the collapse of the Mycenaean palatial system in the twelfth century BC. Only in the tradition of high-quality wheel-made pottery can a convincing case be made on the Greek mainland for any continuity over the so-called Dark Age between Bronze Age and early Iron Age art. In sculpture, except perhaps in Crete, an artistic tradition had to be created essentially from scratch. In painting, however, pots, and not panels or walls, first attracted artists' endeavours, and this created a rather different situation. The survival of potting skills meant that in mainland Greece, though again not to the same extent in Crete, figurative art had to be reinvented within a strong non-figurative tradition, and artists, who may occasionally have encountered Mycenaean objects and certainly handled some imported prestige items from the Near East, had to find a place for figure drawing within that abstract tradition.

All the objects discussed in this chapter were made to be used, not just to be looked at. Much of the sculpture was made to be dedicated in sanctuaries, and by its forms and value expressed the concerns and gratitude of the dedicator. Much of the surviving pottery comes from graves, where pots were initially used primarily to contain the cremated remains of the dead, and later employed also as markers on top of the grave. Both in sanctuaries and in cemeteries these objects addressed contemporaries as well as unseen powers, but the sorts of statement it was appropriate to make in the two circumstances were different, and context as well as date plays a major role in shaping artistic developments. For that reason the sculpture and the pottery of the early Iron Age are in the first place best examined separately.

Detail of 12

Modelling horses

The sculptural tradition which grew up in the early Iron Age in mainland Greece is dominated by small works, mostly in bronze, and by the horse. The Mycenaean world too had lacked large sculptures, but its figurine traditions were dominated by terracottas and by two types: goddess figurines with folded or part-raised arms, and bovine cattle. Although sanctuaries continue to be the main focus for sculptural activity in mainland Greece, the statuettes from the ninth and eighth centuries are more often of horses than of anything else. At the end of the eighth century the horse quite suddenly lost popularity and was never again an important part of bronze or terracotta figurine tradition.

Mostly between 6 and 12 cm. in height, though some are still smaller and some reach 18 cm., bronze horse figurines were made all over the mainland Greek world in the eighth century in a number of distinct regional styles, all of which changed slowly over time. Most were made as independent offerings, though some were attachments for larger bronze items, particularly tripod cauldrons. It is possible both to trace a general evolution and to explore the different choices and priorities made by different 'schools' of artists in different places. And since the regions were not isolated from one another, but artists met quite regularly on such occasions as the Olympic games, according to tradition first held in 776 BC, at which they made and sold their wares, contact and influence can also be traced as different local traditions culled insights and methods from each other.

The earliest bronze horse figurines were inspired in part by work in clay. Clay horse figurines are found both separately and, from the end of the ninth century, individually or in groups, as the handles of lids of vessels. Clay horses tend, in part for practical reasons, to have straight, stout legs, bodies only a little fuller over the flanks, and tall and upright necks with small heads with rounded muzzles. In the earliest bronze horses the legs are often short, muzzles round, and legs and bodies flow into one another without separate articulation. In these early products little use is made of the special properties of bronze, and only the neck marks the animal out as equine. Later products bring out what is distinctive about the horse in a variety of different ways, best illustrated by two contrasting regional products.

The Peloponnesian sanctuaries of Zeus at Olympia and of Artemis at Lousoi in northern Arkadia have yielded a large number of Argive horse statuettes of the middle of the eighth century marked by what might be termed a rider's understanding of the horse [8]. Here the back legs are carefully articulated to catch the lines peculiar to a horse and the way in which those lines give the whole creature a peculiarly delicate balance, but the upper part of the back leg is made to grow into the body in an uninterrupted curve, both in profile and in cross-section, which catches something of the sleekness, as well as the power, of a

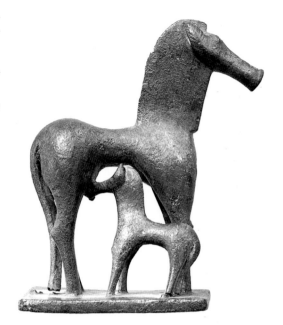

horse's flanks. The withers, by comparison, are of much reduced dimensions, creating a delicate bridge to the rounded power of the forequarters, which slim into a broad neck, of rather flat section, and a round muzzle, slightly thickening at the nose, with laid-back ears. While the nuzzling foal, with its shorter legs and smoother transitions, brings out some maternal softness, the mare here gives a proud and stately impression of power and good grooming.

Perhaps two decades later than this group, a Corinthian artist produced a work differing in the additive technique employed, and very different in conception [**9**]. The finest of a group of fine large stallions, this exceptional piece, 16 cm. high, is unusually highly finished. This is not a rider's horse, it is an artist's horse. Both front and rear flanks are contoured so cleanly, with almost mathematical precision, as to emphasize their hollowness; the body, whose extreme delicacy is a standard Corinthian feature, is here rather more compact than in other Corinthian work, and the neck more upright, so that the curve of the hindquarters is picked up by the curve of the ears. The proud tail, with its elegant double curve, by picking up and drawing attention to the line offered by the genitals further enhances this balance. The neck is given the same width as the top of the forelegs so that they combine into one element, but the continuous front contour is broken in decisive fashion by the fetlocks. The long muzzle, small in diameter and circular in section, has an upward slant which gives the whole creature a frisky alertness, once further enhanced by the insertion of an iron eye, framed by the continuous curve of the ear. The base of the neck is treated to delicate geometric surface patterning which complements the spareness of the plastic forms.

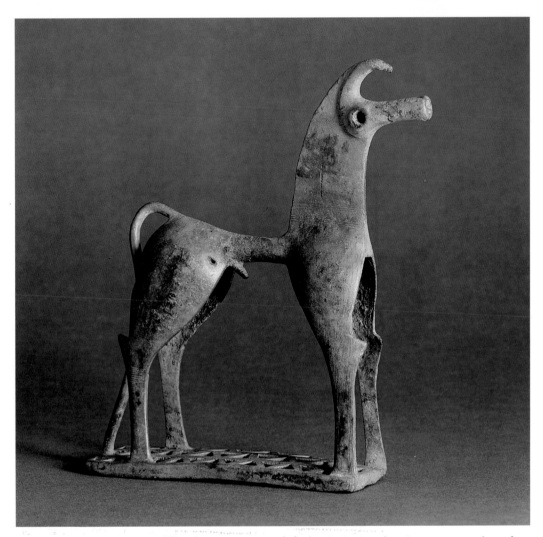

Bronze stallion of Corinthian manufacture, third quarter of eighth century BC. This exceptionally large piece takes a small number of characteristic equine features and treats them as material for an exercise in line and contour, employing engravings that have no relation to the markings of a real horse in order to delight and intrigue the eye.

The Argive mare and foal pair invite the viewer to touch and to turn: they operate fully in three dimensions. The Corinthian stallion operates if not as a silhouette then certainly as a relief, and is essentially to be seen from the side. Where the Argive pair give a sense of recapturing a glimpse of mother and foal together in a field, the Corinthian stallion makes scant reference back to visual experience. A few salient equine details are employed to create a work of art which turns the irregularities and tendernesses of life into regular forms, but combines those forms into a whole which coheres less because that is how horses are than because, for this culture at least, that makes aesthetic sense. Particular features of the horse are taken, purified, and re-combined.

Both these statuettes were probably dedicated in sanctuaries in the Peloponnese. Although there are significant numbers of sanctuaries active in the eighth century which received no horse dedications, many worshippers chose to relate to many different gods through the

dedication of horse figurines, at sanctuaries in towns as well as those in the country. But what exactly were they doing by making such dedications? And how did the form of the bronzes relate to the act of dedication? That there was a social or socio-religious dimension to the dedication of horse figurines in the eighth century is strongly suggested by the fact that the end of the century brings both a repudiation of the style and a virtually complete end to the dedication of all statuettes of horses.

To understand why horses were so important, and why they might in particular lend themselves to this sort of representation, we need to conjure up a view of the social status of the horse. The horse was of little economic use in antiquity. The ox, the donkey, and the mule were the basic traction animals; the horse was good to race but otherwise, on its own or pulling a chariot, offered rapid transportation only to individuals. It may have been of some use in warfare, although the evidence is hard to interpret. There can be little doubt that owning horses was, in the eighth century as later, a sign of status, of conspicuous expenditure, and of power. In offering equine images to the gods, worshippers make a statement both about their own power, and about the power of the gods. In dedicating in miniature a gift whose real-life equivalent would both acknowledge and grant power the worshipper lays claim to be the type of person who deserves the prosperity that allows horse ownership and the power that stems from it. Power can be imaged by animals of various kinds, by virtue of their wildness or their vital role in human survival; but the power of the horse is essentially a social construct. In their different ways both the Argive mare and foal and the Corinthian stallion directly image this social construction, the former by capturing a moment and a relationship, the latter by its very reconstruction of a horse from the analysis of selected equine forms.

Horse statuettes carried a sociological burden, but also a theological one. As they illustrated, and thereby justified, the established systems of social ranking, so they also presumed a divine world which not only shared both the structural principles and the particular values of the human world but also guaranteed those principles and values. Divine power too, as imaged by these horse figurines, was a matter of rank and access to goods, rather than, for example, a matter of brute force. Just as the act of dedication itself presupposes the possibility of negotiating one's standing vis-à-vis the gods, so making dedications of socially constructed status symbols presupposes that the gods too negotiate their powers.

The dramatic history of horse figurines, which disappear virtually completely from the sanctuaries of southern Greece around 700 BC, is thus not a matter of art history alone. But to understand further its social and theological implications, it is necessary to look more widely at the art of the eighth century.

Modelling men

There is some variety in the poses of horses, but they can rarely be said to do anything: they just stand there. Human figures, by contrast, do things. They weep, embrace, dance; they make, carry, and use arms and armour; they ride side-saddle, ride in chariots, play music, handle or fight animals. Statuettes of human figures, too, are found primarily in sanctuaries, but they are far less standardized in type than the statuettes of horses, and although warrior figures are clearly competitive assertions of status many other figures seem more innocently celebratory of human activity.

Eighth-century artists are certainly capable of applying to men the sort of analysis of form apparent in the treatment of horses. This is most obvious in the group from the sanctuary at Olympia of a man grappling with a centaur [**10**]. Here the treatment of the equine part of the centaur is entirely in the tradition of Lakonian work of the middle of the eighth century; indeed it is likely that two surviving bronzes, which share the distinctive marking out of the hoofs, can be identified as by the very same hand. This equine part, and the lower parts of both human bodies where the artist emphasizes the curves of calves and buttocks and the protrusion of male genitals, operate essentially in profile, but from the waist to the head the human figures have no profile and their flattened torsos can be appreciated only from front or rear, when the triangular formalization becomes apparent. It is only from the waist up, moreover, that the figures are engaged in action—violent action, for it seems that the human figure was striking the

10

Bronze group of man fighting a centaur of Lakonian manufacture, third quarter of eighth century BC.

Artists used statuettes of the horse to analyse and explore natural form, but the centaur here seems to have been created not in its own right but to explore encounter and action.

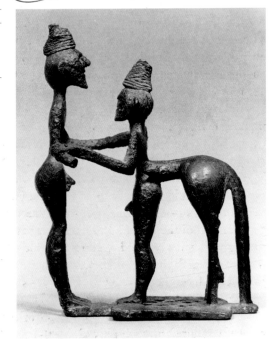

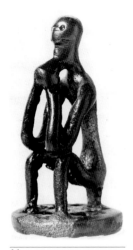

11

Bronze statuette of a seated figure holding something to his lips, end of eighth century BC.

Also Lakonian but in strong contrast to the previous figure, this seated man is conceived in terms of line rather than bulk, and it is the figure's attitude, rather than any fixed attributes, that is stressed, making it quite different from animal statuettes.

centaur with a sword. Here we have a sculptor used to producing horses who treats the human body as a horse's body, bringing out characterizing details. But as man is introduced, so too is action.

The very different treatment of men on their own can be seen in another work of Lakonian workmanship, found this time at Sparta itself at the sanctuary of Artemis Orthia and dating rather later in the eighth century [11]. Far from being a near-two-dimensional analysis of form, this tiny work (7 cm. high) treats the human body as something that can be bent and stretched at will and ignores detailed human features or such issues as clothing. Set on a round base, and to be appreciated only in the round, a gangling but also elegant human body is presented with great economy of means, as the relaxed, slightly vacant, pleasure of the action, be it drinking or making music, is conveyed by pose and balance alone. Human figures don't (just) symbolize, they do things, and the things they do are of interest for their mental as well as their physical side. It can be no surprise that human figures found a continuing place in the artistic commentary on Greek society after 700 BC in the way that horse figurines did not.

The figure as a decorative element

The story of Greek pottery from the end of the Mycenaean period to the end of the eighth century is one of increasing elaboration of geometrical decoration. Although the shapes of pots made during this 'Dark Age' owed something to Mycenaean traditions, there was an important break in decorative conventions. Many decorative elements in Bronze Age pottery can be seen as stylizations of forms in the natural world; the decorative elements of early Iron Age Greek pottery are so purely geometrical as to have led to the classification of the pots, and indeed sometimes the period, as protogeometric (broadly, tenth century), early geometric (most of the ninth century), middle geometric (end of ninth to middle of eighth century), and late geometric (second half of eighth century). Spirals go out, concentric circles come in, and then Athenian pot painters, who seem to have taken the lead throughout the Dark Ages, banish even concentric circles and replace wavy lines by meanders which turn strict right angles; continuous bands of decoration are preferred except where handles interrupt.

The context in which the pots were used at Athens makes it clear that both pot shape and in some cases pot decoration constituted a language. Most of the pots known from this period have been recovered from graves, whether used as containers for ashes (cremation was the normal way of disposing of the dead in much of Greece from the tenth to the eighth century), as grave markers, or simply deposited in graves as grave goods. *Krateres*, which were used in life to mix wine and water according to the direction of the master of the feast, were stood on male graves, amphorae with handles at the neck (in life, storage vessels

Figures first appeared on parts of pots where features such as handles prevented continuous decorative bands; here the frieze of grazing deer and birds around the widest part of this pot divides the decoration between bands of curvilinear motifs on the lower half, and panels of figurative and straight-line motifs on the upper half.

in which wine or oil might be kept) were used to contain men's bones; amphorae with handles at the belly or shoulder level (in life shoulder-handled amphorae at least seem to have been water-carrying vessels) were used on female graves and to contain female bones. The selection of decorative motifs on belly-handled amphorae used as ash urns and on *krateres* used as grave markers in the ninth century so marks them out from other vessels as to suggest that pots with particular decorative schemes were commissioned.

Figures make their way only slowly into this geometric world. In Crete, where rigorously geometric pottery was late to arrive and short-lived, human figures and ships appear on vases in the early ninth century and animal scenes may even be allowed to dominate; but on the mainland the first figures to be used are isolated horses, and a human figure finds a place only in the second half of the ninth century—at the same time as animals of all sorts become relatively common at Athens and terracotta horses appear as lid handles. Figurative decoration becomes a significant part of vase decoration anywhere in mainland Greece only in the middle of the eighth century. In most regional workshops figures are used in small numbers, but in Athens there is an explosion of figurative decoration, and some large vessels are decorated with more than a hundred figures.

The relationship of figures to pots is well seen on two pots, one Athenian and one Euboian, both from the middle of the eighth century, the beginning of the style known as Late Geometric. The Euboian pot, known as the Cesnola *krater* because it was once in the Cesnola collection, was actually found at Kourion in Cyprus [12]. An ovoid *krater* with a lid whose handle takes the form of a miniature *hydria* (water-jug), the shape and the selection of its decorative motifs, particularly the strings of concentric circles linked as if spirals, mark this out from Athenian products. In the conception and use of figures this vessel typifies much of the most elaborate of Geometric pottery outside Athens. The horses, deer, and birds are used as a further decorative motif, arranged not to recreate a scene of life in the wild but to fill a field in a balanced, often symmetrical, way. They appear both in a continuous frieze, in which the space beneath the grazing quadruped is filled, apparently indifferently, by a grazing bird or a lozenge on which a cross is superimposed; and in separate panels, including a central one with a heraldic arrangement. Both in form and arrangement the figures cause minimal disruption to the rhythmic organization of the surface of the vase. Indeed the arrangement exploits their novelty to emphasize the widest part of the vessel with the continuous frieze and then draws the eye from the horizontal to the vertical dimension by the panels between the handles, thus minimizing the disruption caused by the handles and, through the stretching of the long-necked deer of the central panel to chew on the top branches of the tree which separates

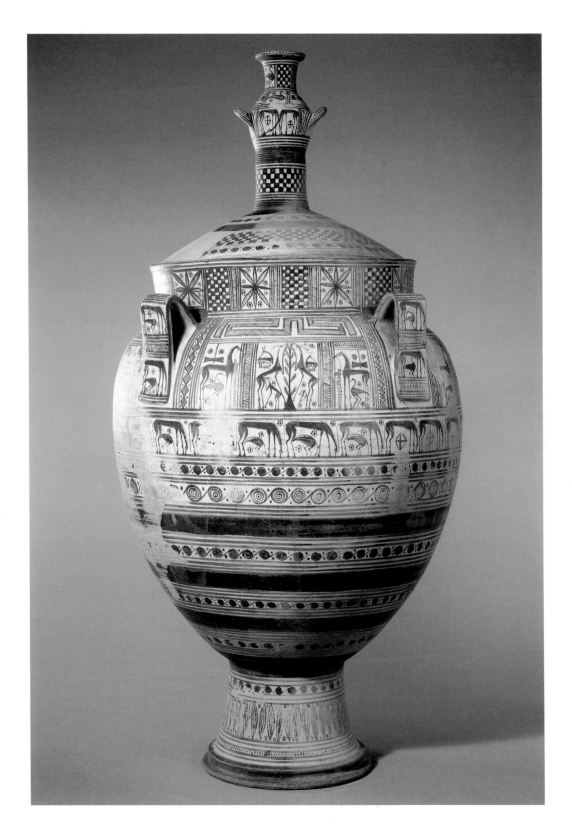

them, drawing the eye upwards to the vertical accent provided by the elaborate handle on the lid.

Are the figures on this vase more than another decorative element, preferred to purely geometric motifs because their irregularity combats boredom? The peculiar role of the horse in the figurines of this period (encourages the notion that their presence here might not be random,) and the close association of horses at mangers with double axes on this pot further reinforces that idea. More than two centuries before this pot was made, a man of power at the important Dark Age site of Lefkandi in Euboia had been buried with a pair of horses, evidently slaughtered on his grave, and a great building had been erected over him. (Without men appearing at all, this pot gives a message of wealth and of power which will have been easily appreciated throughout a world in which the tradition of epic poetry extolled the virtue of Greek and Trojan heroes alike in terms of powers of horse-taming.)

In some ways the Athenian *krater* [13] uses figures in a closely comparable way. The horizontal thrust of a frieze made up by repeating the same warrior and chariot element is counterbalanced by the central focus of the scene of the laying out of a corpse surrounded by mourners which, although continuous, might as well have been three separate panels. Representational figures and filling motifs jockey for position, and the occasional birds seem but a variation on dots in circles or triangles in squares.

In other ways the Athenian pot is completely different (It is not simply that human figures dominate) rather than animals, although that is important, but that we can talk of a scene. The mourners and the dead man on the bier relate directly to one another, the warriors and charioteers form a procession: we can place these figures not just as a snapshot, but as part of a movie, participants not just in an event but in a process. Placed on a pot which marked a man's grave, these scenes do not merely symbolize his status, they call directly to mind both the characteristic acts of a male member of a community and the particular rituals of his departure. A whole series of grave markers from the middle and later part of the eighth century from Athens bears scenes of the laying out of the male or female corpse (gendered by showing women skirted) in the company of standing, seated, or kneeling mourners (often not gendered) who raise their hands to tear their hair. The elements that go to make up these scenes are common, but the variety of ways in which they are combined and the variation in details—such as the small figures at the feet of the corpse or the goats beneath the bier here—have encouraged the view that contemporaries would see particular and not simply generic references in each of these scenes.

A great artistic step has been taken to get from the Euboian *krater* to this Athenian work. It is not a step which involves technical skill in drawing, nor is it a step which changes the relationship between the

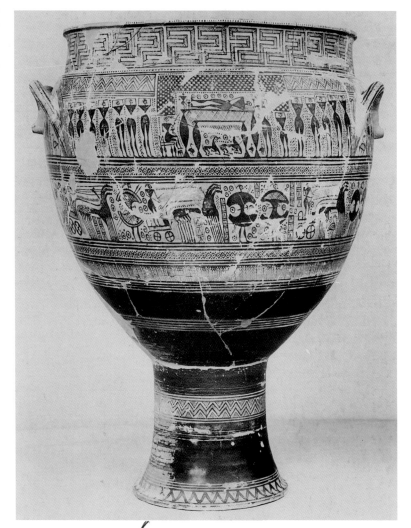

pot and its decoration. What has changed is the relationship between painting and viewer. The figures on the Euboian *krater* take their place with the decoration: just as ornamental intricacy may evoke a world of elaborate weaving and highly wrought jewellery, so the grazing animals and heraldic symbols too evoke a world of wealth without engaging the viewer in any relationship to that world. But the funerary scene and procession on the Athenian pot, whatever their precise relationship to any real-life events, invite the viewer to engage in the world they view and enter into the fantasy life of the before and after of the picture. By drawing attention to the rituals which preceded its own placement on a tomb, this *krater* opens a dialogue between art and life. It is not surprising that this society-specific Athenian Late Geometric pottery was not exported.

The limitations of the scene need to be appreciated, as well as its new potential. The figures remain only variations on geometric

ornamentation. Essentially identical forms are repeated in a composition which depends primarily on addition. By this means the upper frieze very successfully evokes the repetitive and formalized gestures of the thronging mourners and their lamentations at the funerary ritual. In the lower frieze, which lacks the central focus provided by the bier, each repeated figure seems to owe its form to its position in the pattern. The figures in this lower frieze are not exactly duplicated on any other surviving *krater*, and we cannot entirely dismiss the possibility that there are features of the frieze which would have called to a contemporary mind some particular circumstances connected with the dead man or his last rites. It is, however, as symbols that the figures here must function, not as part of a story. Without any attempt to give priority to one figure rather than another, and without any engagement between the figures, there can be no cue to narrative. Whether scenes of warriors and charioteers evoke in the viewer something to be seen in Athens or a memory of epic stories, it can be only a state of being, not of becoming, that is at issue.

Stories and statements

Not all figured scenes on Athenian vases of the middle of the eighth century, of the style known as Late Geometric I, are uneventful, but the events never become stories. Some *krateres* show large-scale fighting scenes in which variously armed warriors duel and corpses pile up. Painters evidently sometimes wished to distinguish between different armies in these encounters, for they employ different shapes of shield for the different sides—square for one side and the 'Dipylon' shield form, seen on the lower frieze of the Athenian *krater* just discussed, for the other. Named after the cemetery at Athens in which many pots showing it were found, the Dipylon shield has been much discussed, for it is not clear that it resembled any contemporary armour and some have suggested that it was inspired by memories of Bronze Age armour. But that both square and round shields are also found, and that the Dipylon shield appears as a blazon on a round shield, warn against reading too much significance into the variations. Similarly, the occasional joined figures that occur among the generally discrete warriors should probably not be seen as alluding to the specific stories of the siamese twin sons of Aktor who appear in epic tradition—particularly since the twin figures appear more than once in one scene. That epic tradition and/or distinguished ancestors who fought in the battles that tradition recorded are being invoked, receives scant support from the rest of the archaeological record.

What happens in later geometric pottery at Athens is not so much the development of art as story-telling, more the exploitation of the relationship between figured scenes and the viewer's situation across a broader range of social settings. Pots in fact largely ceased to be used as

Athenian Late Geometric
oinochoe (wine jug), last
quarter of eighth century BC.
The complex shipwreck scene
on the neck stands out from
the simplified geometric
pattern and bird frieze of the
body. The impression of
confusion given by the
wrecking is in fact carefully
constructed: figures radiate
from the centre of the scene,
and the ribs of the boat afford
visual stability, as well as
support for the survivor.

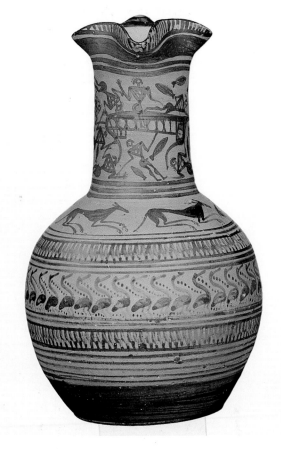

grave markers from about 730 BC, and the pots put into graves now
seem to be those made for use in life, rather than specially for the tomb.

One of the most popular shapes for figured decoration in Late
Geometric II is the *oinochoe* or wine jug, and as it happens we have di-
rect evidence for the active interplay between the users of this vessel
and what appears on that vessel. A party-goer, exploiting the possibil-
ity of writing which seems to have been an eighth-century invention,
scratched on the shoulder of an *oinochoe* one of the earliest of all
Athenian alphabetic inscriptions: 'Whoever of all the dancers now
plays most friskily' (the writing continues but becomes unintelligible).
As the jug is circulated the participants are encouraged to throw them-
selves into the proceedings with the possibility of taking the pot home
with them, as a permanent record of their frisky dancing.

Some, at least, of the images on *oinochoai* seem to have been simi-
larly self-referential. **14** has a body decorated with extremely formulaic
birds and a shoulder with racing hounds, but the scene on the neck is
anything but formulaic. It shows an upturned boat, the sea around it
full of fishes and men. Exactly central, below the spout of the *oinochoe*,
is a figure who is upright and overlaps the boat. Although the upper

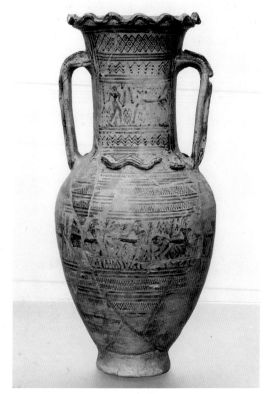

body and hand gestures are much like those of the other figures, the central and upright position argue strongly for this figure to be interpreted as balancing on the keel of the upturned boat. What is the point of this scene? Boats themselves are not uncommon in Geometric art, either in or outside Athens, and shipwreck scenes are also found elsewhere, but does that mean that the painter was thinking of the hazards of maritime life?

Once the scene on this jug is recognized as referring to a particular situation at sea there are three possible ways of interpreting it: the situation may be one of life, one from a story, or it may be in some way allegorical. To take this as a memento for a Robinson Crusoe figure, the sole survivor of a shipwreck, would be to see the scene as transferring the potential specificity of the scenes of laying and carrying out the corpse on the *krateres* and amphorae to this different vessel, and from death to life. To take this as showing the shipwrecked Odysseus, alone of his companions surviving to tell the tale, would be to see the iceberg of the great contemporary tradition about Odysseus in epic poetry raising its tip above the surface of Geometric imagery only here. To take this as a party jug, celebrating the ability to survive the waves of drunkenness which it dispenses, would be to link the pot and its use just as the scenes on the marker vases link to their use, and to suggest that the euphemistic imagery with which the complex play of self-

control and its loss in the regulated drinking of the *symposion* is surrounded in later literature is here anticipated.

It might indeed be that there is both epic allusion and allegory involved here. A Rhodian cup of *c.*720 BC discovered in a grave at Pithekoussai (the Greek settlement on the island of Ischia in the Bay of Naples) was inscribed with playful verses in which, parodying a curse formula and with reference to an epic scene which we know from the *Iliad*, it claimed to be the cup of Nestor and wished that whoever drank from it might be filled with desire by Aphrodite. That inscription, surely written for use at a party, implies that clever play with the epic tradition was a feature of such gatherings. The *oinochoe* which we have been discussing could fit into exactly the same context—playfully presenting the ability to survive a heavy drinking bout without losing one's footing as like Odysseus' ability to survive shipwreck.

It is certainly clear that the world of eighth-century Athenian potters and their clients was a world in which stories, as well as the hazards of life, had a part to play. **15** shows an Attic Late Geometric IIb amphora now in Copenhagen. This is one of a small number of pots, all apparently by the same painter (known as the Painter of Athens 894), which show centaurs. We have already seen the centaur appearing in Geometric bronzes, and indeed a terracotta centaur discovered at Lefkandi on Euboia is the earliest of all Dark Age figurines from mainland Greece. Centaurs will continue to appear from time to time throughout this book because their combination of the domesticated beast and the human offered a convenient visual way of exploring the limits of humane behaviour, but they have a rather marginal place in Greek mythology: apart from Kheiron, the centaur teacher of Achilles, they feature only in stories where either wine or sexual desire causes them to prove disruptive and belligerent. As with the bronze pair of centaur fighting man, so with the centaurs on this amphora no particular story or episode can be identified. The painter seems less to be picking out a scene than moving the viewer more generally into the world inhabited by these monsters, the world of myth. As other painters produce friezes of birds or deer, or friezes of armed men in procession, and so transport the viewer to a rural or a political world, this painter chooses centaurs and transports the viewer into the world of the story-teller.

Tensions

Geometric bronzes analyse and explore forms and may capture the body's sensuous articulations. They concern themselves with individual creatures or with simple relations between a small number of figures. Such concerns seem entirely fitting for works made to be dedicated to the gods, made to be part of an exchange that establishes a relationship with the gods. Geometric pottery looks at the repeated

16

Athenian Late Geometric gold
diadem, third quarter of eighth
century BC.

Gold diadems were made
from matrices which were
also employed to mould gold
facings for furniture. The style
of the animals here, like the
techniques displayed in much
gold jewellery, seems to owe
much to the work of craftsmen
from the Near East, and there
is some evidence for such
men taking up residence
both at Athens and at Knossos
in Crete.

actions of the observed world, the grazing of animals, the marching of men or mourning of men and women, and sees in them a play of shapes and patterns closely comparable to the play of lozenges and zigzags, key-patterns and chequerboards. That reduction of the variety of life to pattern that admits no variation makes routine the scenes depicted, establishing death, and also war, as part of life's cycle, just as grazing is. Just as the Homeric epics with their repetitive epithets establish a stability against which their narrative action is highlighted, so the repetitive patterns of Geometric pots placed in and on graves provide a standard against which the particular life is counterpointed.

Not all the objects that attracted artists' attention, however, were primarily for sanctuary or cemetery contexts. As we have just seen, both at Athens and elsewhere there are signs that in the second half of the eighth century even pots that ended up in graves were not all made for that context. Objects made for other contexts had other concerns, and the pressure created by these concerns can be seen in art from the middle of the eighth century on. Those pressures were essentially twofold: the pressure to conjure up more than just the regularity of human and animal life, and the pressure to turn statements into stories.

The need to do more than bring out the mechanical aspects of life is to be seen very clearly in the relief decoration on some Athenian goldwork of the middle of the eighth century. While some gold bands share the pot painter's approach to human and animal forms, others pioneer a very different style. Found in tombs, alongside pottery with a very different conception of how to refer to animals, gold bands such as **16** almost certainly owe a debt to the arts of the Near East, whose lithe felines and deer they emulate. Like some bronze figurines, particularly those of men, the animals here are sensuous as they ripple smoothly along. These bands were clearly made to be worn, not just to be buried, and their purpose was cosmetic—to add glory and attractiveness to the wearer: it is gold with which Aphrodite decks herself in the Homeric Hymn to her when she sets out to seduce Ankhises. If in Geometric pottery the figures can be seen as symbols which go to make up a statement, here it is not so much what the figures are as how they move, their style, that is important. The wearer of this jewellery can be seen to be doing it in style. The pots are public, formal; these bands are private and intimate. The pots make statements to all Athenians who visit the cemetery; the bands make statements to fellow members of the wealthy élite.

Something of the impetus to turn statements into stories has been seen on the Munich *oinochoe*. This is still more apparent on other Late Geometric II vessels made for party use—*oinochoai*, *krateres*, and drinking vessels. An *oinochoe* in Copenhagen [17] illustrates this pressure. On its neck, carefully centred under the lip, is a 'horse-tamer' figure, a man wearing a sword and holding two horses by their reins. Familiar on Geometric pottery outside Athens, this scene directly recalls the epic epithet 'horse-taming'; it is an image which embodies wealth, power, and skill. But the scene on the body is very differently conceived. Men standing on an oared ship are engaged in battle with men assailing them from the land on either side. Most significant here is the way in which individual warriors are distinguished: those on the ship have Dipylon shields, those on land what are presumably meant to

17

Athenian Late Geometric wine jug, last quarter of eighth century.

Similar in size and form to **14**, this jug has reduced the geometric patterns to parallel lines between scenes and zigzags and rosettes within them, and reduced the animals on the shoulder to a pattern of lines. The formulaic horse-tamer scene on the neck and the fighting on shipboard on the body are centred on the line of the jug's lip, from which the fighting scene develops in both directions.

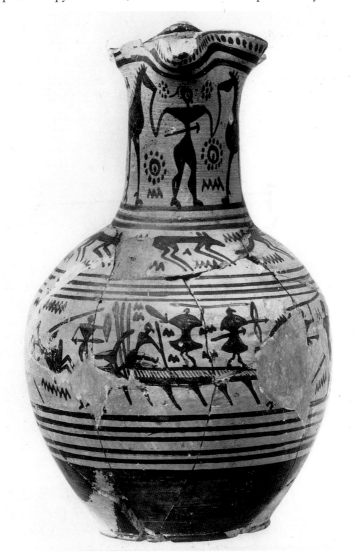

be round ones seen from the side; one fights with sword and shield, one or two with sword and spear, one with a bow and arrows. The contrast with the heavy repetition of a limited range of figure types seen in the monumental marker vases is marked, and is a particular feature of these relatively small party vases. Yet it is hard to make any sense of the variety that is shown here: the composition lacks a single focus, and the individual figures fail to relate to one another in any way that can get a story started. Here, as not on the neck, there is a sense of the artist wanting to do something more than state that real men win prowess in warfare, but not managing sufficiently to diversify the established artistic vocabulary in order to do so. If this scene provided a suitable cue for lively sympotic discussion, we are no longer in a position to pick up that cue.

(On other vessels other artistic innovations suggest a similar desire to establish a relationship between figures such as to be able to turn statements into stories) One *krater* shows a fully manned ship with more than forty rowers, beside which are two much larger figures, one male and one female, the male perhaps taking leave of the female and about to step on to the ship. Both the scale of these figures and the wreath or crown which the woman carries encourage belief that these figures, although crushed to one side, are the centre of attention, and even that they might be particular historical or mythological figures. But the gestures which they are given remain generic, and it is impossible to pin them down securely to any event or story known to us.

One way of understanding the tensions in Geometric art towards the end of the eighth century is in social terms. In many parts of the Greek world during that century, and most clearly in Athens in the second half of the century, burial practices went through a whole sequence of changes affecting the proportion of the population receiving an archaeologically visible burial, the means of disposal of the body (inhumation replacing cremation), the place of burial (from inside to outside the town), the relationship of grave goods to grave (in the tomb or in a separate offering trench), and the wealth and nature of those grave goods. It is not easy to interpret these changes, but there is little doubt that significant social tensions lie behind at least some of the changes. Any easy superiority which a wealthy élite may have enjoyed in 800 BC had been seriously challenged by 700 BC. Outside the burial record, the establishment of new settlements both on the Greek mainland and outside it, particularly in Sicily and southern Italy, attests to a very high degree both of ambition and of mobility. Greeks were engaged in frequent exchange of goods on a significant scale in both the western and the eastern Mediterranean. This created new individual fortunes and also led to increasing familiarity with the artistic products of the east, and the use of those products to mark individual status may well have become open to more and different individuals.

Another way of understanding the tensions is in terms of the changing contexts in which decorated pottery was employed. The demands created by funerary use and those created by party use of pottery were quite different, and we are fortunate in having inscribed evidence which makes clear how intimately involved the pots themselves were in the more or less formalized proceedings of the sympotic party. The willingness to evoke epic tradition and jokingly to invert the formula of a curse, which is seen in 'Nestor's cup' from Pithekoussai, makes sense only in a context where stories are swapped and the familiar may be presented in new and metaphorical guises. Such a context can only have encouraged artists to think in terms of analogy, allegory, and quizzical engagement with traditional stories—(modes of presentation surely much less encouraged by the solemn commemoration of ritual and of individual and group status expected from figured scenes on pots intended to mark tombs.)

But we should not dismiss the importance of cross-fertilization within the visual arts themselves. Bronze figurines and the decoration on Geometric pottery were produced in different circumstances and to meet different demands, but the artists who worked in the one field cannot have remained ignorant of what was being done in the other. The sculptural exploration of characteristic attitudes, and the sensuous appreciation of movement which is to be seen in the Spartan seated figure [11], may share with eastern works some responsibility for the forging of a new animal style in the Attic gold bands. But whatever the situation in the eighth century, the seventh century sees painting and sculpture developing in very close parallel, but in a very distinct visual world.

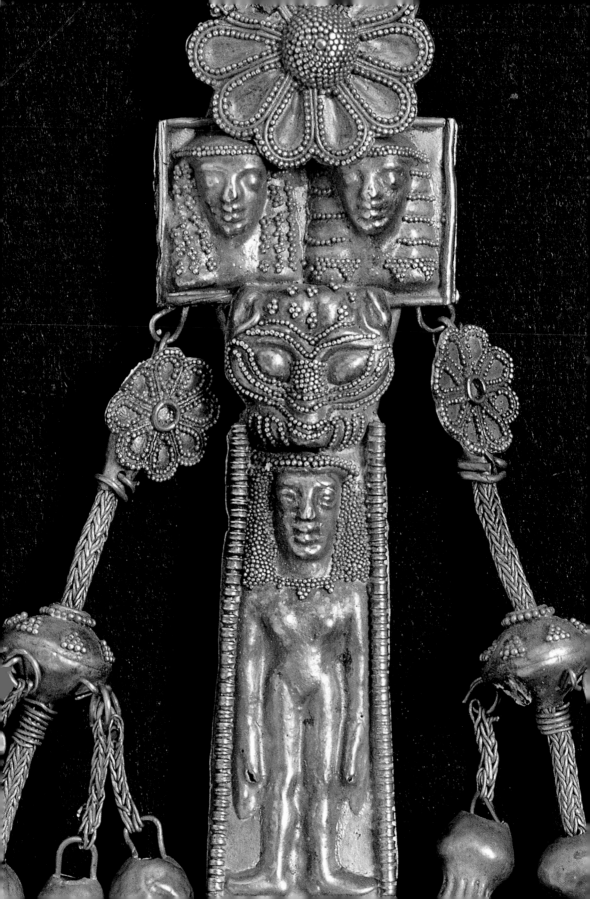

Reflections in an Eastern Mirror

At every turn, the art of seventh-century Greece stares you in the face, and its stare is the inscrutable stare of the east. Out of the tensions apparent in the art and the wider archaeological record from the later part of the eighth century, and out of its contacts with the east, a new view of the world was created. If wealthy Athenians in the middle of the eighth century adopted oriental motifs and forms of expression as a cultural affectation, Greeks of the seventh century came to see the world through eastern eyes. Men and women came to see each other, their past, the natural world around them, and the gods differently. Painting, jewellery, sculpture all helped to effect this change, and they were affected by it. In this and the following chapter I will trace the ways in which the Greeks saw differently after 700 BC.

The art work helped show changes in the way Greeks viewed the world

A fabulous invasion

The animals of the eighth century are predominantly domestic, those of the seventh century fantastic. Creatures of the imagination colonize pots and dedications alike. Not only do fantastic creatures appear in scenes that show stories, but all sorts of parts of vessels of clay, metal, wood, and stone turn into animals' bodies. From the late eighth century moulded snakes writhe their way round the shoulders of Athenian Late Geometric amphorae [15], and the tripod cauldrons, prestigious dedications at major sanctuary sites, sprout griffins' heads. As the seventh century progressed so more and more objects—ritual water bowls, pieces of furniture, stringed instruments—shaped their various supports into animal or human form.

There can be no doubt that this fantastic invasion comes from the east. Many bronze bowl attachments in the form of winged female heads (sirens) are themselves eastern in origin, and it is from the east that the griffin rises. There were two different ways, sometimes combined, of making the griffin heads that rear up from the edge of bronze bowls: beating and casting. Beaten examples tend to have more rounded forms, cast examples sharp contours and finer details; some of them may well have been imported from the east, although no identical bronzes have yet been found east of Cyprus. The earliest cast

Detail of 23

43

Cast griffin-head attachment
from a bronze tripod-
cauldron, first quarter of
seventh century BC, from
Kameiros on Rhodes.

Tripod cauldrons were the
most substantial of all the
bronze dedications that
increased in such numbers
in the second half of the
eighth century as Greeks
chose to dispose of their
wealth in a permanent display
of their piety to the gods.

examples begin later than the beaten ones, and seem to be a Greek
development.

The griffin from Kameiros on Rhodes [**18**] displays the typical fea-
tures of cast griffins: the S-curve of the neck thrusts out aggressively
against the strong vertical accent provided by the tense but delicate ear
and the heavy, rather inorganic, knob on top of the head; the curve of
the upper eyelid is carried on in prominent brows, doubly emphasized
and rendered still more threatening as the short curve is taken up in the
sharp eagle's beak and answered by the pointed and thrusting tongue;
the scaly neck and serrated edge to the mouth further contribute to the
insidious hostility of a beast whose elegant ugliness is still more em-
phatic in the head-on view [**19**]. Although the basic formula by which
the griffin is presented is more or less unchanging, the detailed treat-
ment by Greek artists varies considerably: eyes may be more to the
sides or more to the front, they may be given a roll of lid below as well as
arching brows above; the lower jaw may be more or less curved and the

tongue, if shown at all, curls upwards in varying degrees; knobs and ears vary in length and the ears may bend forwards; both length and curvature of the beak vary and the junction with the head may be smoother or more abrupt. But if the details vary, fear and loathing are never lost: this uncertain combination of snake and bird of prey adds the threat posed by its defiance of the categories of natural history to the menace posed by those savage creatures. The domesticated world of horse, sheep, and ox had been good to think with in the eighth century; seventh-century artists see the world through creatures that are far more slippery and hostile.

Griffins were part of the grand tripod cauldrons that seem to have been a standard way of putting great wealth on display. One such tripod cauldron has been found in a grave at Salamis in Cyprus, but in the rest of the Greek world such objects appear only as dedications, and then only at the most major sanctuaries. But whereas exotic techniques and imagery in the middle of the eighth century at Athens glorified the élite privately, these griffins revealed the élite to the public as east-facing. In the seventh century, indeed, orientalism passed down the social scale to become a feature of dedications which demonstrated only a more moderate wealth, or indeed no special resources at all. But as we move down the social scale or into more private objects we find fewer direct oriental imports, and oriental motifs become more completely adapted to a Greek product, as griffins themselves become adapted as part of the menagerie of both east-Greek and Corinthian pottery or indeed in gold jewellery from Kameiros (on which see below, p. 56).

The small pots, in which Corinthian potters particularly specialized from the last quarter of the eighth century on, were widely distributed over the Greek world, as dedications in sanctuaries and as grave goods. Corinthian potters rejected both the elaboration and the formality of geometric decoration, and specialized in simple line decoration and patterns derived from flowers and plants. Although humans provided the subjects for early figure scenes on these pots, animals increasingly took over. A tiny *aryballos*, or perfume jar, from the second quarter of the seventh century, whose form and content both themselves derive from the east [20], shows very clearly how animals take over, as a panther, a lion with an additional human head, and a winged man crowd out a rather puny warrior. Later small, and even large, closed vessels from Corinth are entirely given over to friezes of animals, natural and supernatural, interspersed with rosettes and other rapidly executed filling motifs. The animals and such characteristic features as the frontal head of the panther, sometimes shared by two facing bodies, derive directly from the east, but they are so completely characteristic of Corinthian pottery that they cannot long have retained much eastern flavour for Greek purchasers. On this *aryballos* it is tempting to see

Protocorinthian perfume jar attributed to the Boston Painter, second quarter of seventh century BC.

Scented oil and the habit of its use seem to have been acquired by the Greeks from the east during the eighth century. From imitating the forms of perfume jars made in Phoenicia and Cyprus, Greeks developed their own more delicate shapes, but signalled the oriental allure of their contents by decorating them with orientalizing plant and animal forms.

the warrior and the panther standing for human and bestial dangers, the lion and the winged man for fabulous dangers: together with the luxuriant shoulder decoration they may be taken to suggest to the potential purchaser that this distillation of lush plants is fit for use by the man who faces up to every sort of peril.

Two revolutions have occurred here. The revolution in subject-matter that contrasts Corinthian pottery of the seventh century with Geometric pottery marks a new commercial strategy. Figure scenes on Geometric pottery seem primarily to remind viewers of life situations, the exotic decoration of Corinthian pottery often advertises exotic content without any appeal to actual or even fantasy life: power and prettiness are the selling features. The power and prettiness rest on the second revolution, a technical one. In early protocorinthian pieces the figures only slowly flesh out the old geometricized forms, and outline drawing is common, but in the late protocorinthian *aryballos*, although the human head protruding from the back of the lion is still presented in outline drawing, elsewhere a new technique is displayed: incision.

Incision was almost certainly learnt from observing eastern metal-work, although it is to be seen also on wooden and ivory objects (see below, p. 16). On pottery, scratching the black glaze off with a sharp instrument in order to make the pale clay show through as white lines against the fully fleshed black silhouettes enabled fine details of anatomy, hair, and so on, to be presented. Not only did the graver give sharper lines than the brush and enable miniature work, but the return to silhouettes, by obviating the need for an obtrusive outline, gave a consistency to the presentation of bodies and distinguished them

21

Bronze statuette of Egyptian goddess Mut from Heraion at Samos, *c.*700 BC.

The sanctuary of Hera at the west end of the coastal plain adjacent to the city of Samos (modern Pythagorio) is outstanding among Greek sanctuaries for the quantity and variety of eastern objects dedicated there. The rich contacts with the non-Greek world which these dedications signal were to have profound effects on the development of Greek art in Ionia.

clearly from their background. Although the two are not necessarily related, Corinthian artists soon combined incision with polychromy, and thus further enhanced their delicacy of presentation. Although not immediately adopted elsewhere in the Greek world, the Corinthian invention of incision was to become basic to painted pottery for almost two hundred years, and was soon used to convey not just form but texture in a way not paralleled on eastern metalwork. Just as in the development of casting in bronze and in the shaping of pots, so in the techniques of decoration, the introduction of the wild is accompanied by the introduction of new precision and artistic control.

Heads, bodies, and gods

In the eighth century painted and sculpted images gave only indirect access to gods: dedications in sanctuaries addressed human relations with the gods through human relations with the non-human world. The construction of temples during the eighth century suggests the development of cult images, images of the worshipped gods, and from around 700 BC images of gods survive [**32**]. The encounter with the outlandish, which we have surveyed above, was an element in a much more direct approach to deities, and the adoption of eastern forms and iconography contributed fundamentally to the formation of images of the gods which were at the same time remote and yet accessible.

Finds from the sanctuary of Hera on the island of Samos include large numbers of objects from the Near East, among which are various eastern statuettes of deities. These statuettes, which include plump naked females and grotesque figures, offered to Greek artists a variety of different models for the representation of human figures in general and of the gods in particular. How Greek artists reacted is well seen by comparing one of the Egyptian goddess figures [**21**] with one of rather few wooden figures that are preserved from archaic Greece, a statuette of Hera of mid-seventh-century date [**22**].

The Egyptian goddess stands stiffly upright, but the body is treated as a series of curves: the curve of the calves narrows at the knees, the curve of the thighs and hips narrows at the waist, above which the curve of the breasts is emphasized by the horizontal ribs of the drapery below them. These curves of the body are complemented by the patterning of the dress whose vertical and diagonal lines are made up in short curved sections that both measure and reflect the curves of the forms beneath, and these curves are taken up in the strongly curving outline of the hair, all the more emphasized because of the contrast with the vigorously straight lines of the head-dress.

The debt of the wooden figure to the Egyptian model can hardly be doubted. Both the overall proportions and the shape of the head-dress point to the assimilation of the Egyptian conventions. But the emphasis in the Greek figure is quite different. The body presents no

22

Wooden statuette of Hera from Heraion at Samos, *c.*640 BC.

The water-logged conditions of the sanctuary of Hera on Samos have ensured that wooden objects, which elsewhere have perished, survive to reveal a craft tradition which both parallels and extends work in stone and bronze, and which may reflect the interests of a less wealthy section of society.

continuous wavy outline; it falls into two separate parts marked off from one another by the tight belt at the waist. Rather than displaying folds that follow body contours, the garment is richly decorated with criss-cross patterns which bear no relationship to the limbs beneath. Although it similarly sets the head into relief, the treatment of the tresses of hair which fall on either side is quite different, both distinctly more elaborate and offering a vertical rather than convex outline, and so taking up the straight lines of the body below. The Greek figure is both less sensuous and less stark than the Egyptian figure: where the latter is minimalist in its detailing the former is almost fussy; where the Egyptian figure stresses form, with but a narrow range of textural variations, it is the surface of the Hera figurine which attracts the eye as the feel of different fabrics, as well as their variously elaborate decoration, is sensitively conveyed. The major difference between the Egyptian and Greek statuettes lies in the relationship between body and head: in the Greek goddess the body ceases to be fleshly and is turned into a highly decorative support for the head. The emphasis on the head apparent in the griffins, and in the panther and the lion with the extra human head on the Corinthian perfume jar, becomes the central feature of seventh-century Greek sculptural presentation of human figures.

The way in which Greek artists took over conventions for representing human forms from the east, but altered their emphasis, can be seen very clearly in jewellery too. And once more it is from the southeastern part of the Aegean, where contact with the east was most frequent, that the best evidence comes. Among a whole series of artefacts of extraordinarily high quality excavated in the nineteenth century from cemeteries at Kameiros on Rhodes is an elaborate piece [**23**] of uncertain use, but perhaps worn on the front of a garment. Made of electrum, a compound of gold and silver which occurs naturally in Asia Minor, it consists of two plaques soldered together, with a large rosette above, and two chains of pendants hanging from either end of the upper plaque with rosettes and then spheres and bells in the shape of heavily stylized pomegranates. The upper plaque has two human heads in relief, their hair marked out by granulation, the lower has a further relief of a naked female figure surmounted by the head of a panther; again granulation is used for the hair of the woman, and to give her a necklace, and for the features of the panther's face. Panther, heads, and female nudity all have their roots in eastern products, and the techniques employed too had been relearned by Greeks from eastern artists in the ninth century BC.

Even within this single piece something of the way in which Greek artists modified eastern motifs can be seen. Not only the nudity of the lower figure but also the rounded forms of the body, the fuller face and undifferentiated hair distinguish her from the two heads above whose

faces are more triangular, mouths less prominent, and hair heavily patterned. The two upper heads approach a formula glimpsed in the wooden Hera from Samos and virtually ubiquitous in all artistic media in the middle of the seventh century. This formula, which modern scholars have come to call Daedalic because it is particularly well represented on Crete, the island with which the mythical craftsman Daedalus was closely associated, can be still more clearly seen in a small ivory sphinx from the sanctuary of the goddess Hera at Perachora, in the territory of the city of Corinth [24]. Originally Egyptian, the sphinx was known in Greece in the Late Bronze Age, made an appearance on Late Geometric pottery, was given a place in his Greek genealogical system by the poet Hesiod writing around 700 BC, and was a core element in the myth of Oedipus. But little other than the material of the Perachora sphinx is exotic. Carved from a small block of ivory of almost triangular section, flat-topped, with shallow forehead

crowned by a decorative braid, and framed by wig-like hair with marked horizontal banding, this is an entirely Greek sphinx. But what makes it Greek also changes its significance: rather than being monstrous, a winged visitor of inscrutable power, this sphinx is dominated by a pensive human visage; we have moved from a world of fabulous beasts to one in which it is their wits that men and women pit against whatever the gods send.

The assimilation of eastern cultural material by the Greeks had started before the beginning of the seventh century and did not cease at its end. The writings of figures as diverse as Herodotus and Plato demonstrate how the Greeks continued to find eastern motifs and ideas good to think with. The story of the use of eastern models in the visual arts to aid the presentation of men and women to the gods and the gods to men and women will be taken up again in chapter 5, where the development of monumental sculpture will be discussed. But arguably the most important development in seventh-century art lay not in any craft technique or single motif, but in a way of presenting the linkage between motifs, and before further pursuing the artistic exploration of the encounter between humankind and the gods we must first examine that great development: the portrayal of myth.

Myth as Measure

In chapter 2 we saw that there were grave limitations on the extent to which the geometric art of the eighth century could refer its viewers to any precise story, whether a life story or a fable. In chapter 3 I have shown how eastern motifs were taken up by Greek artists as a means of embodying the encounter with the world of the gods. But the statuettes, jewellery, and pottery discussed there explore only the situation of encounter, not how the encounter might develop. In this chapter I look at the way in which artists began to exploit the body of traditional tales in order to render vivid not just the *frisson* of the encounter with divinity but the development of a relationship, whether friendly or hostile. Here we see how the resources developed on a small scale in the objects discussed in the last chapter came to be combined in the first major works of art from the Greek world.

The little adopted/borrowed art became part of major pieces.

Myth and pathos: the Mykonos *pithos*

In the late eighth century in various parts of Greece, but particularly in Crete, the Cyclades, and Boiotia, potters responsible for the manufacture of large storage vessels of unglazed clay began to decorate them with impressed decoration to produce relief figures which were further decorated by tooling with blades and pointed instruments. In the seventh century the figurative decoration on these vessels becomes very much more elaborate, and scenes of deities, often with exotic forms influenced by eastern iconography, and of known myths are presented.

The most striking of all these vessels is a *pithos* found, with human bones inside, on the island of Mykonos [**25**]. The neck of the *pithos* has a large scene of the Trojan horse surrounded by (Greek) warriors and with the heads of further warriors appearing at square 'portholes' on the sides of the horse's body and neck. Below there are three lines of metopes—square or rectangular panels—showing one, two, or three figures in each. The top line of panels is on the shoulder of the *pithos*, the other two lines around the widest part of the body. The lower part of the body is blank. The metopes show scenes in which warriors attack women who are sometimes with children. The warriors who surround the horse are largely represented in a formulaic fashion, as heads and legs appearing behind rounded bossed shields and carrying a

Warriors, animals, and deities all decorate relief *pithoi* of late-eighth- and early seventh-century date. Although use of friezes offers some links with Geometric painted pottery, the impressed rosettes and other ornaments and occasional exotic figures suggest influence from the east. Here the great wealth of impressed decoration illustrates a Greek myth: the capture of Troy by the ruse of the Trojan Horse.

diagonal spear. The warriors of the metopes on the shoulder are similarly presented, but those on the body are different: without shields they assail the women or women and children who face them in various ways, their long arms making the action involved clear. The women, likewise large-eyed, are given thick manes of hair, expressive hand gestures, and dresses edged and decorated with lines of tooling of various kinds. One woman, in metope 7, facing a bearded man who brandishes a sword upright before her, is dressed in a particularly elaborate garment which comes right up over her head.

How can we be confident that it is the sack of Troy that is represented? Two factors are important here: the existence of a peculiar object, the wooden horse, and the subordination of individual scenes of slaughter to the scene of the horse. Some relief *pithoi* have all their scenes in friezes, so that even the neck has decoration in strips. Other relief *pithoi* have a dominating neck scene, but decorate the body of the vessel with friezes, with continuous strips of action (if an animal frieze can be called 'action'). Here the dominating neck scene has warriors framed in the square 'portholes' of the Trojan horse; the shoulder and body go on to present warriors in action framed once more in square panels. What we are given in the metopes can be seen as the view that comes out of the horse, or alternatively as the view into the horse, as the view of what the horse holds in store. The body of the *pithos* unpacks the scene on the neck of the *pithos*, and it does so by drawing attention to the framing of a view.

This framing of a view is important for our reading of the scenes on the shoulder and body. The wooden horse was a piece of trickery which enabled the warfare to be taken off the battlefield and into the town. The artist chooses to present the battle in the town as a battle against women and children, with no Trojan warrior appearing to defend his womenfolk. Whether we see the metopes as the view from the horse, the view that the warriors yet to descend have of the task ahead of them, or whether we see them as the view into the horse, as what the Greeks sacking Troy have (to have) in mind, the decision to separate the scenes of slaughter, and to link them so intimately with the cunning trick of the horse, serves to focus attention on the cold-bloodedness of the killing and the way in which sacking a town differs from fighting in the line of battle. The view of a battlefield is friezelike, the line extends across the plain, and all combats form part of an overall battle strategy in which success depends on the performance of all; but the view of a battle for and in the town is necessarily episodic: nothing depends on the individual warrior's cold-blooded murder of a particular woman or child, and the decisions which lead to death and bloodshed are decisions which every individual warrior, fighting with the odds stacked entirely on his side, has to take for himself. The buck cannot be passed beyond the edge of the metope.

Three metopes stand out from the general sequence. At the far right of the middle row (metope 12) there is a lone warrior, drawing his sword from his scabbard and advancing; at the far left of the bottom panel (metope 13) is a lone woman, clasping her hands to her breast; and most important of all, directly below the horse, in the centre of the neck panels, is a single warrior, stabbed in the neck, crumpled over his shield, his right hand grasping the scabbard and his sword undrawn. In the middle of violent encounters we are presented with these three single figures two of them not bound up in the action but able to contemplate what they are going to do and what is going to be done to them, and one the solitary figure of a dead warrior, a single case in which the finger of fate has pointed in a different direction. The decision to employ single figures at all is a significant one, for it makes clear that the emphasis is not purely on action but is in part at least on the assessment, by the actors, by the potential victims of action, and by the observers, of what action will occur. But the decision to include one dead warrior is more interesting still.

Who is this warrior, and why is he shown? Later scenes of the sack of Troy show Trojan warriors dying, as well as Trojan women and children, so is this a Trojan? Or, given the otherwise total absence of Trojan men, should this be seen as a Greek, for again later tradition offers stories of Greek casualties too in this assault. Whether the dead warrior is Greek or Trojan affects our reaction to and reading of the pot as a whole, and, similarly, the way in which we read the rest of the pot will affect the issue of identification.

Literary versions of the capture of Troy, all later than this pot, focus on certain key individuals and episodes—the sacrifice of Polyxena, the murder of Astyanax, the murder of Priam, the carrying off of Kassandra and the Palladion, the recovery of Helen by Menelaos. Such a focus is to be seen in most of the subsequent pictorial versions also, although their degree of elaboration varies (compare **75**, **76**). The Mykonos *pithos* lacks such a single focus on a single brutal act of killing, and there is not just one child killed. The scene of a warrior swinging a child by the leg (metope 17) certainly corresponds to both the literary and the later iconographic tradition about the death of Astyanax, and the singular failure of the exceptionally richly dressed woman in metope 7 to supplicate the bearded warrior who approaches her makes a prime candidate for identification as Helen. But although no two scenes are identical it is not at all clear that all the individual scenes were ever identifiable as episodes known from some version heard or read.

If we take the Mykonos *pithos* to be a series of illustrations from a particular oral or literary epic then we must assume that the figure of the dead warrior was clearly identified in the mind of the artist and, presumably, of at least some of the original viewers. The single warrior

dying of a wound to the neck would in that case be a particular figure who could be named, but in the absence of the relevant text we could not know whether that figure was Greek or Trojan. But the Mykonos *pithos* does *not* inscribe the account of the sack of Troy to be found in the earliest recorded literary versions, the 'Little Iliad' (see below p. 169) and the 'Iliupersis', and there is no ground for inventing an unknown epic tradition, illustrated only on this pot, which recounted this story with different emphasis. In view of that, we must allow for the possibility that the viewer was left to construct his or her own rationalization of the separate scenes without the assistance of 'named' episodes. The question of whether the dead warrior is Greek or Trojan may well have been a puzzle to the earliest viewers, and the prominent placing of this figure may be the artist's way of insistently raising the issue of what difference it makes whether this man is Greek or Trojan, aggressor or defender, dying in the glory of victory or dying 'like a woman' overwhelmed in defeat.

By combining the scene of the Trojan horse and framed scenes of slaughter on a pot used for burial, the artist frames the viewer. This is a pot which alludes to stories, and episodes within stories, but which precludes any easy stringing of episodes together. More importantly still it is a pot which manipulates the issue of *viewpoint*, both encouraging the viewer to see through the 'portholes' of the horse as if he were one of the Greek assailants, and presenting the sack of Troy as a slaughter of the defenceless that necessarily evokes sympathy for the victims of war. A continuous frieze creates a distance between viewer and action in which figures and events simply pass before the viewer's eyes; the metopes collapse that distance and draw the viewer into the events. Whatever the circumstances in which the person whose bones were found in this *pithos* died, the mourners are made to face up to the way in which glory and brutality may be very closely linked. Here is a pot which does not so much tell a particular story as draw attention to the means by which a story is told, draw attention to the way in which any telling of a story has to be a telling from a certain view; there is no escape for the viewer from involvement in the events portrayed.

See myth and die: the Polyphemos amphora

The Mykonos *pithos* can be seen as directly building on developments made in earlier relief *pithoi*, combining old elements in a radically new way. The Polyphemos amphora [26], painted in Athens or perhaps on Aigina in the second quarter of the seventh century, shows very clearly the extent to which there had been a break in pot-painting traditions there. Geometric patterns, with their straight lines and repetition of identical motifs, have gone, the portion of the pot surface covered in decoration has been very much reduced, and the curvilinear dominates. The figures are now extremely large (the scene on the body has

[marginal note, handwritten:] anything

[marginal note, handwritten:] POV on point of view of looking at art. changing point of view or can change everything

26

Amphora from cemetery at Eleusis, Attica, attributed to the Polyphemos Painter, second quarter of seventh century BC.

A combination of silhouette and outline drawing is employed on this middle protoattic amphora to render actions clearly and decisively and to characterize the actors. The precise drawing and incision on the face and paws of the lion give an effect not available on pottery even a quarter of a century earlier but much paralleled in other seventh-century painting.

the largest figures ever painted on a Greek pot), and outline drawing is used as well as silhouette. Although the repetition of figures in the same pose still plays a part, action now dominates, even in the animal frieze, if the scene on the shoulder can really be called a frieze. And in the scenes involving human figures there can be no doubt about what the action is.

On the neck of this amphora three men, the leading man picked out in outline, thrust a stake into the eye of a large seated figure with a wine cup in his hand: the Cyclops Polyphemos is being blinded by Odysseus and his men. This episode is related in the *Odyssey*, but it is possible that the artist and his contemporaries knew the scene from some other oral epic. On the body of the amphora a man departs hastily to the right, pursued by two monstrous figures with curious and ugly frontal heads. A figure in an elaborately decorated dress and holding a staff stands between pursuers and pursued, and behind the pursuers, around the side of the vase, a headless figure with a large scaly body floats horizontally in a floral meadow. The monstrous heads of the pursuers, and the headlessness of the figure behind them, identify the hero as Perseus, with Athena in support, escaping from the sisters of the Gorgon Medusa whom he has just beheaded.

Both these scenes take the viewer into the world of myth and monsters. The Trojan horse, although remarkable, was not unthinkable in the seventh-century Greek city. But giants like Polyphemos, or women with snakes for hair and the power to turn to stone anyone who viewed them, were beyond what it was reasonable to expect to encounter, even in the most far flung of Mediterranean travel. If the Mykonos *pithos*, like the *Iliad*, directs the viewer to review human behaviour in the not unfamiliar circumstances of warfare and the capture of towns by deceit, the Polyphemos amphora, like the *Odyssey*, reflects on human life by way of more distant analogies.

But does the Polyphemos amphora reflect on human life at all? Or is it simply a reminder of entertaining stories heard on mother's knee? Two circumstances, one external to the imagery and one a feature of it, suggest that we have here more than just a random selection of mythical moments which happen to provide suitable compositions for the shape of field available for painting. The external circumstance is that this amphora was found in a cemetery at Eleusis: the bottom of the pot had been broken off so that it could be used to inter a boy aged about 10; it was the only painted amphora so employed in that cemetery, other juvenile burials being in undecorated vessels. When burial in undecorated pots was evidently the norm, this painted pot was specially selected for burial use. Was that chance? Or was there something about its imagery that made such a use particularly appropriate? The feature of the imagery that argues against these scenes being randomly chosen is the thematic link between them: both are concerned with sight and

with sensory deprivation, loss of sight in the case of Polyphemos, loss of all senses in those of Medusa herself and of all petrified by her stare.

A closer look at the images reinforces the sense both that a narrow range of themes is being systematically explored, and that the artist is not illustrating some oral or written text but developing the themes offered by myth in ways possible only in visual images. Take the moment chosen in the Gorgon scene. We might expect to see, as we do in some later representations, the beheading itself or the immediate moment of escape as Perseus carries off the head. Instead, Medusa and Perseus are removed to opposite sides of the central field, and it is Medusa's sisters, with Athena, who dominate. Showing the Gorgon sisters enables the artist to visualize what Medusa was like, at the same time as having her conquered. The Gorgon sisters' heads are quite unlike any other heads in Greek art. They bear no resemblance at all to the Daedalic heads discussed in the last chapter; instead they resemble nothing so much as an orientalizing cauldron: the noses are like winged-figure attachments, the lion- and snake-headed creatures, whose rearing necks sprout from the Gorgons' heads are like ears, and from their necks are like griffins, and the mouth is made up of a band of incised geometric decoration. Thus the painter of a clay vessel manages to suggest that to look at a Gorgon is like looking at a contemporary cauldron dedication, thus assimilating the events of the myth with the experience of the viewer and the encounter with the Gorgon with the experience of coming to face the divine in a sanctuary—a theme which temple sculptures will later pursue. No amount of prose description of a Gorgon's appearance could convey this experience.

This pot continually teases the viewer. Perseus strides away to the right, a black silhouette, while Athena stands with legs draped white; the gorgon sisters are given a bare white striding leg and a draped black standing leg, thus conveying both ambiguity as to their movement, which is heightened by the frontal faces, and ambiguity as to their gender. The body of Odysseus is painted white whereas those of all other male figures are black: is this just to make him different, or does it stand for the way Odysseus' threat was simply not visible to the Cyclops? Polyphemos rests his back against, and his foot over, the frame of the neck panel, but at the top the stake which Odysseus and his companions are thrusting into the Cyclops' eye turns into that frame so that the threat to thrust the stake into the eye and destroy Polyphemos' sight is also the threat to pull the picture off the pot and end all sight of the scene. The background between the figures in all three figure zones is filled with a variety of rosette and other abstract and floral decoration, but one rosette is put at the top of the thigh of one of Odysseus' companions, insisting that the figures too are just areas to be decorated.

This pot depends on the viewer's knowledge of myth, but uses that knowledge as only the starting-point for an investigation of viewing

[handwritten margin notes: "giant"; "things purposely made unclear for the viewers."; "Points out all these possibility ways of viewing the art for the situation"]

and being viewed in which the viewer is repeatedly made aware that it is a pot they are viewing and that the viewed pot plays an active role in the relationship to the viewer. In the story, the cup which Polyphemos holds brought him the deadening of the senses which comes with intoxication; the head of the Gorgon threatened to deaden the sense of all who viewed it. Both seeing and failing to see can be dangerous; this pot introduces the viewer to some of the issues at stake in seeing pictures in a pot. If we are inclined to see only the humour of this, it appears that those who chose to bury a young boy in it saw its serious side.

Myth and ritual: the Hyperborean maidens

Both the Mykonos *pithos* and the Polyphemos amphora take central incidents from myths well known over the whole Greek world and use them to think in different ways about death and dying in the context of burial rites. The third monumental pot which I will examine exploits the newly developed expressive qualities of large-scale figure painting in connection with what was probably only a relatively local story, and although its original context is not known it may have been religious rather than funerary.

Like the Mykonos *pithos*, the so-called amphora [27], which was made thirty to fifty years later, comes from the Cyclades. It is said to have been found on the island of Melos, but the place of manufacture is uncertain. Compared to the Polyphemos amphora it stands out for its order and balance and for its polychromy: ochre tones are used in flat planes, not separated by incised white lines as they are in contemporary Corinthian work. The result is to give a quite different feel to the silhouette forms and to make mass rather than line the basis of picture composition.

The wide-mouthed vessel, best described as a *krater*, has two main bands of figurative decoration. On the neck a central scene of two hoplite warriors in combat over a pile of hoplite armour is flanked by two female figures. On the body four winged horses draw a chariot, on which stand Apollo with his lyre and two maidens, to meet Artemis who awaits it, arrow in one hand and stag in the other. On the rear of the body facing horses flank the head of a woman. In addition there is a frieze of geese on the shoulder, an eye under each handle, and facing women's heads on the foot.

The warriors on the neck are perfectly balanced, so that no indication is given as to who will win, but they are visually contrasted. It is not just that one warrior is largely concealed behind his shield, with its gorgon blazon, while the body and armour of the other is displayed against the inside of his shield: one warrior is given a dark helmet with detached crest, the other a light helmet with dark crest attached. And the women behind the warriors too are contrasted in their dress. Yet

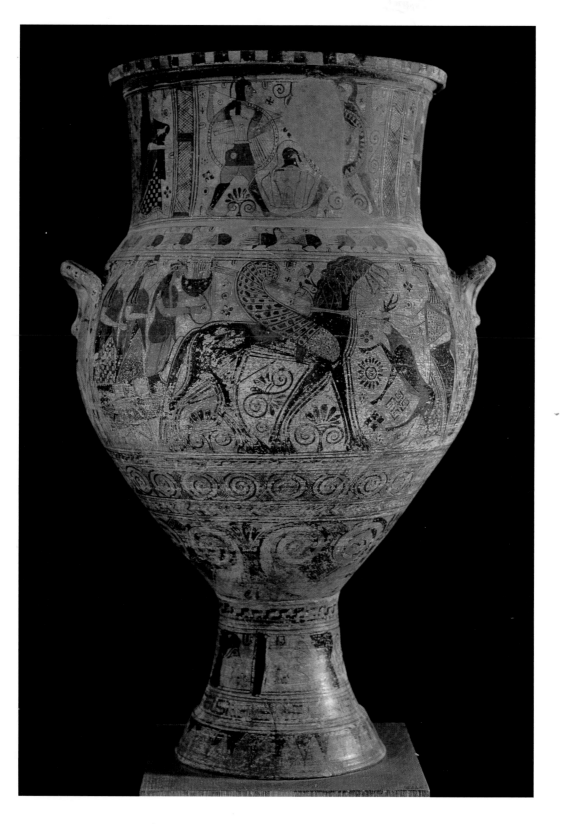

Wide-mouthed vessel,
perhaps mixing bowl, of
Cycladic manufacture, last
quarter of seventh century BC.
Retaining much more of the
discipline and symmetry of
Geometric pottery than the
works of protoattic painters,
this large pot nevertheless
effectively displays the
techniques developed in the
seventh century, particularly
in its use of colour, fine outline
drawing, and incision, and
uses them to clothe every
figure differently.

[handwritten margin notes: "the is thinking of all these complicated ways of view and making connection, → this reflects the thinking he thinks the Greek artists has."]

(none of these contrasts enables an identification to be made with any mythical duel:) carefully as they are detailed, these warriors must remain anonymous. What is at issue here is warfare and the fortunes of war: the two warriors fight over a pile of armour stripped from a fallen warrior; one of these combatants will end up falling and being stripped, and his armour too will go to build up the victor's trophy. The women who watch can do nothing about the outcome, but one household or the other will be bereft.

If the scene on the neck is firmly rooted in the tragedies of the real world, in that on the body the real world meets the world in which the gods are all-powerful. Artemis appears as 'Mistress of Animals' and the horses which dominate the picture are not only equipped with wings but have an extraneous head emerging from the mane. But the maidens who accompany the lyre-playing god seem to be ordinary women, very much like the women who watch the combat on the neck. Who are these women? It is attractive to see in them the pair of Hyperborean maidens who came from 'beyond the north' to bring sacred offerings to the sanctuary of Apollo on the Cycladic island of Delos. Herodotus notes that the people who said by far the most about the Hyperborean maidens were the Delians. This, then, would be a peculiarly local allusion.

(Neither in composition nor in subject matter is there any obvious connection between the scene on the neck and that on the body. Should we suppose that there is any link?) The story of the Hyperboreans may be local to Delos, but the pattern in which women play the central role in cult activity was widespread, and it is tempting to see the women's cult service being here juxtaposed to the (military service of men.) As Artemis' arrow and the shot stag remind the viewer, the gods are powerful, and it is the cultic worship of the gods that makes humanity collaborators (with) rather than victims of, the gods' power. That men have to face only other men, and not gods, in battle can be seen to be owed to the religious work of women. The story of the long journey of the Hyperboreans shows that women's cultic service may be quite as much an ordeal as the encounters of the battlefield. Those services can, however, be seen to lead to positive benefits, perhaps symbolized here by Apollo's lyre, by contrast to the piles of empty armour which constitute victory in war.

A revolution effected

The three pots examined in this chapter represent the finest surviving achievements of painters of pottery in the seventh century BC. These three pots are all exceptionally large and exceptionally elaborately decorated, in a century in which one of the most striking phenomena is the development of small pots, particularly perfume containers, and miniaturist decoration (of which **20** is an example). But while these

28

Athenian black-figure amphora, name vase of the Nessos Painter, last quarter of seventh century BC.

The incision that has replaced outline drawing, and the intertwined lotus buds that have taken over from geometric or cable patterns, have been learnt from Corinthian painters, but their use on a large pot and the narrative content of the scenes of the Gorgons and of Herakles and Nessos make this Athenian product distinct.

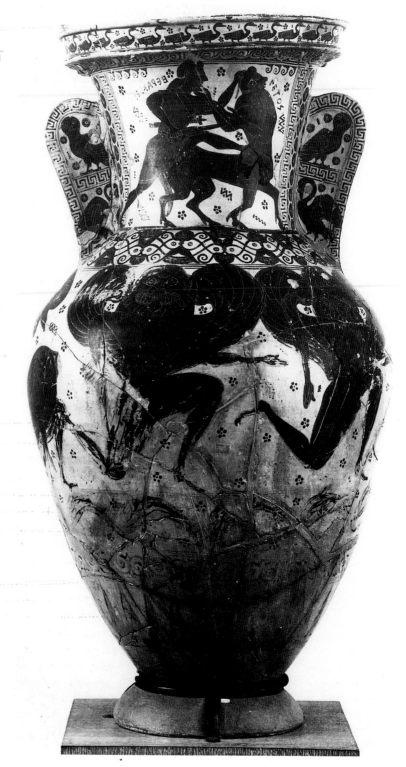

three pots give a misleading impression of the prevailing artistic culture in which most Greeks lived in this century, they reveal very effectively the distance which some pioneering artists had travelled from the world of Geometric decoration surveyed in chapter 2.

It is easy to see that the decoration of these pots was, in formal terms, inspired in no small part by the rich use and development of plant and animal motifs in Near Eastern art and by the narrative skills displayed in some Near Eastern objects; but it is a different matter to account for why Greek artists were so inspired. I have argued in the previous chapter that it was not simply that the amount of Near Eastern material with which Greeks came into contact was larger at the end of the eighth century than ever before; the quite fundamental change in the nature and use of imagery on the artefacts with which Greeks surrounded themselves was a matter of changed perception of the place of humans in the wider world.

There is in Geometric art a rather cosy domestication of the world. The world of dedications is dominated by the horse, the domesticated beast *par excellence*, by sheep, by cattle, by deer, and by birds. The world of the dead is dominated by routine events of life, by processions, and by battles fought by choice and decided by skill. This imagery, like the regular geometric patterns which surround it, is an imagery of control. The few indications that appear in art of the possibility of there being things beyond human experience, such as the centaurs of **15**, are nevertheless strictly contained. Whatever the stories circulating in Geometric society, and there can be no doubt that the stories which we know from the *Iliad*, the *Odyssey*, and from other epics derived from oral tradition, *were* circulating in the eighth century, the possibilities which those stories suggested, that human passions or external powers might escape containment, are simply not taken up in the visual arts.

Whether we examine the élite and their jewellery [**23**] and prestigious cauldrons adorned with griffins [**18**, **19**], or slightly less elevated social strata and their perfume pots [**20**], we find people in the seventh century surrounding themselves with images which, both by their exuberant style and by the creatures they choose to depict, go beyond the bounds of human control. The individual orientalizing objects examined in the last chapter exploit ideas and models borrowed from eastern art to shock, to impress, and to link the conventional and familiar to an unfamiliar, unknowable, and uncontrollable world. The pots examined in the current chapter combine such exotic motifs to explore in a more systematic fashion the problematic features of human relations and of relations to the gods. The traditional stories largely neglected by artists in the eighth century are taken up and combined for the access that they offer to a world in which human wit is pitted against difficulties created by other humans or by powers whose nature and limitations are not those of humankind.

One final seventh-century pot makes the contrast with eighth-century imagery particularly effectively. In the same Athenian cemetery in which the great series of amphora and *krater* grave-markers [13] was erected in the middle of the eighth century, another massive amphora [28] was placed to mark a grave in the last quarter of the seventh century. But if the use was the same, the shape, technique, decoration and imagery are quite different. The body here is not very much wider than the neck, and the transition between them is smooth. The handles, which served no actual function on a vessel too large to pick up and intended for static employment, are filled and decorated. The neck has a heavy rim which provides an additional zone for figurative decoration. Although some use is made of geometric meander borders for the neck panel and on the handles, the amphora is dominated by the figurative decoration of body and neck, and the main additional decoration consists of elaborate floral decoration on the shoulder and animals on rim and handles. All the figures are executed in the 'black-figure' technique, pioneered in Corinth but here used on a very different scale: the silhouette figures have details of limbs, drapery, faces, and so on incised with no use of outline drawing and only a subsidiary role played by the addition of purple and white. The body has a frieze of dolphins leaping from right to left, above which are two Gorgons running from left to right with the beheaded body of Medusa collapsing behind with a bird swooping over it. The neck shows a centaur, labelled 'Netos' (Nessos), being attacked from behind with a kick and a sword by a man labelled 'Herakles'. The centaur thrusts his hands back to Herakles' chin in supplication. The power of Herakles is brought out by the way his right leg pushes over the border against the handle and his head obtrudes into the border above. In neither image is any attempt made to show the 'full' story: no Perseus appears on the body, no Deianeira, whose rape by Nessos is being punished, on the neck. The images do not so much tell stories as exploit them. Human ability to grapple with the monstrous and win links these two scenes, but particularly in the context of a cemetery, the dangers are by no means wiped out, as the continued pursuit of Perseus by Medusa's sisters clearly shows. By contrast to the centaur statuette and the centaur procession discussed in chapter 2 [10, 15], this centaur has a very particular context. By contrast to the funeral, procession, and fighting scenes of Geometric marker vases, this vase puts death in the context not of the life lived but of the constant human struggle with unseen powers. In common with the other pots discussed in this chapter this is a pot whose images prompt close observation and pose questions, questions that are finally unanswerable.

The myths most prominent here, and on much other seventh-century pottery, are not those most prominent in surviving seventh-century poetry. Even when a story occurs in both art and literature, as

with the scene of the blinding of Polyphemos, there is no reason to suppose that it is the literary version of the story known to us that has inspired the artist. But we should see both the keen exploitation of myth in art and the creation and preservation of two monumental products of oral epic tradition, the *Iliad* and *Odyssey* as products of the same world. In the late eighth century thousands of Greeks travelled the Mediterranean, trading east and west and settling at numerous sites in Italy and Sicily. This not only brought about a massive increase in Greek knowledge of a wider world, it also weakened or broke down completely ties with the home community) individual shiploads of Greeks had to survive on their wits and by their own devices in a world that might as well turn out to be hostile as friendly, might well bring violent death or massive material gain.

Different groups and individuals no doubt reacted differently to these widening horizons. It is tempting to see both the narrowness of Late Geometric art as part of a parochial reaction, paralleled by the obsession with control in the two earliest poems surviving from Greece, Hesiod's *Works and Days*, which insists on the necessity of staying at home and working hard at agriculture, and his *Theogony*, which attempts to systematize the varied traditions about the birth and relationships of the gods. But by shortly after 700 BC the new world could not be ignored and had to be faced. The way in which artists such as those responsible for the four works examined in this chapter faced the new world set Greek art on a new course.

Life Enlarged

5

Religious activity in early Greece took a number of different forms. The small bronzes, tripod cauldrons, and statuettes discussed in earlier chapters were votive dedications, made in celebration or anticipation of the gods' gifts. The dramatic centre of religious ritual was animal sacrifice, as a domestic beast (sheep or cow) was slaughtered and cut up, the fat and bones burnt for the god or goddess, and the rest of the meat cooked and consumed by the worshipping group. But from the eighth century onwards the form of religious activity which came to have the greatest influence over the appearance of sanctuaries was the worship of the deity embodied in the cult statue, a statue that had to be properly housed and so required the building of elaborate temples.

Already in the eighth century temples were being built that were distinctly larger than domestic dwellings, reaching 100 ft in length. The importance of such buildings is indicated by the dedication of terracotta temple models in sanctuaries. But it was only in early seventh-century Corinth that temple buildings came to employ building materials not used in private buildings: stone for the walls, and terracotta tiles for the roofs. At the sanctuary of Poseidon at Isthmia in Corinthia the temple was further distinguished with painted friezes.

In the late seventh century the pattern of a stone-built room surrounded by a wooden colonnade and roofed with tiles was further reorganized to establish a pattern of details which together formed what became known as the Doric order [29]. The columns were made to rest on a foundation with three steps, were fluted and given a swelling ring at the top supporting a square block (the abacus) and then a plain architrave beam. The gable roof then rested on blocks with vertical grooves, known as triglyphs, separated by square holes (metopes), which might be filled with decorated panels or sculpted blocks. The whole of the upper part, the entablature, was articulated with details, round pegs, projecting plates and strips, and with some decorative mouldings which introduced an element of curvature into the flat surface. None of these features had any functional role, even in the earliest examples which do use wood, but they made constructional sense to the eye.

The precise origins of the Doric order are unclear. A general debt to

29

Reconstruction of the entablature of the temple of Apollo at Thermon.

The scheme of trabeated architecture in which the beam across the top of the columns is supplemented by a frieze of metopes and triglyphs has been enormously influential in the history of western architecture, perhaps because the combination of the vertical emphasis of the grooved triglyphs with the horizontal force of their sequence helped prepare for the resolution of the thrust of the columns in the triangular gable.

metope

triglyph

architrave

abacus

the stone architecture of Egypt, which was becoming better known by Greeks in the later seventh century, seems likely. But neither the plan nor the details are Egyptian, and we should credit some individual Greek architect with the idea of producing a construction which made visual sense independently of the technicalities of the actual structure. Whatever its origin, the Doric order, rapidly converted into stone, established itself on the Greek mainland as *the* way to build temples, and the spaces which it provided for painted or sculptural decoration, the metopes and the pediment at the end of the gable, became the single most important locations for city-commissioned sculpture.

Within a few years of the invention of the Doric temple another innovation occurred in sanctuaries, this time one more securely connected with Egypt. Greeks began to dedicate life-sized and larger than life-sized stone statues of standing figures of naked men, proportioned according to the canon of proportions employed for contemporary Egyptian statues. The *kouros*, as this form of statue became known, along with the draped female equivalent, the *kore*, became the dominant dedication in Greek sanctuaries and an occasional feature of mainly Athenian cemeteries for more than a century.

In this chapter I trace the importance of these developments for the history of Greek art, looking first at the use of the spaces created by Doric temple architecture and then at the *kouros* and *kore*.

The art of revelation

The Doric temple took over two decorative spaces from earlier buildings, and added two more. The existing spaces were the walls, painted at Isthmia, and the inner space, which was the home of the cult statue. After Isthmia, decoration of the walls of temples seems to have been rare, and although I will look briefly at a possible early cult statue [32] in discussing the forerunners of the *kouros* later in this chapter, in

general so little archaic cult statuary survives that we can say next to nothing about the way this interior space was used. But the two new spaces are quite another matter, their potential for decoration was realized from the beginning and their peculiar demands stimulated new forms of sculptural expression.

The temple of Apollo at Thermon in Aitolia in north-western Greece, the earliest known manifestation of the Doric order, had metopes of painted terracotta which were just under a metre wide and a little less high. Although few survive intact the fragments show considerable experimentation, including splitting a single mythological story over two metopes and varying the scale of the figures depicted. The metopes incorporate their own painted rosette frame, and the artist then exploits this for visual effect, particularly to emphasize the speed of the running figure of Perseus, escaping with the Gorgon's head, by having him overstep the margins of the frame.

The metopes could not be seen from close to, and bold silhouettes were therefore required, but the painters nevertheless showed a subtlety in drawing considerably in excess of that visible on the rather smaller fields of contemporary vases. Of particular interest from this point of view is a metope [**30**] showing two seated women facing each other. Here the border is used not in transgression but to give an

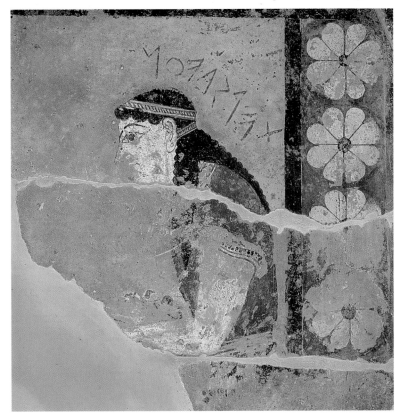

30

Painted terracotta metope from the temple of Apollo at Thermon, second half of seventh century BC.

Remains of painting other than on pots are rare from archaic and classical Greece, and this example is particularly precious, revealing not only that metopes attracted figured decoration from their very invention but also that remote Aitolia in north-western Greece, despite lacking its own pottery tradition, could be a leading patron of painting.

intensity and intimacy as the women lean forward in concentrated but silent communication. Look at the sharp profile of the woman on the right, her eye intense with its large black pupil, her eyebrow dipping sharply towards her nose, her features delicately detailed in red (note the ear), and her arms tensely resting on her lap, nursing an object that is no longer distinct.

We would be at a loss to know what is going on here were it not for the painted label across the top right-hand corner of the panel: this woman is Khelidon. That name opens up one of the more horrifying of Greek myths: Khelidon was raped by the husband of her sister, who then tore out her tongue so that she could not reveal the crime. But she revealed it by weaving a written message, and together she and her sister Aedon killed the husband's son, boiled him, and fed him to his father. When he discovered what had been done the husband tried to take revenge, but the two women, also known as Philomela and Procne, were turned into birds (Khelidon is the word for swallow, Aedon for nightingale). The label here enables the other woman to be identified as Aedon, the object in the lap of Khelidon as the head of the boy.

What is such a horrible story doing on the metopes of a temple? The other stories explored in these metopes are the beheading of the Gorgon and perhaps the madness of the daughters of Proitos. Perseus' adventure is easily seen as a straightforward struggle between good and evil, in which good is victorious. The story of the daughters of Proitos can be read as a cautionary tale: (they were once the most beautiful women in Greece but, driven mad by the gods for despising them, they exposed and lost their beauty and roamed wild as animals in the mountains.)What of the story of Khelidon?

This Thermon anthology of myth reveals some coherence if we think in terms of the visual properties of the stories. In the case of the Gorgon, the artist enables the petrifying face to be looked upon while it lives; indeed, Medusa is herself frozen by the artist and her evil power is both seen and contained. In the case of the daughters of Proitos, the beauty which lured suitors when it was decently hidden, but which was then exposed and destroyed when they roamed wild, is revealed in a way that is both erotic and bestial: we see both what has been and what ought not to be seen. In the case of Khelidon, we relive the experience of Aedon, uncovering Khelidon's rape by reading what was woven into a garment, as we read and realize the significance of the writing on the metope and have our understanding of the image transformed. Viewed in this way, (these scenes form an extended commentary on the role of art in revelation,) and as such appropriately frame the entrance to a temple in which the worshipper came face to face with the revelation of the god in his image.

We know of no other temple decorated with the story of Khelidon,

The Gorgon Medusa and her children on the pediment of the temple of Artemis at Corcyra (Corfu), first quarter of sixth century BC.

The Gorgon shares with her sisters on the amphora by the Nessos Painter [28], not just her pose but the same precision and delicacy of line to display the frightful grimace; here the naturalization of Geometric forms, which already distinguishes 28 from 26, is taken still further.

but the Gorgon became very popular as the subject of temple sculpture. The earliest of all known pedimental sculptures [31], the pediment of the temple of Artemis at Corfu, carved shortly after 600 BC, showed a central running Gorgon with, anachronistically, Khrysaor and the winged horse Pegasos, her children born after her decapitation. This group is framed by two large felines with frontal heads, and with much smaller sculptures of gods fighting titans in the angles. More than three metres high, but high above the ground, the Gorgon is carved in clean bold shapes, but with delicate detailing of such things as the border of her *khiton*, her hair, and the snakes that form her belt and spring from her neck. Her rounded face is quite unlike the heads of the Daedalic tradition, by which the group in the right-hand angle is still influenced, and makes much of the repetition of rounded forms in hair, brows, cheeks, and teeth. Those rounded features also dominate the frontal head of Khrysaor, whose appearance thus reveals his origin. The contrast between the rounded modelling of Medusa and the very flattened body of the lion gives the Gorgon an added liveliness. In this pediment we are not being told the story of Perseus and the Gorgon, but presented with the Gorgon's power: here again, the worshipper is prepared by the architectural sculpture for the awesome epiphany of

Beaten bronze figures of
Apollo, Artemis, and Leto from
the temple of Apollo at Dreros
on Crete, *c.*700 BC.

The technique used here,
known as *sphyrelaton*, seems
to have been learned from the
east. Much Cretan bronze-
work of this period shows
eastern influence, but the
separate articulation of the
limbs of Apollo and of the
waists of the two goddesses
marks these as Greek work
(compare **21** and **22**).

the gods. The format was evidently effective enough to merit repeti-
tion: a Gorgon between lions was probably the centre-piece of the
pediment of the temple of Athena on the Athenian Acropolis in the
second quarter of the sixth century, and in the west at the same period a
rather smaller terracotta Gorgon features in the pediment of the
temple of Athena at Syracuse.

Revealing gods, reviewing men, offering women

If there were any large sculptures in the eighth century they were of
gods. Various literary texts attest to wooden cult statues, but none sur-
vives. The earliest figures of substantial size to survive are three made
of beaten bronze from the temple of Apollo at Dreros on Crete [**32**]
and plausibly represent Apollo, Artemis, and their mother Leto. The
two female figures are columnar, but the figure of Apollo, twice their
size at 80 cm. high, is more articulated: the legs are shaped, the thighs
join a triangular abdomen in such a way as to give prominent hips, the
rib-cage is lightly indicated and the arms are free from the sides of the
body. With large, centrally placed eyes and a thick neck Apollo visually
accosts the viewer.

From the middle of the seventh century, limestone and marble
began to be used extensively for sculpture. They were used both in con-
junction with temple buildings of stone, as on Corfu, and as earlier in a
unique lintel from Prinias in Crete carved with reliefs of women and
panthers and supporting figures of seated women above, and for inde-
pendent sculptures. Probably shortly after the middle of the century a
life-sized marble figure of a woman was dedicated on Delos [**33**].
Carved upon the figure is the dedication: 'Nikandre dedicated me to
the far-shooting arrow-pourer, daughter (*kore*) of Deinomenes the
Naxian, excellent above all, sister of Deinomenes, now wife of
Phraxos.' The figure is badly abraded, but the pose is clear enough: the
woman stands staring forward with arms straight by her sides; she
wears a simple belted *peplos*, which reduces the body to little more than
a block with rounded edges, and beneath it her toes and the soles
of her sandals protrude; her face accords with the Daedalic conven-
tions (above, pp. 48–9), with the hair divided into four separate tresses
on each side.

A fragment of a similar, but slightly larger, head from Samos of the
same date suggests that Nikandre's *kore* was not an isolated experiment
with large stone sculpture. Within another decade or two these female
figures had been joined by male equivalents. Just as Nikandre's *kore* was
anticipated by such statuettes as the wooden figure from Samos [**22**],
so standing naked male figures with frontal gaze had been a feature
of small bronze statuary for some time; a good example just under
20 cm. high, with the waist marked with a belt, survives from mid-
seventh-century Delphi. The earliest indications of life-sized stone

Life-size standing statue of
a woman dedicated by one
Nikandre to Artemis on Delos,
third quarter of seventh
century BC.

The earliest life-size stone
figure to survive from Greece,
the flatness of this *kore*
suggests a debt to work in
wood. The sharp curvature
at the waist, strongly con-
trasted with **21**, is again to
be noted here.

statues in this form are two battered heads and upper parts of torsos
from Thera, apparently from a cemetery, and from Delos. From the
end of the century, or soon after, comes a finely preserved marble
statue, apparently from Attica [**34**]. This *kouros* is particularly import-
ant, not only for the fine details, but also for its proportions. Greek use
of the second Egyptian canon of proportions is recorded by Diodoros,
but although Nikandre's *kore* approximates to those proportions, this
kouros alone exactly corresponds, so that if the distance from toes
to eyes is divided into twenty-one equal squares, the knees fill the
seventh square, the navel completes the thirteenth square, and the
breast completes the sixteenth square.

 If Greek sculptors were inspired and assisted by Egyptian practices,
the sculptures that resulted were nevertheless quite distinct [**35**]. Greek
artists strip the Egyptian body of its loin-cloth and of flesh, and
remove from the legs and arms the supporting stone left in by
Egyptians working in harder granite. They simplify the face, both in

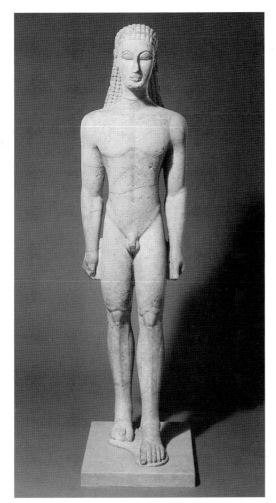
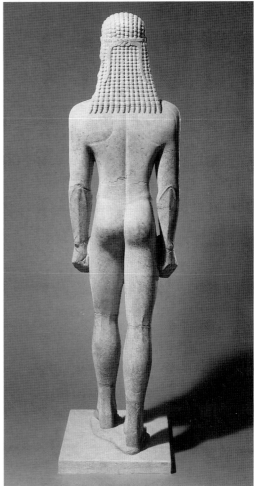

34

Life-size standing statue of a naked man ('New York *kouros*'), first quarter of sixth century BC.

Not only does this *kouros* conform exactly to Egyptian canons of proportion, but in its bodily contours (no sharp break at the waist) and some details, such as the hair, Egyptian sculpture seems to have inspired a break from earlier Greek practice.

terms of planes—mouth is linked to eye in two planes in this example, but sometimes in just one—and in terms of line—the brows continue the line of the flat sides of the nose as they repeat the curve of the eye, introducing no sudden junction and no contrasting line. By contrast both to Egyptian and to Daedalic heads, the hair, though similarly braided, barely frames the head. The result is stark, not just in its form but in its total lack of any sense of individuation or of character. Though beardlessness was a mark of youth in Greece, the absence of facial hair here seems merely part of the effacing of particularities.

How are we to account for the difference between the Egyptian and Greek statues? The new large stone statue tradition clearly did overlap with the old bronze statuette tradition in some ways: very similar dedicatory inscriptions accompany both statuettes and *kouroi*, declaring them to be thank-offerings for services rendered by a god, and/or bids for future divine favour. Both statuettes and *kouroi* share nudity, frontality, and an inactive stance. But the *kouroi* operate on a very

Granite statue of Mentuemhet, prince of Egyptian Thebes, early sixth century BC.

The Egyptian statues whose example influenced the development of the *kouros* are clothed with a particularity which the Greek standing male eschews.

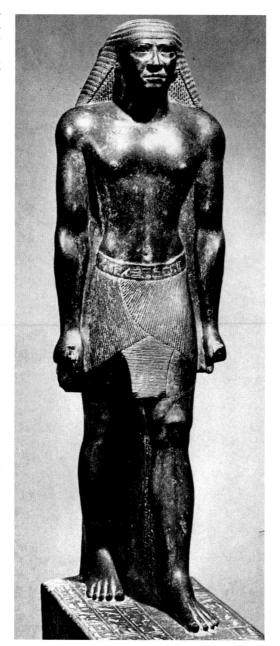

different scale and relate in a very different way to the viewer; given the readiness of the Greek sculptor to abandon the Daedalic heads and leggy proportions of statuettes, we need to explain the retention of nudity and the simplifications of bodily form in some way more closely related to the context and role of these sculptures.

The Egyptian statues are images of power and embody the power of the individual they represent. The Greek *kouroi* were certainly expensive and prestigious offerings, and must have drawn admiration and

The most renowned of ancient sculptors, Telekles and Theodoros, the sons of Rhoikos, who made the statue of Pythian Apollo for the Samians, are said to have spent time among the Egyptians. The story goes that half of the cult statue was made in Samos by Telekles, and the other half completed by his brother Theodoros at Ephesos. When the parts were put together they so harmonized with each other that the body seemed to have been made by one man. This kind of work is not practised among the Greeks, but is particularly perfected among the Egyptians. Among them, the proportions of statues are not judged according to what appears to the eye, as it is among the Greeks, but when they lay out the stones, divide them up and set to work on them, at that stage they derive the module, from the smallest to the biggest. They render the whole proportions of the living creature dividing the lay out of the body into twenty-one parts, plus a quarter. So whenever the craftsmen agree the absolute size with one another, they work separately and make parts commensurate with one another to so great a degree of accuracy that the peculiarity of their practice causes amazement. The statue in Samos was made in accordance with the Egyptian technique, split in two and divided down the middle from the head to the genitals, but both halves completely alike at every point. They say that it is mostly comparable to Egyptian work, being a statue that has its hands stretched down the sides and the legs apart as if walking.

Diodoros, *Library* 1.98.5–9. Diodoros' *Library* is an attempt at Universal History written in the first century BC. Diodoros is thought to have visited Egypt and his description of the second Egyptian canon is essentially correct. It is more difficult to judge how true is the story of Theodoros and Telekles: Theodoros, who lived in the sixth century BC, was also credited with the developments in bronze casting and making the first self-portrait.

respect for the individuals who put them up, but they do not embody power. *Kouroi* refuse identification, whether with man or with god. They figure the male human body, but not a particular body; they have all the potential to act but are engaged in no action: feet apart they make no feature of rootedness, but, feet flat, they do not actually move. Without attributes and without motion they give no grounds for telling a story. The Egyptian statue with its sleek physique, gently rounded musculature, and characterful face reveals to the viewer the nature of the ruler, but the analytical anatomy and plain features of the New York *kouros* make no definitive statement about man at all. Only the choker, by drawing attention to the nakedness of the rest of the body, might seem to suggest that the nakedness makes a positive statement.

What then are the advantages of a statue that is so stark? Surveying the use that was made of *kouroi*, it is clear that one advantage is that it was not adapted to any single role. Primarily used as a dedication in a sanctuary, it appeared both in sanctuaries of Apollo, Poseidon, and other male deities and in sanctuaries of the goddesses Hera and Athena. But the *kouros* also had a role outside sanctuaries, at least in Attica, where it was used as a marker on men's graves. The flexibility of

36

Life-sized standing statue of a naked man ('Anavyssos *kouros*') from Attica. Third quarter of sixth century BC. Comparison of this body to the body of the New York *kouros* shows how the proportions have been altered (particularly with regard to the length of the thighs) and reference to the male body has been enriched by moulding, rather than simply inscribing, anatomical features.

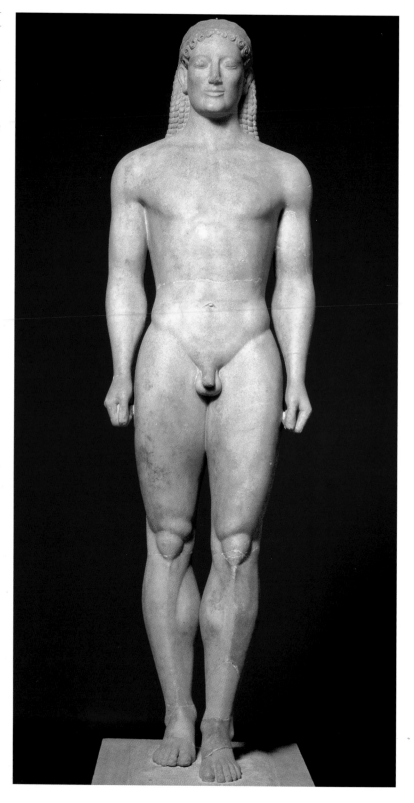

the *kouros* extended also to scale. Although the majority of surviving *kouroi* were around life size or a little smaller, from early in the sequence over-life-size *kouroi* were produced, reaching almost 5 m. in height in the case of a Samian example and around 9 m. in height in one example on Delos, not fully preserved.

Whereas the Corfu Gorgon or the Egyptian prince impress themselves upon the viewer, the viewer writes himself upon a *kouros*. The stone figure, from near or far depending on its scale, returns the viewer's gaze without adding any mood or experience; indeed, unlike the gaze returned by a mirror, this gaze does not duplicate the mood or experience of the viewer. The man who looks on a *kouros* finds himself being looked upon by a figure that is male and impassive: here is a male who stands firm, unbending, and constant. Such a figure makes a dutiful servant to the gods or to the city, but also an image of the unageing constancy of the gods themselves.

Something of the potency of the *kouros* emerges when the *kouros* form is linked to a grave epigram. Shortly before the start of the last quarter of the sixth century a marble *kouros* was set up as a grave monument in a country cemetery to a young Athenian who had been given the name of the Lydian king Kroisos by his aristocratic parents [36]. The base, traditionally, but perhaps wrongly, associated with this *kouros* from Anavyssos reads: 'Stand and have pity at the tomb of the dead Kroisos, whom raging Ares slew as he fought in the front line'. Those who pass by the roadside burial ground are invited to stand, read, and lament. As they stand they find their gaze meeting the gaze of the *kouros*, find in the smiling but stony gaze of that figure an image of their own mortality. Here is a figure of a young man, carrying the potential for a full life, frozen in death. The pathos here is a product of the reticence of the *kouros*: it is the epigram which tells the circumstances of death, not any feature of the sculpture; and it is war, figured in the god Ares, which brought death, not any particular enemy. The *kouros* stands in the same relationship to the viewer as it would have stood to Kroisos, and the Athenian viewer liable himself to be called to fight for the city can see himself in the dead man.

In basic form this later *kouros* is identical to the New York *kouros*, but in detail the treatment is distinct. Where on the New York *kouros* the anatomy is delineated, on the Anavyssos *kouros* the anatomy is modelled. Where the New York *kouros* is made up of flat planes, the Anavyssos *kouros*, though as tightly constructed, bears few traces of its origins in a block of stone—a contrast particularly marked in the treatment of the buttocks. Where the New York *kouros* simplifies the face so that only eyes, nose, and mouth impinge on the rounded surface, the Anavyssos *kouros* gives separate form to cheeks and chin. None of these features make the Anavyssos *kouros* into an individual, rather than a type, but they enrich the reference to the male body and in doing so

Standing female figure, under life-sized, from the Athenian Akropolis ('Peplos kore'). Third quarter of sixth century BC.

Exceptional among the large number of korai dedicated on the Athenian Akropolis in the late sixth century for the simplicity of her clothing, the Peplos kore shares with Nikandre's kore [33] a body that is minimally contoured, but has bold and lively facial features that accost the viewer.

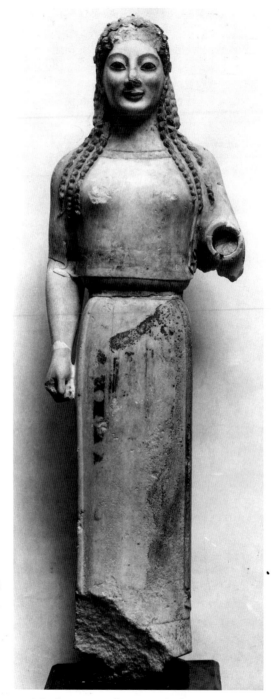

enrich the sense of potential, the sense that this sculpted man belongs to the same world as the viewer. They show something of the scope that the naked male form offered to sculptors, who, in hundreds of *kouroi* produced during the sixth century, explored different ways of bringing out what it was to be a man.

Standing female figure, under life-sized, from the Athenian Akropolis (Akropolis 594). 530s or 520s BC.

Contrast the varieties of texture, fold, and form in the garments here with the flat forms of the Peplos *kore*. The woman who offers a present to the gods is treated as a study in presentation. Athenian sculptors of this period experimented also with similarly draped male bodies also making offerings.

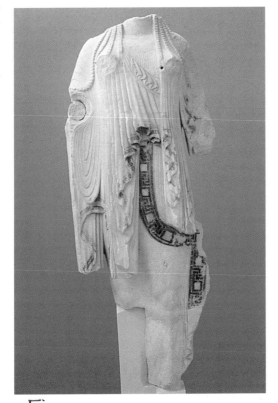

The explorations of what it was to be a woman, in the tradition of Nikandre's *kore* [**33**], went in a different direction which reveals something of the different social position of women and which offered different opportunities to the sculptor. The statues of single women, which are also found both as dedications in sanctuaries of goddesses and gods, sometimes set up by men, and as markers on women's graves, share with *kouroi* the frontal faces and may share the arms by the sides, but they usually have feet together, may hold an offering in one hand, and are invariably clothed. Sculptors explore not only the effect of varying facial features, but also the varying possibilities for rendering garments and relating the fall of the dress to the body beneath.

A particularly rich series of marble *korai* from late-sixth-century Athens includes two more or less contemporary with the Anavyssos *kouros*, one of great formal simplicity [**37**], where the heavy *peplos* gives the body a simple straight outline interrupted only by the belt, and another [**38**] where the elaboration of the layers of drapery gives a highly complex form with much play of line, texture, and of the relationship between drapery and the body beneath. Once highly coloured—traces of colour and of decorative patterns remain on the *peplos*—the Peplos *kore* gives an impression of delicacy, slenderness, and youth, which the pert features of the face and the simple styling of the hair reinforce. The rich patterns and teasing layers of the drapery of

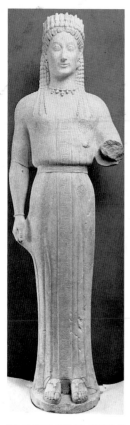

39

Slightly over life-size standing female figure from cemetery at Merenda in Attica, middle of sixth century BC.

Found buried in a shallow pit along with a *kouros*, this *kore* decked with jewellery and with highly decorated, if simple, clothing, is identified by an inscription as by a sculptor from Paros, named Aristion, from whose hand other works are known (see further, p.129 below).

Acropolis 594 [**38**] give the eye much more to explore, and turn viewing the fully dressed woman into a tactile experience. Both *korai* extend a hand, now lost, with an offering, and in doing so enter into an exchange with the viewer. These are not figures with whom even a woman will immediately identify, too much has been done to make them individually distinct (though hardly recognizable individuals). Rather these nubile women figure woman's position in society as go-between, making offerings to the gods, whether as individuals or as cult personnel, and were themselves offered in marriage to link patrilineages.

A funerary epigram, which this time can be securely associated with a particular sculpture [**39**], again expresses very clearly the role of the sculpture as standing in the place of woman as object of exchange. Once more from a country cemetery in Attica, this time near the ancient village of Myrrhinous in eastern Attica, the grave epigram declares: 'Sign of Phrasikleia. I will always be called *kore* having obtained that name from the gods instead of marriage.' It seems that use of *korai* as grave-markers was less frequent than such use of *kouroi*, but it may be that it was precisely because Phrasikleia died on the eve of marriage that a *kore* was in this case considered appropriate. Slightly earlier in date than the two *korai* we have just been considering, Phrasikleia's belted *peplos* has elaborate geometric decoration, she has a piece of jewellery round her neck, and a crown on her head. *Kore* is a word that can be used, as in the inscription on Nikandre's *kore*, for daughter, and so this epigram declares that Phrasikleia will never pass from daughter to wife. But Kore is also the name by which Persephone, the daughter of the goddess Demeter snatched away by Hades, was known, and we should see an allusion here too to Phrasikleia's being snatched away to the underworld. It was the lot of an Athenian woman to be moved from man to man, and to be given a name, as so-and-so's wife or so-and-so's daughter, by men. The extended arm of Phrasikleia, a standard feature of dedicatory *korai*, here gives an element of pathos, for this woman can never be an item of exchange: she has been given in exchange only to death.

That sculptors were never tempted to explore woman *as* woman, rather than woman in a context of social exchange, was probably less a direct product of the impropriety of displaying a woman's naked body and more the product of women having no independent place in society: always they appeared as the daughters or wives of men. Men who did have that independence did also, of course, live lives embedded in relations with others, and the sculpted man reflects that. Alongside the naked *kouroi* alternative representations of men occur. During the first half of the sixth century men appear in sanctuaries carrying calves or sheep (both sacrificial beasts); later in the century, under the influence of *korai*, they may appear simply clothed and in the posture of a *kore*.

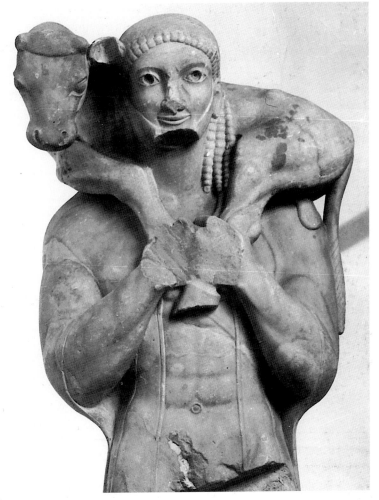

Calf-bearer (*Moskhophoros*) dedicated on the Athenian Acropolis in the second quarter of the sixth century BC. The surviving votive inscription declares: '[Rh]onbos son of Palos dedicated me'. The presence of the sacrificial animal makes this piece quite different in effect from a naked *kouros* and raises issues of the way men's agricultural activities relate to the gods.

Like *korai* these are not images upon which the viewer is necessarily free to write himself, rather they offer themselves as role models. It is a mark of this difference that such men may be obviously youthful or obviously mature: the fine *Moskhophoros* from the Athenian Acropolis sports a trim beard [**40**].

Kouroi have no narrative at all, *korai* and clothed variants on *kouroi* have only a common story of exchange. Yet by their very reticence, by the very familiarity which the absence of a particular story creates, and because there is no peculiar story to read, these sculptures intrigue and challenge the viewer. The very constraints of the form give sculptors the opportunity to evoke, excite, and exploit a bond of sympathy in the viewer by enriching their reference to the human form and by variations in the detailed presentation. As they produce sympathy so they also encourage reflection, not so much on the actions of the world around but on the essence of the world within, on the viewer's own life and how that life relates to the gods and to other men and women.

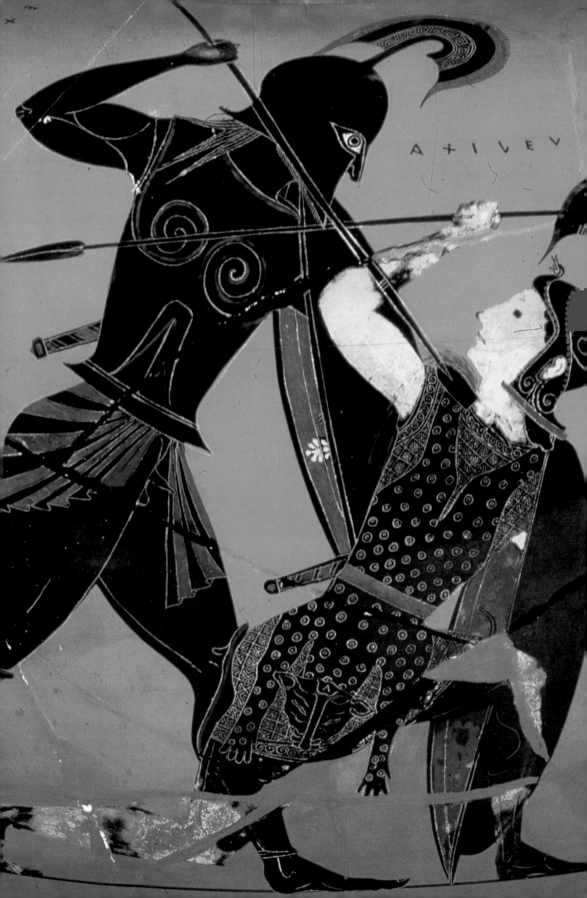

Marketing an Image

(handwritten note: look @ the change in commercial painted pottery)

If the artistic possibilities of painted pottery were, as we saw in chapter 4, enormously expanded by work on large pots which did not move far from their place of manufacture, the commercial possibilities of painted pottery were equally transformed by the small pots dominated by animal friezes produced by Corinthian workshops. There are some reasons to think that an export market displaying some discrimination was already a feature of the late eighth century; by the beginning of the sixth century there can no longer be any doubt that potters in various parts of the Greek mainland were producing pots to compete in specific markets across, and even beyond, the Greek world—a world which was now extending into North Africa, the Black Sea, southern France, and north-eastern Spain. Once Corinthian potters had pioneered an attractive and highly distinctive packaging which sold goods, particularly perfumed oil, because it both guaranteed a contents and marketed an image, other Greek potters, even if manufacturing only for a local market, were challenged to produce even more persuasive packaging and even more attractive images.

(handwritten margin note: Reasons related to changes.)

Transforming a formula

Both in Athens and in east Greece, some pot painters tried to compete with Corinthian products by imitating them; so in east Greece existing figure styles were adapted to make their wine jugs emulate Corinthian products in decoration as well as function. But the shapes that Athenian and other artists adopted were often not the shapes that were most popular in Corinth, and the resulting repertoires were quite different.

(handwritten margin note: adopted least popular styles)

In Athens we have already seen how the black-figure technique, and some of its decorative traditions, were adopted in the late seventh century for pots of a size in excess of anything produced in Corinth [28]. But the most striking examples of the employment of the Corinthian style on a pot shape which seems not to have been very popular in Corinth itself is the production in the decade or so after 600 BC of large mixing bowls, known as *dinoi*, and stands which reach a height of almost one metre. The miniature animal friezes familiar on small Corinthian pots, along with some elaborate floral bands, are

Detail of 50

Globular mixing-bowl
(*dinos*) and stand, signed
by Sophilos, first quarter
of sixth century BC.

The procession of named
divine guests to the marriage
of Peleus to the sea-goddess
Thetis encourages the viewer
to circle round this vessel in
which wine was mixed, and to
enjoy identifying the various
gods and goddesses who are
individually characterized.

expanded to match the greater scale of these works, and around the top part of the bowl, where it is at the height of a reclining banqueter and can also be seen from above, is placed a figured frieze showing a mythological subject. One finely preserved example, which like many subsequent Athenian pots found its way into a tomb in Etruria, shows yet another scene of Perseus and the Gorgon. But that frieze also contains a scene of warriors duelling between waiting chariots that could be imagined to have a Trojan War setting, and one of the iconographic developments apparent on slightly later products is indeed the eruption into Athenian art of scenes related to Achilles.

The early sixth-century Athenian *dinos* and stand in the British Museum [41] has three related claims on our attention: it is the largest surviving work by the first Athenian artist to sign his own name, Sophilos; it marks the beginning of large-scale use of painted labels to identify figures, and objects, in Athenian art; and it marks a new departure in Athenian iconography.

Modern scholars are able to associate different pots as being by the same hand or produced by the same workshop back into the Geometric period. Individual artists had habits of drawing, preferences for particular decorative motifs, and favoured iconographic schemes which mark them out from others and give their works a more or less obvious individuality.

As we have already seen (p. 35), it is through customers scratching

Connoisseurship

Distinguishing the hands of individual painters of pottery is a complicated exercise, since few artists seem to have consistently signed their work. Identification of an artist depends partly on choice of pot (some painters prefer large pots, others cups or *lekythoi*, and so on), partly on scene and composition, but partly also on the details of drawing, especially the drawing of features over which it is reasonable to suppose that the artist spent little time, and the drawing of which was more or less an unconscious mannerism.

The ankles illustrated here were all drawn within the same quarter-century, and it is on the basis of them, in part, that, in numerical sequence, we identify works by Euphronios, the Kleophrades Painter, the Berlin Painter, Makron, and Douris.

Detail of 74

Detail of 89

Detail of 76

Detail of 78

Detail of 81

graffiti on pots that we know the Greeks to have taken up the use of an alphabet in the eighth century; in the seventh century painters themselves began to write labels (as in **28**), or messages relevant to the use of the pot. In the Euboian world this led to a handful of seventh-century artists identifying themselves, but in Athens and Corinth it was only in the sixth century that this occurred, and Sophilos is the first Athenian artist to do so. This is more than just an antiquarian fact, for a signature shows both a pride in the product and a desire to attract future orders; the scale and elaboration of this *dinos* seem to justify the artist's self-promotion.

Since we have no independent information about Sophilos, or practically any other vase painter, the importance of labelling lies first in the confirmation it can give that stylistic features do indeed identify an individual artist, and second in the iconographic consequences of giving figures names. The episodes from myth which we have seen being employed in seventh-century art are dramatic and unique: the blinding of the Cyclops and beheading of the Gorgon could not be mistaken for any other episode. Already in the middle of the seventh century the greatest of all protocorinthian artists, known as the Chigi Painter, labelled a scene of the Judgement of Paris, and in succeeding years artists in various regional workshops occasionally labelled figures. Sometimes the label merely confirms what might otherwise have been guessed, as when an Athenian artist labels a centaur 'Netos' and his bearded assailant 'Herakles' [**28**]; but often the labels convey information which details of iconography could not convey: so a Rhodian artist ties a conflict over a fallen warrior to the events related in the *Iliad* by labelling the dead man 'Euphorbos' and those fighting over his body 'Menela(o)s' and 'Hektor', and the painter of an early Corinthian mixing bowl gives a *symposion* a mythological setting by labelling participants 'Herakles', 'Iphitos', and so on.

In the case of Sophilos' *dinos*, the labels convert a wedding procession attended by various more or less outlandish individuals into the wedding of Peleus and Thetis. This is a moment of great importance: here for the first time in Athenian art we have a scene which, like that Corinthian *symposion*, is firmly mythological but essentially undramatic. The dramatic confrontations with monstrous creatures in protoattic pottery necessarily remain at a distance from the viewer; indeed, I have argued above that part of the point of these scenes is that they signal and belong to another world. Bringing the viewer into contact with an alien world played an important part in helping him or her to construe the experiences of coming face to face with the gods, of confronting death, and even of gaining access, through its perfumes, to the exotic world of the Near East. But in a domestic setting and within the city, other myths were more appropriate vehicles for contemplation.

Sophilos exploits the long uninterrupted band around the top of the *dinos* to parade a full selection of gods, all duly labelled, being received by Peleus to celebrate the marriage, which has already taken place (we must imagine Thetis to be already behind closed doors in the marriage chamber). The procession is headed by Iris, the messenger of the gods, and a group of four goddesses, all richly dressed, who include Hestia, the goddess associated with the hearth, and Demeter, the goddess associated with fertility and agriculture. Dionysos, the god of wine, follows this group, making one of his earliest appearances in Greek art: his central position, and the way he stands out between the four goddesses and the even more striking figure of Hebe, suggest that he is of particular importance. After Hebe, and looking back, comes a centaur, Kheiron, carrying a bow and laden with the spoils of the hunt, followed by Themis and three Nymphs; then comes the first of several chariots in which the major Olympian gods ride: first Zeus and Hera and then Poseidon, Aphrodite, Apollo, Artemis, and Athena. At the rear comes the fish-bodied Okeanos with his wife Tethys, Eileithuia, the goddess of childbirth, and the lame Hephaistos, the smith god, riding on a mule.

Is this whole scene more than simply an excuse to show all the gods and goddesses and their attendants at once? This particular *dinos* ended up in a tomb; but Sophilos painted the same scene again on another *dinos*, of which only fragments survive, which was dedicated on the Athenian Acropolis. That dedication would seem to reinforce the suggestion that the attraction of this scene is the number of gods it includes. But the presence in the procession of figures who hold no special place in the divine pantheon, such as the centaur Kheiron who was to become tutor to Peleus' and Thetis' son Achilles, suggests that the story itself is important. This marriage represents a point at which mortals and gods meet and mix. It leads to glorification for men, in the exploits of Achilles; it also leads to great trouble for them, since it was at this wedding that Hera, Athena, and Aphrodite fell to arguing about their beauty, an argument resolved by the judgement of Paris with all its consequences in terms of the stealing of Helen and the Trojan war. If Kheiron points forward to Achilles, and the Muses to the singing of his exploits, the Moirai or Fates seem to point to the more gloomy side of the future. Whether as a gift at a wedding or as a dedication in a sanctuary, this scene adopts a highly realistic view of the problems and the possibilities involved.

The wedding of Peleus and Thetis provides the central image on another signed Athenian pot, the François vase, the work of Kleitias and Ergotimos, made perhaps a decade later [42, 43]. Here only one of the six friezes which cover this pot is an animal frieze, and even that is quite remote in style from Corinthian work. All the others show episodes from myth, and labels are copiously used, even for inanimate

[handwritten margin note: Not just images of all the gods are important, but the story it tells.*]*

42

Athenian volute *krater* signed by Kleitias as painter and Ergotimos as potter (known as the 'François vase' after the man who excavated it from an Etruscan tomb), end of first quarter of sixth century BC.

On both sides three of the four friezes with human figures run primarily from left to right and one has important accents running in the other direction. Here the lowest of the four friezes, by running counter to the others, emphasizes visually that Hephaistos is *returning*.

43

The other side of the François vase.

The shape of this mixing bowl, and particularly of its volute handles, shows how potters were influenced by craftsmen working in metals.

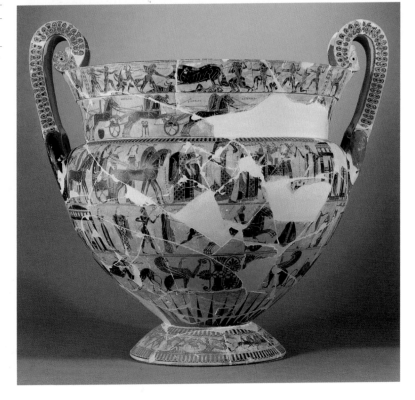

objects such as fountains and seats. Both in its combination of related stories and in its drawing style this pot constitutes something quite new in Athenian painting.

The scenes on this pot include both crucial moments in stories, as when (**43**, top) Peleus and Meleager are about to spear the Calydonian boar, and moments where the crucial action is past, as with the dance of the Athenian maidens and youths freed from the Minotaur (**42**, top) or the marriage of Peleus and Thetis itself, or to come, as with Achilles' pursuit of Troilos (**43**, second frieze up). Allusions to past or future episodes are frequent in the friezes. The body of Antaios beneath the boar seems likely to allude to the death of the man who taunted Atalanta, seen here just behind Meleager, with not hunting in a manly enough way; beside Atalanta is Melanion, the man who won her hand in marriage either by his prowess as a hunter or by using trickery to beat her in a race. A fountain house, a dropped water jar, and the running figure of Polyxena signal the circumstances in which Achilles ambushed Troilos, but the gods around the fountain house seem to allude to Achilles' subsequent *killing* of Troilos in a sanctuary. For all these allusions writing is crucial: this is a pot which demands to be read.

But if this cup is highly literate, is it also literary? Does it illustrate stories which passed down from generation to generation as part of the common stock of entertainment and education, or does it illustrate some particular text? The various scenes on the pot seem to be held together by two sorts of association. On the one hand there are a set of scenes which trace the story of the house of Peleus, from his participation in the hunt for the Calydonian boar, through his marriage to Thetis, to the role in the Trojan War of their son Achilles, who puts on funeral games for his companion Patroklos (**43**, second frieze down), ambushes Troilos, and finally, on the handles, is himself carried dead from the battlefield by Aias. On the other hand there are scenes which offer parallels to these episodes: the processional return of the god Hephaistos to Olympus (**42**, second frieze up) parallels the celebration of Peleus' wedding to Thetis; the battle of lapiths and centaurs and the liberation of the Athenians from the Minotaur parallel the deliverance from the Calydonian boar, and link Peleus' exploits to those of the Athenian hero Theseus. Such typological parallels are one of the means by which poets too from Homer on have enriched their narratives.

It happens that we also know of one poet contemporary of Kleitias, named Stesichoros, who traced the finally tragic story of Peleus and Achilles through a golden amphora made by Hephaistos, given by him to Thetis in return for her hospitality, and finally used by her for the ashes of the dead Achilles. Not only is the bringing of an amphora by a frontal-faced Dionysos to the wedding made the central feature of one side of the pot, but one of the Muses is, exceptionally, named

Stesichore. Although this is not an inappropriate name for a muse, its uniqueness and the similarity with the name of the poet has led one scholar to suggest that a particularly close connection with a particular poem is being signalled. The very copiousness of the writing on this pot, by suggesting that the precise identity of everyone and everything matters, might be held to indicate a desire to invoke not just particular stories but a specific version of a story. But the discrepancy of the amphora which appears on this vase in the hands of Dionysos, whereas that in Stesichoros was given by Hephaistos direct to Thetis, should warn us against seeing this vase as an illustration of a text: rather we have a painter connecting scenes and bringing out particular features of an assemblage of known myths in a way independent of but parallel to the way in which poets also worked.

With the François vase we are a long way from contemporary Corinthian products. Although the use of incision and the organization of the pot's decoration in friezes both owe much to developments in Corinth, Kleitias has taken the representation of myth, the exploitation of parallels between different stories, and the use of writing, much further than did any Corinthian artist. He has also made important graphic and compositional advances. He draws much more detail than any earlier artist, both when showing human and animal anatomy and when showing textiles, and he continually varies the details, making the viewer explore each figure anew. He pioneers the use of paired figures: particularly in the topmost friezes on each side, the boar hunt and the boat returning from Crete, he makes repeated use of figures who are side by side and engaged in similar actions so that one sees only part of the figure behind, which becomes a sort of shadow of the figure in front. The parallelism between the figures again encourages observation of small differences in pose, and when in one case the paired figures are Atalanta, painted white as a woman, and Melanion, the

contrast is made particularly striking. The miniature work developed in Corinth is here being exploited within the framework of a much larger pot, as Attic and Corinthian traditions are effectively married.

Playing the market

Although the François vase ended up in a tomb at Chiusi in Etruria, there is reason to think that its remarkable features were not a result of Kleitias deliberately seeking to please a foreign market. But other Athenian painters certainly did make pots specifically for foreign markets, and for the Etruscan market in particular. Although these pots are often not particularly high in artistic quality, they are of some interest for the history of art since they show what sorts of painting there was a mass market for.

One class of pots apparently almost exclusively exported to Italy were the so-called Tyrrhenian amphorae, produced by a relatively small number of painters in Athens during the second quarter of the sixth century. These amphorae are marked by their shape, their combination of an animal frieze with, on the handle zone of the shoulder, another frieze showing a scene from myth or of human life, their choice of subjects for that latter frieze, and their use of writing. Although many of the myths which appear on these pots were painted also by earlier artists, the painters of Tyrrhenian amphorae liked to emphasize violence. They also introduced scenes which are not myth but life, particularly scenes of revelling and of sexual encounters. Writing is extensively used on these pots to identify mythological characters, though the iconography is normally very explicit and few Greek viewers can have needed to read to identify the scene. In fact many labels on these amphorae are incomprehensible, jumbles of letters which do not form words at all: clearly the status of the label did not depend on its being readable.

The difference between the ambush of Troilos shown on the François vase and the death of Troilos on a Tyrrhenian amphora [44] well illustrates the way these pots delight in horrific moments. Troilos' body lies beneath Achilles who engages Hektor in combat over an altar, and between the two spears is Troilos' tiny decapitated head. The altar, implying that Achilles has killed a man who sought sanctuary, the tiny head, emphasizing the youth of the victim, and the decapitation bring out the cruelty of Achilles' act. Yet Achilles is literally backed up by the goddess Athena, who holds a victor's wreath ready for him, and by Hermes, and we know that the two Trojan warriors behind Hektor will be unable to assist him. The name labels are used to increase the pathetic effect. On another Tyrrhenian amphora, in which Achilles is made to use Troilos' decapitated head as a weapon, Achilles' name streams out before him, anticipating his swinging the head forward against Hektor; here it is Hektor's name which comes forward

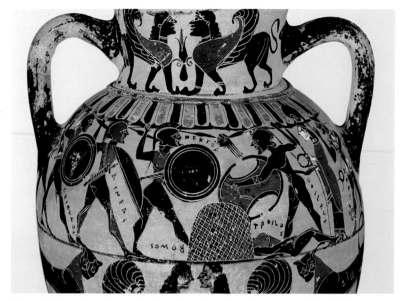

44

'Tyrrhenian' amphora made in Athens for the Italian market and attributed to the Timiades Painter, second quarter of sixth century BC.

The starkness of the drawing here contributes to the violence of the scene. The presence of the gods and the express identification of the central feature as an altar (*bomos*) ensure that the viewer does not overlook the fact that this is no ordinary battle scene.

from his head and curls down before the decapitated head, directing the viewer back to Achilles, whose own label is behind him. Troilos' label has to bend through right angles as it meets Achilles' leg, reproducing the inability of the young Trojan to resist the Greek champion (on the other representation just mentioned Achilles' spear actually cuts Troilos' name in two).

Cups, which come to form a far larger part of Athenian potters' output after 600 than they had before, were also extensively exported. Many share with Tyrrhenian amphorae an abundant use of writing, and there is a considerable overlap in iconography, although cups rarely emphasize violence to the same degree. The exterior of cups offered scope for more or less frieze-like treatment, and in the middle of the century the exterior decoration was commonly restricted to the band between the handles or the band of the lip. The interior could also be treated as a series of concentric friezes, but examples of such treatment are few, and a single scene in a circular field was more normal. Some painters exploited the fact that the interior scene would be submerged in wine, and painted fish there or Herakles' struggle with a sea monster. Others chose Dionysiac scenes, or turned the circular space into a Gorgon's head. Such exploitation of the circumstances in which the user viewed the scenes painted on a cup is in the tradition established already in the eighth century with 'Nestor's cup' and the Munich *oinochoe* (see above p. 35-7); it was highly appropriate for vessels employed exclusively in the context of drinking parties in which men competed in wit, song, sexual prowess, and capacity for alcohol.

A band cup from the middle of the century [**45**] shows well both the similarities with Tyrrhenian amphoras and the particular developments that cups encouraged. On one side the band shows the return of

Hephaistos which had featured on the François vase, on the other Dionysos and Ariadne. But both episodes are submerged by the surrounding procession of satyrs and maenads, who dance and caper, bringing in wineskins and making evident their sexual excitement. The miniature figures are carefully co-ordinated and display great delicacy of gesture, so that the various antics of the satyrs are differentiated within a procession which maintains the steady rhythm of a dance. Abundant use of added colour not only draws humorous attention to the satyrs' extremities but turns the main figures from silhouettes into solid coloured blocks. Particularly to be noted is the satyr just behind Hephaistos' donkey. Centrally placed, like Dionysos in Kleitias' procession on the occasion of Peleus and Thetis' wedding, this satyr too gazes out of the picture plain and engages the viewer, drawing attention not only to himself but to the figure in front of him. This use of a frontally faced satyr, much repeated on black-figure pots, makes the viewer complicit in the scene, not just a spectator but a participant, not indeed just a viewer but a voyeur; this is not just an illustration of a myth, it is a celebration of an exciting event in which the user of the cup is a participant. As the dancing maenads are in no way differentiated from the girls who dance at the party, so the drinker is asked why he does not join the satyrs in their activity, why he does not see Dionysos' capture of Ariadne and Hephaistos' glorious return to the company of the gods as models for his own abandonment of worldly restraints on this occasion.

Athenians were not the only potters to respond to and exploit a foreign market, and it is worth a brief foray here into a rather different

Athenian band cup attributed to the Oakeshott Painter, middle of sixth century BC. In these miniature friezes it is gesture that captures the viewer's attention: the range of gestures of the sexually excited satyrs here is small, but the subtle variations give an impression of individual characters.

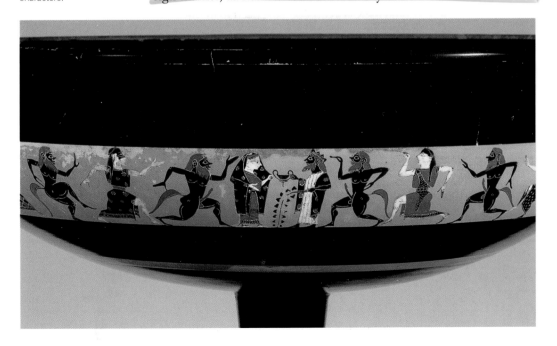

46

Interior of a Lakonian cup, name vase of the Arkesilas Painter, middle of sixth century BC.

Sparta, which had a classical reputation for austerity, was artistically vibrant during the eighth to sixth centuries, producing ivories, metalwork, and pots of a quite distinct character [**10**, **11**]. This colourful and detailed scene seems to show Spartan interest in the settlement at Cyrene in Libya, with its kings named Arkesilas and its trade in agricultural produce.

vase-painting tradition. Pottery production in Lakonia, Peloponnesian homeland of the Spartans, became important only in the last quarter of the seventh century. From then for more than a century Lakonian pottery, and particularly cups and mixing bowls, was widely exported, albeit to a particular selection of destinations among which the island of Samos and the Greek settlements in Libya were particularly prominent. Much of the imagery on Lakonian pots relates to their use in the *symposion*, with scenes of drinking, revelling, and so on. But whereas the exterior is the only or most important area of figured decoration on many Athenian cups, Lakonian artists filled the inside of cups with decoration, often illustrating themes not seen on Athenian pots.

The scene of a figure labelled Arkesilas supervising a weighing operation [**46**] is an outstanding example of the particular style and content of Lakonian cup painting in the middle of the sixth century. The circular space is divided by a groundline below which two running figures carry sacks to add to a pile and a further small figure sits bundled up and labelled 'Phylakos' (guard). Above, the large and elaborately dressed figure of Arkesilas sits under an awning, up which crawls a lizard. He takes part in the weighing and bagging of a white fluffy substance, which appears on both pans of the balance. The use of writing to name figures and objects is much like its use by Athenian

artists, but the painting style, the organization of the picture space, and the subject are not at all like anything Athenian. White and shades of yellow, brown, and purple are all extensively used, and only on the bodies of men and animals is incision employed. The anatomy that is incised is highly individual, as one glance at the knees of the figures will show. Athenian artists, and indeed many Lakonian artists, tended to paint few large figures inside cups, but here we have small figures, and as a result the fact that the field to be painted is round is less apparent. The groundline, the top of the awning, the beam of the balance and its support, and the strong vertical accents provided by the figure of Arkesilas on the left and the figure of 'Sliphomakhos' pointing upwards on the right-hand side create an essentially four-square frame. Arkesilas was a name used in the royal house of the Battiads who ruled Cyrene in Libya, a place known for its flocks and for the production of silphium, an umbelliferous plant now extinct. But Arkesilas is also a name known from Sparta itself in the fifth century, and it is not clear whether this is an exotic Libyan or a domestic Lakonian scene. Nor is it clear whether we should take the groundline as a literal floor and imagine sacks being weighed and stowed on board a ship. What does seem clear is that we are being shown authoritative control being exercised over a commercial operation, something not entirely inappropriate, perhaps, on a vase which ended up in a grave at Vulci in Etruria.

The creation of the contemplative viewer

Tyrrhenian amphorae and cups display well the way in which Athenian artists, increasingly confident in their control over their resources, made their work stand out among the competition. What marks out this Athenian work is the careful selection of episodes from myth which would appeal to those who liked stories to be eventful, the learned employment of script (even if that script was in fact nonsense), and the more or less witty exchange with the user of the vase. But although the amphorae and the cups have much in common in technique and in imagery, the situations in which they were used were different enough to encourage different sorts of development. Amphorae, water jugs, and even more mixing bowls, stood about in party rooms, to be gazed at from afar: one really could expect someone to have a good chance to examine the many friezes of the François vase. Cups had to make a more immediate return: passed round, picked up, drunk dry, whirled around in the game known as *kottabos* to cast out their dregs towards a fancied boy, cups were always on the move: their engagement with the drinker was more intimate, but it had to be at a glance.

From the middle of the sixth century, the different demands made by cups and by larger pots, and in particular a realization of the opportunities the different shapes offered for different sorts of scene, scenes

to be gazed at or scenes to be glanced at, began to lead to specialism among artists. Although there continued to be some artists who painted both cups and larger pots, divergent traditions developed. Two painters active in the middle of the century reveal clearly, if in very different ways, the various directions in which explorations were made.

The 'Amasis Painter' derives his name from the fact that he paints pots which declare themselves made by a potter called Amasis (one other painter is known to have painted for Amasis too). Not all the pots painted by the Amasis Painter are signed as potted by Amasis, but none is signed by any other potter. The Amasis Painter was primarily a painter of large pots, to whose hand can be attributed amphorae of various shapes, wine jugs, and *lekythoi*; but he also painted *aryballoi*, and variously shaped cups.

The Amasis Painter was a virtuoso who brought life to painted pottery. He painted the whole of life: men run, drink, hunt, ride horses, drive chariots, consort with Dionysos, wrestle, box, play the *aulos* and the lyre, dance, pay court to women and boys, masturbate, marry, put on armour, go to war, and get locked in combat; women weave, play the *aulos*, amorously encounter men, marry, and wave warrior husbands goodbye; dogs defecate. By contrast, he painted only selective scenes of myth. There is Perseus decapitating the Gorgon, a small number of exploits of Herakles, including several versions of his entry to Olympos, Poseidon in stables, Achilles arming, Menelaos recovering Helen, and one Amazonomachy. Athena and Poseidon are shown facing each other on two amphorae, and on another appear on opposite sides along with other gods or men; Dionysos faces two dancing female devotees on one amphora [49] and is surrounded by young men or men and women on several others; Artemis appears with Apollo and a palm tree on one *lekythos* and as Mistress of the Animals on another; in none of these cases is there any story involved. Several vases showed satyrs engaged in treading grapes.

On his large pots the Amasis Painter develops the processional composition already witnessed in Sophilos and Kleitias. Most of his amphorae figure four, five, or six standing figures on a side, usually with a distinct central figure or object around which the scene is organized and which is crucial to its identification. Physical contact is minimal, except where a fight is in progress, and even overlap between figures is limited except among devotees of Dionysos; construing what is going on and how the figures relate depends on gestures: Amasean figures communicate with their arms or, occasionally, by a 180 degree turn of the head. This extreme simplicity of composition, along with the choice of uneventful moments to represent, marks Amasis out from earlier artists. It also changes the relationship to the viewer.

Pots which choose dramatic moments and pots which smother themselves with writing encourage the viewer to think that looking at a

picture is like reading a text. Where there is writing, it provides the nouns and the figure drawing supplies the verbs: together they make up a story. Where there is no writing, the inclusion of distinctive individuals, whether monstrous or human, or peculiar objects serves to identify the nouns, and the composition again supplies the verbs. The Amasis Painter is very sparing with written inscriptions, often chooses scenes where it is impossible to identify figures securely, or even to say whether they are men or gods, and when he employs identifiable figures he involves them in actions that are so undramatic as to make identification of a known incident difficult or impossible. In the hands of the Amasis Painter looking at a pot becomes much less like reading a text.

These features are well illustrated by the scenes on a one-piece amphora of the Amasis Painter's favourite shape, the so-called 'Type B', now in the Louvre [**47**, **48**]. On one side a man in a cap and a short red *khiton* and carrying a spear and a shield advances towards two other men with spears, while looking back over his shoulder at a young winged figure also in a short *khiton*. On the other side a naked young man carrying a dead hare meets an older man dressed in *khiton* and *himation* and carrying a spear, behind whom is a dog and another bearded man in a cap and with a wrap over his arm. Neither scene can be identified with any particular story, even though the winged figure is clearly not part of normal visual experience.

Unable to fix what is going on by reference to any text, the viewer is left to puzzle out the possible relationship of the figures from the visual clues given. The composition is crucial in both cases. In **47** the lion-head shield is the central feature, identifying the visually most prominent figure as a warrior, whose determination to advance to the right is marked both by the direction of the head and by the diagonal formed by his spear, when all other spears are vertical (a feature which also enables the artist to put a vertical spear in the space between each figure without ever having two spears in one space). The warrior's reversed glance implies that his attention has just been caught by the figure behind, who has just arrived, and that figure's colourful wings turn him into some supernatural messenger. The winged figure and the naked young man in front of the warrior have essentially identical hand gestures, which, with the backturned head, suggest that the warrior is being placed in a position with contrasting messages coming from the different directions. Whether the viewer takes the winged messenger to speak of imminent death is the viewer's decision.

In **48** the central feature is the hare, and the puzzle for the viewer is the relationship between the hare and the figures. Hunting hares was a way of demonstrating prowess, and in particular was a way in which an older man proved himself worthy of the affections of a younger male lover. On a cup in the Louvre the Amasis Painter himself showed a se-

47

Athenian amphora attributed to the Amasis Painter, middle of sixth century BC.

The Amasis Painter is a master of gesture, of bold blocks of colour, and of the telling use of detail. Much of his drawing is extremely simple, but where it is necessary to attract the viewer's attention he shows a sudden fussiness of detail, as here to emphasize the elbow, and therefore the gesture, of the winged figure.

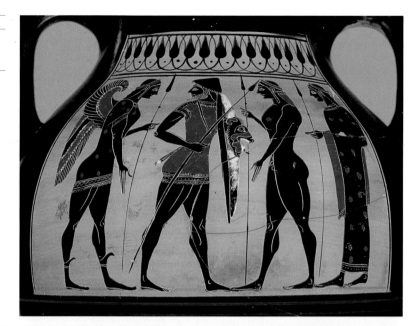

48

Other side of same amphora. Much of the Amasis Painter's work explores encounters between men and women or between figures of different ages. Age and gender are clearly but simply indicated on this pot: the young men are naked and beardless, the mature men are bearded but may still be naked, the women and old men are clothed.

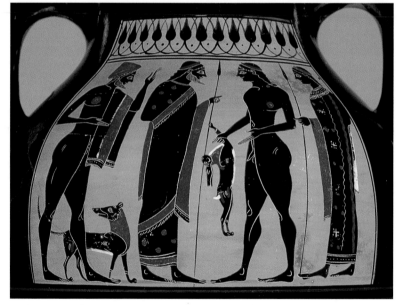

ries of pairs of lovers and an array of love gifts, cocks, a deer, a hare, even a panther, being handed over by an older man to the younger male, or in two cases female, partner—the drinker who uses that cup can choose his own role model. On the amphora the young man himself holds the dead animal, but has he hunted it himself or has he been given it? If he has received it, who has he received it from? He faces an elaborately clothed older man, can that be the hunter? Or is the hunter the gesticulating man with the hat and the dog, who looks rather like a hat-wearing hunter shown on a jug by the Amasis Painter in the

British Museum? What we think is going on in the scene depends on what we decide about the identity of the hunter, and each viewer must decide what interpretation of the relations between the figures best fits the limited information available.

If there is no 'correct' story to be identified behind either scene on this amphora, nor is there any single way of combining them. The parallelism between the organization of the pictorial space in each case encourages consideration of their relationship, and the similarities between the naked young men and between the hatted figures encourage the viewer to wonder if they are to be seen as the 'same' figures. Should we see narratives of disruption on both sides—the warrior disrupted by the winged figure on one side, the hunter interrupted by the man in the *himation* on the other? Should we think of warfare and hunting as two ways in which men display their manly virtue, in the face of different risks but with the final results equally obscure in both cases?

Another use of the hare further emphasizes the way in which the Amasis Painter raises questions, and so insists that the viewer contemplate rather than glance. A neck amphora [**49**] shows two young women in extremely elaborate garments and jewellery, their arms around each other, dancing before Dionysos and extending to him a hare. The feeling of power over wild nature acquired during some Dionysiac rituals, and the capture and tearing apart of wild animals which might ensue, is sometimes shown on later vases [**81**]. Here the fawn held by one worshipper and the panther skin which she wears point to that power over nature, not least by the way they have become simply further elaborations of her costume, and the union of the two women into a single joint figure might be taken to allude to the feeling of oneness with god and with other worshippers which Dionysiac worship produced. The hare can also be seen in this light, but at the same time it serves to liken the religious relationship between Dionysos and his female worshippers to the relationship between similarly ivy-crowned and bearded drinkers and the young women recipients of love-gifts. A frieze of clashing warriors around the shoulder of this amphora encourages the viewer to see this, and the scene of Athena facing Poseidon on the other side of the pot, as a significant confrontation, but the viewer's question about the nature of that confrontation is never answered.

It is unusual for the Amasis Painter to use only what is in effect two figures on the side of an amphora, and unusual too for them not to be enclosed in a panel. Such a composition is rather more common in the work of the greatest of his contemporaries, Exekias, and it is tempting to see Exekias' influence in this particular pot. Exekias, who signs work both as potter and as painter, had a much shorter active career and his very much smaller output consists almost entirely of amphorae. He concentrates very largely on scenes involving gods and the heroes of

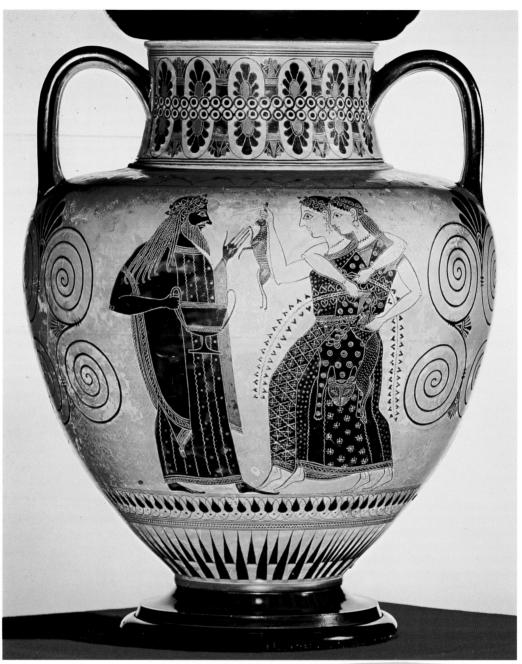

myth. Although on occasion he paints undramatic moments and simple 'up and down' compositions with parallel figures, of the sort that the Amasis Painter preferred, Exekias most characteristically chooses moments of great, indeed tragic, drama, and risks complex compositions with overlapping figures and a good deal of physical contact.

Story matters in Exekias, and the viewer is drawn into contempla-

tion not by uncertainty about how a story will end but because he or she knows the end only too well. On an amphora very similar in shape and subsidiary ornament to that on which the Amasis Painter portrayed Dionysos and the dancing female worshippers, Exekias paints a scene of the fatal encounter on the battlefield between Achilles and the Amazon queen, Penthesileia [**50**]. He chooses the very moment at which Achilles' spear enters the Amazon's neck, but rather than bring out the gory horror of the moment of death, as Tyrrhenian amphorae do, he brings out its tragedy. What makes this scene tragic? Two compositional features are at the root of the tragedy. The composition, as well as the Amazon queen, is on the edge of collapse. The dominant lines, formed by the bodies of the two warriors, run from lower left to upper right. Achilles' spear begins to form an opposing diagonal that will run from upper left to lower right, but as it enters the body of Penthesileia and stops it never reaches the ground. Penthesileia's name, by nearly but not quite continuing this line, emphasises the truncation and so the imminence of collapse. Yet the moment portrayed is a moment of resistance: the line of Penthesileia's shield is taken up and turned back inwards towards Achilles by the crest of her helmet, and for an instance forces are equalized. At that instance the glances of the two warriors meet, and the killing becomes not merely a matter

Athenian amphora signed by Exekias as potter, third quarter of sixth century BC.

This apparently simple composition hides much subtle detail which differentiates the two warriors: Achilles' front foot is flat on the ground, Aias' has a nervously raised heel; Achilles' shield bears a snub-nosed satyr, Aias' a flat Gorgon; Achilles' eyebrow is a single fine line, Aias' drawn with two lines.

of physical strength but an act with a moral dimension. Later literary accounts insist that Achilles fell in love with Penthesileia at the moment he killed her; whether or not Exekias was familiar with such a tradition, there can be no doubt that he painted here a scene of Achilles coming to contemplate, but too late, exactly what it was that he was doing in killing this woman.

The effect of this painting depends in large part on the warriors being Achilles and Penthesileia, but not on the viewer knowing any particular story about their encounter. Rather what is important is the baggage of associations which the two, and particularly Achilles, carry with them. The Achilles who was the subject not just of the *Iliad* but also of other oral epics of which we now know only indirectly, was both the supreme warrior and a man doomed to die. He was a man of great wrath and ruthlessness but also a man of high principles. A man of close affections and loyalties, as in his relations with Patroklos, he was nevertheless independent and finally solitary. It is because Achilles is not merely the most efficient killing machine but also a figure of great sensibility, and himself to be a victim, that the viewer can respond to the painter's invitation to fill with his contemplations the pregnant silence of the moment in which he kills Penthesileia.

The exploitation of the associations surrounding heroes to create a dramatic story which does not depend upon any particular story told

by others is seen even more radically in the most famous of all Exekias' scenes, the scene of Achilles and Aias playing dice [51]. The encounter between Achilles and Penthesileia had been represented in art from the late seventh century; probably no previous artist had shown Achilles and Aias playing dice. Following Exekias the scene became extremely common on vases and was even represented in sculpture, and it is not improbable that the power of Exekias' image was the reason for this. Why did so apparently trivial a scene achieve such importance? It is not the fact that two men play a game, but that it is these two men who play that matters. With great economy of means Exekias conjures up the setting inside a tent (the two shields lean against its walls), the sense of the game being played in a moment snatched from more serious combat (Achilles wears his helmet and both wear greaves and body armour and hold their spears in readiness), the defeat that faces Aias (he declares his throw a 'three', while Achilles announces a 'four'; and Achilles, with helmet, is made physically dominant), and a more general sense of doom (promoted by the faces on the shields).

The tension that grips the scene is not just the excitement involved in winning or losing any board game, nor the unease induced by the conflict between the elaboration of the cloaks of both warriors, intricately woven by a devoted family now far distant, and the grim conditions of war, but the anxiety that comes from knowing the fate of the two men. Achilles may have the upper hand now, but, in a scene which Exekias painted more times than any other, it is Aias who will pick up Achilles' body from the battlefield and bring it back limp and lifeless to the Greek camp over his shoulder. Aias may recover from *this* defeat, but when pebbles are piled up on another board to decide that someone other than he will get Achilles' armour, Aias will commit suicide by falling on his sword, another scene that Exekias also painted. Both Aias carrying off Achilles' corpse, which appears on the handle of the François vase, and Aias' suicide had long been popular images, and there can be little doubt that even a sixth-century viewer unaware of Exekias' own predilections would have made the links, and sensed the tragedy implicit in this scene.

The subsequent popularity of the scene of Achilles and Aias dicing enables us to see what artists made of the scene in immediately succeeding years. Some choose to balance the figures still more evenly, removing any visual or verbal indication of who has the upper hand; others make the issue far clearer by introducing an Athena who indicates, finally by handing over Victory, which way her favour lies. Some take up the hints of imminent war and move the board and players outside, even have battle rage around them, so suggesting that the game was not just a moment snatched but a moment illegitimately snatched by warriors who should be joining in the fray, and so playing up associations with Achilles' withdrawal from battle in the *Iliad*.

The association with Aias' final fate is brought into artistic play when scenes of the vote to decide the recipient of Achilles' armour become popular and borrow the iconography of the dicing scene. The existence of all these variants is both good evidence that there was no particular literary text or oral tradition which Exekias was illustrating, and an indication of the compulsion to unpack its implications which Exekias' scene induces in the viewer.

Who is it one kills in war? How do we decide what is a trivial and what an unbearable defeat? Exekias' paintings raise those questions, and emphasize the fragile grip men have over their own circumstances and the mental fragility produced by war and conflict. Where the Amasis Painter encourages those who view and use his pots to think about the complexity of their relations to those around them and the nature of the encounters in which they are engaged, Exekias throws into the context of the *symposion* issues of life and death. Given the range of the poetry performed at the *symposion* we should not be surprised at this: it was not just in requiring brilliant repartee and arousing sexual desire that the *symposion* was intellectually and emotionally demanding. But nor should we be surprised that Exekias' deep seriousness had fewer followers among his fellow pot painters than did his drawing style.

The painters of large pots in the last generation in which black-figure reigned supreme in Athens can be broadly seen to divide between Amaseans and Exekians. Many painters' amphorae are dominated by essentially processional scenes consisting of a number of parallel figures, often enlivened by use of blocks of added colour. Others have a single pair of figures, often in conflict, dominate the scene. A few are more ambitious and attempt to exploit the possibilities which having numerous figures gives for suggesting reactions, while also focusing on dramatic incidents. Two examples will show what could be achieved.

Scenes of Herakles were particularly popular throughout the second half of the sixth century. A canon of twelve labours seems to have become established only with the sculptures of the temple of Zeus at Olympia in the second quarter of the fifth century (below, p. 173–4), and artists by no means limited their attention to Herakles' various struggles with animals. On a belly amphora [52] an artist known, from the subject of another of his paintings, as the Swing Painter, painted Herakles assailing Busiris and his fellow Egyptians. The story of Herakles giving his come-uppance to Busiris, son of Poseidon and ruler of Egypt, who had the custom of making an annual sacrifice of a stranger as an insurance against natural disaster, first appears in Greek art in the early part of the sixth century. In his version the Swing Painter shows Herakles taking the Egyptians literally in hand over the altar on which they intended to sacrifice him, and over which Busiris

Athenian amphora attributed to the Swing Painter, third quarter of sixth century BC.

The bold use of colour here both clarifies the complicated scene and lends an appropriate exoticism to Herakles' fight with the hostile Egyptian king Busiris and his men over the altar on which the Egyptians sacrificed strangers.

himself already slumps. With abundant use of added colour, which serves to stress both the exotic nature of the Egyptians and the ferocity implicit in Herakles' lion-skin, and with a range of violent gestures, the painter vividly captures the issue of treating men as beasts while ironically bringing out the beast element in Herakles.

If the Amasean inheritance is clear in the Swing Painter, it is the Exekian which dominates the so-called Leagros group. On a *hydria* belonging to this group [**53**] the Exekian theme of the warrior carrying a dead comrade off the battlefield is redeployed to show a male warrior carrying off a dead Amazon. The figures are not named, and by contrast with Exekias' practice they are not isolated. To the left the battle continues to rage; we see a fallen Amazon and a Greek warrior continuing the fight. To the right a heavily armed warrior departs from battle, his helmet raised; he casts a backward glance as if wondering at the central action. Ahead of him is another warrior in Skythian hat and carrying an axe. The presence of these other figures, and particularly that returned glance of the retiring warrior, raises a question which would not otherwise be prominent: just why is a Greek warrior

Athenian *hydria* attributed to the Leagros group, last quarter of sixth century BC.

The 'Leagros group' is so called from the presence on their pots of inscriptions greeting one Leagros as beautiful. On this *hydria* an arming scene is juxtaposed to a scene which borrows from the scheme of Aias removing Achilles' corpse from the battlefield for the carrying off of a dead Amazon, and thereby highlights the questions 'Who is under the armour?' and 'Whose armour is it?'

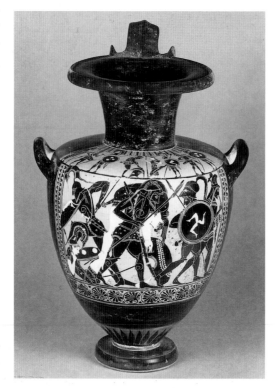

carrying one of the enemy Amazons from the battlefield? Should we identify the Greek as Achilles and the Amazon as Penthesileia? We may choose to see here the sequel to Exekias' scene, or we may choose to find the issue generalized: what sort of relationship and how much sympathy is appropriate between warring enemies? When is it appropriate that personal feelings, or generalized humanity, neutralize political enmity? Can we only recognize that those who fight us are human once they are dead? The *hydria* (water jar) was a shape popular with the Leagros group; it gave renewed scope for the juxtaposition of two scenes on a single side, a tradition which the Amasis Painter had continued on a variety of amphora shapes but which Exekias largely eschewed. Here the shoulder shows an arming scene, encouraging a generalizing reading of the scene on the body.

Colourful dramas outside Athens

Although Athenian vases have dominated this chapter, and although Athenian pots had come to dominate the whole Mediterranean market by the end of the sixth century, work of very high quality was produced elsewhere in the Greek world also, and not least in the area from which most surviving Greek pots come—Italy. A glance at two 'schools' of vase painting established by Greek artists on Italian soil will show something of the quality of pot painting outside Athens.

A group of *hydriai* found at Caere in Etruria exploit the possibilities

of polychromy to a much greater extent than any Athenian pottery. Although many of the myths which inspired the Caere workshop were those that inspired Athenian painters—adventures of Herakles, the Calydonian boar hunt, the return of Hephaistos—the approach is often distinct, and the humour more explicit. Instead of showing Herakles capturing the three-headed hound Kerberos, he is shown [**54**] bringing him back to a terrified Eurystheus, the man who had ordered his capture. Colour is vital here, in a picture which can truly be said to be painted, but the drawing to be seen in the heads, and particularly the eyes, of Kerberos is also bold but sensitive. By choosing to show Kerberos' encounter with Eurystheus, rather than that with Herakles, the artist is able to show the frightfulness of the beast without making Herakles seem in any way unheroic; rather Herakles' stature is enhanced by the pusilanimity of the man who compelled him to labour.

The so-called 'Chalkidian' vases, made in southern Italy in the second half of the sixth century, come in a much wider range of shapes. The style of the workshops responsible seems to have been rather eclectic, for they incorporate animal friezes in a Corinthian style on pots which in their shapes, their favoured subject-matter, and their subsidiary ornament are very Athenian. Within the broadly Athenian 'feel' of the scenes, there is much innovative iconography. An amphora

54

Hydria from Caere in Etruria, third quarter of sixth century BC.

Eurystheus may have hoped that Herakles would end up at the mercy of the many-headed Kerberos, the dog of Hades, which he ordered him to capture, but when Herakles returns with the monster the tables are turned. The three heads here replicate the impression of many separate jaws received by anyone faced by a hostile dog at the end of a leash.

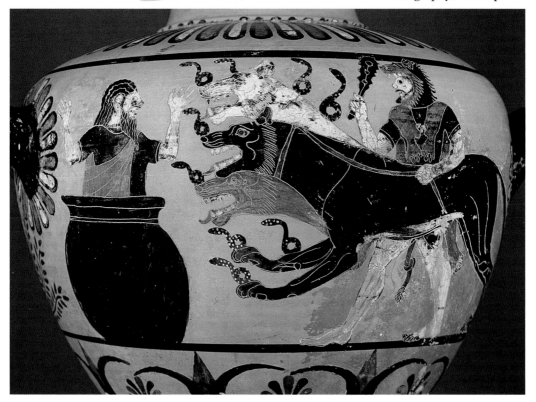

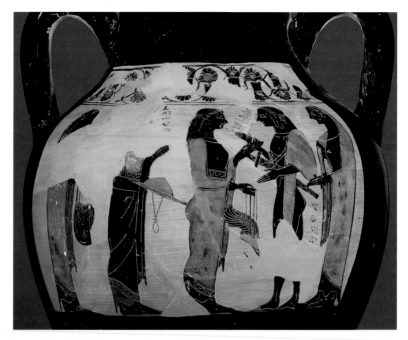

in the British Museum shows on one side [55] a procession of figures: three quite richly dressed young women line up to present to a young man with a sword three gifts, a bag, a hat, and a pair of winged sandals. Behind the young man stands Athena. Perseus is here acquiring from the Stygian nymphs what he needs for his encounter with the Gorgon Medusa: winged sandals to get him there, a helmet of invisibility, and a bag in which to put the head after the decapitation. While the gifts point the viewer forward to the rest of the story, to identify the three young women the viewer needs to know that even to get these items Perseus had to master the Graeae, sisters of the Gorgon, by capturing the one eye and one tooth they share between them. The choice on this side of the moment of planning complements the picture on the other side of the same pot [56] in which, again with Athena's support, Herakles engages with the three-bodied Giant Geryon. Showing the three bodies of Geryon rotating around a shield seems to be an idea that goes back to the end of the seventh century, but striking here is the decision to make one of those heads frontal and the central feature of the scene. Elaborately framed with helmet and crest, the head confronts the viewer, as the dying are commonly made to do, both showing itself to be 'out of it' as far as the action of the picture is concerned, and making a pathetic appeal to the viewer. Whatever Perseus succeeded in doing, the mask of the Gorgon is still to be seen in the field of battle.

If the complex organization here of both picture plane and narrative is compared to the friezes of Sophilos or Kleitias discussed at the beginning of the chapter, the extent to which the aims and the techniques of painters changed during the sixth century becomes

56

Other side of same amphora. Triple-bodied and winged, the monster Geryon, whose cattle Herakles was sent to capture, was often presented as a sort of one-man hoplite phalanx. Here Geryon has only one pair of legs and the heads rotate to show Geryon's bodies in three different states— slumping forward dead, collapsing backwards, and still battling on.

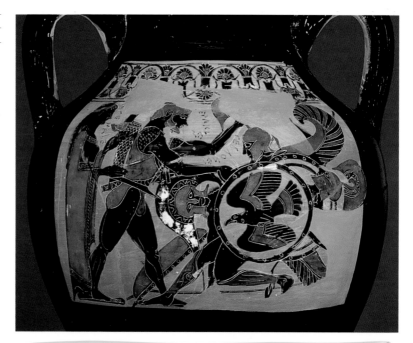

apparent. Stimulated by widespread demand, and by the possibilities of producing pots for particular uses that involved images being viewed in ways and contexts that were more or less predictable, artists experimented with a whole range of ways of intriguing the viewer. Brilliant polychromy, vivid and even gory dramas, detailed written commentaries, pensive reflections, all these were tried out during the century as the cemetery ceased to be the most important patron for potters and the *symposion* increasingly dominated the market. A constant tension can be perceived between meeting expectations created by previous works and offering something strikingly new. We see this in Athens in the way the Amasis Painter takes on innovations made by Exekias, and later artists play variations on the characteristic style of both. But we can also see such competition between city traditions, not just in the way in which Athenian black-figure established itself on a Corinthian foundation but in the way in which in the second half of the century Chalkidian painters pick up and play with the current compositional and iconographic fashions which Athenian artists had put on parade.

Pot painters worked for a market determined by the pockets and tastes of private individuals. But alongside the private interest in illuminating an individual's life and choices by reference to myth, fed and fostered in their productions for *symposia* by painters and poets alike, there was also in the sixth century a burgeoning city interest in the relationship between myths and public life that was to have profound effects not just on the public imagery of the city but on pot painters also, and it is to this that we must now turn.

amphora: the amphora was the basic storage vessel for liquids, and undecorated amphorae survive in very large numbers and in a variety of shapes, but particularly in a long thin version with a pointed foot. The shapes shown here are two found in sixth-century Athenian pottery, the 'Type A' amphora and one of several types of neck amphora. For examples see **51** and **49**.

dinos and stand: the *dinos* was an alternative to the *krater* as a bowl for mixing wine. Pictures of it survive more often on pots than do examples, perhaps indicating that it was a more popular shape in metalwork than pottery.

aryballos: the *aryballos* was a vessel for oil, carried by men who exercised in the gymnasium.

hydria: a vessel for water, with two handles for carrying and a third for pouring. The form shown here offered opportunities for decoration on the shoulder as well as the body. See **53** and **75, 6**.

cup or *kylix*: shallow vessels on raised feet were the most popular drinking vessels at parties and were made in a variety of shapes and sizes. See especially **4** and **68**.

kantharos: a drinking vessel with high handles which commonly appears in the hands of the god Dionysos himself (see **4**, **49**).

krater: a bowl for mixing wine, made in a number of different shapes and sizes, some of which manifestly copy metal vessels. The calyx *krater* was much liked by Euphronios (see **73** and **74**). For a volute *krater* see **42, 43**.

lekythos: a container for oil used particularly to offer oil on graves and as an offering in graves of classical date (see **115**).

psykter: this curiously shaped vessel was made to contain ice and stand inside a *krater*. Its intimate link with the *symposion* is evident in its decoration, see **89**.

oinokhoe: a jug for wine. For two early examples see **14** and **17**.

skyphos: another drinking vessel popular at the *symposion*, see **4**.

stamnos: this vessel is particularly associated with scenes of Dionysiac ritual (see pp. 151, 189), but the range of functions it performed is uncertain.

pelike: the use of the *pelike*, which was fashionable only for a relative short period in the fifth century [**93**], is uncertain.

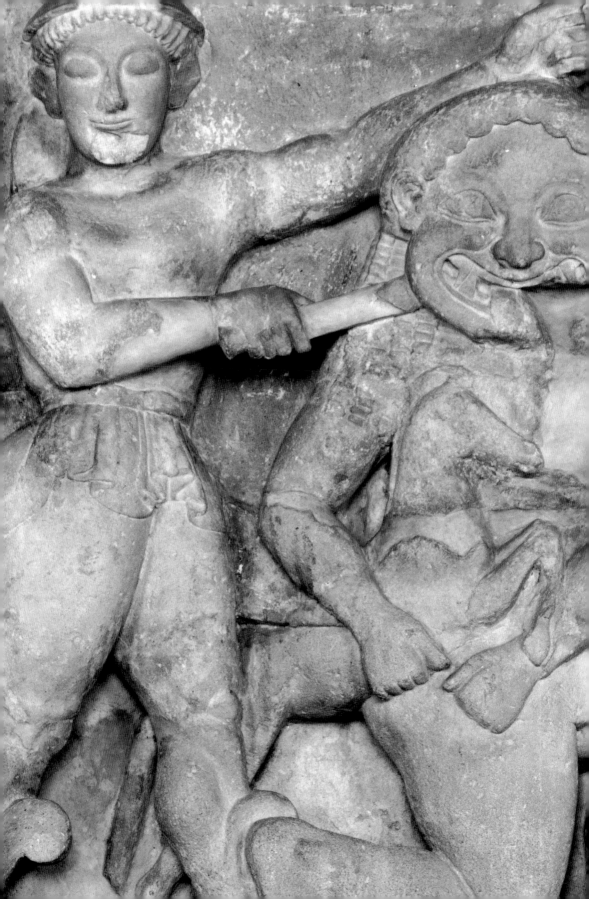

Enter Politics

7

The earliest sculpture on stone temples was, as we have seen in chapter 5, dominated by the encounter with the divine, particularly as figured in the terrifying face of the Gorgon. In the course of the sixth century, however, artists began to explore aspects of the human encounter with gods other than merely their frightening power. In doing so they also explored aspects of relations between men which bore directly on the public life of the city: art became political.

Greece down through the seventh century had been heavily regionalized. Geometric pottery can be divided into regional styles, and the distinct 'schools' of seventh-century pottery production and decoration are similarly regionally based. Although men lived out their lives in the relatively small self-governing communities that were the Greek cities, there seems, prior to the sixth century, to have been little attempt by those cities to mark their boundaries by cultural differentiation. Seventh-century Cycladic pottery seems to have been equally at home on a number of politically independent islands; the pottery known as protoattic may have been made on the independent island of Aigina as well as in the territory of Athens; Corinthian pottery was both widely distributed and widely imitated.

During the sixth century individuals' identities became increasingly bound up with the city of their birth. As they competed for the same markets, sixth-century potters and painters continued to adopt ideas pioneered elsewhere, wealthy men continued to seek wives for themselves and husbands for their daughters among the élite of other cities, and temple architecture continued to follow broadly regional patterns; but when the institution of coinage spread with extreme rapidity through the Greek world in the middle of the sixth century few cities were content to use coinage minted elsewhere. City-specific coins were struck whose types sometimes made direct or punning reference to the city that minted them: Athens came to mint coins with the head of Athena and Athena's owl [57], the city of Phokaia made coins with a seal for which the Greek name was *phoke*.

One way in which cities distinguished themselves was by laying claim to particular mythical heroes or episodes. Greek cities had a common inheritance of myth which is reflected by the widespread

57

An Athenian silver owl, last quarter of sixth century BC. The earliest Greek coins were minted in electrum in Ionia. Silver coins were first struck in the middle of the sixth century, and in the next fifty years a very large number of cities minted distinctive coinages of their own. The earliest Athenian coins bear a variety of types, but from the 520s the city struck coins with the owl and head of Athena.

popularity in seventh-century art of such scenes as the blinding of Polyphemos by Odysseus, the beheading of the Gorgon by Perseus, or Herakles' attack on the centaur Nessos. But if Odysseus was not the exclusive property of the people of Ithaka, where he was held once to have ruled, other stories did have relevance primarily to the people of one particular place. Herakles remained the common property of all Greeks, vastly popular in Athens as well as in central Greece and the Peloponnese where his adventures were sited. Theseus' achievements in ridding the world of monsters were not unlike those of Herakles, but although he had some universal appeal, his story seems to have become closely bound up with one city: Athens. Theseus made an appearance in the last chapter on the François vase, liberating Athenian men and maidens from the Minotaur, but only in the last quarter of the sixth century did scenes of Theseus become popular at Athens.

It was not only in thumping a particular city's tub that sixth-century art was political. Reflections on politics, whether on topical political events or on long-standing political issues, may be inspired by seeing parallels in stories which do not, on the face of it, engage patriotic or partisan interest. The painters of pottery whose work was examined in the last chapter encouraged viewers not simply to glance at but to engage with the scenes on their pots. Such engagement may variously lead to moral or ethical reflections or reflections on sexual relations and gender roles; but the very act of reflecting on an aspect of contemporary practice is bound, like Exekias' engagement with the ethics and ways of war, always also to be political.

In this chapter I look at the inter-relation of art and politics in a half-century which witnessed several developments crucial for the history of the Greek city. Between 525 BC and 475 BC. Sparta gave a formal structure to her network of alliances in the Peloponnese and thus assured her political and military dominance of the Greek mainland. Athens, meanwhile, assisted by Spartan military might, got rid of a tyranny which had kept up close relations with similar regimes elsewhere; it became a city in which the people ruled themselves through the institutions of democracy—a popular Assembly attracting five to six thousand adult male citizens, and a Council of five hundred citizens selected by lot. Most important of all, Persian expansion in Anatolia brought the Greek cities of Asia Minor under Persian control and threatened the Greek mainland. This concentrated Greek minds and obliged the rulers of Greek cities to weigh up against each other the importance of Greekness, on the one hand, and of being independent of their Greek neighbours, on the other.

Politics enters the sanctuary

For the first three-quarters of the sixth century temple sculpture in both mainland Greece and the Greek west focused on the encounter.

The encounter with the Gorgon [31] continued popular in pedimental sculpture, and viewers were brought up short by meeting gods and heroes face to face. Representing such encounters posed a number of problems for artists, particularly in terms of composition. When the line of sight of sculpted figures comes directly out of the picture plane, a direct link is established with the viewer, but this is at the expense of one important means of establishing links between the sculpted figures themselves. To choose frontal compositions in temple sculpture is to display a strong preference for encounter, and so also to prefer the tableau to the narrative scene.

A rich series of metopes from temples at Selinous in south-western Sicily illustrates clearly the way sculptures could place emphasis on the temple as the place at which men come face to face with gods and heroes. Frontal faces dominate the surviving metopes from both Temple Y (*c.*550–530 BC) and Temple C (*c.*530–510 BC), which also had a Gorgon pediment. Temple Y presented the gods to the worshipper in a

58

Metope from Temple Y at Selinous, third quarter of the sixth century BC.

The viewer is made to confront the attractions of Zeus the bull, as he seduces Europa, by looking at the god's/animal's face, with its highly decorative fringe of hair, head on; his journey over the sea is alluded to by the dolphin shown leaping beneath him.

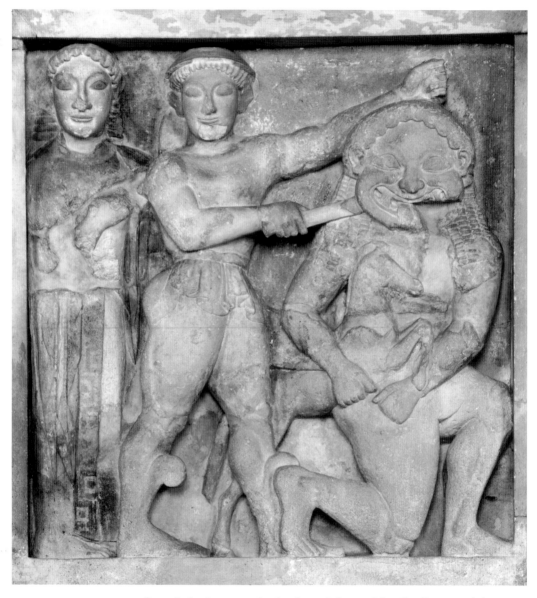

frontal chariot team, in the frontal faces of Apollo, Leto, and Artemis, and as the frontal face of Zeus the bull carrying Europa off over a sea that is represented by dolphins [58]. The metopes of Temple C essayed a decapitation of the Gorgon [59], a frontal Herakles carrying off the two Kerkopes, upside down but frontal, and two further frontal chariot teams.

The force of these frontal compositions is brought out most clearly by analysis of the metope of Perseus. Medusa is by definition frontally faced, but neither Perseus nor Athena customarily face the viewer. Because Perseus stares out towards the viewer, she or he is not simply fazed by the Gorgon, but made an active partner in its decapitation, for

Metope from Temple C at Selinous, last quarter of sixth century BC.

By presenting the legs of the figures in profile, and by showing those of Perseus to be muscular, the sculptor manages to convey a narrative force at the same time as freezing the action at the moment at which the evil power of the Gorgon is harnessed for future good on the aegis of Athena, seen here supporting Perseus.

the viewer becomes as it were the polished shield into which Perseus looked to guide his murderous actions without having to look directly at the petrifying face. The frontality of all the figures makes the decapitation a state of affairs, not an episode in an ongoing saga, as if the worshipper's proper activity is to reflect the power of gods and heroes back against monsters. This 'timelessness' is brought out by the anachrony of having the horse Pegasos, who sprang from the open neck of the headless Gorgon, already clasped to her side by its mother.

Frontal chariots seem to have become the single most popular motif in temple sculptures in the second half of the sixth century. They were to be found at the centre of the west pediment of the Siphnian treasury at Delphi and on both pediments of the temple of Apollo there, rebuilt in c.520–510 BC. But if the accent on frontality in these buildings was traditional, in other ways the sculpture of both buildings broke new ground.

Various cities had been building treasuries at Delphi, as also at Olympia, during the sixth century, but the marble Siphnian treasury is not only the best preserved, it was almost certainly the most richly decorated [60]. Built according to the architectural conventions of Ionia and the Aegean, rather than those of mainland Greece, it had sculpture in both pediments, sculpted *akroteria*, a sculpted entablature frieze, and statues of women (caryatids) in place of columns at the front of the building. Elaborate architectural mouldings framed the sculptures and the doorway, colour was extensively used on both mouldings and sculptures, and this small building must have presented a striking contrast with the Doric Sikyonian treasury built a quarter of a century

60

The Siphnian treasury at Delphi, built c.525 BC.

The use of marble enabled the architects to make the most of the greater ornamental possibilities of the Ionic order of architecture. Doric and Ionic orders were both regularly employed in the Aegean islands, but Ionic seems to have made one of its first mainland appearances here.

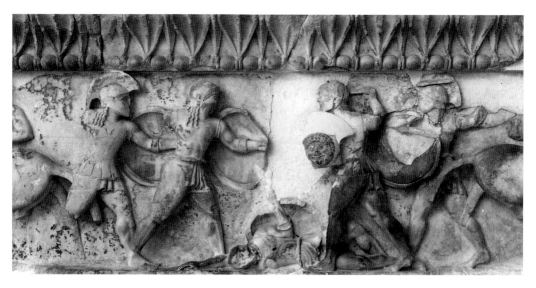

East frieze of Siphnian
treasury at Delphi, *c.*525 BC.
The sculptor makes the most
of the curved shields to
enhance the sense of figures
in the round and so bring out
the physical force involved in
war, as the shadow of mortality
is cast over the combat of
Achilles and Memnon by the
presence of the fallen body of
Antilokhos.

earlier, onto which it backed, and whose metopes also make use of frontal sculptures.

It is the frieze of the treasury that is most important artistically. Each side has a separate subject. A signature identifies the east and north friezes, both showing battles, as by the same sculptor. The south and west (front) friezes are in a distinct style and show an abduction and perhaps a Judgement of Paris. We can identify the scenes on the east and north friezes with more certainty than those of the south and west because the artist painted in the names for the figures, in the manner we are familiar with from pottery. And indeed both the frieze composition and the narrative focus of the sculptures link them to pot painting.

On the east side, that is the back of the treasury, to which the visitor to the sanctuary comes first, the left half of the frieze shows Zeus, surrounded by the other Olympian gods and goddesses, weighing the souls of Achilles and Memnon to see which would die in their combat. The right half of the frieze shows these two, surrounded by other Greek and Trojan warriors and chariot teams, fighting over the dead body of Antilokhos, with the frontal Gorgon on Achilles' shield above the frontal face of the corpse [**61**]. Both halves of the frieze display a vigorous symmetry that matches the delicately balanced decision about the heroes' lives.

The frieze on the north side of the treasury, which ran along the side of the Sacred Way through the sanctuary and so was the most prominent to visitors, shows the battle of gods and Giants. It too divides into two parts, but in a less symmetrical way. The left-hand end [**62**] centres on the chariot of Dionysos and Themis, drawn by lions, as the gods and goddesses advance from the left to right; the right-hand end is dominated by Giants who are the same size as the gods and armed as

Greek hoplites. The figures overlap and interlock in a composition which leads the eye from one end to the other without break, ever enticed forward by the constant flow of information in the form both of inscriptions and of intricate detailing. Whereas the friezes on east and west are designed to be viewed from a static position, the artist here takes advantage of the uninterrupted field offered by the continuous frieze to involve the viewer in the dynamic activity that is shown, and an innovative use of a three-quarter head for the victim of Themis' lion further inserts the action of the frieze into the space of the viewer. The different composition goes with a difference in subject: on east, and probably on west too, moments of decision are represented: Memnon's fate is settled; Paris reckons Aphrodite as the most beautiful goddess. But here on the north nothing decisive happens: this combat is a state not an event. On east and west the display of judgements encourages the viewer to make judgements; on this north side the viewer engages in the action but is never made to pronounce on it.

Although encounters of various sorts happen on each side of this treasury, the viewer is not made to encounter either the gods or their power in any direct way. The only faces confronting the viewer in these scenes are the faces of the dead. As is perhaps appropriate for a building that was rather a place to keep and display treasures than a place of cult, these are not sculptures in which the viewer meets the gods. Rather the friezes encourage reflection on relations between gods and men: Paris decides that Aphrodite is most beautiful, but it is the goddess who encourages him to think that he can therefore run off with Helen; Achilles overcomes Memnon, but it is because the gods have decided his fate that Memnon dies; the Giants, who arrogantly challenge the authority of the gods and suffer for it, are portrayed as just like human warriors. Motivation, judgement, and the ability of human strength to achieve results are all subject to analysis here: we witness the taking, the execution, and the results of what are essentially political decisions. Some scholars' attempts to see particular political allusions in the names or the Giants and the curious emblems some of them have on their helmets surely go too far, but this is nevertheless highly political sculpture.

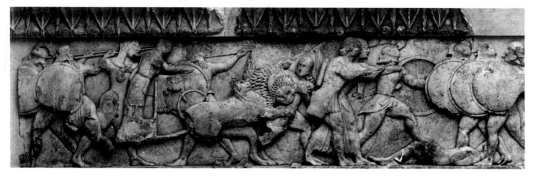

The battle of gods and Giants was extremely popular in temple sculpture of the late sixth century. It was taken up on the rebuilt temple of Apollo at Delphi and on the so-called 'Old Temple of Athena' on the Athenian Acropolis, where it brought a new dynamism to those pedimental compositions. From now on, although frontality was often retained for the central figures of gods or goddesses, narrative compositions were to dominate the rest of the pedimental space. Once narrative replaced encounter the way was open for community, as well as personal, issues to be offered up for analysis. Making narrative rather than encounter central in this way had profound effects on sculpture, for where previously the viewer had been offered a binary choice, to identify with the facing figure or to see in it an alien power, figures bound up in narrative offered a wide variety of other possible positions to the viewer, positions which were negotiated through more or less detailed allusion to the paraphernalia with which the viewer was familiar from his or her own experience. The frontal face, whether of *kouros*, Gorgon, or god, had necessarily displayed essence; the figure immersed in narrative could be freed to respond to context. And reading figures in context is necessarily a matter of politics.

The political force of pedimental sculpture comes out strongly in the pediments of the temple of Aphaia on Aigina, carved during the first two decades of the fifth century, when relations between this small island and neighbouring Athens were sufficiently strained to lead to military confrontation. Not two but four sets of sculptures are known from this temple; it appears that the original sculptures were removed shortly after they were put up, and replaced by new sets on different subjects. Although archaeology can reconstruct what happened, it

Heroic politics

The Thebans wanted to get revenge on the Athenians and sent to Apollo at Delphi. The Pythia said that they had no chance of punishing the Athenians on their own, and ordered them to bring the matter to the 'many voices' and seek help from 'the nearest'. So when the messengers returned, the Thebans held an assembly and discussed the oracle. [After other possible interpretations had been discussed] someone then said 'I think I understand what the oracle wants to say to us. Asopos [the mythical figure after whom the main river at Thebes was named] had two daughters, Thebe and Aigina. Given that these were sisters, I think that the god is telling us to ask the Aiginetans to help us get punishment.' Since there was no better idea than this offered, they straightaway sent a request to the Aiginetans asking them to come to help in accordance with the oracle, on the grounds that they were the nearest, and the Aiginetans responded to the request by sending [statues of?] the sons of Aiakos to help them.

Herodotus, 5.79–80. This story shows how important myth was in the political relations between Greek cities. On this occasion the Aiginetans respond to myth with myth, but when that does not bring success, the Thebans request that aid be given in the form of real men.

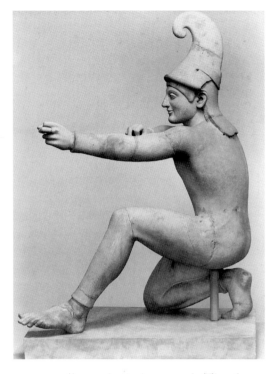

cannot tell us why it happened. The first sculptures seem to have shown an abduction, perhaps the abduction of the nymph Aigina, who gave her name to the island, and an Amazonomachy; the new sculptures showed two successive sackings of Troy, the first by Herakles and Telamon, and the second by Agamemnon's army, which included Telamon's son Aias. Telamon and Aias were descendents of Aiakos, the son of Zeus and Aigina, but were claimed as their own by the Athenians as well as by the Aiginetans. Who had a right to the presence and support of such mythological ancestors was a matter of considerable political importance, as Herodotus' account of the quarrel between Athens and Thebes at this time makes very clear. In this context to replace sculptures that were politically anodyne with sculptures that were politically tendentious seems unlikely to have been accidental: so expensive a change of plan seems best explained by politics.

The differences between the old and the new pediments were not a matter of subject alone. The new pediments differ in style not only from the old but from one another. Comparison of an archer from the west pediment [**63**] with the Herakles of the east pediment [**64**] shows how much less emphasis the sculptures of the west pediment give to either physical or mental strain. The archer of the west pediment is delicately balanced (note especially the lifted toes of the left foot) and his arm and eye contribute very effectively to a daring composition in which the viewer is drawn outward from the centre, rather than into the centre as in the east. Herakles, on the east pediment, maintains a

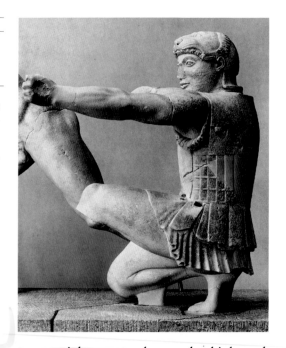

Herakles from the east pediment of the temple of Aphaia on Aigina, beginning of fifth century BC.

The calmness shown by Herakles here is that of a man who believes himself to be in control of his circumstances, not that of a man oblivious of them, and the arms and body display the physical strain of a man holding taut a bow as he waits for the right moment to shoot.

more upright stance as he stretches his bow, the pressure on the left leg revealed in the taut lines of muscles; but at the same time, the softer modelling of the face, coupled with a lion's-head helmet in which the senses (nose and eyes), rather than weaponry (teeth), are stressed (contrast **52** above), brings out the seriousness of killing people in war. This difference in tone is further emphasized by the contrasting dying warriors of the two pediments, where the eastern examples convey a slackness and self-absorption absent from the stiffer pose and blander modelling on the west.

It is traditional to account for differences between the two pediments by reckoning the second eastern pediment not just from a different sculptural workshop but later in date than the second western pediment. That may well be true, but it is important to note that the differences in style achieve different effects. On the west the Greeks vigorously clear the stage for the dominion of Athena; on the east Athena stands pensive in the middle of a regrettable war. The Greek campaigns against Troy were particularly poignant for the descendants of Aiakos, since mythology held that Aiakos had helped Apollo to build the walls of Troy in the first place. Herodotus says that the enmity between Athens and Aigina was an old one, but what the pedimental sculptures seem to stress is the changing face of the politically expedient. If the west pediment lends itself to tub-thumping patriotism, the east pediment suggests a more quizzical, even perhaps more cynical, approach to who the current enemy is, an approach perhaps not inappropriate at a time when Greeks had to worry about the potential hostility of Persia as well as of their Greek neighbours. Athens

Herakles and the Kerynian hind on a metope from the Athenian treasury at Delphi, early fifth century BC.

This is an unusual and bold composition in which the physical effort involved in mastering the hind is emphasized by the breaking of the frame. The limpness of the drapery brings out by contrast the tenseness of Herakles' muscles.

seems at one stage to have persuaded the Spartans that Aigina was contemplating siding with Persia, although in the end, following Spartan intervention, the Aiginetans joined the Greek cause and got themselves listed alongside the Athenians on the monument at Delphi celebrating the defeat of the Persian invasion.

Conflict seems to have been the dominant theme in sanctuary sculptures of this period. In the last decade of the sixth century the west pediment of the temple of Apollo at Eretria showed Theseus' abduction of the Amazon Antiope. A dedicatory group from the Athenian Acropolis, very close in style to the west pediment at Aigina, showed Theseus attacking a male victim, who may be Procrustes. Theseus' 'labours' appeared in sculpture for the first time as a set, along with the labours of Herakles, on the Athenian treasury at Delphi, a building said by the ancient writer Pausanias to have been built from the spoils of the Athenian victory over the Persians at Marathon in 490 BC, although archaeologists have often suspected that it must have been begun earlier. Whereas the metopes of earlier temples, such as those at Selinous [**58**, **59**] or the Heraion at Foce del Sele in Italy, frequently

show one figure, three figures, or more, these metopes almost universally adopted compositions showing two figures in conflict. The whole run of thirty metopes constituted a sort of 'theme and variations' in which, with a great deal of daring compositional innovation to vary the nature of the encounters [65], the viewer was invited to compare the young Theseus and the older Herakles and to compare their victims, human and bestial. Scenes of conflict could hardly fail to be political in the years after the Persian defeat at Marathon, but Herakles' prominence argues against seeing Theseus as a particular symbol of Athenian superiority, and the presentation of the Amazons as ordinary hoplite warriors, rather than exotic orientals, does not encourage their close identification with the Persians. The political issues remain generalized: we should remember that in the 480s the Athenians did not know whether Persia or Aigina posed the more immediate threat.

Death, politics, and the gymnasium

Gods were powerful, quixotic, lustful, and immortal. Only the rich could hope to aspire to an irresponsible life like theirs. But the gods were not themselves identified as upper class. When his family erected a *kouros* as a memorial to a young man who had died in battle (above, p. 81), they did indeed erect a monument that, seen in a sanctuary, might have been taken to stand for a god, but this did not in itself make the *kouros* an élite figure. In early sixth-century Athens neither statues erected in sanctuaries nor statues and reliefs used as grave markers draw attention to the particular life-style of the wealthy: men carrying calves [40] or sheep to sacrifice might come from a range of social backgrounds.

The life-style of the wealthy began to invade Athenian sanctuaries and cemeteries towards the middle of the sixth century. In the second quarter of the sixth century figures on grave monuments acquired accoutrements which linked them to infantry service or the gymnasium, and accompanying scenes with horses and chariots. In the middle of the century the first dedications of large equestrian statues appeared in Attic sanctuaries, and equestrian funerary monuments followed. As we have seen already [37–9], the *korai* dedicated on the Athenian Acropolis became increasingly elaborate. Kroisos [36] was still identified as a warrior only in the inscription, but many others preferred to provide visual clues of their status, and by the end of the century elaborate bases with multiple scenes had appeared, both for grave reliefs and for *kouroi*. Comparable developments can be found all over the Greek world in the second half of the sixth century, from Sicily to Lycia.

Conveying status in what was clearly an increasingly competitive world of display presented new challenges to sculptors. No longer was it enough to produce a well-executed formulaic figure; now the sculp-

66

Funerary *stele* from
Orkhomenos in Boiotia, first
quarter of fifth century BC.
This figure is a far cry from
the youthful athlete, sturdy
warrior, or unblemished
kouros found on Athenian
graves in the sixth century.
Not only is this a mature man,
but his shoulders are rounded
and bowed and he leans
heavily on his stick. These
details, and the contextual
implications of the dog, intro-
duce pathos to the funerary
monument.

ture had to offer context as well as essence and capture if not the indi-
vidual then certainly the nature of the group to which his characteristic
activity linked the figure represented. One result of this is that
sculpted figures begin to acquire a definitive age. A grave relief from
Orkhomenos in central Greece [**66**], perhaps carved shortly after 500
BC, shows a man leaning heavily on his stick, around which a devoted
dog winds itself to stretch up towards its master who offers it a locust.
Although the foreshortened feet of the elaborately posed figure might
belong to a man of any age, the swathing woollen mantle and the treat-
ment of the bent head and shoulders, as well as the beard, identify this
as an old man.

This relief is characteristic of the new competitive and status-
conscious world in another way also: it is signed. *Kouroi* were rarely
signed, but sculptors' signatures began to become relatively common
on other works during the second half of the sixth century, so that for
the first time it is possible to assemble a corpus of certain artists' work
(see also **39** above). This relief is signed by Alxenor the Naxian, and he
adds an injunction: 'Look!' It may be that this injunction should be
read like the 'Stand and pity' which begins the inscription on Kroisos'
kouros monument, but it is also possible that it should instead be read as
drawing attention to Alxenor's own artistry. Alxenor was from the
Cycladic island of Naxos; artists travelled widely, serving a large, lively,
and perhaps not undiscriminating market, and most of the outstand-
ing sculptures from sixth-century Athens seem to have been made by
artists from elsewhere, primarily from the Cyclades and east Greece.
Sculptors, like the potters and painters discussed in the last chapter,
needed to make sure that they made their mark and that their mark was
recognized.

If presenting a single figure on a relief with some signs of the world
in which the figure moved created one set of challenges, presenting the
scenes of the everyday activities of the wealthy on the bases of *kouroi*
and reliefs created another. Showing athletic activities demanded an
ability to reveal relationships between individuals that were not simply
the hostile face-to-face encounters that we have seen in temple sculp-
tures. It was not simply that the poses demanded were more various;
the bodies were naked. A *kouros* base from Athens [**67**] shows on its
front side a ball game which unites six figures in a single composition as
a ball is thrown from one side to the other over the heads of two central
figures. The activity here is conveyed by the exchange of glances and by
the body language of the varied lively poses of the figures. Whereas the
Siphnian treasury frieze largely presents figures as either profile or
frontal, here the sculptor has endeavoured to show a range of views of
the body and to make the twisting of the torso appear by showing par-
tial views of deformed musculature. The display of the body beautiful
was, as we will see in the next chapter, a major concern of those

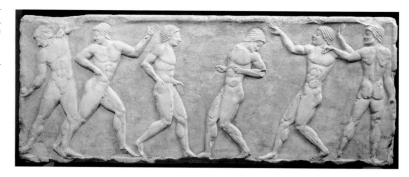

67

Base of *kouros* recovered from Themistoklean wall of Athens, around 500 BC.

The *kouros* monument which this base once supported stood over a grave in the main town cemetery of Athens. The scene on the base provides a context for the *kouros* in a way not dissimilar to that in which inscriptions did for such *kouroi* as that of Kroisos [**36**].

who frequented the gymnasium, and the sculptural innovations here attempt to convey something of that display in stone.

Monuments such as that of which this base was a part belonged to a world in which the name and the work of the sculptor were the object of intense competition among members of the city élite. Both cemeteries and sanctuaries became, in the second half of the sixth century, places where the achievement of prominence by an individual or a family, and by the artists they employed, could be permanently marked. Athens' Acropolis, where in around 600 BC the dedication of Sophilos' *dinos* (p. 91) would have made a considerable impression, had by 500 BC become a place crowded with elaborate *korai*, equestrian statues, large dedicatory reliefs directly alluding to the life of the dedicator, and the like. Solon in the 590s had created, or reinforced, formal property classes, and Aristotle tells us of an equestrian monument put up on the Acropolis by a man proud of the upward mobility that had brought him into the class known as 'knights'. How many other monuments celebrated success against criteria formally established by the city we cannot know, but every act of marking status was a political act, and the competition visible in tomb-markers and dedications is the artistic corollary of the struggles for political power between members of the élite. In the middle of the century those struggles brought about the tyranny of Peisistratos and his sons; in the last decade similar struggles brought power to the people as one of the noblest of Athenians, Kleisthenes, gave enhanced power to a popular council and assembly in return for the support of the people against an aristocratic rival.

Competition among the élite stimulated sculptors working in Athens, but the political turmoil it brought did not make it popular with the people. Whether popular disapproval was itself enough to curb the wealthy 'doing it with sculpture' in cemeteries, or whether, as a passage of Cicero suggests, funerary monuments were restricted by law, little monumental sculpture survives from Athenian graveyards that can be dated to the two decades before the Persian invasion of 480 BC. By then, however, the impetus to new forms of sculptural expression, created by these competing individual commissions, had put in sculptors' hands an armoury of devices which remained even after the

market for which they were created disappeared. But before turning to the longer-term consequences of developments just discussed we must catch up with the effects of related pressures on the painters of pots.

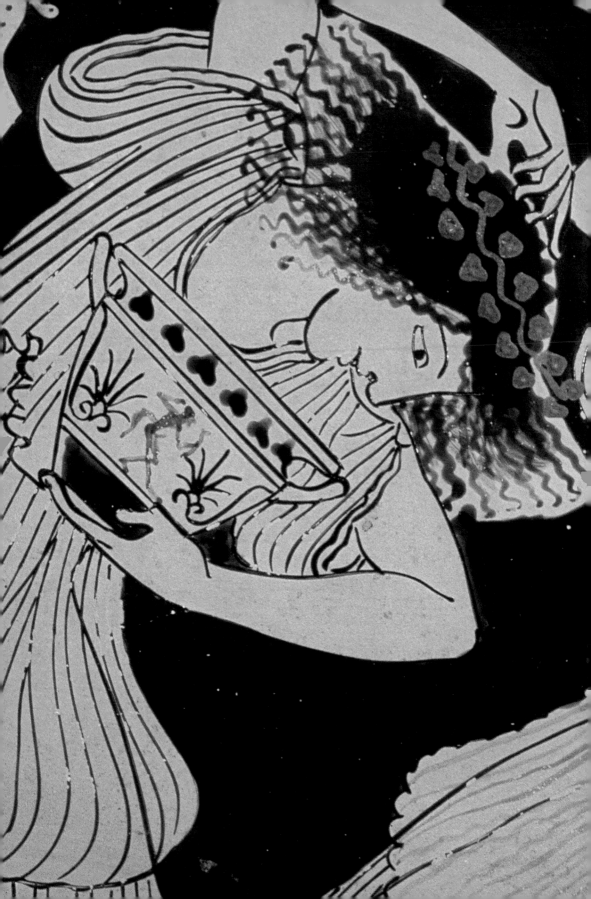

Gay Abandon

Role-play and the body at the *symposion*

A Gorgon stares out of the centre of a black-figure cup; a pair of eyes greet the drinker who raises the cup. Such sights met many party-goers in many parts of the Mediterranean who used Athenian cups painted in the second half of the sixth century. But the drinker who picks up this large cup (some 34 cm. in diameter) is in for surprises. When he slips his hand under the cup to grasp it by the foot, he finds his fingers curling around a penis and testicles [**68**]. When he raises the cup to drink, he finds inside [**69**] not just the face of the Gorgon but a *sympo-sion* scene in which all the drinkers are draped in long garments and half of them have their hair tied up in turbans. What is more, one of the drinkers brandishes a slipper at the naked boy who brings round the jug of wine.

This was not a cup to be admired in a glass case, this was a cup to be used. Just as we refer to the 'foot' of a cup, so the Greeks too named the parts of a pot after the human body—the handles were 'ears', the interior of a cup its 'face'. But if the foot of this cup amuses by substituting other body parts from those named, it does much more in use. Two other large black-figure cups from the same workshop, with feet similarly consisting of male genitals, show between their eyes scenes of love-making. A slightly later red-figure cup shows a large cup with a foot this shape being used by a naked woman, with the penis pointing towards the drinker. When we add to this the choice of a satyr, rather than a Gorgon or mask of Dionysos, to appear between the eyes, and the threatening of the serving boy with a slipper, the explicitly sexual game being played by this cup cannot be doubted.

If the joke of the foot is crude, the *symposion* shown on the inside of the cup is sophisticated [**69**]. In a luxuriant vine arbour, whose gentle warmth is marked by the discarded garments hung over the branches, one man, in less elaborate clothing, plays the double pipes, and the party-goer in front of him sings. The turban head-dress worn by the singer has orientalist associations, an aura of luxury and of effeminate softness that came, at more or less the time this cup was painted, to be particularly associated with the lyric poet Anakreon.

One particular detail of the drawing on the interior suggests that

Large Athenian black-figure eye-cup (the Bomford cup), last quarter of sixth century BC. Drinking from this cup must have made party-goers extremely self-conscious. As if being stared at by the eyes of the cup and the face of a satyr and grasping a foot of this shape were not enough, the cup is so large (34cm. in diameter) that to control it accurately and not spill the contents while drinking will have demanded a steady and sober hand.

potter and painter have deliberately combined the scene of delicacy on the interior, where sexual activity is never more than implicit, with the explicitly sexual foot. As is most obvious with the figure threatening the serving boy, none of the reclining participants have feet. On a pot where the foot is itself replaced with male genitals, that the participants are without feet is surely not a matter of chance or oversight: the lack itself draws attention to the party-goers' sexuality—if they too have no feet what do they have instead?

Added colour, of which only traces now remain, once enlivened the Gorgon with tusks and teeth, and the party-goers' garments with white dot and red stripe decoration. But it was always the silhouetting of the figures against the light background that made them legible. The black silhouettes show very effectively both the actions of the figures—the thrown-back head and raised arm of the singer, the offering round of a cup, the expostulating or appeasing gesture of the serving boy—and also the play of glances between the figures as one reclining figure twists his head round to observe, perhaps enjoy, the encounter between boy and slipper. But there is a striking contrast between the three-dimensional form of the genitals and the flatness of these figures. Their poses involve twisting round and incised curves mark the muscles on their arms, but the *symposiasts* never occupy space, never acquire any sense of bodily presence. The sexuality of these figures, as of all figures shown in the black-figure technique, is a matter of actions and costume, not of physical attractions. The explicit foot combines with the veiled sexuality of the *symposion* to give this cup a sexual charge and sexual excitement that the interior alone could not sustain. Potter and painter have pooled their considerable ingenuity to achieve something that the painting technique alone was not able to manage.

The black-figure technique of pot painting was a means to a wide range of ends. From the massive figures of the Nessos Painter's amphora [**28**] to the miniatures that appear on band and lip cups [**45**], and from the long friezes of the François vase [**42**, **43**] to the monumental encounters of two figures on an Exekian amphora [**50**], the same means served very different ends. With gestures clearly

The composition is extremely
carefully balanced here (look
at the distribution of the feet
along the ground-line), and
the drawing of the bodies is
done with a great economy
which effectively contrasts
with the intricate decoration of
the garment of the figure to the
left and of the item of clothing
hanging up behind.

upright elements. On one side we see Athena and Artemis watching
Apollo and Herakles struggling for the Delphic tripod (the same scene
appeared in the east pediment of the Siphnian treasury); on the other, a
trainer observes two men wrestling, while to the right another young
man lifts an older man off the ground. The two compositions rely
primarily on graphic gestures and clearly suggested eye lines—both
devices well performed in black-figure. In the scene of Herakles and
Apollo only details mark the tentative exploitation of the peculiar
bodily possibilities of red-figure: the sleeve hole at Herakles' left arm,
the curvature of the breasts of Athena and Artemis, Artemis' neckline,
the gathering of folds over Artemis' arm and round her buttocks.

In the gymnasium scene on the other side, the possibilities of em-
bodiment are intrinsic to a scene which is almost devoid of narrative
content. The central wrestling pair engage in three dimensions (most
successfully at the armpit of the right-hand wrestler), while the man
being lifted on the right twists round to face the viewer frontally. As we
have seen above, frontal faces frequently signal that a figure is 'out of it',
whether through musical or other ecstasy or through pain or death, but
here the face that accosts the viewer seems rather to invite the viewer's
regard, to encourage the viewer to enter into the spirit of the scene. Just
as, on the other side, Artemis is shown enjoying the scent of a flower as
she also enjoys the struggle between her brother Apollo and Herakles,
so here the beardless youth on the left of the scene, whose stick marks
him out as occupying the position of 'trainer' usually reserved for an
older man, also holds a flower to his nose. This beautiful young man,

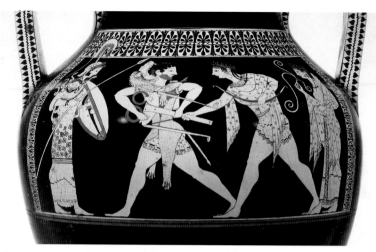

the pottery and then incising interior details, the background was
painted black, the figures reserved, and interior details were painted in.
By contrast to the outline drawing technique used in protoattic pottery
[26] and occasionally in black-figure [49], the use of a black back-
ground kept the stark contrast between figure and background that
rendered gesture so readily legible. But by contrast to black-figure, the
light surface of the bodies made it possible to give the impression of a
third dimension.

The possibilities created by showing light figures against a darker
background may have been in part revealed by sculpted reliefs, whose
background was generally painted in a darkish tone, or they may, more
arguably, have been displayed by the use of gold-leaf figures on silver-
work. But the coincidence between the invention of the red-figure
technique and the arrival of scenes whose primary reference was to life
rather than myth, and particularly the gymnastic and partying life of
the wealthy, encourages belief that the new technique was pioneered
not out of technical restlessness, or simply in emulation of the appear-
ance of other works of art, but in order to meet new marketable, and
socially desirable, iconographic ends.

Bodies and flesh

The red-figure technique is about embodiment, about enfleshment.
One of the earliest pots painted in the technique reveals nicely both the
continuities between black- and red-figure painting and the new de-
parture that the new technique represented. The pot is signed by the
potter Andokides, in whose workshop the black-figure cup just dis-
cussed [68, 69] was probably made; the artist who painted it is known
as the Andokides Painter and probably worked in both black- and red-
figure techniques. The compositions of both sides of this amphora,
found at Vulci in Etruria [70, 71], lie directly in the tradition to which
the Amasis painter belongs—a central encounter is framed by two

The classic black-figure technique was incision, cutting through to the light clay of the pot with a sharp tool to create a fine line. So fine were the lines that could be

Detail of 51 Detail of 56

drawn in this way that intricate woven patterns could be reproduced, as here by Exekias [51]. But many black-figure painters combined incision with other techniques, of which the most common was adding colour—almost always with

Detail of 46 Detail of 73

more concern for the appearance of the picture than for the imitation of life [56]. Outline drawing never entirely died out, even when black-figure was in vogue, and the Arkesilas Painter moves easily between incision and painting with a brush [46]. The invention of red-figure depended on the development of the strong black lines known as 'relief lines' because the paint stands out from the surface. But those strong lines were employed alongside more translucent paint, which was often used, as here, for less important anatomical details [73]. The possibilities for variety of line were most

Detail of 118

highly developed by painters working in the white-ground technique who carefully loaded their brushes to give a particular vigour to the fall of drapery [118].

viewer, and to make their works insistently intervene in the concerns of the community. Although the north and east friezes of the Siphnian treasury, with their prominent use of gestures and names, operate primarily with an armoury that painters of black-figure pottery could match, the bulging muscles of warriors' calves, which give them a bodily presence [61], and the three-quarter face of one warrior [62], which establishes continuity between the space of the frieze and the space of the viewer, exploit possibilities which the black-figure pottery could not offer. So also the sense of being intimate with the world of the sculpted figure, which both the relief by Alxenor [66] and the *kouros* base showing ball players [67] promote, is dependent on the palpable physical presence of the figures in a space which adjoins the space of the viewer.

The technical revolution by which red-figure decoration came to replace black-figure decoration as the most common way of painting Athenian pots has to be understood in the context of this desire to forge a more intimate relationship between the viewer and the scene viewed, manifest in sculpture and in such black-figure pots as the cup just analysed. During the last quarter of the sixth century Athenian painters began to experiment with a reversal of the black-figure technique. Rather than painting black figures on the unpainted surface of

Interior of same cup.

The presence of standard sympotic features—pipe playing, lyre, and singing (compare **4**)—only draws attention to what is not at all standard here—the setting of this *symposion* outside and the turbans worn by several drinkers.

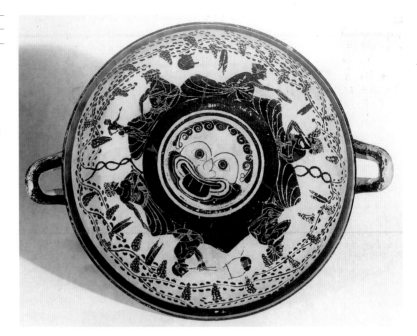

shown up against a light background, black-figure was good at showing activity, whether that activity be rumbustious or more a matter of poise than of movement [**51**]. What is more, the black-figure technique was good for settings, since the light background allowed space within which objects and figures could be placed. Some of these possibilities were fully exploited by sixth-century Athenian artists; others were hardly exploited at all.

Although it is short-sighted to see black-figure painting as having some particular 'natural' functions or the style adopted by artists working in black-figure as determined by the technique, it was not well adapted to all purposes. Just as wearing black flatters the figure by flattening it, so figures painted in black were bound to be flat. Incised lines could convey the patterning of textiles in a striking way [**51**], but they could not convey interior contours to nearly such good effect. Since gestures convey action effectively, the difficulty of giving any impression in black-figure of a three-dimensional rounded form was unimportant so long as artists' attention was focused on showing actions and their consequences, paraded as a tableau before the viewer. But if an artist desired to make the painted figures physically present before the viewer, to bring out their character and coherence not just as a set of actions but as bodies, the black-figure technique could be nothing but a source of frustration.

The invention of the red-figure technique
In the last chapter I tried to show the ways in which sculptors began to bridge the gap between the world carved in stone and the world of the

whose features closely resemble those of Apollo, and indeed of Artemis, suggests, by his sensuous delight in the flower, that the viewer should appreciate this scene not as a scene of struggle but as a scene of display. This gymnasium, like that in which the young men on the *kouros* base played ball [67], is a site where the aesthetics of manhood are contested.

Games with names

Pot painting shares its interest in the gymnasium with monumental sculpture, but pottery has to itself the exploration of the more intimate scenes of the *symposion*. What the painters who used the red-figure technique were able to add to such representations of the *symposion* as we have seen in black figure is revealed in a detail from a *stamnos* signed by Smikros [72]. Here we see, as we did on the black-figure cup [69], a pipe-player and a singer; but here not only does the greater scale enable much more play of detail, both singer and piper are present as bodies. For the naked torso of the singer and for the drapery of the piper the painter exploits the possibilities given by combining both heavy black and thin brown paint for the rendering of both form and texture, while the variation in thickness of the painted lines as the loaded brush empties itself, best seen here in the piper's drapery, gives a vitality to the contours which the lines describe. The black-figure cup invited open laughter as it was passed around, and its tangible joke was corroborated by the scene revealed as the wine was drunk; this pot encourages intimacy by its own sense of physical closeness.

But Smikros' pot has one surprise in store. The labelling familiar in myth scenes in black-figure is employed here too, and employed to name the singer 'Smikros'. Although Exekias may allude to the contemporary potter in labelling negro squires attending Memnon in his confrontation with Achilles 'Amasis' and 'Amasos', black-figure painters never identify themselves as participants in scenes. But in early red-figure, and particularly among the group that has become known as 'Pioneers', we do find such claims to participation, along with what may be friendly taunts. Of the other artists of the group, Euphronios shows Smikros, Phintias has Euthymides toasted by a prostitute at a *symposion*, and Euthymides claims to have painted 'as Euphronios never managed'.

That these painters name each other is particularly intriguing because of who else they name. The habit of writing exclamations about the beauty of young men begins with Exekias' repeated exclamation that 'Onetorides is beautiful' (*kalos*, a word which also implies nobility) [50, 51]. It becomes rife among the Pioneers and their late-black-figure contemporaries. Some of the subjects of such exclamations are almost certainly to be identified with historical personages of high status, such as Phaÿllos, three times a victor at the Pythian

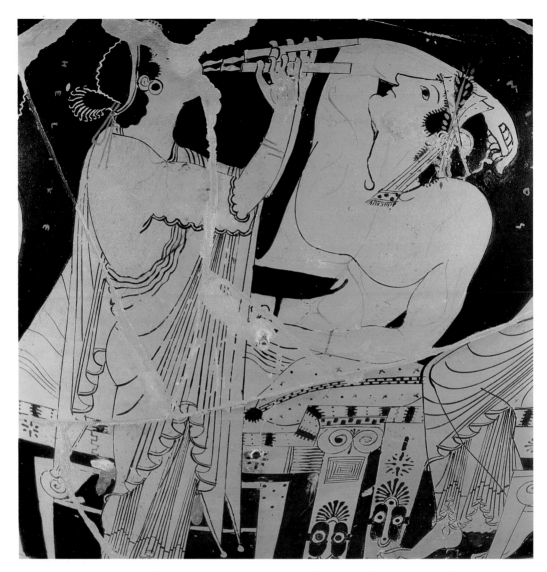

72

Detail from an Athenian red-figure *stamnos* signed by Smikros as painter, last quarter of sixth century BC. The couches are elaborately decorated and the figure labelled 'Smikros', who throws back his head to sing, wears a wreath and a fillet: appearances matter at the *symposion*. The flat black silhouette of his cup serves to emphasize the way in which by contrast his body occupies space.

Games, and Leagros, a member of perhaps the wealthiest family in Kerameis, the area of the city of Athens where the Potters' Quarter was situated (see also **53**). By putting themselves and their workshop rivals into the thick of the élite *symposion*, Smikros and his fellow artists compound the intimacy which the drawing itself produces and encourage in all who view the pots the fantasy of participation in the activities shown. By also showing women, bare to the waist or entirely naked, holding *symposia* on their own at which they toast fellow painters and look out of the picture space to meet the gaze of the viewer, the painters continue to emphasise the eroticism of the *symposion*, and to involve the viewer in it, just as, by other means, the artist of the black-figure cup, discussed above, had done.

Many pots with *kalos* names have been found in Etruria, and it is

highly unlikely that they were made with the expectation that they would be used in the company of the person named. The full amusement value of naming particular beauties or inserting the painter himself into élite company can have been appreciated only in the workshop and on display in Athens. Whoever finally used these pots, it is fellow artists and habitués of the Potters' Quarter who are invited to admire these works.

Virtuoso exhibits

Attracting admiration from fellow artists seems to have been high on the agenda of these painters. Euphronios in particular went in for virtuoso displays of painterly technique. He painted large pots, with a preference for calyx *krateres* whose flaring shape offered an unusually large and unusually flat surface for decoration. On these vessels he painted gymnasium and *symposion* scenes, exploring the naked male body in a wide range of poses [73], but also scenes of Herakles and the Homeric scene of Sleep and Death carrying off the body of Sarpedon from the battlefield (a scene he also painted on a cup). A fragmentary calyx *krater* shows Herakles, materially aided by Athena, attacking the brigand Kyknos [74]. In pose (look at Kyknos' legs), in attention to detail (look at the eyes or at Kyknos' feet), in concern for anatomy (look at the back of Herakles' hand), in the variety of textures evoked (Herakles' lionskin, Athena's aegis, Kyknos' armour), in the variety of strength and thickness of line, and in the composition (note the competing lines offered by Herakles' and Athena's spears and by Herakles' eye and shield arm and the upper arm of Kyknos), this is a display piece.

The attention to detail exhibited here, and in similar pieces, encourages description in terms of realism. Is Euphronios trying to show the three-dimensional body 'as it really is'? That the painting makes the body vividly present to the viewer there can be no doubt: the excitement of the moment is enhanced as the viewer smells the blood and hears the crash of the armour of the falling figure. But that vividness does not depend upon a realist's devotion to detail, it depends upon a highly selective representation: observable features of human anatomy are combined with lines that owe their presence to their pictorial function alone. So, lines of muscles appear on Kyknos' left thigh which a leg, when bent back as his is here, simply does not show. And conversely, whereas the frontal face of Kyknos is given multiple wrinkles on either side of his nose, the face of Athena is totally, and impossibly, devoid of contour. As a formidable enemy to Herakles, Kyknos must show his muscles, regardless of pose. As a goddess, Athena must remain ever serene. Euphronios and other early red-figure artists are not interested in imitating nature for itself, but communicating with the viewer not just the actions but the bodily presence of the figures

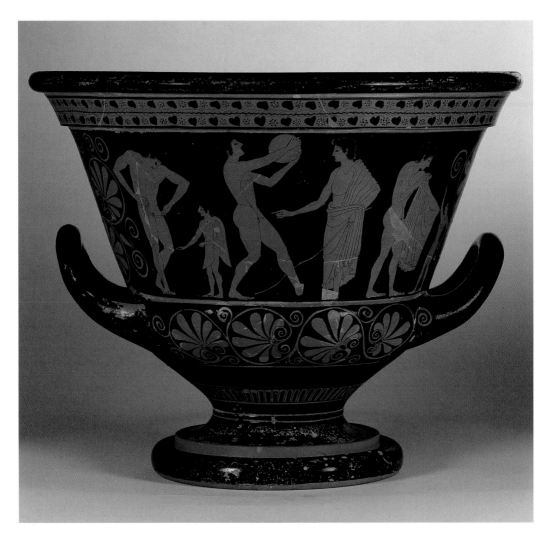

73

Athenian red-figure calyx
krater attributed to
Euphronios, end of sixth
century BC.

The varied activities of the
gymnasium are used as a way
of exploring the male body.
Here a discus player named
Antiphon is instructed by a
trainer named Hipp[ar]khos,
an anonymous athlete
attended by a slave ties up his
penis (see below p.165), and
one Polyllos folds his cloak
prior to oiling himself from
the *aryballos* which a slave
brings him.

they show, and convincing the viewer that they could communicate
those things better than could fellow artists.

The scope which red-figure painting gave for overpowering the
viewer, as Euphronios does here, continued to be exploited by artists
who learnt from him. Because of the variety of tones and textures of
line it could deploy, and particularly the dense and wiry relief line, it
was much easier in red- than in black-figure painting to keep overlap-
ping figures distinct. This enabled the depiction of much more compli-
cated relations between figures, so that more than one incident could
be shown happening at the same time. The finest examples of simulta-
neous action come in depictions of the sack of Troy, painted as contin-
uous friezes on cups and on the shoulders of *hydriai* by a number of
different painters in the first quarter of the fifth century.

If we compare the scene of the sack of Troy by a painter known as
the Kleophrades painter [**75**, **76**], with the friezes of the François vase

[**42, 43**] or the Siphnian treasury [**61, 62**], or the narrative moments painted by Exekias [**50, 51**], we can immediately see how different is the red-figure artist's armoury. Although dramatic gestures abound in the Kleophradean scene, the composition has no single focus; there are no spectators here, all are engaged in distinct actions of their own. The actions are woven together through the wide range of different poses in which bodies and legs are seen from front, back, and sides, the lower parts of bent legs are hidden, and the heads of corpses are wrenched back. Painting on a shoulder which is essentially a circle with a hole in the middle, considerably more length is available at the figures' feet than at their heads, and this is exploited to lend an intensity to the interactions that is marked particularly by the bent head of the palm tree, which is legible and at the same time pathetic and defiant.

Central in this presentation is the attack by Achilles' son Neoptolemos on the defenceless Priam, who sits on an altar, the limp body of Hektor's son Astyanax, bleeding from multiple wounds, on his knees and facing out at the viewer. To one side, this murderous scene is framed by resistance as a Trojan woman actually goes on the offensive. On the other side the scene is ambiguous. The naked body of Kassandra, amidst despairing women, grasps the statue of Athena as 'the lesser Aias' (so-called to distinguish him from the Aias we met in chapter 6) approaches with drawn sword. What will happen next? Some in antiquity certainly held that he raped her—and that the statue of Athena averted its eyes to this violation of a virgin body and a virgin's sanctuary. But Pausanias tells us that in a wall painting at Delphi painted in the second quarter of the fifth century the painter

74

Detail of a fragment from an Athenian red-figure calyx *krater* signed by Euphronios as painter, end of sixth century BC.
Euphronios exploits the red-figure technique to provide an unprecedented degree of detail in a complex composition organized with immense care. The Gorgon on Athena's aegis is markedly less horrific than earlier Gorgons, and her frontal face contrasts with the monstrous face of the brigand Kyknos whom Herakles and Athena here defeat.

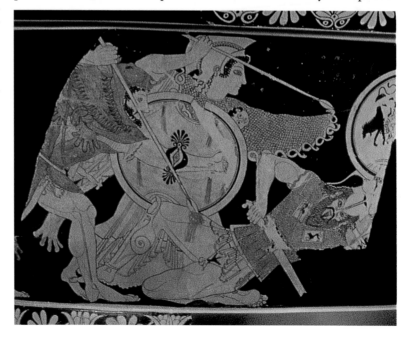

Athenian red-figure *hydria* attributed to the Kleophrades Painter, first quarter of fifth century BC.

The Greek warriors have come out of the Trojan horse, dealt with those Trojans who managed to arm themselves, and now proceed to slaughter the aged, women, and children (compare **25**). The well-armed Greeks contrast with Trojans whose blood already bespatters their bodies as they vainly try to cover their bare heads with their hands.

76

Continuation of same scene. Kassandra, whose nakedness expresses both vulnerability and that she is sexually desirable, is here caught between the supplication of the goddess and the supplication of the lesser Aias. The weapon of Aias poses the more immediate threat, but the continuation of the story has Athena securing Aias' eventual punishment.

Polygnotos is said to have shown the lesser Aias taking an oath about his 'outrageous act', apparently denying rape (see below, p. 169). Here Aias' hesitation is palpable, but so are Kassandra's erotic charms. Athena's shield is interposed between the two, but as to whether that will stop Aias the viewer is left to decide. At the ends of the frieze are scenes that are more certainly hopeful: Aeneas carries his father off from the city, and two Greeks rescue Aithra, mother of Theseus and handmaid to Helen. The pregnant expectation, created by the way bodies with perceptible bulk are crowded together, is not just laden with doom.

Herakles' attack on Kyknos [**74**, cf. **56**] belongs happily among the unproblematic deeds of a cultural hero ridding the world of threats to good order. The painter's virtuosity reinforces confidence that this is a world in which evil is punished and justice upheld by the gods. The Greek sacking of Troy gives no such comfortable message. Even if Kassandra was not raped, the fate of women captives was hardly a happy one; Aias died in a shipwreck on his way home, Neoptolemos went on to sack Delphi and was killed there; the end results of this sack were good news for no one. The sacking of cities was a topical subject in the first quarter of the fifth century, and it is not surprising that the sack of Troy is by far the most popular of all Trojan scenes in early red-figure Athenian vase painting. But the Athenians were not always grateful for having their attention drawn to the destruction of cities: the playwright Phrynikhos was fined after he put on a play about the sack of the Ionian city of Miletos by the Persians in 494 BC. If the drama of Euphronios' scene is the drama of a well-told story, the urgency that the Kleophrades painter produces in his sack of Troy matches and reinforces the urgency of the political issue.

The isolated image

If red-figure painting enabled works of a complexity and virtuosity previously unknown, it also enabled striking simplicity. First exploited in decorating the interior tondos of cups and plates, this simplicity was then transferred to larger vessels, amphorae and *krateres*, where it served to pioneer a whole new approach to narrative and a new relationship between the viewer and the pot.

The isolated figure against a plain background had never been a feature of black-figure painting, although some late-sixth-century painters of black-figure cups were inspired by red-figure work to try it out. The greatest early exponent of the isolated image was the painter Epiktetos, an artist whose long career of painting cups and similar shapes of pots seems to run from early in the last quarter of the sixth century to late in the first quarter of the fifth. Epiktetos regularly signed his work, and among the earliest signatures are one on a *krater* by the potter Andokides and others on cups which employ black-figure as well as red-figure technique. His latest work includes painting for the potter Python, and Python is regularly associated with another great early fifth-century pot painter, Douris (see below, p. 164).

A plate signed by Epiktetos, which was found at Vulci and is now in the British Museum, illustrates the art of the simple tondo image at its most impressive [**77**]. Two garlanded revellers make their way home after a party. The younger man pipes their way, while the older feels the strain of the partying. The circular field, re-echoed in the artist's signature, which runs clockwise from the right hand to the left foot of the older reveller, and by the curved back of that reveller himself,

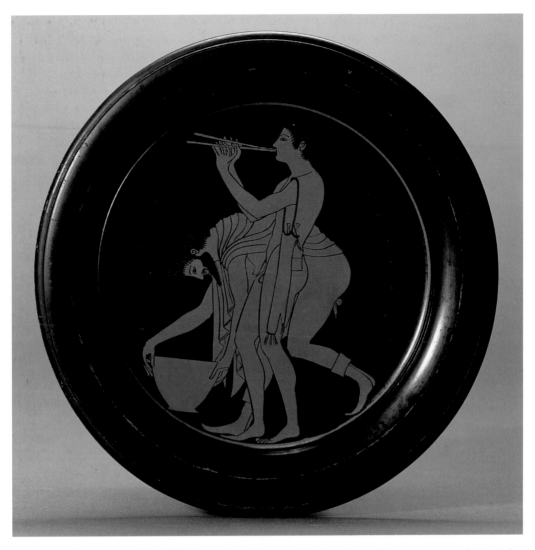

is skilfully employed to emphasize the rolling progress of the older man. The younger man's sobriety is brought out by his upright pose, and reinforced by the vertical lines of the case for his pipes, which hangs from his shoulder, and by the way he holds the pipes up. The profiles are clean, the balance delicate, and the physical forms suggested with great economy of line. Although in other works Epiktetos shows an interest in twisted poses and oblique views, here the bodies are made substantial by the simplest of means, the showing of one arm or one thigh behind the other, the genitals appearing behind the line of the leg, the gathering of drapery.

Painting one figure in front of another, as Epiktetos does here, invites the viewer to compare and contrast the two figures. Such a challenge is on occasion extended by Epiktetos to more than one picture on the same pot. On another cup, also in the British Museum,

77

Athenian red-figure plate signed by the painter Epiktetos, *c*.500 BC.

Although we may see life itself in the effects of drink on the party-goer, that revellers in Athens wore only cloaks and boots is no more likely than that their genitals stuck out behind like this when they bent over. Witty images of attractive boys and over-exposed men on pottery offered models for life only in the same way that over-exposed women on the covers of glossy magazines are reflected in the streetwise girl.

78

Athenian red-figure bell *krater* attributed to the Berlin Painter, first quarter of fifth century BC.

Hard to understand in realistic terms, the folds of Zeus' garment give a strong sense of urgency to his movement in pursuit of his beloved. As with the sword of Aias attacking Kassandra [**76**], Zeus' sceptre here points to his sexual intentions as well as his regal status.

he combines a *symposion* scene, including a man singing as a woman plays the pipes, a scene of Herakles attacking the Egyptian Busiris, who would have sacrificed and feasted on him, and a scene of revelling in which a young woman dances to a young man's pipes.

Both the use of the single isolated image and the 'compare and contrast' technique were developed rather further by a younger contemporary of Epiktetos who has come to be known as the Berlin Painter. The amphora in Berlin, from which he takes his name, superimposes not two but three figures: a satyr, a fawn, and the god Hermes. The viewer has to look twice to determine that it is Hermes, not the Dionysiac satyr, who hold a wine-cup and wine-jug, and the satyr, not Hermes, who holds the lyre that Hermes invented and the plectrum. Ironically, given that this pot has given him his name, such superimposition is almost unique in the Berlin Painter's work; his 'compare and contrast' technique more normally involves both sides of a pot.

A bearded male figure strides vigorously across one side of a bell-shaped *krater* [**78**], his right arm extended in front of him. This is not a gesture that occurs in black-figure painting, but in the early part of the fifth century it becomes a standard way of indicating 'erotic pursuit'. Not only, however, does his beard set this garlanded male apart from the normal youthful pursuer, but he carries a sceptre in his left hand. This sexual aggressor is Zeus. But whom does he pursue? Given Zeus' *amours*, the viewer simply cannot know what to expect on turning the *krater* round.

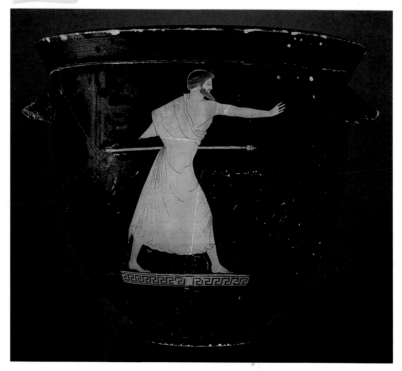

79

Other side of same pot.

As Ganymede twists round to give impetus to the hoop he not only exposes his body to Zeus and other admirers but reveals the details of anatomical drawing that, along with overall proportions and handling of paint, help to identify the hands of artists who do not sign their work—ears and nostrils, collar- and breastbones, ankles, musculature, and genitals (see p. 88).

A naked young man, also wearing a garland, bowls a hoop with his right hand while holding a cockerel in his outstretched left hand [**79**]. The cockerel, a favoured gift, guarantees that this is a young man with an older lover, the object of a successful pursuit. This is a balanced composition, complete in itself: the forward momentum of the boy is arrested by his turning backwards to add momentum to the hoop, so that the lower part of the right leg is almost frontal; the curvature of the hoop picks up the curved profile of the pot and is continued on one side by the bowling arm and on the other by the curved hand that nestles the fowl and by the fowl's breast.

Only the viewer who has already seen the other side of this pot knows that this young man is Zeus' beloved Ganymede, and that we do not here have the full story. But the viewer who has already seen Zeus also finds that the story which the motif of erotic pursuit suggested does not end quite as simply as they had imagined. Such a viewer expects to find the question 'Whom does Zeus pursue?' answered by the appearance of a particular beloved. But instead of closing the story, this picture of the beloved opens up a new question: who gave Ganymede the cockerel? At whose party did he get the garland? How should we understand the narrative sequence here? Does Zeus have a rival who has already paid court to this Ganymede? Does a rival for a young man's love lurk round the far side of every mixing bowl? The device of the isolated figure is exploited here to open up gaps in any story that the

viewer tries to tell. In doing so the world of myth is made to meet the world to which the drinker belongs.

Sex, drink, and the gods

Throughout this chapter we have seen how the world of the red-figure image meets the world of the viewer with a new intensity. The artists' greater ability to make their images take up space that is continuous with the space they themselves occupy encourages them to put themselves into that space as participants at the parties they paint. The possibility of making bodies adopt a new variety of poses and carry off a wider range of gestures encourages viewers to think that this is not simply a distant parade that they see, but that they are given a private view from a particular point. The possibility of superimposing figures and objects, without rendering the image illegible, recreates a sense of the mêlée which meets the casual glance of the participant, whether in war or at a crowded social event. The exposure of the vulnerability and the erotic attraction of naked bodies enriches the range of emotional responses.

So far in this chapter we have seen the effect of that new intensity on more or less fantastic scenes of the leisured life of the élite and of myth. But just as the human relationships involved in the stories of myth and the familiar actions of daily life were scrutinized in new ways, so too relations with the gods were freshly re-examined.

The god whose face most frequently appears on vases is Dionysos, the god who presided over the *symposion* and the revel. As far back as the François vase [42, 43] artists had shown a special interest in Dionysos, even when his part in a mythical episode was trivial (as was Dionysos' part in the story of Peleus). Though satyrs play hardly any role in Greek stories of the mythical past, painters increasingly took an interest in using them, alone or in Dionysos' company, as a mirror of human activity and as a way of exploring limits of what it was socially acceptable for men to do. Similarly the female devotees of Dionysos, with or increasingly without Dionysos himself or satyrs in attendance, attracted painters' attention. The amphora by the Amasis Painter discussed earlier [49] is a good example of the way in which some mid-sixth-century artists began to investigate the nature of the relationship between his female worshippers and the god.

Satyrs were a favourite subject with early red-figure artists. The greater freedom of pose and gesture which the new technique afforded enabled satyrs to be shown gambolling in more and more outrageous ways. Satyrs may appear alone, but often the female devotees of Dionysos appear as passive objects of satyrs' attentions (as in the scenes in which satyrs approach sleeping women, which become popular at this time), as willing or unwilling partners in their revels (they can be shown using the *thyrsos*, that marks them out as Dionysos' followers,

Interior of an Athenian red-figure cup signed by Hieron as potter and attributed to Makron as painter, first quarter of fifth century BC.

The flourish of the satyr's tail and the vine limply curling around the pot are just two of the ways in which the skilful artist makes a composition primarily made up of vertical elements seem entirely at home in a circular field.

as an offensive weapon), and also effecting their own worship of Dionysos without satyric intervention.

Satyrs and the female worshippers of Dionysos, known as maenads ('mad women'), did not form a symmetrical pair. Men might dress up as satyrs to put on plays in which familiar myths were made fun of by being set in a world of satyrs rather than men, but a man could never be mistaken for this composite creature with its horse's ears and tail. But maenads were simply women; it was what they held (particularly the *thyrsos*), and what they did (particularly in handling animals) that marked them out, not any anatomical difference. Artists might joke by showing a man's head balding in a way which imitated a satyr's, or a garment hung up in such a position as to make a man look as if he has a satyr's tail (as the Triptolemos Painter does on a cup in Tarquinia), and they certainly enjoyed the freedom to turn a satyr into an actor or an actor into a satyr by the addition or removal of a pair of furry shorts with tail and phallus attached. But with maenads the possibility that the scene was of 'real' women was always present.

One prolific red-figure artist of the early fifth century was particularly keen on exploring sexual relations and the relationship between god and worshipper through images of satyrs and maenads. Though he named himself rarely—he more commonly named the potter he worked with, Hieron—more than four hundred pots, mainly cups, can

The mask of Dionysos on its draped pillar and the altar next to it (just visible at the very bottom of this photograph) forms a still centre around which the female worshippers flow in a sea of movement, their heads thrown back ecstatically and each one moving independently, self-absorbed.

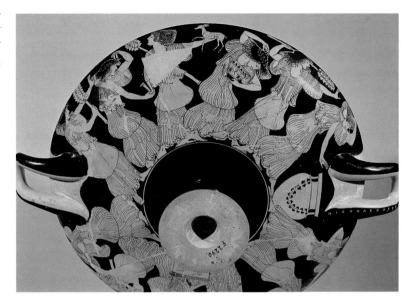

be attributed to Makron, and some 8 per cent of them show maenads. Along with the even more reticent 'Brygos Painter' (he often names Brygos, the potter he worked with, but never himself), and the self-advertising Douris [**89**] (comparatively keen on his own signature), Makron dominated Athenian cup production in what was to be its heyday. Although in some ways Makron is the least enterprising of these three artists, most conventional in his choice of scenes, least concerned to connect all three scenes on a single cup, his Dionysiac scenes offer much interest.

Inside a cup found at Vulci Dionysos stands leaning on his *thyrsos* and listening to a satyr playing the double pipes [**80**]. On the outside of the same cup [**81**] maenads who variously play pipes, wield *thyrsoi*, carry a mixing bowl, and brandish a tiny fawn, dance excitedly around a blood-spattered altar beside which stands a mask of Dionysos on a pillar draped with a garment elaborately decorated with dolphins. The embodied god and satyr of the interior safely belong to a world apart from men, but the mask idol on the exterior is a feature of regular religious ritual. What then of these female devotees? The world of cult and the world of mythical creatures meet in this cup—a cup used in yet another Dionysiac world, the world in which Dionysos is met in the wine of the *symposion*. A man drinking from this cup is likely to find himself more familiar with the activities of the world of satyrs, with which his sympotic activities will often surround him, than with the maenadic world of exclusive female rites. And where, between these various worlds, is Dionysos? What have the ecstasy and the wild animals to do with the *symposion*? How does the tune the maenad's pipes play compare with the tune played by the satyr—or by the young man or girl at the party? What is a mixing bowl doing at the women's ritual?

Athenian red-figure bell *krater* attributed to the Pan Painter (name vase), second quarter of the fifth century BC.

Comparison between the two sides of this pot shows the range of drawing styles which the painter was able to command. The easy informality of the highly unrealistic swirls of the goatherd's garment contrasts with both the archaizing formality of Artemis' clothes and the refusal of Aktaion's rich cloak to crumple, even in the most adverse circumstances.

(how can you have a mixing bowl and no jug, ladle, or cups?) Is that ritual really just a female *symposion*?

If the questions about Dionysos' identity and what it means to worship him which this cup raises are merely quizzical, other artists came to use similar juxtapositions of scenes to scrutinize the relations of men and gods with rather more ferocious intent. The bell *krater* after which the Pan Painter is named shows on one side what is manifestly another erotic pursuit [**82**]. The god Pan, with goat's head and feet and a tail on a sexually excited human body bounds after a rustic figure who, like many objects of erotic pursuit, looks behind him as he flees the outstretched hands. In the background is a herm, the bearded head of the god Hermes on a four-square pillar fronted with an erect phallus, a familiar sight in the Athenian countryside.

Pan was newly introduced to Athens as a god when this pot was painted. He was granted public cult only after the Athenian messenger sent in 490 BC. to tell the Spartans about the invading Persians had met him in his native Arkadia. Pan had no role in traditional myths, but he became the god held responsible for panic in armies and also for sexual obsession. His cult came to be full of laughter, noise, dancing, and perhaps a certain licensed abandon.

The Pan Painter augments by visual wit the jokiness of the story he creates. That the goatherd, who still holds the lash with which he is

83

Other side of same pot.
The way in which the toe of
Artemis just transgresses the
border of the scene suggests a
delicacy to her movement that
contrasts with the cruelty of
her action.

supposed to drive the goats, should himself be fleeing before a goat is a nice piece of comic reversal. That he flees before a sexual assault plays on the reputation which goatherds had for satisfying their own sexual desires on their flocks, a reputation which we know from Theokritos' pastoral poetry. But the way in which the goatherd has caught the awkward bounding movement of the legs which Pan displays, and which is surely meant to call to mind the stiff-legged motion of goats, is a painterly joke, as is the herm in the background and its exaggerated features (the Pan Painter was peculiarly fond of herms). The viewer's first reactions to this scene are surely of unalloyed amusement—the goatherd getting his come-uppance, the god of sexual obsession sexually obsessed. A glance at the other side of this pot, however, begins to turn the joke sour.

With a theatrical gesture, Aktaion collapses, mauled by his own highly mannered hounds [**83**]. The goddess Artemis prepares to overdetermine with her arrow the hunter's demise. The figures yawn apart, as if in physical measure of the goddess' revulsion, and the arrow in the middle becomes a focus of attention. We are here in a very different world from the rustic rough-and-tumble of Pan and the goatherd. Aktaion's refined features, his luxurious cloak, and his sword mark him out as an urbane young man, one of the smart set. Artemis, richly attired as huntress, acts without impetuosity as she deliberately takes

aim. If the goatherd's role reversal is amusing, Aktaion's is not. This is the stuff not of comedy but of tragedy.

Why does Aktaion meet such a fate? Antiquity knows three reasons why Artemis took offence at Aktaion: because he boasted that he was a better hunter, because he sought her hand in marriage, or because he came across her naked. The last version is only known from sources much later than this pot, but the presence of this scene on the same pot as Pan's sexual pursuit suggests that we should read a sexual element into the story of Artemis and Aktaion. The gods pursue men as they will, with impunity; but any man who presumes to pursue a goddess....

The tragedy of Aktaion raises issues in human relations with the gods which are not trivial: the constraints on freedom of action are at issue. Are human beings mere playthings of the gods, exploited at the gods' fancy, tolerated when they do not impinge on the gods' interests, but exterminated if they presume to be independent actors? Should the love life of the gods be regarded as a matter for human amusement, or as the rape of the servant by the employer? In the late sixth century philosophers had begun to raise questions about whether beings as immoral as the gods of Greek tradition could really be gods, or gods really be such immoral beings, and Athenian tragedians would take up such issues. This mixing bowl, with its strongly contrasted sides, may be seen in the context of such debates.

The Pan Painter is often referred to as a 'Mannerist' because of the exaggeration he so regularly employs in his drawing. This pot shows very clearly the effectiveness of such exaggeration in cueing the viewer in to the issues being raised. The elongated phallus of the herm ensures that we turn our attention to the sexual harassment of other gods than just Pan; the mechanical dogs that posture around Aktaion and frame his beautiful head ensure that we see this not as a nasty hunting accident but as something deliberately set in motion by a greater power. The development by red-figure artists of the means to evoke the forms, the poses, and the gestures seen in real people (best glimpsed here in the twisting form of Artemis) also enables them to send further messages by departing from 'reality'.

This chapter began, as it has ended, with a pot which plays games at the *symposion*. The desire to paint new sorts of scene to satisfy the demand for entertainment at parties may well have been what encouraged the invention of the red-figure technique in the first place. The revolution that the new technique represented should not be underestimated, for it spawned not only new iconography but a whole new relationship between painter and viewer in which, in a variety of ways, the viewer was made to put his own behaviour, as well as the behaviour of others, under scrutiny. The very large number of surviving pots enables us to recapture something of the intensity of the interactions in the Potters' Quarter, and to see how painters emulated

and outdid each other, producing images that must have bordered on the outrageous in Athens just as they do for us today. How far those images are the product of a particular ferment in the Potters' Quarter, and how far that ferment extended to society more widely, it is hard to know. But the Pan Painter is one of the last pot painters in whom such ferment can be sensed.

Cult, Politics, and Imperialism

9

From dissent to totalitarianism

The years in which the painters of pots at Athens vigorously explored the most intimate of human relationships were years of very considerable turmoil, strain, and danger. Establishing a new constitution, in which every freeborn Athenian adult male could play a part, involved intense political debate. So lively were the arguments that the Athenians invented a black-balling device, known as ostracism, by which they could vote to exile an individual from the city for a decade because they feared the political effects of his presence. War with one neighbour after another, with the Boiotians and Chalkidians in the last decade of the sixth century, with Aigina (see above, p. 124–6) in the first decade of the fifth, was immediately followed by warfare against the Persian invader. The Athenians first beat off a seaborne invasion at Marathon in 490 BC, and then abandoned their city to resist and defeat a combined land and sea invasion in the battles of Salamis in 480 and Plataia in 479 BC. Success in those battles, coupled with a reluctance on the part of the largest and most powerful of the Greek states, Sparta, to get involved at sea and far from her potentially rebellious servile population of Messenian helots at home, gave Athens an opportunity that she readily seized to take over the continuing campaign to drive the Persians from the Greek cities of Asia Minor. Within twenty years of the Persian invasion Athens was running a network of over two hundred allied cities from whom either active military support in ships or regular monetary payments were demanded, and the battle against the Persians was pursued as far as Cyprus, Phoenicia, and Egypt. But success in war did not mean political consensus at home: by 460 both Themistokles, the Athenian most responsible for turning back the Persian invasion, and Kimon, the general whose activities had done most to create and sustain the new league of allies, had been banished from Athens, and Ephialtes, a politician who had driven through further radical democratic reforms, had been assassinated.

Warfare and internal strife were equally familiar in most other Greek cities during this period. During the fifty years from 510 to 460 BC the Spartans had, in addition to playing a major part in defeating the 480–479 Persian invasion, repeatedly launched invasions of Athens

Detail of 92

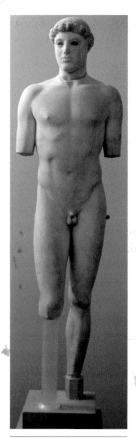

84

Free-standing marble statue of a youth, known as the 'Kritian Boy', from the Athenian Acropolis. Close to 480 BC.

This boy takes his name from a perceived similarity with the head of Harmodios on copies of the statue from the 'tyrannicide group' by Kritios commemorating the killing of Peisistratos' son Hipparchos as the founding event of democracy. That group was commissioned shortly after 480 BC to replace an earlier monument that the Persians had taken away.

in attempts to secure a friendly regime there, invaded Aigina and Argos, battled against their own allies in Arkadia, had one king commit suicide and sent two other kings into exile, and experienced a major revolt of the *helot* population. Western Greeks faced a separate foreign invasion, as the Carthaginians launched an attempt to conquer the whole of Sicily and first they and then the Etruscans were fought back by an insecure alliance of Greek cities. In the Greek west, as on the Greek mainland, smaller cities regularly fought their neighbours, sought or repudiated alliances with larger cities, and experienced marked changes of regime or constitution. The Persian and Carthaginian threats had offered another lever to be employed in internal and inter-state politics, they had not suppressed dissension; indeed it was only a small minority of Greek cities who actively took part in the resistance to the Persian invasion.

In the middle of the fifth century, however, the situation on the Greek mainland and in the Aegean changed. So successful had the Athenians been in organizing the cities of the Aegean against Persia that they achieved a military dominance that enabled them to exercise an imperial power over their allies, particularly by means of the navy sustained with allied tribute. That imperial dominance not only led to Athens suppressing political revolution among her allies, and imposing upon them democratic regimes friendly to herself; it also effectively suppressed political revolution in Athens itself because her position in the Greek world, and her prosperity, came so clearly to depend on maintaining her empire. Cities outside that empire were similarly encouraged to internal accord and good relations with Sparta by fear of Athenian ambitions: how best to keep Athens under control became the major item of disagreement among cities not under her sway.

The changed situation was no narrow matter of politics. The considerations which brought about markedly reduced political dissent within Athens brought also a concern with areas of life that were not directly political, as Athens moved towards a degree of totalitarianism previously unknown within Greek cities. For all the notorious free abuse of political leaders that marks the comedies of Aristophanes, the Athenians did move censorship laws and politicians did prosecute both playwrights and philosophers. The execution of Sokrates, in the first year of the fourth century, appropriately marks the end of this least liberal phase of Athenian democracy.

The changing political agenda at Athens and in other Greek cities during the fifth century had major effects on arts of all kinds, and particularly on public sculpture. The wealth of the Athenian empire indirectly enabled the Athenians to indulge in an unprecedented programme of political and religious buildings in marble. Athenian totalitarianism had its effect on the way in which citizens were presented, producing a classical idealism to which later revolutionary

Sexuality and the standing male

Shortly before, or just possibly shortly after, the Persian sack of the Athenian Acropolis in 480 BC, one further *kouros* was dedicated there [**84**]. Whatever its precise date, this was certainly the last in its line. This standing figure with its right leg advanced and arms by sides, known as the 'Kritian Boy', conforms to the basic conventions of, and yet nevertheless stands clearly apart from, the classic *kouros*. For this is indeed not merely a beardless male figure but a boy, whose soft flesh, trim but undeveloped musculature, and genitals are those of an adolescent. The greater specificity which the increasing richness of reference to the male form inevitably brought with it makes the fiction that this is a universal symbol impossible to sustain; rather than mirror the gaze of the viewer and enter the viewer's story, this boy turns his head intent upon his own story in which the twist of his hips guarantees that he is an actor and not merely a spectator. No longer engaged, the viewer now searches for clues about that story, eyeing the boy up and down and appreciating the attractions of his youthful body. The world and delights of the *symposion* have here entered the religious sanctuary.

85

Marble statue of a young man from the Phoenician settlement at Motya in western Sicily, second quarter of the fifth century BC.

This figure may have been part of a group, and is perhaps a charioteer or a priest. The peculiar garment displaying the figure's sexuality as well as the sculptor's ability to reproduce the physical form of a man raises the question of what the imitation of natural form is for.

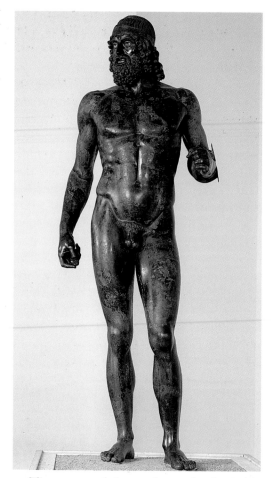

Bronze statue of a warrior ('Warrior A') from the sea of Riace Marina in Italy, second quarter of fifth century BC.

How does one commemorate the successful in war? The sensitivity of the anatomical detailing on the Riace bronzes suggests that the sculptor answered that question by positively exploiting the possibilities for comparison and contrast offered by having a series of similar warriors.

The same artistic trends are clearly visible in a marble figure from the western fringe of the Greek world, the Carthaginian settlement at Motya at the western tip of Sicily, of perhaps a decade later, although our ignorance of the Greco-Punic cultural setting makes this figure harder to place socially [85]. The head, turned in attention to some unknown object or event, the short hair, ending in a ring of curls, and the swing of the hips, emphasized by the firm and highly demonstrative placing of the left hand, all parallel or take further features to be seen in the Athenian boy, but the clinging garment shrink-wrapping the body gives this figure a quite different overall effect. Neither the fine stretchy fabric nor the broad breast band can be paralleled in either sculpture or vase-painting, and we do not know whether this is a regular or a ceremonial costume, or, if the latter, what the ceremony might be. But whatever the basis for this garment or this pose in real life, the sculptor has chosen so to model the body through the garment as to display an assertive musculature and a confident, even aggressive, masculinity. We do not know how exotic a figure the aristocrats from Greek cities cut who met to play at the great Panhellenic festivals, dominated in

these years by men from Greek Sicily, but the Greek sculptor has here created a distinctly exotic image which nicely sums up the combination of the Greek and the alien which the Greeks of Sicily came to represent.

By the middle of the fifth century visitors to one or other of the Panhellenic festivals were faced with a monument in which martial achievement and manliness were even more strikingly explored and celebrated. Recovered from the sea off Riace in southern Italy in 1972, these two slightly over life-sized bronze figures [86, 87] are likely to have been part of a larger monument, perhaps in commemoration of the Persian wars, and to have been lost while being carried off to Rome. The quality makes it probable that we are looking here at the work of an early classical sculptor whose name is preserved in ancient litera-ture, but, given the paucity of other original classical statues in bronze, precise identification must remain speculative.

The two bearded figures stand in similar poses, their left forearms held horizontal to support now-lost shields, their right hands loosely clasped around a spear. The figure known as 'A' [86] was marked out by a diadem and wreath, 'B' [87] wore a helmet. Technically the figures are so similar as to suggest that they are contemporary products of the same workshop. But in other ways the figures are markedly

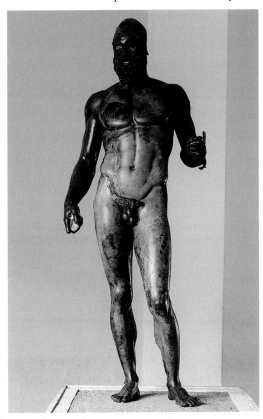

87

Bronze statue of a warrior ('Warrior B') from the sea of Riace Marina in Italy, second quarter of fifth century BC.

Plumper and generally less physically fit than Warrior A, this man looks towards the viewer with a certain nervous-ness and uncertainty. For all the delicacy with which the male body is here captured, comparison with Polykleitos' *Doryphoros* [88] shows how firmly rooted to the ground the Riace warriors remain.

contrasting. 'A' is tautly alert and at the peak of physical fitness, with a sharpness to his gaze which has made some attribute an angry mood to him; 'B' is much more thin-fleshed, his muscles sagging slightly, his gaze less reactive though no less penetrating, and his stance a more settled one from which he seems more reluctant to move. Some scholars have been inclined to attribute the differences to different sculptors, or to a chronological gap between the two figures, but that seems to mistake the conscious exploration of different characters for the unconscious quirks of different artists. Whatever other figures may have contributed to the monument as a whole, the productive counterpoint between these two figures can hardly be accidental.

Whether either of these figures represented a historic figure, rather than some god or hero, we cannot know, but their particularity is not in doubt. That particularity is not merely a matter of mood and temperament, age and life-style, it is also a matter of sexuality. This is very clearly shown by modern reactions: even if the visitors whose responses to an Italian sociological investigation suggested that 'A' was more sexually attractive to women and 'B' to men were responding to a leading question, the afterlife of 'A' as a (hetero)sexually active male in Italian pornographic comic magazines seems good independent evidence of his sexual potency to modern viewers. Whoever they stood for, these statues represented to the viewer real men, so instilled with life that viewers' reactions come close to the reactions they might experience when seeing live men of similar appearance.

Although the Kritian Boy and Motya figure suggest that a similar reaction might be elicited by a marble figure, the use of bronze for these statues has an important influence on their appearance. Greeks learnt from the Near East in the eighth century to make bronze statues by the 'lost wax' method, in which an original sculpture in wax over a clay core was covered with clay and then bronze poured in to replace the wax which was melted away; but the first life-sized statues so produced to have survived date to the late sixth and early fifth century (a bronze Apollo recovered from the Peiraieus harbour and the Delphic charioteer). The techniques were quickly refined and the Riace bronzes were made by an indirect method which gave a more consistent thickness of bronze. The refinement of casting technique indicates the demand from sculptors, who wanted more scope to present bodies in extended and unbalanced poses that were awkward or impossible in marble. But bronze had other advantages too, besides its tensile strength. Because the process of making a bronze statue is more one of moulding and of building up than of cutting away, the whole relationship between sculptor and sculpture is different, and tactile qualities are much more prominent. Textural effects are further promoted because the surface of bronze reflects rather than absorbs the light, so that a much greater range of surface treatments is possible than can be achieved in marble,

88

Marble copy of Roman date of the *Doryphoros* (Spearbearer) by the Argive sculptor Polykleitos, middle of fifth century BC.

In the transfer from bronze to marble it is likely that much of the sensitivity of Polykleitos' original has been lost. It is nevertheless clear that although this was a more mobile figure than either Riace warrior, its musculature was heavier and lacked the same individuality.

as can be seen very clearly in the treatment of hair. In the Riace statues the possibilities of bronze are further enhanced by adding silver for the teeth of 'A' and copper for the lips and nipples of both statues and by soldering on such extras as eyelashes, as well as by inserted eyes, a technique also adopted in marble for the Kritian Boy.

Bronze swiftly replaced stone as the material normally used for free-standing sculptures, and marble was restricted to reliefs and architectural sculptures until Praxiteles revived its use for independent works in the middle of the fourth century (see below, p. 228). One result of this is that very few original classical free-standing statues remain: others have been melted down so that their bronze could be re-used. Surviving marble copies of bronze originals, largely made in the Roman period, show, however, that whatever classical standing male figures shared with the Riace bronzes in technique, they differed markedly in other respects.

The contrast between the Riace warriors and the classical free-standing statues of just a decade or two later is clearly visible in what was *the* classic statue of a man, Polykleitos' *Doryphoros*, or spear-carrier [**88**]. Variations between the marble copies which survive make it clear that copyists altered the original in various ways to suit Roman taste, but Pliny the Elder's description of the *Doryphoros* as 'a virile-looking boy' shows that the contrast between the young man's beard-less face and the thick-set mature body was a feature of the original. Polykleitos was famous for the doctrine that there was a single fixed set of desirable proportions for the representation of the human body, and he wrote a book about this called the *Canon*: 'perfection,' he wrote, 'arises in detail through many numbers'. The *Doryphoros* has an easy naturalism: his whole body is given a vibrancy by the contrast from side to side between tensed and relaxed muscles, and his raised left heel (much repeated in later works) gives the pose an instantaneity lacking in the Riace bronzes. But we no longer look here upon a 'real man': we cannot square the over-developed architectural musculature with the clear skin of the face; we know that we look upon a construct, whose airy gaze contrasts to the intensity seen in the eyes of Riace 'A' and further discourages the viewer from creating a particular story for this figure.

Polykleitos' *Canon* was an idealist work, and his self-absorbed Doryphoros makes no direct contact with the experiences of the viewer. The statue may have been a representation of Achilles, but it is appropriate that it became known simply by a generic title, for this is very far from giving the viewer any hint of the angry Achilles of the *Iliad* or the passionate lover of Patroklos whom Aeschylus had presented to an Athenian theatre audience earlier in the century. The sexuality so manifest in the Riace bronzes is here dispelled, and the personal is no longer on the sculptural agenda.

89

Athenian red-figure wine-cooler (*psykter*) signed by Douris as painter, first quarter of fifth century BC.

Drinking games and sex games are combined on this pot on which the various vessels characteristic of encounters with Dionysos, both as wine and as god, are entrusted to a group made up entirely of satyrs. When this pot was placed inside a wine mixing bowl these satyrs would perform their antics on the very surface of the wine.

90

Athenian red-figure calyx *krater* (wine mixing bowl), name vase of the Niobid Painter, middle of the fifth century BC.

Although all the figures are solemn, there is little consistency of mood or of scale in this puzzling scene. The figure in the centre foreground is a giant compared to the stocky Herakles above him, and the vigorous reaction of the figure just visible at the far left contrasts with the general air of stillness.

The body of private imagery

The changes in the way the male body is presented and represented in sculpture can be paralleled on painted pottery, where a very marked change is to be seen in both style and iconographic preferences in the middle years of the century. This can be well illustrated by comparing just three pots, one painted shortly before and the others painted two or three decades after the Persian wars.

A wine-cooler (*psykter*), signed by the painter Douris, comes straight out of the sympotic tradition discussed in the last chapter [**89**]. Made to be filled with ice or cold water and sat inside the *krater* in which the water and wine was mixed, this was perhaps the most private of party vessels. On this example Douris paints satyrs revelling, one dressed up as the god Hermes and the others playing various excessive games with wineskins, cups, and *kantharoi*. Not only is much virtuosity displayed by the satyrs, but Douris displays his own skill in balancing the acrobatic and dancing bodies. Although drawing with great economy Douris repeatedly uses the familiar shapes of the vessels with which the satyrs play to emphasize the satyrs' own forms, as in the satyr who holds a cup behind his own buttocks. Bodies are very much

at issue here, as the ligaturing of all the satyrs who are not sexually excited, except the satyr playing Hermes, shows. Ligaturing may have been practised in the gymnasium [73] and early red-figure artists often show athletes with the ties binding the penis visible, but showing the penises of revelling men or satyrs curled up or back on themselves, with no ties visible, seems to be adopted as a visual symbol of urbanity and sexual continence, not dependent on any parallel in real life. The effect is to draw attention to the sexual potential of these figures far more effectively than merely showing the penis would do.

The bodies displayed on the name vase of the Niobid Painter are no

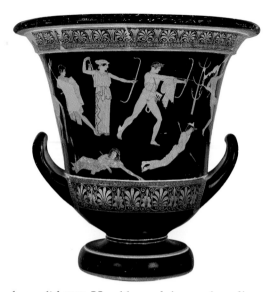

91

Other side of the same pot. Niobe's children are slaughtered to punish their mother's excessive pride in them. Although mentioned in the *Iliad*, this was not a scene much represented in art, except on violence-loving Tyrrhenian amphorae. Here multiple ground-line is well used to show the bodies scattered and so effectively to convey the defencelessness of the child victims.

less solid [**90**]. Herakles and the two beardless naked men beneath him have their rib-cages, as well as their musculature, carefully depicted, and the poses of the seated and recumbent figures enable the space they occupy to be clearly indicated. But whereas the scene by Douris was easy to construe because the figures relate straightforwardly to one another, the relationship between the figures here is quite opaque, and although Herakles and Athena can be identified the moment depicted cannot be deduced. All the viewer's attempts to create a narrative here are blocked by the uncertainties of spatial relationship as figures occupy a number of different groundlines not clearly related one to another.

This puzzling arrangement seems almost certainly deliberate, since on the other side of the vase multiple groundlines are used to clear effect [**91**]. Apollo and Artemis are shown shooting dead the children of Niobe who had based her boast of superiority to Leto, mother of Artemis and Apollo, on these children. The indiscriminate slaughter is well conveyed by the scattering of the bodies of the victims across the surface of the pot, and the rugged landscape which tree, ground lines, and half-hidden figures reveal provides an appropriate setting for the weeping mother who, according to myth, would be turned into a rock.

But if the Niobid Painter could make good use of multiple ground lines, why does he not do so on the side showing Herakles? A clue to the answer to this may lie in an odd detail of his drawing. On the Niobid side of the *krater*, as on other pots attributed to him, the painter depicts a tripartite division of the male abdominal muscles; on the Herakles side the division is quadripartite. Among earlier artists both tripartite and quadripartite divisions can be found, but individual artists tend to be consistent, particularly within the scope of

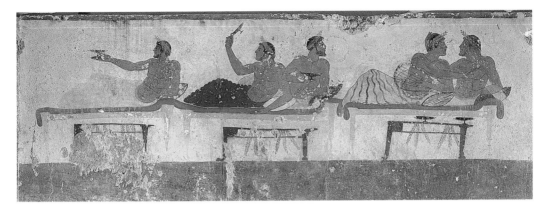

92

Symposion scene from the long sides of the Tomb of the Diver, Paestum, perhaps of the 470s BC.

The furniture, gestures, and drawing here are very comparable to those to be found on contemporary Athenian vases, but the use of blocks of colour suggests that there were traditions in wall painting that are not much reflected in red-figure pottery.

a single pot. The most straightforward explanation for his divergent practice here is that he is copying the figures on the Herakles side from some other work of art, and the most probable candidate is a wall-painting.

The only well-preserved example of fifth-century Greek wall painting is the Tomb of the Diver from Paestum in Italy. The scenes on this tomb show both how similar wall painting and pot painting could be in their basic techniques and draughtsmanship [**92**], and the effects of having a polychrome palette and the possibility of a light and spacious background. But this is a simple work, and we rely for our knowledge of more elaborate pieces of fifth-century wall painting largely on literary texts, and in particular on a very full account in the guidebook of Pausanias (2nd century AD) of the paintings in the Knidian Clubroom at Delphi. Pausanias' account indicates that the figures were disposed on multiple ground lines, up and down the picture space, and that the painter, Polygnotos, paid particular attention to depicting facial expressions.

In the scene with Herakles the Niobid Painter seems to have lifted individual figures from a wall painting and to have recombined them, utilizing multiple ground lines but not restoring the original spatial arrangements. He is giving a selection of quotations rather than a continuous excerpt, perhaps conscious that when figures are moved from a light to a black background all sense of space will in any case be lost. Like the expressive faces of the central figures, which lead nowhere because taken out of their original context, the bodies here are displayed primarily to refer the viewer back to painted originals; the third dimension is invoked to remind the viewer of a two-dimensional model.

The Niobid Painter, who on other pots paints scenes inspired by satyr plays and perhaps by sculpture, seems to have been exceptional in his interest in other artistic media. But, from the middle of the fifth century, scenes making reference to life seem to have become distinctly less common on pots, and in several of the finest works the reference is primarily to art. An excellent example of this is to be seen on a *pelike* by

a painter known as the Lykaon Painter [**93**]. Odysseus is shown in the centre of the scene sitting on a rock, his sword drawn and two slaughtered sheep at his feet; behind him stands Hermes, who starts at the appearance of the ghost of Elpenor who (as in the story in *Odyssey* XI to which unusually precise visual reference seems here to be made), appears from the underworld to beg Odysseus to see that he is properly buried. The figures of Odysseus and Hermes here are remarkable for the care and detail of the drawing, seen particularly in their footwear, but they remain little more than silhouettes. The figure of Elpenor, by contrast, is exceptional for the way in which it occupies space: presented in close to three-quarter view, and with his arms spread out

93

Athenian red-figure *pelike* attributed to the Lykaon Painter, third quarter of fifth century BC.

The floral decoration at the handles to left and right of the scene is by the same hand as florals on pots attributed to two other painters, Polygnotos and the Kleophon Painter, who presumably belonged to the same workshop. The vegetation (although not clearly visible here) around Elpenor as he rises up before Odysseus and Hermes seems deliberately to continue the decorative florals, and to emphasize that both are equally artificial.

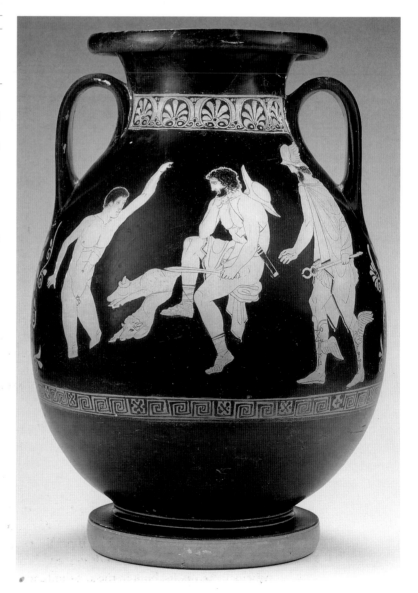

At the spring above these women are written 'Deïnome', 'Metiokhe', 'Peisis' and 'Kleodike': of these names that of Deïnome alone is in the so-called *Little Iliad*, and I think that Polygnotos made the other names up himself. Epeios is drawn naked, throwing the Trojan wall down to the ground; above it rises just the head of the wooden horse. Polypoites the son of Peirithoös is tying a ribbon round his head, and beside him is Akamas the son of Theseus with a helmet on his head—the crest of the helmet is shown. And there is Odysseus; Odysseus has put on his breastplate. Aias the son of Oileus stands by an altar with his shield, taking an oath about what he dared to do to Kassandra; and Kassandra sits on the ground holding the cult statue of Athena, and has wrenched the wooden statue from its base as Aias dragged her away, suppliant though she was. The sons of Atreus are drawn, these too with helmets on: a snake is wrought on the shield which Menelaos has, this is because of the portent that appeared during the sacrifice at Aulis. Near these men who are extracting the oath from Aias and straight on from the horse beside Nestor is Neoptolemos killing Elassos, whoever Elassos is. He is shown like someone who has little life left in him, but Neoptolemos is striking Astinoös, who is a figure mentioned by Leskhes [the author of the *Little Iliad*], with the sword although he has fallen to his knees. Polygnotos showed Neoptolemos alone of the Greek force still murdering the Trojans, because the whole painting was intended to be placed over the tomb of Neoptolemos. Throughout his poetry Homer gives the son of Achilles the name Neoptolemos, but the epic poem *Kypria* says that he was called Pyrrhos by [his father-in-law] Lykomedes and that Phoinix [Achilles' tutor] gave him the name Neoptolemos ['Young War'] because Achilles began to fight when still young.

Pausanias, *Guide to Greece*, 10.26.2–4. This passage reveals well both the detailed way in which Pausanias describes the paintings in the Clubhouse of the Knidians, which were more than five hundred years old when he saw them, and the way he reads the paintings in the light of his knowledge of Greek literary accounts of the same events.

into the landscape as he presses on the rock to ease himself up, Elpenor becomes a real physical presence. Yet Elpenor is the only one of these figures who is in fact bodiless, for he is a ghost. The painter has chosen to give weight to a phantom, while giving no emphasis to the bodies of human figures; he chooses to emphasize the trickiness of his art and to show it startling the arch-tricksters Hermes and Odysseus. Elpenor's is a Polykleitan body, and the Polykleitan body is shown up as an artist's fiction. The play of the image here has nothing to do with the pot or its use; even in private art the agenda has become self-referential.

Opening the body's story: the sculptures of the Temple of Zeus at Olympia

The implications of the transformation of the human body are nowhere more dramatically apparent than in the two great architectural monuments of the middle of the fifth century, the temple of Zeus at Olympia, completed around 460 BC, and the Parthenon on the Athenian Acropolis, built in the 440s and 430s.

1 Tripod
2 Nike
3 Centauromachy
4 Labours of Herakles
 (6 metopes)
5 Zeus of Pheidias
6 Pelops vs. Oinomaos

94

Ground plan of the temple of Zeus at Olympia, indicating the location of the sculpture.

The temple was built in the 460s and 450s BC employing local low-grade shelly limestone for the architecture but marble from the Cyclades for the sculpture. The gold and ivory cult statue by Pheidias, which came to be regarded as one of the wonders of the world, was added in the 430s after, and in competition with, Pheidias' statue of Athena for the Parthenon.

The temple of Zeus was a product of the old world, where success at the Olympic games could significantly enhance a political career and where warfare between Greeks was predominantly a matter of fighting one's neighbours: it was the spoils of war with the neighbouring people of Pisa that enabled the Eleans to build the vast temple, practically identical in proportions to the temple of Aphaia on Aigina, built thirty years earlier (see above, p. 124), but almost as wide as that temple was long. The sculptural decoration, in imported Parian marble, was of a richness unprecedented in a building of this size: the two pediments and the twelve metopes over the *pronaos* and *opisthodomos* all featured sculpture [**94**]. Several of the individual scenes have no earlier parallel, and the whole programme is closely tied in with the particular circumstances of this sanctuary.

Competition is the theme which unites the sculptures. The east pediment [**95**], looking out towards the racetrack, showed Pelops competing against Oinomaos in a chariot race, the prize for success in which was the hand of Oinomaos' daughter; the west pediment [**96**], looking down on the wrestling ground, showed the fight against the centaurs who disrupted the marriage feast of Peirothoös; and the metopes showed Herakles performing twelve of his labours, and established those twelve as the canonical labours.

The manner of representation pulls no punches. Such sculptures as those decorating the Siphnian treasury or the temple of Aphaia [**60–64**] had shown action, and even indicated the general outcome, but they had not shown a definite moment. Here the east pediment, through the device of the seer who has a premonition of what is going to happen [**97**], imbues the moment before the race begins with not just the tension of anticipation but a complex play of knowledge and ignorance, innocence and guilt. Oinomaos, the story went, challenged all suitors for the hand of his daughter to a chariot race, the price of defeat, for either party, being death. Oinomaos, who possessed the swiftest of horses, had disposed of twelve suitors this way and nailed their heads up on his palace. Pelops knew that he would not win by fair means, resolved to win by foul, bribed Oinomaos' charioteer with a

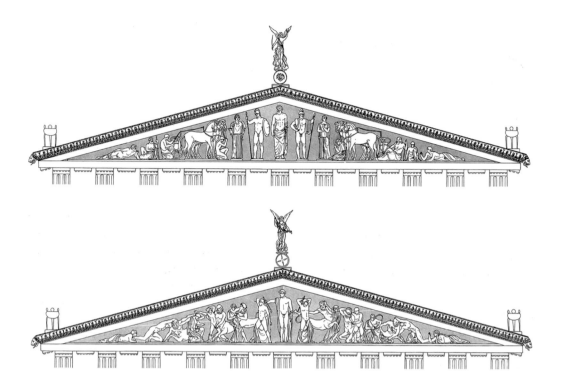

promise he later failed to keep (to replace the chariot lynch-pins with wax ones), and so procured victory, Oinomaos' death, and his daughter as bride, but also a curse upon his family.

Nothing that we have previously seen in Greek sculpture prepares us for the seer and his role here. He shares with the Kritian Boy and the Riace bronzes the attribute of a definite age: his flesh sags over his chest and folds up above his belly in a representation of old age which is made the more vivid by its juxtaposition to the pre-adolescent chariot boy and the youthful figure of the river Kladeos, immediately behind him in the right-hand corner of the pediment. But the moment at which he is caught is not just a moment in the course of a physical action, such as the sculptor Myron caught at about this time in his famous 'Discus Thrower' and 'Athena and Marsyas', but a moment of new mental clarity. Although the face is moulded with very simple forms, the attention devoted to eyes and to the slightly open mouth, along with the gesture of the right arm, afford to this one actor a single moment of vision that transforms the rather static tableau at the centre of the pediment by illuminating their past actions, present intentions, and future fates. Pelops and Oinomaos line up here, with their chariot teams alongside, as did competitors in the games; without the seer to tell their story the acts and intentions of those competitors remained inscrutable, but this story guarantees that no mask of innocence can prevent the malicious suffering in the end. The viewer is given the key here by which to read the results of this race, and is encouraged to pay

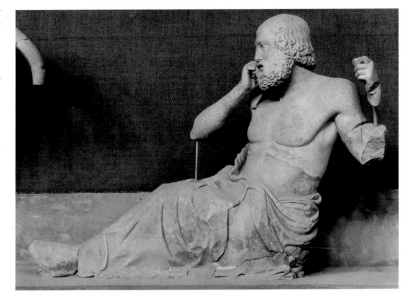

97

Figure identified as the seer
from the east pediment of the
temple of Zeus at Olympia,
c.460 BC.

Because no figure in archaic
sculpture is shown at a
particular moment, no single
archaic figure ever affects the
way we read other figures in a
group; but here by momentary
gesture and facial expression
the figure of the seer creates
the narrative which fills the
static central group with
tension.

98

Figure of Apollo from the
centre of the west pediment of
the temple of Zeus at Olympia,
c.460 BC.

Whereas the seer's expression
supplies a narrative to the east
frieze, there is a sense in
which it is the narrative of
the west frieze that gives an
expression to the central
figure of Apollo. The Apolline
seriousness and calm here
is not simply a standard
attribute: against the violence
perpetrated by the centaurs
it becomes judgemental.

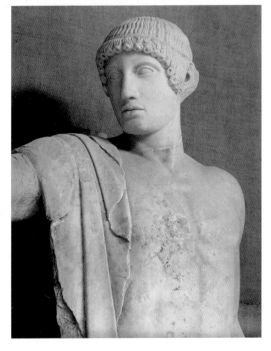

equal attention to the possibility that those who compete in the games
know more than they declare and that some may win by means more
foul than fair.

What the lost head of Zeus at the centre of the web of deceit on the
east pediment conveyed we cannot tell, but on the west pediment the
central figure of Apollo is well preserved, and shows rapt, nervous at-
tention (note the slightly parted lips) to the pain and suffering around
him [**98**]. The west pediment does not focus on a single moment, but

on an ongoing struggle and the different ways in which the individuals involved react. There are displays of determination, as in the deadened features of the lapith whose wrinkled brow and flared nostrils alone betray the pain inflicted by the teeth of the centaur sunk into his arm [**99**], but there are also expressions of great emotional intensity, as in the woman spectator whose every feature evinces the agony involved in helplessly looking on as injury is done [**100**]. Once more here there are challenges and paradigms offered to competitor and spectator alike, but once more also questions of motivation and fair play, of what divides human from inhuman behaviour, are central.

By comparison with the agony of the pediments, the metopal sculptures are celebratory of human ability to conquer monstrous challenges and win through. Herakles is shown engaged in some labours, successfully bringing back the spoils of others. The compositions are so planned that those scenes in which the labour is in progress exhibit a

99

Struggle of Lapith and centaur from the west pediment of the temple of Zeus at Olympia, *c.*460 BC.

The sculptors at Olympia render human bodies and drapery in a wide variety of styles: compare the treatment of the hair here with that in the preceding and following plates, or the drapery over the Lapith's legs here with that over the legs of the seer on the east pediment [**97**].

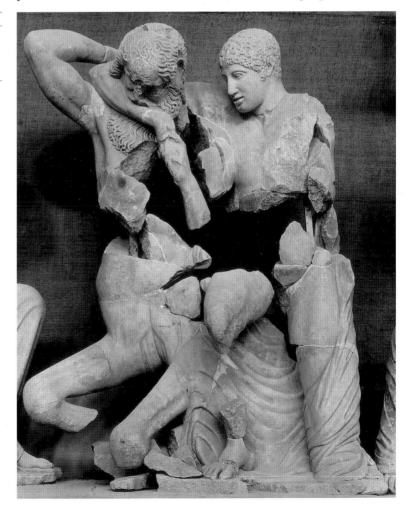

100

Lapith woman from west pediment of the temple of Zeus at Olympia, c.460 BC.

The weight of pain is conveyed here not simply by the facial expression, particularly brows and mouth, but by the heavy fall of drapery as things inanimate as well as animate are made to share in the distress (compare the palm tree in **76**). The way in which every element shares in the pathos of the moment makes the name 'Severe Style' appropriate for sculpture of this period.

tension between two diagonals or between a diagonal and a vertical, while those scenes in which the labour is successfully completed are dominated by parallel verticals. So, in one of the best preserved metopes [**101**], Athene, Herakles, and Atlas appear side by side, as Atlas brings back to Herakles the apples of the Hesperides, and Herakles prepares to give back to Atlas the burden of supporting the heavens. Athene is supportive but yet distant, and her support costs her no effort; Herakles is still trapped beneath the weight of heaven as he tenses his muscles and forces back his shoulders to maintain the balance, while Atlas regards him with cautious admiration as he presents the apples. Those who compete are here guaranteed support, but while that support may make it possible for them to complete their tasks it does not remove the burden.

By inserting various spectators into the fields of the sculptures themselves, the Olympia sculptures engage their viewers in the ethical issues particularly raised by competitions at Olympia. The range of individuals, young and old, men and women, cunning and innocent, bestial and divine, involved in competition all encourage the viewer to see into and sympathize with the different predicaments of different participants in the festival's events. Yet at the same time, by taking on the east a very specific story and on the metopes successive episodes involving a single character, these sculptures make viewers face up to how they will react to specific events.

Closing the body's story: the sculptures of the Parthenon

If the expenditure involved in the building and decoration of the temple of Zeus at Olympia seemed to contemporaries excessive, it will not have done so for long. Not much more than a decade after it was completed the Athenians embarked on a much more excessive endeavour: the Parthenon [**102**] was entirely marble; it was longer, wider, and had columns fractionally higher than the temple of Zeus; it had metopes all round the exterior, rather than just above the porches, a continuous sculpted frieze around the outside of the cella, and a colossal gold and ivory cult statue that so outshone whatever there was at Olympia that a similar piece was promptly commissioned from the same sculptor for the Olympia temple. There is little doubt either that the Athenians intended to surpass the temple of Zeus and all other mainland temples, or that they succeeded in doing so. Having amassed a larger league of allies (effectively subjects) than had ever been known in the Greek world, and accumulated very considerably more wealth than any Greek city had ever previously enjoyed, the Athenians were determined not simply to be superior but to proclaim that superiority. Despite conversion to a church, and some deliberate vandalism, the building remained largely intact until the gunpowder stored inside it by the Turks was ignited by a Venetian mortar bomb on 26 September 1687.

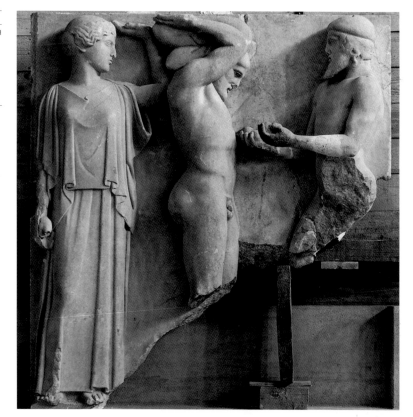

101

Herakles, with assistance from Athena, supports the world while Atlas fetches for him the apples of the Hesperides: metope from the temple of Zeus at Olympia, c.460 BC.

Shortly before the temple of Zeus at Olympia was built, the temple of Zeus at Akragas had employed colossal male figures shown supporting the architrave between the external columns. Given Olympia's links with the west, the idea and pose of Herakles here may be inspired by the Sicilian precedent.

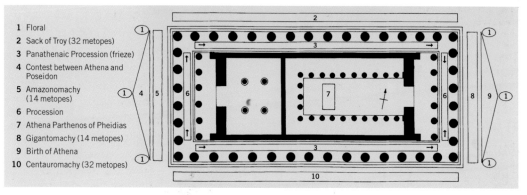

1 Floral
2 Sack of Troy (32 metopes)
3 Panathenaic Procession (frieze)
4 Contest between Athena and Poseidon
5 Amazonomachy (14 metopes)
6 Procession
7 Athena Parthenos of Pheidias
8 Gigantomachy (14 metopes)
9 Birth of Athena
10 Centauromachy (32 metopes)

102

Ground plan of the temple of Athena Parthenos on the Akropolis at Athens, indicating the location of the sculpture. The temple was built in the 440s and 430s BC entirely from marble quarried from Mount Pentelikon and transported by specially constructed roads.

The centrepiece was the gold and ivory statue of Athena 12 m. high, now lost, which can be reconstructed from later miniature versions. That statue was the responsibility of the sculptor Pheidias, who ensured that its gold plates could be detached in the event of a crisis of Athenian finances; the gold and ivory used here probably cost more than the rest of the temple and its sculptures put together. Desire to display this statue to greatest advantage determined the unusual octastyle arrangement, the consequent slenderness of the columns in relationship to their height and low entablature, both of which established a new pattern for Doric temples, and the use of shallow

103

103

Metope from north side of the Parthenon, showing women seeking sanctuary as part of the sequence presenting the Greek sack of Troy, 440s BC.

Although the surface has been almost entirely destroyed, the representation of a cult statue (Athena) on a base and of a small winged figure of Desire (Eros) flying from the shoulder of the left-hand woman makes it clear that the sculptors chose to present Helen as still desirable victim of the Trojan War.

104

Metope from north side of the Parthenon, showing Greeks closing on potential victims during the sack of Troy, 440s BC.

This scene has to be read with the metope next to it, and together they tell a story clearly shown on a contemporary vase: Menelaos approaches Helen with his sword drawn, intending to kill her, but at the sight of his unfaithful wife he is overcome with desire and drops his sword.

prostyle porches at either end of the cella rather than deep porches with columns *in antis* as at Olympia (compare **94** with **102**). There were sculptural consequences, too, to the architectural decisions: the octastyle arrangement increased the number of metopes, and the shallow porches, by making the cella a constant distance in from the external colonnade all the way round, made possible a frieze that could be viewed in a consistent way from every side.

Visitors to the Akropolis approached the Parthenon from the west, through the Propylaia, an architecturally innovative gateway building constructed immediately after the Parthenon itself. The first sculptures visible to them were those of the west pediment, showing Athena

and Poseidon, which were largely destroyed in a Venetian attempt to remove them. They showed some episode in the battle of the two gods for patronage of Athens, Athena offering the olive and Poseidon the sea, watched by old Athenian heroes. Below the pediment Amazon warriors were to be seen fighting Greeks on the metopes; the condition of surviving fragments is poor, but in the absence of any other indications, and given the Attic setting for the pedimental scene, it is likely that contemporary viewers would have seen here the Amazon invasion of Attica resisted by the hero Theseus. Coming closer to the temple the visitor would glimpse through the colonnade the continuous sculpted frieze, and by moving along and linking up the glimpses caught between the columns would make out young beardless horsemen being marshalled into a procession by bearded elder men. At the south-west corner of the frieze there are figures facing each way, but whether visitors turn on to the south side or walk down the west and round to the north side they find themselves moving with the procession, as the horsemen gather pace and gallop east.

Caught up and carried along in this lively and largely unarmed procession, viewers might nevertheless find themselves somewhat bemused. They were joining triumphant horsemen, but it was the rejection of the horseman *par excellence*, Poseidon, that they had witnessed in the pediment, and the horse-riding Amazons who were the enemy in the metopes. They were joining too a triumphant procession of men, yet it was a woman who had won out with Athene's victory: did the defeat of the aberrant women Amazons count for more than the goddess?

The metopes, and the development of the frieze on the north and south sides, will have done something to resolve these questions. The poorly preserved scenes of the sack of Troy on the north side seem to have presented the viewer first with the victims of war, in the refugee family of Aeneas (North 28), and then with the culprit of war, Helen, seeking sanctuary at the statue of Athena (North 25 [103]). A small winged figure, the figure of Desire (Eros), appearing at Helen's shoulder guarantees that Menelaos, approaching in the next metope, will not use his drawn sword against her (North 24 [104]). On the south side the viewer faced repeated scenes of centaurs carrying off women and battling with Lapiths, once more at the marriage feast of Peirithöos. Much better preserved, these metopes present the two basic episodes in a wide variety of ways. The male body is spread out for admiration, both exultant in victory (South 27 [105]) and limp in death (South 28); the centaur presented successively as lascivious (South 29), full of humane sympathy (South 30 [106]), wearing the most bestial of masks (South 31 [107]), or close to godlike in nobility (South 32). The differences in conception displayed in the centaurs have sometimes been put down to the employment of better and worse, older and

105

Metope from south side of the Parthenon, showing Lapith battling with centaur, 440s BC. There is an element of ballet here, both in the pose of the Lapith and in the way his clothing is made to hang as a backdrop against which his displayed body can better be appreciated. Note the skill with which the Lapith has been carved virtually free of the background.

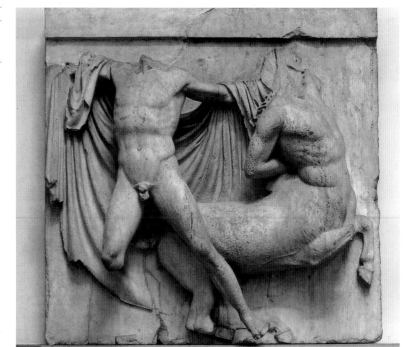

106

Metope from south side of the Parthenon, showing Lapith battling with centaur, 440s BC. Against the triumphant display of drapery in the last plate, the squashed folds of the drapery here convey the crushing of this Lapith by his thoughtful and sympathetic centaur opponent.

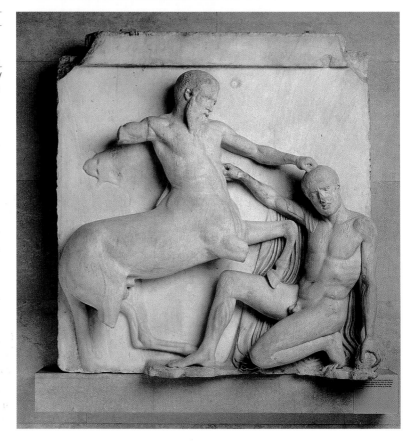

107

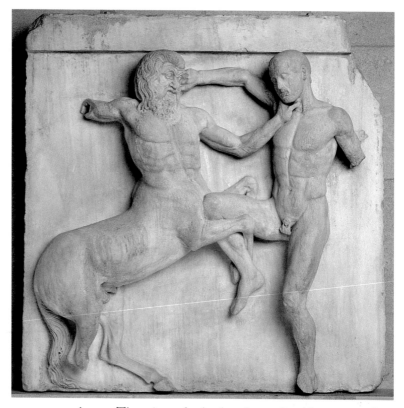

107

Metope from south side of the Parthenon, showing Lapith battling with centaur, 440s BC.

The stiffness to the carving here turns this into a slightly comic battle between two wooden opponents, giving a very different view of the nature of the combat to that seen in the previous illustration.

younger, sculptors. There is no doubt that the quality of execution does indeed vary, and it must be the case that no army of marble sculptors of equivalent size had ever previously been marshalled for a project. But juxtapositions such as those visible in these four easternmost metopes of the south side can hardly have been fortuitous, and the manager of the sculptural programme, whom ancient sources suggest to have been Pheidias, may have deliberately suited his craftsmen to the particular tasks he asked of them.

By comparison with the variety of centaurs, the Lapiths appear almost blandly uniform. Different sculptors are more or less successful in achieving balance or rendering hard muscle but soft flesh, but these beardless yet mature human figures share a head which varies only between calm and strained determination (compare **106** and **107**). This uniformity is exactly paralleled in the developing frieze. As viewers make their way along the south or north sides they watch the young horsemen get the procession organized [**108**], and then move swiftly away [**109**]. The small but spirited horses, their nostrils flaring and veins pulsing, present their riders with different challenges, and the riders meet those challenges in different ways, but whatever the diversity of pose, action, and dress the faces of these young riders are very uniform, serious, their alert eyes well opened, brows slightly wrinkled and mouths just a little downturned at the corners.

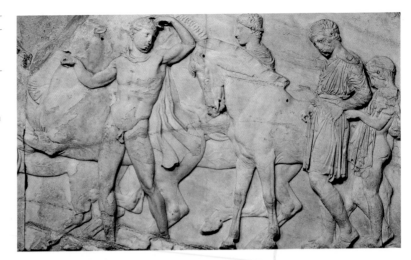

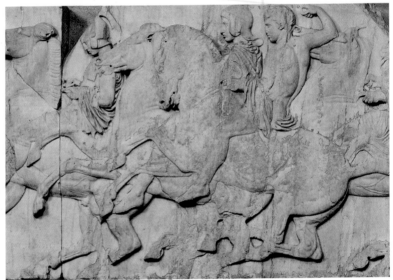

The young men in the Parthenon metopes and frieze are kin not to the Lapiths at Olympia but to Polykleitos' *Doryphoros* [**88**]. Like the out-of-scale horses, they are conventional constructs that offer the viewer not the clues to a story about individuals, like the story of the Olympia east pediment, but rather an image of a world where active young citizens are uniformly beautiful and competent, each of them ready to cope with any circumstance that may come their way. The citizen viewer sees himself here through an improving mirror which takes away not only any beard or bodily deformity but his very individuality.

Towards the east end of the frieze the cavalcade gives way first to chariots, which men armed as hoplites run with and mount, and then to a more stately procession of men with lyres, pipes, water pots, trays, sheep, and cattle, all the accoutrements necessary for a grand sacrifice

110

Panel from east frieze of the Parthenon, showing gods and goddesses, 430s BC.

Temple sculptures traditionally showed gods and heroes, but only on the east side of the Parthenon frieze can figures be definitely identified as gods and perhaps identified as heroes—the heroes from whom the ten Athenian tribes, artificially created at the end of the sixth century, took their names. The quality of carving of the gods seems particularly high.

[102]. The sense that the viewer is approaching a sacrificial scene continues when the corner is turned to the east side, and women are found with jugs and bowls for libations, along with an incense-burner and other uncertain objects and other women who are empty-handed. In front of them come elderly men standing in groups and talking, and in front of them a group of seated male and female figures [110], drawn to a slightly larger scale, who look back at the approaching procession; there are enough distinguishing features here (Demeter's torch, for example) to make it plain that these are gods. There was an established ritual, carried out in conjunction with certain festivals, at which seats and tables were set out for the gods, and here, among these ideal citizens, the gods indeed come down to be present. But what exactly are they attending? Everything has prepared us for a central scene with priestly officials and a sacrificial altar, but instead the scene in which the two halves of the procession unite involves five indeterminant figures, three of them juvenile, two bundles, and a folded piece of cloth [111].

Two main interpretations of this scene have been offered. One, recently preferred, suggests that we have here indeed the sacrifice which we have been led to expect, but that the sacrificial victim is not an animal but the young girl who is handling the folded cloth. That cloth is the cloth in which she will be dressed for the sacrifice. An Athenian myth held that Athens had once been saved from invasion by the sacrifice of the daughters of Erekhtheus, and this story was in the 420s celebrated as the foundation of the cult of Athena on the Akropolis in a tragedy, part of which survives, by Euripides. If it is indeed the preliminaries to that sacrifice that we see on the frieze, then the frieze will

111

Enigmatic central panel from the east frieze of the Parthenon, where young women carrying bundles, and a young man or woman in the act of handing over a folded cloth to a man, attract no attention from the gods around them.

celebrate the central place of the women of Attica in saving their city and establishing the city's rituals. The other interpretation sees in the folded cloth the garment which a group of young girls spent a year weaving while living on the Akropolis, and which was presented to the goddess at the greatest of all Athenian festivals, the Panathenaia. The procession which the viewer has joined will, on this view, be the grand procession at the Panathenaia.

Both these interpretations have to explain why the central action is so indeterminate. Why do we not see Athena being robed in her new garment (after all, a metope [103] shows a statue of Athena)? Why do we not see the daughter of Erekhtheus being slaughtered over the altar? In the latter case we can appeal to a general sensitivity to representing the moment of sacrifice, even of animals. In the former, we must appeal to the situation of the viewers. Viewers who had processed round the temple, following the action of the frieze, found themselves puzzling over this central scene from a position directly in front of the east entrance to the temple. If they lowered their eyes as they contemplated the problem, their gaze was met by the resplendent gold and ivory statue of Athena. That, not the olive-wood statue that was the traditional recipient of the new garment, was the object of *their* procession. This possibility of integrating the scene on the east frieze into the viewers' overall experience of the temple sculptures tells in favour of seeing a Panathenaic procession in the frieze.

That the epiphany of the goddess should be seen as central to the viewer's experience of this east side seems confirmed by the sculptures of the east pediment, which showed the birth of Athena from the head of Zeus. The central part of the pediment is lost and we are unable to compare this birth of Athena with earlier pedimental representations of the theme, but the surrounding gods and goddesses largely survive

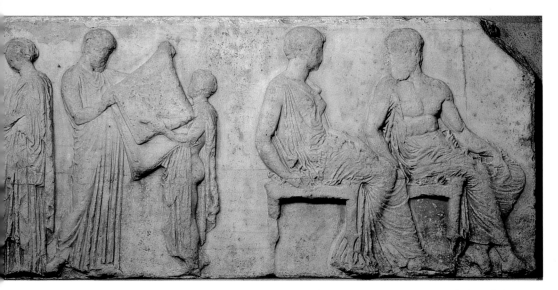

[112, 113], apparently manifesting as little interest in Athena's birth as they do in the central scene on the frieze. These pedimental gods rival in variety of poses the gods of the frieze, but they are modelled in much more demonstrative style. In particular the reclining figure identified as Aphrodite [113] has the forms of her body emphatically moulded by swathes of drapery that encourage sensual delight far more than the naked form of the parallel figure of Dionysos on the other side of the pediment. Although, once more, the stylistic differences between frieze and pediments have been ascribed to the later date of the pediments, the last of the temple sculptures to be cut, we should see the vigorous presentation of the gods here as part of the religious experience of epiphany: it was central to the experience of visiting a place of cult that the gods became more real, more real even than one's fellow citizens.

The Parthenon not only offers more to look at than any earlier temple, it also directs that viewing much more closely. Both the setting of the temple, with its attendant entrance court, and the placing and subject matter of the frieze encourage viewing in a particular order with the various connections that result. This manipulation of the experience of viewing goes together with a manipulation of the image of the citizen. The way they view the procession makes viewers join the procession, and as they become part of it, it (re)forms their view of who processes and why. To object that the frieze fails to show features which we know to have been part of the Panathenaic procession is to miss the active role which the frieze takes on because of the way it is viewed.

The sculptural programme as a whole is both celebratory and tough-minded. Victories over forces from outside—Amazons on the east, centaurs on the south, Trojans on the north, Giants on the east—

Sculptures from the east pediment of the Parthenon, showing gods at the birth of Athena, 430s BC.

From left to right the sculptor seems to have shown: the horses of the sun rising, Dionysos, Demeter and her daughter Persephone (see **122**), and Artemis. Dionysos appears youthful and naked, rather than clothed and bearded as had been traditional: the god manifested as a head on a draped pillar [**81**] here acquires a body.

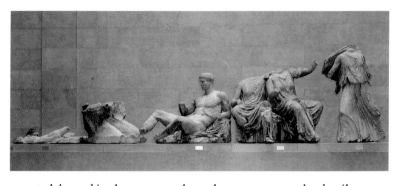

were celebrated in the metopes, but where we can see the detail we can see that the cost of such victories was also explored: we meet the victims from Troy, we find that the Amazons are actually just like Greeks (as they were also on Athena's shield, though often in pot paintings they wear eastern trousers), and we find that centaurs can be humane, feeling and excite sympathy. If there is no glorification of war here, nor is there rejection of violence. By showing the human face of even monstrous enemies, the sculptures assimilate these mythical wars to the interstate warfare that continued to grip the Greek world. In Thucydides' history of the great war the Athenians fought against the Spartans and their allies in the last three decades of the fifth century, war is presented as a violent teacher, but also as the product both of fear and of the possession of power. In concentrating on the course, rather than the causes, of conflict the metopal sculptures encourage concern instead with the efficacity of a fighting machine, in the glamour of which the frieze catches the viewer up.

The violence of representation

Whatever the course of individual conflicts, the success of Greeks is never in question in these sculptures; appropriately the gold and ivory Athena held Victory in her hand. In the course of the decades following the completion of the Parthenon, however, Athens lost as well as won battles. When in the 420s a new small temple of Athena Victory (Athena Nike) was erected at the west end of the Akropolis to replace an even tinier earlier shrine, its sculpted frieze showed battles in progress. The sculpted slabs of the balustrade surrounding this temple were more remarkable in both iconography and style.

On each of the three sides they presented a seated Athena, various winged Victories, some setting up trophies, and a Victory handling a sacrificial ox. At least one of the Victories was shown in the very act of raising the knife to kill the victim, a victim almost certainly shown as male. Both that choice of moment, and the sex of the victim, make this a sacrifice in a military context and not to Athena (goddesses receive female victims). What we see is the sacrifice before battle juxtaposed to the raising of trophies that happened when battle was won. Athena

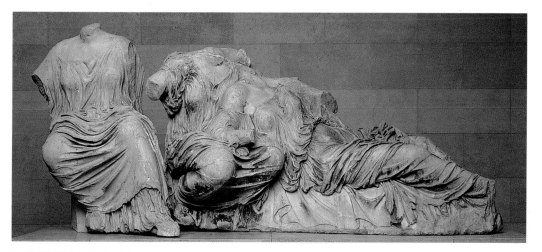

113

Sculptures from the east pediment of the Parthenon, showing gods at the birth of Athena, 430s BC.

Aphrodite reclines against a goddess of uncertain identity, with Hestia, goddess of the hearth, behind. That this representation of the goddess Aphrodite brought out her sexual appeal prepared the viewer to face Pandora, the first woman and made by the gods as a trap for man, whose creation was shown on the base of the cult statue.

here oversees victory which is seen not as a single event but as a state of affairs, where fighting and trophy building are continuous.

The sculptural style is best illustrated by a Victory involved neither in sacrifice nor in trophy building [**114**]. With her abundant drapery slipping from one shoulder and modelling rather than concealing the form beneath, this figure fiddling with her sandal offers comparison to the Aphrodite of the east pediment [**113**]. That the goddess most associated with sexual desire should be herself sensuously desirable is an appealing trope, but why should Victory be so presented? The seductive display of a female body excites men to desire possession, as men also desire to possess victory. As sexual desire itself cannot be constantly maintained, so this female body cannot in fact be possessed, there is no body separate from the drapery that can be revealed; so too Victory is momentary and evanescent and every trophy must be the prelude to further battles.

The game of mimesis that we have seen the Lykaon Painter play [**93**] becomes here intensely serious. The rich invocation of human forms, which in the Riace bronzes [**86, 88**] stimulated desire through the recognition of fellow members of the city community, has been redirected to conjure up a tantalizing community always out of reach, where maturity still wears a boyish complexion, violent assaults can be calmly disposed of, and long-limbed young ladies offer their bodies to the gaze. The art of classical Athens has turned its attention away from the ordinary events of daily life, away even from the everyday fantasies conveyed by the world of satyrs, and fixed the gaze upon a world where all conform to an ideal pattern, where individual expression is suppressed, and where all are equally desirable.

As the war with Sparta progressed some Athenians contemplated the conquest of Carthage and the Athenian Assembly voted to send an enormous force to fight against Syracuse in Sicily for the sake of a tiny and only part-Greek Sicilian city of which they knew little. Ruling

114

Relief sculpture of Nike (Victory) from the balustrade of her temple on the Athenian Akropolis, last quarter of fifth century BC.

Seen by visitors before they even entered the monumental gateway to the Akropolis, the sculptures of the Nike balustrade, with their frank sexual appeal, prepare the way for the place that desire has in the Parthenon sculptures where Eros makes his appearance both on the metopes and on the east frieze [103].

their allies had required the Athenians to regard themselves as different, and they had come to make demands on those allies that demonstrated Athenian power without bringing benefit to either party. Athenian speakers in Thucydides' *History* notoriously treat particular situations by raising general considerations. Lightly to wear an empire demanded that the Athenians disregarded particularities and misrecognized themselves. Such misrecognition is the food of aspirations, but feeds itself on violence. The balustrade sculptures of the Athena Nike temple reveal the violence at the heart of the representation of classical art.

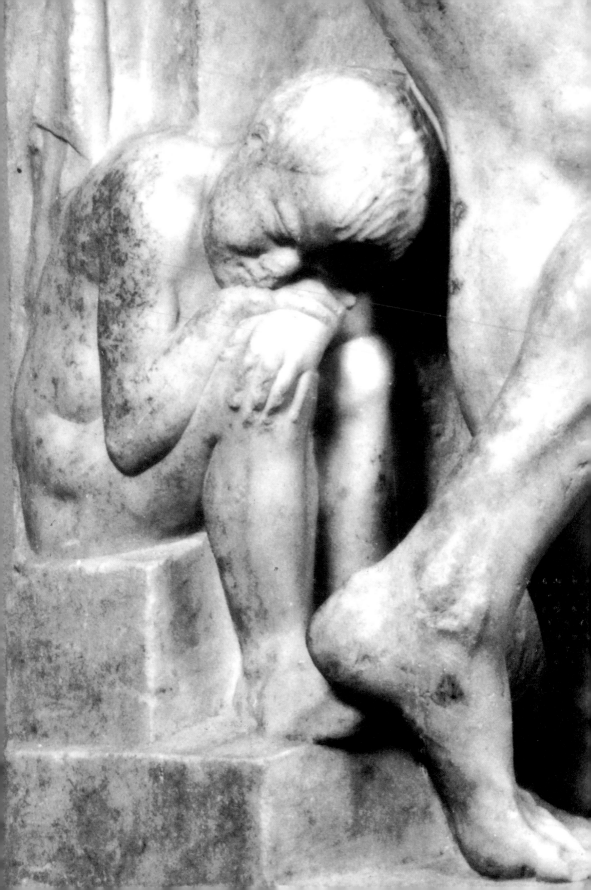

The Claims of the Dead

Grave offerings

The custom of marking graves with monumental pots had died out with the seventh century at Athens, but pots had continued to be deposited in or close to graves. From the end of the sixth century, when the number of surviving graves at Athens suddenly increases massively, one pot shape comes to dominate these grave assemblages: the oil flask or *lekythos*. The *lekythos* seems to have been used to make offerings of oil at tombs, as well as deposited in graves [**115**], but many *lekythoi* were made with a deliberately small oil capacity compared to their large exterior, which suggests that achieving an imposing size (often 20–30 cm.) and large surface for decoration was important.

Although initially conservative, in that they continued to be dominated by black-figure into the fifth century, these *lekythoi* came to be markedly innovative both in technique and in iconography. In technique, the important development was imposing the black-figure not on the red clay ground but on a white ground. This change was only of limited significance while the figures continue to be silhouetted in the black-figure technique; its importance lies in the revolutionary potential that was unleashed once the red-figure technique was applied on the white ground. In iconography, a number of mythical scenes which are related to death appear, some familiar, such as the daughters of Pelias boiling a ram, several of them making a first appearance on Athenian pots, as with the sphinx carrying off a young boy. But there are also other scenes which seem less closely connected to death: satyrs and maenads were common, and an important series of *lekythoi* shows maenads dancing around a mask of Dionysos in some sort of cult activity. Forty years later similar scenes would appear on a group of red-figure *stamnoi*, but the *lekythoi* seem to have pioneered the exploration (if not the accurate representation, satyrs appear in these scenes too) of a particular religious ritual. One *lekythos* takes us into a world of fantasy not previously encountered, showing a scene of flagellation and other forms of torture being applied by satyrs to a woman tied to a tree [**116**].

Black-figure *lekythoi* were exported in considerable numbers, especially to Sicily, but they tend not to be artistically challenging. At least in Athenian contexts, where we can be more sure that those who

Detail of 121

115

Athenian white-ground *lekythos* (oil flask) attributed to the Sabouroff Painter, *c.*450 BC.

Just as *lekythoi* dominate the array of pots placed on the tomb shown here visited by a youth and a woman, so the pot shape most frequently represented in classical tombs was the *lekythos*. The object on the top of the tomb here is a lyre (compare **92**).

purchased the pots got the pictures they wanted, they are most interesting for what their imagery tells us about the sort of world into which the dead were placed. It was a world where anyone's death could be imaged in the battle of Herakles with a monster, Perseus with Medusa, Achilles with Penthesileia, where the fate of every soul was weighed by the gods—it was a world of chariots and *symposia*. Poor graves and rich graves distinguish themselves in that the rich put more of these *lekythoi* into their graves and might add a red-figure vessel or a piece of jewellery, but rich and poor do not employ distinct bodies of imagery.

Early in the fifth century, painters of *lekythoi* began to experiment with using outline drawing (the red-figure technique) alongside, or to replace, the black-figure technique on their white-ground *lekythoi*, and white-ground *lekythoi* so decorated came to dominate the home, though not the export market in these vessels. The new outline drawing on a white ground offered a painterly potential that was only slowly realised, but its adoption had an almost immediate marked effect on iconography.

Outline drawing relates quite differently to a light background than to a dark, most particularly because figures on a light background are set in space as figures on a dark ground are not (see above, pp. 135–8). What is more, use of a light ground makes possible the addition of a full range of colours, not just the rich reds and purples which had been employed by some black-figure artists, but a full range of pinks, creams, yellows, and, in due course, greens and blues. In black- and red-figure, colours had been used for details, in white ground they could be applied extensively as washes, for flesh or drapery. In all, white-ground offered scope to painterly techniques where red-figure was constrained to remain graphic.

Along with the use of outline drawing on a white ground, comes change in the nature of scenes depicted: what black- and red-figure do so well, that is show gesture and action, outline drawing on a white background is much less good at. Use of colour enabled the effective juxtaposition of figures, the white background allowed a sense of action in a space, and the possibility of even ordinary brush lines showing up strongly against the light background gave scope for more varied quality of line and so more directly expressive drawing; but all these were displayed to best advantage not in evoking mythical action but in more contemplative scenes. Black-figure *lekythoi* operated in a world of imagery very close to that of early red-figure; white-ground *lekythoi* turned away from mythical adventures, away from satyrs and maenads, and away from the *symposion*, to show departing warriors [117], ladies with their maids, the dead at their tombs [118], visits to tombs [115], or Hermes or Charon, the ferryman who took the souls of the dead across the Styx, taking the dead to Hades. The dead who were buried with white-ground *lekythoi* were entombed in a world quite different from

Athenian black-figure *lekythos*, from which the 'Beldam Painter' is named. Second quarter of fifth century BC.

This is a unique scene that cannot be associated with any known myth: four satyrs torture a naked woman tied to a highly stylized tree, assailing her with a whip, a hefty stick, and pincers, while a fifth satyr stares directly out of the picture and so implicates the viewer in the scene.

that in which the previous generation, with their black-figure *lekythoi*, had been interred.

It is tempting, but probably an exaggeration, to see the invention of the white-ground technique as responsible for this change in the world of the dead. Figures as fundamental to this new world as Charon, never seen on black-figure *lekythoi*, hardly appear at all before we find them on white-ground *lekythoi*. New artistic techniques do indeed enable new worlds to be seen, but that may be precisely why they are invented. In this case, the gap between the earliest use of outline technique on black-figure *lekythoi*, in the years before the Persian Wars, and the widespread adoption of the technique, along with the new imagery, around 460 BC suggests that the technique had to wait its moment. What is more, the failure of white-ground *lekythoi* to get much beyond Attica and the neighbouring island of Euboia, as black-figure *lekythoi* had done, must mark consumer resistance elsewhere to the new style, and that resistance is likely to relate to imagery as well as to technique.

But if the new technique did not itself give birth to a new world for the dead, it may well have been responsible for spreading new attitudes to the dead and their commemoration. There is no doubt that how the dead were commemorated was an issue in democratic Athens. Quite

Athenian white-ground *lekythos* attributed to the Achilles Painter, third quarter of fifth century BC.

The objects on the wall place us in an interior space into which the helmet and shield mark intrusions. The use of colour brings out a contrast of texture between the softness of the woman's garments and the hard-edged helmet.

[handwritten margin notes: 4b Persian war: limitation to funerary monuments; the point was not to glorify individuals.]

apart from the possibility that limitations were imposed on funerary monuments by legislation shortly before the Persian wars (see above, p. 138), the classical practice of listing the war dead by the 'tribe' to which they belonged and by their personal names, but without use of father's name or name of *deme* (village or ward), indicates a desire to commemorate citizen deaths for the city while not clearly attributing the glory to identifiable individual citizens (one monument records no fewer than three dead citizens of the same name in the same tribe, who are therefore indistinguishable). While not promoting the individual, the imagery of the black-figure *lekythoi* also situates the dead in the world of the élite. But the imagery of white-ground *lekythoi* is not focused on that élite world. Warriors do appear, but it is their departure from their household that we are shown [117]; scenes of ritual at tombs [115] highlight the activities of the mourning family, not of the deceased; to be taken to the underworld by Charon or Hermes is the fate of all the dead, not the privilege of any particular group. The focus has moved from the life lived to the loss that death constitutes and to the state of being dead: little about this new imagery could offend even the most egalitarian of democrats.

[handwritten margin note: Focused on the state of being dead.]

It is important to see not just what the style and imagery of white-ground *lekythoi* avoids doing, but what it particularly promotes. Two aspects deserve emphasis: first, death is no longer monstrous, as the sphinxes and winged demons on archaic monuments had suggested, but is a journey that all undertake, under the benevolent guidance of Hermes and Charon; second, death is primarily a family event. It is the family who are shown bringing offerings to tombs, it is inside the

[handwritten margin note: White-ground promotes: death no longer monstrous; it a journey.]

family home that scenes of 'mistress and maid', or warriors taking leave, are to be situated. This family is caught at a moment in time: women appear with children, emphasizing their maternal role, but there is little sense of the family as a multi-generational unit—by contrast to archaic epitaphs which stress dying young and the relationship between the generation commemorated and the generation putting the monument up. This classical image is not of the patrilineal family as the basis of property, wealth, and power, it is of the affective family, in which women dominate.

The part played by style in this discourse is well illustrated by a large *lekythos* attributed to the Achilles Painter [**117**]. A well-dressed woman sits casually, her arm thrown over the back of her chair and her hand hanging in a relaxed way, as a man, presumably her husband, stands before her, helmet and shield in hand. She gently places her right sandal on top of his right foot, and they contemplate each other in silence. Although the fading of the colours used for the drapery has made the drawing of the body beneath more prominent, the man's genitals and woman's breasts must always have been visible through their clothing: though both heads are in profile both bodies are placed in something

118

Athenian white-ground *lekythos* attributed to 'Group R', a group of artists associated with the so-called Reed Painter, last quarter of fifth century BC.

'Group R' introduces new, and very fragile, colours into white-ground—green and blue. Even when, as here, much of the colour has vanished, the brightness of those hues gives a strong sense of unreality that contrasts with the realism of the face of the main figure.

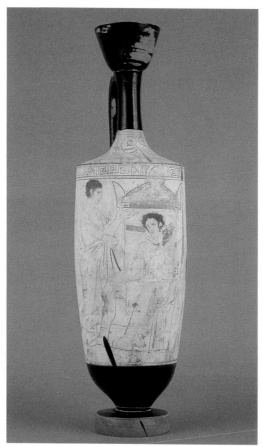

like three-quarter view; they are bodily present, as the curvature of the shield further emphasizes. That bodily presence promotes the sense of intimacy between the figures, and the viewer's sense of looking in on a private scene. At the same time, the too elegant, impassive, profile faces, and the indeterminate age of the figures (if she is his wife she should be fifteen or so years younger than him; if he is her son he should be at least fifteen years younger than her…), stand between these figures and the world of observed reality. Because of the shape of the *lekythos*, only one figure can properly be seen at a time: the viewer has to turn the vessel to recover the full situation. The result of this is to place emphasis not on either individual figure, since both are presented incomplete, but on the relationship between the two. The viewer is encouraged to empathize with the situation, but kept from independent relations with either figure.

The work of the Achilles Painter is marked by effective use of colours, largely ochres, the combination of profile heads with non-profile bodies, an avoidance of direct reference to death (no tombs, no Charon), and a discrimination between the care devoted to expressive details, especially head and hands, and a looser style elsewhere. Few subsequent artists share his aversion to the tomb, and they work with an increasingly rich palette, but in the hands of the finest artists the concentration of affective response on the head is taken still further. Outstanding is the work of 'Group R' as it has come to be called, a group working in the final decade of the century with an artist known, from the vegetation in Charon scenes, as the Reed Painter. A young man sits in front of a tomb, a young woman on one side, carrying his helmet, a young man on the other [118]. The poses here are less perfectly captured than by the Achilles Painter, and the detailed drawing of the bodies does not always bear close examination (look at the right arm of the central figure), but the drawing of the young man's head

Pliny on the achievements of Parrhasios

Parrhasios was born at Ephesos and he made many contributions to art. He was the first to give pictures *symmetria*, the first to render animation in the face, elegance in the hair, wit in the lips, and artists agree that he takes the palm in rendering outlines, which is the most subtle part of painting. For rendering bodies and the mass of things in paint is a mark of great skill, but one in which many have obtained glory, but to render the outline contour of bodies and to make the painted outline capture the vanishing of the real body is rarely successfully achieved in art. For the very contour should go around and give the limit in such a way that it promises other things behind itself and shows even what it hides.

Pliny *Natural Histories* 35.67–8. Parrhasios (see p. 11 and 209), was prominent in Athens at the end of the fifth century. There seems to have been a dispute between Parrhasios and his contemporaries Apollodoros of Athens and Zeuxis of Herakleia as to whether contours were best established by line or by shading.

gazing moodily out of the picture space is quite unlike anything we have seen before, and connections with developments made by the panel-painter Parrhasios have been suggested. The hair is a rich brown mass from which occasional strands escape. The eyes are shown in enormous detail—we see pupil and iris, upper and lower lashes, brows. The mouth is full and serious. As if to set off this detail, the clothing, its original colour now lost, is conveyed with great brio, as a loaded brush energetically conveys both shape and weight. The man at the tomb does not interact with his companions, and we should surely see him as the deceased and them as mourners. Nor can the viewer disturb the heavy reverie of a dashing soldier, gloriously commemorated in a monumental tomb, but dead. For all that this is a figure that takes up space, there is, by contrast with the work of the Achilles Painter, no glorious body. For all the glamour of the handsome face, this is no pin-up. We are left with only moody contemplation.

Putting the dead body in its place

By the time that Group R was at work, the grave monuments which the artists painted on the *lekythoi* closely resembled those being erected in Athenian cemeteries. But at the start of the history of the white-ground *lekythos*, in the 460s BC, private grave monuments seem to have been unknown at Athens, whether they were formally banned or simply informally recognized to be unacceptable (see above, p.138). Scholars debate whether the monuments shown on the early white-ground *lekythoi* were wooden memorials, that have perished leaving no trace, or whether they are simply imaginary. In the latter case their representation on pots may have done something for their rehabilitation, for some time in the third quarter of the fifth century grave *stelai* reappear at Athens.

The new sculpted reliefs share the world of the white-ground *lekythoi*, a world remote from that of archaic funerary reliefs. There are some single figures, but most reliefs show more than one person; there are some indications of athletic and rather more of military connections, but the dominant setting is domestic. Women in fact dominate the classical Athenian tombstones produced in the remainder of the fifth and the fourth century until Demetrius of Phaleron imposed a further ban in 317 BC.

The memorial of Hegeso [119] shows just how similar the grave reliefs can be to the white-ground *lekythoi*. Although it is perhaps forty years later in date than the *lekythos* by the Achilles Painter, it shares both artistic tricks (profile faces but bodies turned towards the three-quarter view; concentration on heads, hands, and foot; serious down-turned mouths) and overall mood, as the well-dressed lady contemplates the contents of the jewellery box which her maid brings to her. But whereas the *lekythoi* often seem to offer a glimpse into a

Grave *stele* of Hegeso, wife
of Proxenos, erected at
Athens in the last quarter
of fifth century BC.

As often, the lower status
of the slave maid is here
conveyed by her simpler
clothing and the covering
up of her hair, which contrasts
strongly with the elaborate
coiffure and generously cut
garment of Hegeso, whose
footstool further emphasizes
that she is a lady of leisure.

private world, here, in a work destined for permanent display in the
public space of the cemetery, not for a single ritual use and then unseen
deposition, the private world is very much brought out to meet the
viewer. In a trope almost universally repeated in funerary monuments
(note the knee of the defeated hoplite in the *stele* of Dexileos [3]), the
chairback and the maid are here made to overlap the architectural
frame of the *stele*, so that the figures are not confined into a space but
place themselves into the space of the viewer as if emerging from the
confinement of the stone slab.

Hegeso's is a reticent monument: we are told only her name and the
name of her husband. Such brevity is normal, although occasionally a

longer epigram indicates something further about the family. It is precisely the contrast between this normal practice of generic commemoration, where individuals are presented as 'the sort of person who...', and the commemoration of Dexileos, which insists even on his particular age, that so marks that monument out to us and must have done so also for contemporaries.

The reticence on display here is both a social and a political reticence. Respectable women were not named in public while alive; if it was necessary to refer to them in the course, for instance, of a law-court speech, then they were referred to by their relationship to some man— wife or daughter of so-and-so. This was part of a general denial of individual rights and agency to women, who were not citizens in any Greek city and in Athens had very limited property rights or legal rights. The style and imagery of the grave reliefs both reflect and reinforce the denial to women of an active role in social or political life. Although later in date than either the pediments of the Parthenon or the balustrade of the temple of Athena Nike, Hegeso and her maid, and most of the female figures on other classical *stelai*, share nothing with the demonstrative women to be seen there; rather, they are presented in a style much closer to that of the Parthenon frieze—admirable certainly and not unattractive but hardly assertive. And as their style does not parade seductive charms, so they engage in no other independent action, and in particular in no action that impinges on the world outside the household.

Despite the absence of an active role for the sculpted women of these grave *stelai*, however, the contrast between archaic Athenian cemeteries, with hardly a woman's form to be seen among the sculptured monuments, and the classical Athenian cemetery, in which women's forms were dominant, suggests that a more positive side to this imagery should be contemplated. After all, repressing images of women might seem to be a more straightforward response to women's repressed status than their display. Why was it that men, who alone held the monetary resources with which to commission these works, thought it a good idea to commemorate wives and mothers in this way?

At about the same time as white-ground *lekythoi*, with their emphasis on the family, became popular the Athenians began to define themselves in a new way. The dogma that Athenians had been 'born from the ground' and had always lived in Attica was stressed, perhaps particularly in speeches made over the war dead, and from 451/450 onwards, in accordance with a law for which Pericles was responsible, to be an Athenian citizen one had to claim not just a citizen father but a mother whose father was Athenian. In the archaic period, at Athens and elsewhere, wealth and status had been the qualities which the élite demanded in a wife, and marriages had frequently been made across political boundaries; now, wealth and status had to come second to

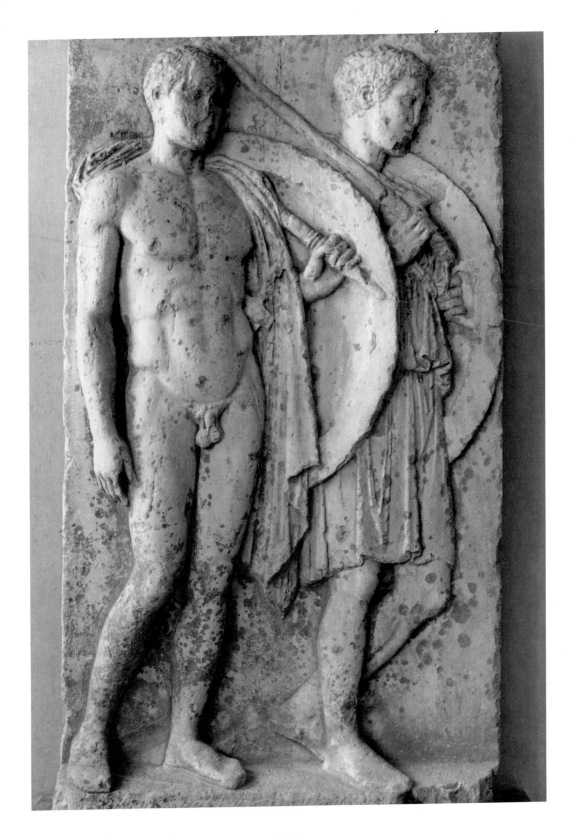

Grave *stele* of Khairedemos
and Lykeas, from the Athenian
island of Salamis, end of fifth
century BC.

By exposing to view the desir-
able body of a sculpted youth,
Khairedemos places himself
and by implication all Athen-
ian hoplites into the ranks
of athletic heroes and of the
naked cavalrymen of the
Parthenon, ideal represen-
tatives of an ideal city.

Athenian birth. Who one's wife was had previously been a personal matter; now, it was a matter of public political interest. For the purposes of legitimating children and making Athenian citizenship open to them the woman had to move out from the private into the public realm. That is precisely the job that sculpted reliefs well perform: whether or not that signal had any wider effect on Athenian society, these *stelai* do signal that women matter.

While the women of classical *stelai* invite comparison with those on white-ground *lekythoi*, the men often refer much more directly to free-standing sculpture. The monument to Khairedemos and Lykeas [120], which is more or less contemporary with that to Hegeso, owes much in the swing of the hips, twist of the body, and gaze over the viewer's shoulder into the distance, to Polykleitos' *Doryphoros* [88]. Though their shields mark them out as hoplites, these two remain as far from the field of war as is the *Doryphoros*. Unlike the soldiers on the Achilles Painter's *lekythoi*, or even those of Group R, these two are taken out of the domestic setting and the companionship of other young people and are presented simply in each other's company. The effect of making them a pair is to defuse any notion of individual heroism, while the effect of removing all signs of civilian life is to obscure affective ties, something that happens all the more because no father's name or *deme* name is given in the inscription. Differentiated by facial hair and consequent clothing, this mature youth and equally young bearded man are left standing for citizens doing their duty. If Hegeso is buried in the domestic setting, Khairedemos and Lykeas are as effectively orphaned of family support.

The monument of Dexileos shows how it was possible to manipulate sculptural language and conventional funerary idioms to create a grand memorial and make a very particular political statement (see above, pp. 15–16). Few other fourth-century monuments strike out on their own in that way, but during the course of the century the colossal funerary monument, less now a relief than an architectural frame for free-standing or near free-standing sculpture, became much more common. It appeared not just in the main cemetery of Athens, always a place worth displaying in, but even in so remote a place as Rhamnous in north-eastern Attica, where only villagers and the garrison of the fort could be impressed. In these later fourth-century monuments individuals are less and less commonly identified by their activities, and it is the inter-relationships between figures that are emphasized, inter-relationships into which, in some cases, viewers too are directly drawn as they are accosted by the gaze of one of the figures.

Perhaps the most powerful of all these monuments is a damaged relief to an unknown man which was found in the bed of the River Ilissos at Athens in 1874 [121]. A massively built, but softly modelled, naked, and beardless man perching on a *stele* or boundary stone, his legs

121

Grave *stele* found in the Ilissos river at Athens, third quarter of fourth century BC.

The massive body of the young man here dwarfs the trim forms of classical youths such as Khairedemos: this is an image of personal power rather than of conformity to the type of citizen, and the impact that this *stele* makes depends on the consciousness that that power has been subdued in death.

interesting

crossed in relaxed manner and a small hunting club hanging from one arm, gazes out at the viewer. Half under his legs, on the base of the *stele*, sits a young boy, arms on knees, face on arms, but open-eyed. On the other side of the young man's legs is a dog which stretches its nose to the ground to sniff around the stick and feet of an elderly cloaked and bearded man whose deep-set eyes stare intently at the young man as he rubs his whiskered mouth with one hand. The despairing misery of the small boy, the deep wonder of the old man, the aimlessness of a dog waiting for someone to put it to work, all these are brilliantly captured. Yet it is the figure of the young man that haunts the viewer, haunts because he is so emphatically present and yet insistently absent: everything, the boy, the dog, even the too-penetrating gaze of the elder, points to his not being there. But there he is, and not just there but with his eyes fixed on the viewer and demanding a response.

If it is the ordinary that funerary *stelai* in general celebrate, this monument makes the ordinary extraordinary. Scholars talk of the old man as the father and the boy as a slave-boy, but the way this composition is set up makes it no more compelling to postulate kinship between the old and young man than between young man and boy, for the old man's gaze is not one of longing or affection but of wonder. Similarly, suggestions that the young man's nudity is 'quasi-heroic' underestimate the effect of the casual pose. The viewer is by no means so

certainly dealing here with unmotivated nakedness, as in the *Doryphoros* or the soldier Khairedemos: if the *stele* against which the young man leans is the boundary stone of a gymnasium his nakedness is immediately naturalized. The soft modelling of this figure, face as well as musculature, remove it from the world of the *Doryphoros* and place it in the observed world. This is in many ways the sculptural equivalent of the Lykaon Painter's Elpenor [93], and as with Elpenor, so with this figure, the shock of coming to terms with the physical absence of a person so physically present is at the heart of the work's power and fascination.

The *stele* from the Ilissos stands out even from other late fourth-century grave monuments, but it does so by employing in a funerary commemoration devices and techniques which sculptors had developed in other contexts and to other ends. To approach the Parthenon frieze through its similarity to the earliest classical grave *stelai* would be to miss the degree to which that whole style was bound up with an intensely state-dominated view of society, albeit one subject to much contemporary debate; to approach the sculptural achievements of the fourth century through this work, which unexpectedly addresses and puts on the spot the individual viewer, is arguably to go immediately to the centre of the fourth-century transformation of classical idealism which will be the subject of the next two chapters.

Art and the afterlife

The tradition explored here, in which the imagery employed in commemorating death focuses on the life lived, the funeral, or at most the journey to the underworld, is undoubtedly the dominant tradition in Athenian art. Even at Athens, however, there are some signs that men might choose to think more about the possibilities of new life after death than about the old life lost. A grave of the mid-fifth century, from Athens or nearby, has yielded a set of three white-ground cups, all by an Athenian painter known as the Sotades Painter; these cups have exceptionally beautiful and delicate scenes that in one case certainly, and in the other two probably, refer to the revival of the dead.

The myths represented on these cups do not enable us to connect the deceased with any known religious cult that believed in rebirth or life after death, but such cults are well known from other evidence. One such cult is that of the Orphics and, although the origins and early history of Orphism are shrouded in mystery, a number of texts, themselves discovered in tombs, have shed some light on Orphic beliefs and practices. Graves in south Italy, Thessaly, and Crete have yielded inscribed gold leaves that prescribe what the deceased must do to join the 'initiated followers of Dionysos', sometimes referring to a judgement before Persephone, the daughter of the goddess Demeter carried off by Hades, and sometimes making clear a belief that the soul of the dead

Nikomakhos painted the Rape of Proserpine [=Persephone]; this picture was in the temple of Minerva on the Capitol at Rome, above the little shrine of Iuventas. Also Victory driving a chariot aloft which the general Plancus [43 BC] put up on the Capitol. Nikomakhos was the first to give Odysseus a hat. He also painted Apollo and Daphne, and the Mother of the Gods sitting on a lion, also the famous maenads with satyrs creeping up on them, and the Scylla which is now in the Temple of Peace at Rome. There was no other artist who worked faster. They say that he was hired by Aristratos the tyrant of Sikyon to paint a monument to the poet Telestes that he was erecting, and that the date by which it was to be finished was specified; Nikomakhos arrived not long before, the tyrant already in the mood to punish him, and completed the commission in a few days with remarkable skill and rapidity.

Pliny, *Natural Histories*, 35.108–10. It may be too much to identify Nikomakhos as the artist of the Vergina *Rape of Persephone* on the strength of this passage, as the excavator of that tomb suggested, but the coincidence of rapid technique and a record of painting Persephone and chariots is notable. This passage is also testimony to the rape of Greek monuments by the Romans extending to painting as well as sculpture.

person would be reborn in some other creature. In the later fourth century one soldier had a commentary on the Orphic story of the origin and genealogy of the gods burned with him in his grave at Derveni in Macedonia, and the fragments not consumed by the flames suggest the development of a critical theology of some sophistication.

Artistic traces of such beliefs are quite hard to find on the Greek mainland. South Italian painted pottery shares the Athenian interest in the representation of graves or of the deceased as they were in life, but also shows scenes of Orpheus and of the underworld, and the much more varied contents of graves there makes it likely that myths not necessarily connected with death, such as the story of the rape of the daughters of Leukippos (see below, p. 207), may have acquired a particular significance through being placed in tombs.

Interest in the fate of the soul in the underworld and belief in life after death should not, however, be thought to have been restricted to a crazy minority. The best artistic evidence for this comes from the recently excavated Macedonian royal cemetery at Vergina. A large painting of Persephone being snatched off by Hades in his chariot covered one side of a small tomb here [**122**]. The painting is done with swift and confident strokes and the three-quarter view of the chariot and horses managed so well as to make the painting leap at the viewer. All is violence, flurry, and emotion, with graphic hand gestures and facial expressions. This is an all too rare glimpse of the skill of fourth-century wall-painters, otherwise known only from later writers, and shows line and colour being employed to create an intense drama. Whoever commissioned this painting for this tomb saw death not as a mere fading out of life, but as a violent struggle and a dramatic new beginning.

122

Wall painting from Tomb II at Vergina, Macedonia, third quarter of the fourth century BC.

Nothing in the painting of pottery, not even the sensitive freedom of line displayed in Group R [**118**], prepares us for the enormous contrast between the handling of paint here and that in the fifth- century Tomb of the Diver [**92**], bringing home how much we have lost with the loss of wall and panel painting. But as **133** shows, quite different styles were also current when this tomb was painted.

Some kind of promise of a better afterlife for initiates was a feature of the Eleusinian Mysteries, which were well established by around 600 BC, and the transmigration of the soul is a doctrine already associated with Pythagoras and the community he founded in south Italy in the second half of the sixth century. But evidence for widespread interest in what happened to the soul after death and for Orphic and Dionysiac mysteries is a feature of the end of the fifth and of the fourth centuries. How far we should see a causal relationship between the interests of these mystery cults and artistic developments is unclear, but, as the next chapter will try to show, fourth-century art develops both an interest in the place of the individual in dramatic narrative, and an interest in the emotional impact of violent events, that employ the skills on show in the Vergina tomb painting in broader and more public contexts.

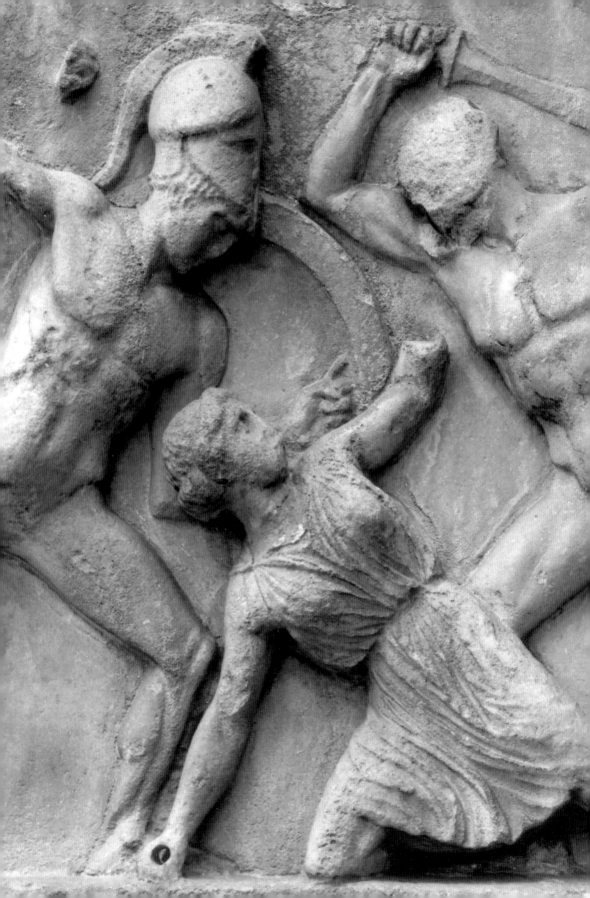

Individuals Within and Without the City

Breaking the classical mould

Whether through conformity or through defiance, artists working at Athens reveal, both in the great public sculptures discussed in chapter 9 and in the private monuments of chapter 10, the constraints of working in an imperialist and self-conscious democratic city. Transplanted to a different context, the same artists produced quite different work. In this chapter I explore the transforming consequences of taking the forms forged in the fifth-century city into the very different social and political situations found outside Athens and around the fringes of the world of the Greek city in the fourth century.

According to Pausanias the small city of Phigaleia in south-west Arkadia in the Peloponnese got in no less a figure than the architect of the Parthenon, a man named Iktinos, to rebuild the temple of Apollo at its out-of-town sanctuary in the mountains at Bassai [**123**]. Built of local dark grey limestone and surrounded by grass rather than bare rock, this temple, with its long and narrow proportions that seem to have been determined by an earlier temple on the site, contrasts strongly with the Parthenon [**102**]. But inside the rather old-fashioned exterior is an interior quite as innovative as the short wide cella of the Athenian temple [**124**].

The interior of the Bassai temple gives the impression of having an Ionic colonnade, but the columns turn out to be but carved wall-ends with widely flaring mouldings at the base and Ionic capitals whose continuous curve is hard to parallel elsewhere. Add to this a carved frieze above this 'colonnade', the (first) Corinthian capital (on the column centrally in front of the main door, but well in front of the back wall of the cella), and the existence of a side door which could let light directly into the cella behind this column, and the disorientation of the temple-goer is complete.

The interior of the Parthenon heightened the impact of the gold and ivory statue of Athena; the nature of the cult statue at Bassai is not

1 Rape of Leukippidai
(6 metopes)

2 Amazonomachy

3 Centauromachy

4 Return of Apollo
(6 metopes)

known, but arguably the atmosphere which the interior creates, with its play of shadow and unexpected light, had a much more dramatic effect on the viewer than the Parthenon's unusually light spaciousness and gleaming wealth, quite independently of any free-standing statue of Apollo there may have been. And what contributed not least to the effect on the viewer were the dramatic scenes spinning around the visitor's head in the frieze that topped the Ionic colonnade. Iktinos had worked closely with Pheidias and his sculptors on the Parthenon, creating a novel space for the sculpted frieze that guided worshippers round that temple and prepared them for the revelation of the great cult statue. At Bassai the architect and sculptors must have worked just as closely together, but here they rather divert than channel the attention of the worshipper who approaches the cult centre.

Externally the Bassai temple had no sculpture, but above the front and rear porches were carved metopes. Earlier temple metopes tended each to show a separate action, or at most to split an action across two metopes, but at both ends of this temple the metopes apparently constituted a single sequence, as if they were indeed a continuous frieze separated by triglyphs. Although preservation is somewhat fragmentary, the metopes at the rear seem to have shown Kastor and Polydeukes running off with the Leukippidai, whose immortal father was Apollo, and those at the front the celebration by dancing women of the spring-bringing return of Apollo from the Hyperboreans of the wintery north (compare **27** above). Aphrodite, who also had a temple in this sanctuary, and Artemis seem also to have been represented in these metopes, along with a figure who might be Arkas, who gave his name to Arkadia. Through these two sets of sculptures the viewer was alerted both to the positive power of Apollo and to the violence which the power of fecundity and fertility might attract.

The continuous interior frieze showed two violent struggles: centaurs attack women [**125**], and Amazons attack men [**126**]. On the metopes, women appear as victims and as part of the world of ritual celebration; on the frieze, they appear both under threat and threatening. Battles with centaurs and Amazons had been represented on the

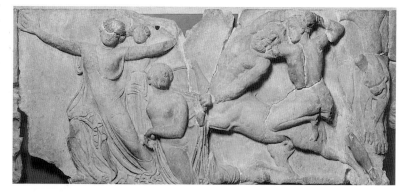

125

Part of the Centauromachy from the frieze of the temple of Apollo at Bassai, *c.*400 BC.

The eye is encouraged to run rapidly along the frieze by the way in which lines are created that run continuously from one figure to another. Here the centaur's body picks up a line that runs from the right foot to the left knee of the Lapith and carries it on through the head of the woman grasping the cult statue to the outspread right arm of the woman on the left.

126

Part of the Amazonomachy from the frieze of the temple of Apollo at Bassai, *c.*400 BC.

Throughout the frieze there is a constant contrasting of surfaces and shapes. Here the hard round form of the shield is set against the straining flesh of the warrior on the right and the taut drapery of the Amazon in the middle, and the flesh of the warrior of the left is contrasted with the crumpled drapery of his Amazon victim.

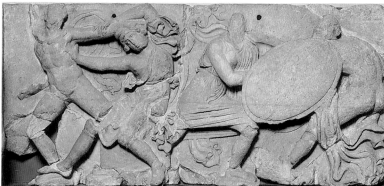

[handwritten margin note: No particular order → no start or end]

Parthenon metopes, and battles with centaurs on the west pediment at Olympia, but showing the combats as part of a continuous frieze dramatically changes the viewer's engagement. The Parthenon metopes had isolated particular encounters, the Olympia pediment had focused attention on a particular moment, but this frieze rolls individual incidents into a continuous and endless play of violence and heroism in which the eye is allowed no rest. That scholars have endlessly debated the order in which the frieze panels were originally placed is not just a product of confusing structural details, it is also a sign that there is no hierarchy of incidents here, no single story with a beginning and end to be told.

The viewer fresh from the Parthenon frieze finds the Bassai frieze shocking. The order which restrains even the most violent of Parthenon horses is here dissolved in flashing diagonal lines; the attractive young flesh of the elegantly poised Parthenon horsemen is replaced by rather short and plump figures whose strainings often do not show them off to advantage (see the figure on the far right of **126**). The drapery of the Parthenon frieze enhances the dignity of the well-turned out citizen; the drapery on this frieze veers between the ugly naturalism that insists on showing the horizontal creases in a garment stretched between the legs of an Amazon (the second figure from the left in **126**), and an ebullient fantasy that has cloaks curl around the heads or feet of figures, filling space in a heroic, but far from life-like, display.

The marked contrasts between the grubby details of life and the idealizing of art both bring out the brutality of warfare and draw attention to the process of representation. When the woman whose clothes are being torn off by a centaur is shown clinging to a cult statue [**125**], the juxtaposition of her sensuous naked body to the formal cult figure brings the artist's selective mimesis to the fore along with the viewer's sympathy. For a modern viewer familiar with Pliny's story of Parrhasios painting a curtain over his picture so convincingly that his fellow artist Zeuxis tried to draw it back, the unveiling of the woman's body here is inevitably an unveiling of the artist's skill. And just as Zeuxis found himself actively engaged in Parrhasios' illusion, so the Bassai frieze involves the viewer.

Pediments and metopes could not be viewed from close to, and nor could the Parthenon frieze, but the distance at which they keep viewers is a product of the way they make them glimpse tableaux or observe actions that pass before their eyes. The Bassai frieze was physically much closer to the viewer, and it does not allow passive spectatorship. Figures stare out from the frieze, accosting the viewer with dramatic gestures. The woman who flings out her arms to come between the viewer and the sculpted cult statue (at the left-hand end of **125**) can stand for the effect of the frieze as a whole: it actively intervenes between the viewers and their worship. The frontal faces of centaurs and their victims, the diagonal glances of Amazons looking out of the picture plane to co-ordinate action, these challenge the viewer to respond. And the way in which the appeals of woman-as-victim are succeeded by the far from helpless signals of woman-as-fighter both require and render problematic a discriminating response.

The Parthenon frieze encourages the viewer to join a group, to claim a part in the worshipping activity of the city, and to rejoice in the

Pliny on Zeuxis and the grapes

Parrhasios is said to have entered into a contest with Zeuxis, and after Zeuxis had exhibited at the theatre grapes painted with such success that birds flew down to the stage, Parrhasios exhibited a curtain painted to represent truth so well that Zeuxis, glorying in the judgement of the birds, demanded that the curtain be drawn back and the picture shown. When he realised his error Zeuxis conceded the prize with honest shame, saying that he had tricked birds, but Parrhasios had tricked him. It is held that later Zeuxis painted a boy carrying grapes, and when the birds flew down to the grapes Zeuxis walked up to the work with the same frankness and said 'I have painted the grapes better than the boy, since if I had perfected the boy the birds should have been afraid of him.'

Pliny, *Natural Histories* 35.65. This is the founding text for the conception of art as mimesis, as the imitation of nature in such a way as to deceive the viewer into thinking that it *is* nature. But the attractions, and for critics like Plato the dangers, of mimesis lie as much with what the artist can *do* with an image so rich in its reference

benevolent presence of an incomparable gold and ivory Athena. The Bassai frieze addresses itself to individuals; the parading of struggling Greek warriors before the eyes is interrupted by the appeals for sympathy and collusion from their opponents, as well as from those they defend, and offers no group with which the viewer can straightforwardly identify. This difference between Parthenon and Bassai may be appropriate to the cults involved: Athena was the main city goddess at Athens and her annual festival was the grandest of the grand series of Athenian religious feasts; Apollo at Bassai was Apollo Epikourios, Apollo the Helper, and although Pausanias was told that this related to Apollo's role in bringing health, the unusual finds of votive armour at the sanctuary suggest that Epikourios might rather refer to a different kind of help, that provided by the *epikouroi* for which Arkadia was famous, mercenary soldiers. The citizen soldiers parading on the Parthenon have their decisions taken for them, they fight as the city; mercenaries are always there because of their own act of will and have to take their own decisions.

But if the individualism of the Bassai frieze was promoted by the cult, and by the remoteness of this sanctuary from the controlling ideology of the democratic city, it was also a response to more purely artistic challenges. To turn back from the Bassai frieze to the Parthenon frieze is to turn from a movie to a still photograph. With the Parthenon frieze every moment is essentially the same, at Bassai a moment has been caught which will pass, the situation will change, lives will have been lost—or saved. The dramatic tension of the east pediment of the temple of Zeus at Olympia, quite absent from the Parthenon, returns here, not in the sense of there being a single crucial moment, but in the sense of life being a succession of chances and choices endlessly demanding decisions.

Facing suffering

Much Greek religious activity was communal. Although coming face-to-face with a divinity was an individual experience, sacrifice was something only carried out by and for a group. Much of the imagery with which worshippers were surrounded in sanctuaries itself placed them in, or faced them with, groups. Sometimes this was explicit, as in the sacrificing groups shown on votive reliefs, sometimes it was implicit, as in the statues celebrating athletic victories that might have been theirs. But not all the blessings for which gods were asked and rewarded were blessings generally desired, in particular the healing of a sickness was specifically personal. Evidence for specialist healing cults increases in the fifth century, and the importation to Athens of the cult of Asklepios, who was to become the most important healing god of all, can be precisely dated to the year 420/419 BC. At much the same date the cult of the hero Amphiaraos, also credited with healing

powers, was developed at the site of Oropos in the borderland between Attica and Boiotia.

Healing cults created a demand for relief sculptures of a new kind. To representations of groups of gods and goddesses, or of worshippers presenting animals to a god for sacrifice, were added representations of the healing encounter between worshipper and god which figured what the dedicator desired to happen, or celebrated what the worshipper believed to have happened. An example from the Amphiaraon at Oropos [127] shows the healing of a wounded shoulder. This is shown both as the moment when the snake of the god visits the patient as he sleeps on a couch in the sanctuary (itself symbolized by the presence of a votive relief just like this one), and as the moment when the god, in human form, dresses the wound. The healing that happened invisibly is here conceived of, and presented as, parallel to what was seen to have occurred in the sanctuary. This relief marks a new artistic departure in the way in which it turns what happened to a particular individual, named in the dedicatory inscription beneath, into a visual narrative: it is the healing of the dedicator, rather than the ability of the god to heal, that is here put on display. Whereas traditional votive reliefs with their sacrificial processions commemorated human service to the gods, this

128

Figure of a dead Amazon from the west pediment of the temple of Asklepios at Epidauros, end of first quarter of fourth century BC.

Dead bodies in earlier sculpture tend to lie prostrate beneath the feet of warriors; here this Amazon is elevated, her death insistently made part of the narrative rather than pushed to the side.

relief turns the tables and puts at the centre a god's service, not just to humanity but to a particular person.

Even when the relief sculpture at a healing sanctuary was not itself artistically innovative in its imagery, as this votive relief is, placing conventional imagery in a new context could have an equally radical effect. The out-of-town sanctuary of Asklepios at Epidauros in the Argolid, which is most famous today for its large and wonderfully preserved theatre, was not a civic sanctuary—the city of Epidauros had a separate civic theatre. Men and women came to the sanctuary of Asklepios not to join in the celebrations of civic pride, or for reasons of state, but to seek or record physical healing. But in choosing once more to make the sack of Troy and a Greek battle against Amazons the subjects of the pedimental sculpture of the temple, built in the 370s, the sanctuary authorities transplanted into a world of personal suffering themes that on the Parthenon had drawn attention to the challenges of imperialism, and the sculptors responded with graphic displays of physical effort and physical pain written on face and body [**128**].

As on the Bassai frieze, so here, it is in capturing body positions previously eschewed that the strong sense of physical presence is conveyed. Dead, this Amazon does not stretch out decorously on the ground, as the victim of a centaur would in the Parthenon metopes; her slack body drapes itself across the back of her horse, her head hangs limp, her arm falls like a plumb line. The viewer feels the weight of this body which stretches taut her clothing across her breast, and in acquiring weight the body loses all sense of death as glorious. The calm face, relaxed in death, signals only loss.

The expressionless face of the Amazon communicates the more powerfully at Epidauros set against the strained and emotive faces of other figures. It is against the invitation that other figures give to enter into their thoughts and passions that the blank face of the dead

Amazon points up what death excludes. The Bassai frieze said it with the physical body, which the Parthenon frieze had silenced while exposing, but at Bassai, as on the Parthenon, only beastly centaurs said it with the face. The architectural sculpture of the fourth-century Peloponnese restored the face to its role in the story.

The recently excavated temple at ancient Skillous (modern Mazi, just across the Alpheios from Olympia) featured a pedimental battle of gods and giants in which giant faces are modelled with an intent plasticity [129] which makes even the Olympia seer seem reticent [97]. The dull dead eyes and smooth skin of the sea-monster's head, which he wears for a helmet, contrast with the intent gaze of the giant who contracts not just his brows but his whole forehead as he engages in battle. No surface is left unmodelled here, as if time and experience have themselves carved this Giant's face.

Such vigorous modelling was only one way of drawing attention to the juncture between physical and mental action. Half a century later the fragments surviving from the sculpted pediments of the temple of Athena Alea at Tegea in eastern Arkadia show faces whose lack of emphasis on particular features serves further to focus attention on the deeply set eyes [130]. The turning of the head of the figure identified as Telephos, whose battle against Achilles was shown on the west pediment, alerts the viewer to the hero's perception of danger; the anxious glance, cool if the head was horizontal, more passionate still if it was

129

Head of a Giant from the pediment of the temple at Mazi in Elis, first quarter of fourth century BC.

Like Phigaleia, ancient Skillous (modern Mazi) was not an important place—we would hardly know of it at all had not the Athenian historian Xenophon settled there in exile. The existence of high-quality architectural sculpture from temples such as this is a measure of the extent to which exploring conflict and personal relations was part of what it was to worship at any Greek temple.

Head of Telephos from the west pediment of the temple of Athena Alea at Tegea, third quarter of fourth century BC. Telephos was the offspring of the rape of Auge, priestess of Athena Alea, by a drunken Herakles. Telephos became King of Mysia and encountered Achilles in battle when the Greek expedition to Troy landed in Mysia in error. Telephos was wounded in the battle, his wound festered, and only much later did he gain healing from Achilles' own spear in return for a promise to guide the Greeks to Troy. Here he wears his father's characteristic lion skin.

tipped back, induces a sense of anticipation. Whereas the anticipation of the Olympia seer acted primarily to indicate the events about to unfold, Telephos' anticipation brings the viewer into direct contact with the demands on the hero to make decisions and face up to danger. To penetrate under the heavy brows is to be forced to empathize with the hero in his struggle.

Telephos had been the central figure of a famous play by Euripides, which was named after him, but although he would feature on that major hellenistic monument the Great Altar at Pergamon, his representation here was novel. One reason for choosing to show him at Tegea was no doubt the local connection: the east pediment of the Alea temple showed the hunt for the Calydonian boar, whose tusks and hide were preserved inside, and Telephos too was linked to the sanctuary, for he was born as a result of the rape of the priestess of Athena Alea by Herakles. But Pausanias' mention of statues of Asklepios and Hygieia (Health) in the sanctuary suggests that the long-festering wound which Telephos received from Achilles may also have been important (the boar-hunt too apparently showed one of the hunters already wounded). If this is correct, then the change of emphasis from fifth-century temple sculptures is marked: not only do we not have the glories of victorious combat emphasized, but the stress will not even lie with the painful necessity of fighting against others who share humaneness, if not humanity: the stress here is on fighting as a source of wounds. The power of this head cannot be divorced from its context.

The architect of the temple of Athena Alea is said by Pausanias to

Kallistratos on Skopas' Maenad

Skopas, moved by as it were some divine inspiration, instilled divine possession into the making of the statue. Why don't I describe to you the way in which his craft is inspired from above? The statue of a Maenad made from Parian marble had been transformed into a real Maenad. The stone, while staying in its natural form, seemed to escape the laws of stone, for what appeared was really an image, but the sculptor's skill had made the representation a representation of real reality. You would see that the stone that was really hard was softened to give the impression of female flesh, achieving a radiance that got the female just right, and stone which had no power to move displayed knowledge of bacchic revelry, and responded to the god entering within it. When we saw the face we stood speechless, so clearly was perception expressed by one who had no perception, the Dionysiac possession of the Maenad was manifest without there being any possession, and all that the soul displays when stung by madness, all the signs of passion, shone out through the sculptor's skill blended with secret reason.

Kallistratos, *Descriptions* 2. The description of works of art became a popular literary genre during the revival of Greek literature in the first three centuries of the current era which has become known as the Second Sophistic. Kallistratos wrote in the third or fourth century AD and his *Descriptions*, inspired by a similar earlier work by Philostratos, describes fourteen statues.

Ivory head from 'Tomb
of Philip' at Vergina, Mace-
donia, third quarter of fourth
century BC.

Occasional ivory pieces sur-
vive from archaic sanctuaries
[24], but although ivory work
clearly remained important
(as for the gold and ivory cult
statues of the Parthenon,
Olympia, and elsewhere) we
have only the most exiguous
remains of the continuing
tradition. This head comes
from a highly decorated couch
and indicates how much high-
class decorative work has
been lost.

have been Skopas of Paros, to whom Pausanias also attributes the
statues of Asklepios and Hygieia which flanked the image of Athena.
Skopas is much celebrated as a sculptor in ancient writings on art,
which list a number of works by him, almost all of them figures of di-
vinities. None of those figures survive and even the longest description,
of a statue of a maenad, gives little indication of how it was that the
sculptor managed to 'escape the laws of stone' which it celebrates. But
it is not unreasonable to think that the impression of divine possession
which Skopas gave to his maenad might have relied upon an invitation
to the viewer to enter into the mind of the sculpted figure in a way sim-
ilar to that offered by the Telephos figure. Whether or not the hand of
Skopas was responsible for the surviving fragments, they offer the
most direct access we have to the style of one of the sculptural masters
of the fourth century.

 We have no information at all on the sculptor of the ivory head
[131] found in the so-called 'Tomb of Philip' at Vergina in Macedonia
(see above, p. 202). It is one of fourteen ivory heads which seem to have
been part of the sumptuous relief decoration of a couch which was
placed in the tomb. In the absence of any further information it is not
possible to tell whether the heads represented mythological figures or

historical or contemporary figures, although the excavator was so struck by the strongly marked character of the figures and resemblance of some of them to other representations of the Macedonian royal family as to dub three of the heads 'Philip', 'Alexander', and 'Olympias'.

The head illustrated here shows well the intensity and individuality of the expressions on these figures. The furrowed brow, deep-set eyes, upward gaze, slightly parted mouth, and drawn chin work together to suggest a figure in physical and emotional distress. This is further heightened when this head is compared with others that fix their gaze sternly ahead, or tilt head and eyes gently downwards in pensive concentration. On all the heads the sculptor exploits the variety of textures which ivory can suggest, contrasting soft smoothness of young flesh with the oily thinness of old skin, and, especially around the eye-sockets, the craggy structure of the skull close beneath the surface.

Comparing the Telephos head from the pediment at Tegea with this head from a couch at Vergina reveals the range of works of art in which a passionate interest in individuals' reactions to their circumstances was displayed. Where in the fifth century monumental sculptures and cheap painted pottery alike focused attention on shared human capacity to come to terms with circumstances and unite against common threats, and showed in an individual's actions and decisions simply the mirror of the decisions and actions of all, these fourth-century works refuse to subsume the particular to the general, encouraging viewers to put on the shoes of the figure represented, not with a view to enhancing their sense of shared experience but to come to terms with the varieties of pressures different individuals have to cope with.

The constant tension between the interests of the individual and those of the group to which the individual belongs provided subject-matter for the *Iliad's* exploration of the wrath of Achilles and equally for the speeches put in the mouth of Perikles by the historian Thucydides in his account of the war between Athens and Sparta (431–404 BC). At no time can Greek cities have failed to be conscious of the difficulty of maintaining the fiction of the common good in the face of the diversity of needs and desires among their inhabitants. The sculptures of the Parthenon maintained a fiction that Greeks, whether fighting centaurs or taking part in the procession of the frieze, were unchanging, while centaurs were various. The Vergina couch reliefs and the Tegea pediments alike acknowledged that this was indeed a fiction: communities had to be built by coming to terms with difference, not by ignoring it. Both for the federation of Arkadian cities, to which Tegea belonged in the 360s, and for Philip's Macedon, rift by regional tensions that would in the end lead to his assassination, how that difference could be faced was an open problem. Telephos' wound was healed only by the man and weapon that caused it.

Life stories

Although outside the confining ideology of democratic Athens, the space offered by the temples at Bassai, Mazi, Epidauros, and Tegea remained a space that belonged to a community, and the language in which the sculptured bodies communicated remained a civic language, for all that it was used to analyse individual experience. But the Vergina couch belongs to a different space, the space devoted to a great individual. The Greek city had never before known such spaces: even in the archaic period with its traditions of rule by 'tyrants', individuals who arrogated political power to themselves in defiance of constitutional norms, the spaces of the city had remained community spaces. In the fourth century, and particularly on the fringes of the Greek world, the big man came to impress himself upon the Greek state in a monumental way.

The paradigmatic 'big man' monument is that begun by and devoted to Mausolos at Halikarnassos, from which all subsequent mausolea take their name. Over 40 m. high, on a base 30 by 36 m., the Mausoleion consisted of a podium, surmounted by an Ionic colonnade and a stepped pyramid. It was begun during Mausolos' life to be his tomb, and perhaps a shrine to him as hero. The podium was ringed with a huge quantity of free-standing and relief sculpture at various levels, portrait statues were placed in the colonnade, and the whole was topped by a chariot group. Ancient accounts claim that all the best-known fourth-century sculptors worked alongside Mausolos' court sculptor Satyros on the monument—Skopas, Bryaxis, Leochares, Praxiteles, and Timotheos.

A considerable amount, though not a large proportion, of the sculpture from the Mausoleion survives, most of it in the British Museum, and scholars have spent much time and effort attempting to divide the most substantial element remaining, the Amazon frieze, between the sculptors who are supposed to have worked on the monument. There is certainly wide variation in style and quality among what survives: unbridled ferocity and classical impassivity are found side by side, as are quite different approaches to male anatomy and female dress. The use of thrusting diagonals to create a fast-moving composition, seen at Bassai, is on display here in a more extreme form, with the figures rather more spread out and the lines further emphasized by use of very high relief. Where Bassai, though itself unusually adventurous in its poses, used repeated motifs to link Centauromachy and Amazonomachy, here, where the Amazonomachy is the only subject, there is an enormous range of poses, and some very unlikely scenes, such as an Amazon sitting backwards on a leaping horse shooting at the Greek warriors behind, are carried off with great panache.

The strengths of the frieze can be seen in a panel from the south side [132]. To the left is a strongly focused composition: two warriors, one

132

Panel from the Amazon frieze on the south side of the Mausoleion at Halikarnassos, middle of fourth century BC. The division of the frieze into separate episodes makes it possible for distant viewers to appreciate what is going on without having to keep their eyes constantly on the frieze as they move round the monument.

with his sword raised to slash, close in on a fallen Amazon who looks towards her principal assailant, with appeal for mercy in her deeply cut eye. The way in which the line of her body is continued in the raised arm of the warrior on the left and paralleled by the line of the body of the warrior on the right, while the line of her right leg is continued by the powerful thigh of the warrior to the right and paralleled by the line of her own arms and by the body of the warrior on the left, serves to pin her figure down relentlessly. To the right of the panel another Greek warrior, his cloak spraying over his shoulder to balance the curve of his shield before him, pulls an Amazon from her rather stiffly carved horse. The warrior's right arm, thrust across a frontal body that is braced by his straight left leg, gives the impression of great power. Earlier sculpted battles against Amazons often showed Greek warriors bareheaded; here the thrust-back helmet is regular, turning every warrior into the likeness of an Athenian General portrait (see below, p. 222), of the type best known from the bust of Perikles.

The Amazon frieze was only 60 cm. high, and was 30 m. or more up on the monument, so it is unclear how much detail would have been visible. Transported to Halikarnassos, and to the monument of a Hellenized, rather than a Greek, ruler, who held power under Persian oversight and whose wife played an unusually prominent political role, the battle between Amazons and Greeks acquires a *frisson* which it lacked on mainland Greek temples. The energy with which the composition imbues the figures, and the passion displayed by the violence of the action and the details of features, combine to turn this conventional subject into a life history of encounters with hostile others, of obligations which are put on along with the hoplite helmet, of irreducible differences of gender as men and women both must, and yet can never, fight on the same ground.

If we are to see in the Amazon frieze of the Mausoleion not just a mythological reflection of the heroic greatness of Mausolos but the image of the life story of the ruler of Hellenized Caria, the painted frieze on the outside of the so-called 'Tomb of Philip' at Vergina can be seen to represent the life of the Macedonian ruler in a more straight-forward way [133]. This frieze shows young men, on foot and on horseback, hunting animals during winter in a wood. Hunting was surely a common pursuit in well-wooded Macedonia, but this is no ordinary hunt. Four different animals are the victims of this hunt: to the left a deer, in the centre a boar and a lion, and to the right a bear. Four different sets of men are hunting: men completely naked, men on horseback wearing belted *khitons*, men wearing a cloak and the Macedonian hat known as the *kausia*, and a man with *khiton*, cloak, and *kausia*. Everyday and exotic animals are mixed here, with men on every grade of the social hierarchy. This is the setting for a life that appropriates myth. Ancient literary sources tell us that it was the Macedonian custom that until he had killed an enemy a man had to use for a belt the band pipe-players used to help lip-control, that a man reclined at feasts only after he had killed a boar without using nets, and until that time he remained seated. Here that latter achievement seems to be shown as the second grade in a series of manly achievements that justify privileges at feasts, differential clothing, and progression from foot to horseback. The excavator was keen to see in the two mounted figures Philip himself (the sole bearded figure) and Alexander, and the logic of the hierarchy supports this. The frieze presents both the literal stages of promotion through the Macedonian social hierarchy, and an image of the conflict and struggle with human enemies that marked the life of the Macedonian upper class. If the views on the after-life which are implied by the scene of the rape of Persephone from another Vergina tomb [122] were widely shared, then this scene may deliberately have been placed on the exterior of the tomb: the struggles of life shown here are left behind by the deceased, whose life after death was marked by struggles of a new sort.

Although the condition of the frieze leaves much to be desired, it represents an important monument in the poorly preserved history of large-scale painting in Greece. It shows how much there was in

common between sculpture and wall-painting, as in the variety of poses and the darting diagonals of the composition. But it also shows a sense of space and recession, and a use of landscape elements, which is paralleled neither in surviving sculpture nor on painted pottery. Where the Mausoleion frieze presents figures against a wall, here there is no wall, and the figures, particularly the horses, move in and out of the picture plane as well as across it (compare **122**). The Mausoleion frieze continued the old practice of colouring its background brightly (in ultramarine); this painting makes full use of the possibility of a light background against which trees, nearby rocks, and distant hills are more or less faintly outlined. Neither surviving remains of earlier paintings nor literary descriptions give us cause to believe them to have achieved so effective a landscape setting. It is perhaps not entirely fanciful to see the integration of figures into a landscape here as the artistic reflection of the way in which myth and life interpenetrated at the Macedonian court where myths were not just good to think with, as in Mausolos' Caria, but paradigms that were actually lived through—and not least, with momentous results, by Alexander the Great himself. Hellenistic rulers would take further these possibilities for promoting themselves in the divine and mythological personages they chose to have represented on their monuments.

Portraits and power

When a *kouros* or a sculptural relief was placed on a sixth-century BC grave, there can be no doubt that it stood in some sense for the individual whose grave was marked. The *stele* of the old man and his dog [**66**] associated the man whose grave it marked with a specific situation in life, but while we can reasonably expect that the deceased was indeed elderly, just how closely the old man of the *stele* physically resembled the appearance of the occupant of the grave when alive, is another question, which we are in no position to answer. The old man does not belong to a much repeated 'type', in the way that the *kouros* does, but that does not mean that it was desire to imitate the forms of the individual man that determined the way in which he was commemorated.

Physical features may convey a propositional content which does not depend upon their imitating, or their being recognized as imitating, the peculiar selection of traits by which an individual is recognized. The age of the seer on the east pediment of the temple of Zeus at Olympia [**97**], or the youth and uniformity of the horsemen on the Parthenon frieze [**109**], exploit established associations so as to suggest to the viewer ways of relating the particular figure to the rest of the scene shown. To find in such sculpted figures identifiable individuals, carrying their own histories with them, would be to bring in associations which would complicate interpretation of the scene as a whole, and might indeed undermine the scene's coherence.

134

Obverse of a silver *stater* of Metapontion, 330–300 BC. The southern Italian city of Metapontion here adopts as an image of the city's legendary founder Leukippos the type of helmeted head used at Athens in commemorative portraits of generals. By the use of this type the city advertises the value that the civic community puts on heroism in the hoplite ranks.

Bringing in too much of an individual's history may be problematic even when it is a specific individual who is being commemorated. Grave monuments serve not just to remind those who have known a person whose acquaintance they have lost but also to draw sympathy from those who have not known the dead man or woman at all, and it is vital that they bring out what the deceased shares with the viewer and do not set him or her apart. So, too, when cities erect statues in honour of individuals who have distinguished themselves in public service, they may explicitly note that they do so in order to encourage others to serve equally well: it is that they have well fulfilled a public role, not their personal idiosyncrasies, that is commemorated. So it is that at Athens statues erected to celebrate the achievements of generals took very much the same form, best known from examples labelled 'Perikles', regardless of the general commemorated [134].

Such conventions were enabling rather than restrictive. Similar features appear on similar commemorations because it is through comparable features that the claim to comparable achievements is conveyed. But there could indeed be a variety of different ways of saying distinct things. Lucian, writing in the second century AD, describes a statue of the Corinthian general Pellichos, made in the fourth century BC by the Athenian sculptor Demetrios, as 'the one with a pot-belly, a bald head, half exposed by the hang of his garment, with some of the hairs of his beard blown by the wind, and with his veins showing clearly, just like the man himself'. Despite the last claim, we should recognize the influence of the traditional descriptions of Odysseus, whose bandy-legged appearance belies his heroic strength and skill as far back as the Homeric poems, as well as the influence of the appearance of Pellichos himself, on this manner of representation.

The greater interest in the experience and role of the individual that is visible in later fifth- and fourth-century sculpture involved also a greater interest in the varied appearance of men and women. Already in the fifth century sculptures had been made representing famous men of the past, men such as the poet Anakreon, and in the fourth century such posthumous representations seem to have been increasingly popular. Statues of the tragedians Aeschylus, Sophokles and Euripides were erected by the Athenians in the 340s, and a very different portrait type was developed for Sokrates [142]. Some of these posthumous portraits, such as those of Sokrates, may have borne some resemblance to the appearance of the individual portayed, but in general these statues were more concerned with the *sort* of person these giants of the past were than with recording exactly what they looked like.

Although the best-known ancient work on physiognomics (falsely attributed to Aristotle) dates to the 3rd century BC, there was already a lively interest in the relationship between physical and psychical features in the fourth century. Certainly the exploration of character

135

Jasper gem signed by Dexamenos, last quarter of fifth century BC.

Although the iconography of gems frequently reflects that of sculpture and painting, there are also occasional items which take advantage of the small scale of a gem, and the closeness with which it can be examined

136 and 137

Obverses of tetradrachms of Ptolemy I of Egypt (323–305 BC) and Lysimakhos of Thrace (306–281 BC).

Several of the associates of Alexander the Great who divided up between them on his death the empire that he had created made play with their connections with Alexander by putting his portrait head on their coins. The portrait type lying behind these two coins, minted far apart, is recognizably the same—the type created by Lysippos. In both cases Alexander displays the horns associating him with the God Ammon, and on Ptolemy's coin he wears an elephant scalp.

visible in fourth-century sculpture, even when represented only in later copies, seems in some cases to have involved considerable physiognomic detail. A head on a gem of around 400 BC illustrates this well [**135**]. Signed by one Dexamenos, and not identified with any particular individual, this gem displays a sharpness of detail, particularly around the eye, and a keenness of feature that encourage the viewer to attribute to the possessor of such a head a similarly acute perception. The careful moulding of this head so as to contrast the hard forehead with the soft cheeks, the fleshy nose with the gristly ear, marks it out from the numerous heads on contemporary coins which, whether they stand for deities or personifications, tend to the bland or generalized (compare **134**).

If more or less detailed representation of the appearance of others was a way of understanding them, projecting an image of oneself was a way of encouraging a particular perception of who one was and what one was about. Although later tradition tells of Pheidias including likenesses of both himself and Perikles in the Amazonomachy on the shield of the Athena Parthenos, we have no good contemporary evidence for such deliberate projection until Alexander the Great. Alexander's father, Philip II of Macedon, was perhaps the earliest individual within the Greek cultural orbit to possess the personal power to be in a position to project his own image in this way, but although, like his son, he founded cities which bore his own name, he did not put his own portrait head on his coins, and it is not clear whether any portrait statue of him was made before his death.

Alexander seems to have been acutely aware of the importance of his image, in life as well as in portraits. His decision to retain the beardlessness of the age at which he assumed the Macedonian throne must have been consciously taken. It is youthful vigour which lies at the heart of surviving portraits [**136, 137**], and the literary tradition holds that Alexander bestowed his approval in particular on Lysippos' portrayal of him with face turned gently upwards and a liquid gaze in the eyes. This image fits in with nothing in the pre-existing portrait tradition, and has to be understood rather in the context of the creation of personas for mythological figures, such as we have seen in Skopas' pediment at Tegea. Rather than see the ivory heads from the Vergina tomb as themselves portraits, we should probably recognize in them the model on which the new type of portrait promoted by Alexander was developed. Alexander did not fit into the mould of the classical city, and just as in life he confused myth and reality in his emulation of the god Dionysos and of heroes such as Herakles and Perseus, and in his own aspirations to divinity, so in his image he took over the features developed to represent myth. In art as in politics, with Alexander the mould of the classical city had well and truly been broken: the individual could no longer be contained within the city.

The Sensation of Art

12

The story of archaic and classical art told in this book ends in a conventional place, with Alexander the Great. Like most conventions, this one has an element of the arbitrary. Many of the themes and trends which have been noted in this book could be traced on into the art of Hellenistic, and indeed of Roman, Greece. But the third quarter of the fourth century BC does see both ends and beginnings.

Greek city states continued, for centuries after Macedonian and even after Roman conquest, to run themselves through the structures developed in the sixth and fifth centuries. But the independence which marked at least the larger classical cities had been lost: cities continued to determine their own festal life and run their own amenities, but they no longer made wars and treaties by a single decision of their sovereign assembly of citizens. The citizens themselves no longer fought, if they fought at all, in a citizen body and for the land which they owned and farmed. Both the economic structures and the social relations within cities slowly transformed themselves, and however democratic city institutions remained the cities became effectively plutocracies whose territories, once teeming with small independent farmers, increasingly provided country estates for the affluent few.

Removing from the city the determination of its own future removed also preoccupation with war and relations with others. The great sculptural projects of fifth-century Athens, or even of Bassai, became literally unthinkable. And when the erosion of vital decision-making from citizen meetings reduced political participation from a way of life to a rich man's hobby, how individuals presented themselves in relation to fellow citizens and to others outside the citizen body ceased to be a consuming interest. Alexander's was only the first 'face of power', and within a decade of Alexander's death Athens had seen the last face that was simply the face of a citizen, for the Macedonian overlord at Athens banned sculpted funerary monuments; henceforth there were portrait sculptures in plenty ascribing individuals to particular roles, but 'citizen' ceased to be a role itself deserving of memorial.

It is a mistake, however, to see what happens to art at the end of the fourth century purely in terms of loss. As the last chapter tried to suggest, the institutions and ideology of the city state could be powerfully

Detail of 138

constraining, most of all in a city as rigorously democratic as classical Athens. The undermining of democratic confidence in the fourth century, brought about both by military failure and by the critiques of those who either theorized or practised alternative forms of government, increased the space in which artists could operate and opened the way to thinking differently both about individuals and about power relations.

In the last chapter I described how both action and passion were differently explored in the fourth century, and emphasized the ways in which the viewer is made more strongly to empathize with the sculpted figure. In this chapter I look at the ways in which viewers were made to accept the sculpted figure as part of their own world, and at the transformation that this brought about for the status of the artist.

Body language

In many ways the bronze recovered from the sea off the island of Antikythera in 1900 [**138**] is a highly conventional, and not particularly distinguished, piece. The pose of the body and legs, and the treatment of the musculature owe much to the tradition reinforced by Polykleitos' *Doryphoros* [**88**]. Two features mark this statue out as a product of the third quarter of the fourth century: the head, and the raised arm.

Much about the head would not have caused surprise to a fifth-century viewer: the features are impassive, the modelling undramatic, the hair quite regular although unusually aggressive. But the deep-set eyes and slight swelling and furrowing of the brow take us into the expressive world of fourth-century sculpture discussed in the last chapter: they make the young man's gaze puzzled, rather than just gently wistful; whereas the *Doryphoros* looks on at action elsewhere with merely a hint of interest, the Antikythera figure personally engages with the world in which he is situated.

The raised arm is still more revolutionary. Use of bronze had enabled sculptors ever since the second quarter of the fifth century to break out of the confines of the stone block within which archaic *kouroi* had been carved. But even works with extravagantly spread arms had continued to present themselves to a particular view. The extended arm of the Antikythera bronze renders all viewpoints unstable by ensuring that either arm or body are seen in seriously foreshortened view. The viewer has to move round this statue in order to get to grips with it in three dimensions. In compelling the viewer to move this statue places itself roundly in the viewer's own space: no longer can it adequately be seen behind glass, as in a showcase; viewers have to accept it into the world in which they themselves move.

The destabilizing arm works on its own to bond viewer and sculpture; indeed it was taken up and used on its own, to even more dramatic effect, by the sculptor Lysippos, particularly in the Apoxyomenos, his

statue of a man scraping himself with a *strigil* after exercise, a work now known only from copies. But in the Antikythera bronze the hand was not extended gratuitously. Scholars once speculated that the figure was throwing, or had just thrown, a ball, but the arm is not sufficiently extended to have thrown, nor sufficiently in action to be throwing; rather it must be holding something, and the most attractive suggestion is that this is Perseus holding the head of Medusa. The addition of the petrifying gaze of the Gorgon not only increases the instability of the extended arm, but introduces a narrative into the movement around the statue which that instability encourages. The viewer is encouraged not to observe Perseus in action, but both to move round behind Perseus to discover who is being turned to stone, and to move into Perseus', and the Gorgon's, line of sight and be petrified. The changing subject position, which the circulating viewer experiences, raises intensely the question of Perseus as a responsible actor: no wonder his brow displays regretful uncertainty.

The involvement of the viewer in the action means that more than just empathy is at stake here. The viewer does not merely feel for the dilemma of a Perseus who has so much power over others, for the viewer oscillates between joining Perseus' gaze and taking part in his turning the object of his sight to stone, between experiencing the frisson of being the object of that gaze, the one who is turned to stone, and observing Perseus inflicting this punishment on another. Able to be co-perpetrator, victim, and story-teller, able indeed to determine what story is told, the viewer's relation with Perseus becomes dialectical, argumentative, rather than merely sympathetic or antipathetic.

The foremost exponent of the body language displayed here was the Athenian Praxiteles, son of the sculptor Kephisodotos. Praxiteles began working in bronze but switched to working in marble. He continued to employ poses developed in work in bronze, but now substituted the capacities of the translucent stone to render softer surfaces and a wider range of textures for the reflective bronze and its tougher skin.

Only one work has survived which we know to have been identified in antiquity as an original by Praxiteles. The traveller Pausanias was told in the second century AD that the statue of Hermes and Dionysos [**139**] which he saw in the temple of Hera at Olympia was by Praxiteles. The work that Pausanias saw was excavated at Olympia in the nineteenth century, but whether it can indeed be attributed to the hand of the fourth-century sculptor is much debated. The techniques employed and the 'aggressively three-dimensional' drapery over the supporting pillar (contrast **140**, **141**) point to a later date, but the arrangement of the figure and at least some features of the head of Hermes conform very well to fourth-century practice in general and to Praxitelean proclivities in particular. Whether we can see here the

139

Marble statue of Hermes with the infant Dionysos, from the sanctuary of Zeus at Olympia. Mid-fourth or third century BC. Although the high degree of polish may not reflect Praxiteles' own practice, this piece gives a good impression of the way in which the diffusion of light by marble can be used to capture the elasticity of flesh and muscle.

traces of the chisel that Praxiteles held, or whether we see, yet again, the copy of a Praxitelean work, or even a work merely inspired by Praxitelean practice, this piece serves well to reveal tropes that we can with some confidence attribute to the master.

Hermes stands, once more, in the pose bequeathed by Polykleitos, with the weight on the right leg and the left heel raised. But Praxiteles gives a slight exaggeration to the swing of the hips, as if Hermes was weighed down by the baby Dionysos, whom he supports on his left arm. Mature, but still youthful, with hair in the marble equivalent of the style featured in the Antikythera bronze, Hermes dangled a bunch of grapes, now missing, before the child, and observed the infant's grasping reaction with an unmoved interest. Although later texts do make Hermes one of those set by Zeus to protect Dionysos from the wrath of Hera, the feeding with grapes does not seem to reflect any famous mythical incident. It is wit, rather than tradition, that surely lies behind this choice of subject: the young god of wine is made to show precocious interest in the fruit of the vine.

This gently amusing conceit acquires considerable depth from the way in which the sculptor executes it. The raised and outstretched

arms, both of Hermes and of Dionysos, serve here again to encourage the viewer to move around the pair, not here so much in order to enter into a relationship with either party as to unpack what their relationship is. Some thirty years earlier, Praxiteles' father Kephisodotos had produced a group in which a female embodiment of Peace supported on her arm an infant figure of Wealth. By swapping Hermes for the conventional female nurse, and by introducing grapes rather than more conventional infant sustenance, the relationship between the older and younger figures in the later group is made very much more complex. By giving Hermes melting features (one of the features scholars sometimes take to indicate a later than fourth-century date), the sculptor produces a tension between the masculine Polykleitan body and the tenderness of gaze associated with the mother, and so signals the issue of gender roles. Wine was man's business, not only in the sense of not being children's business, but also in the sense of not being women's business (see above, pp. 29–30). In being nurtured by a male god, Dionysos is being initiated into a man's world. Hermes takes on the mother's role, but plays it perversely, introducing the child to addiction. Hermes himself was early celebrated as a trickster from birth, responsible for stealing the cattle of Apollo on the evening of the same day on which he was born. Is he tantalizing the baby Dionysos here? Is this a game? Or is it serious?

This group of Hermes and Dionysos has brought strong reactions from modern viewers. Many find it repulsive, too impossibly sweetly sentimental. Such powerful feelings themselves attest to the success of the work: viewers scrutinize the relationship between the pair of gods and pass judgement, they enter into the world that these figures occupy and react as they might were this a pair of real people. If the loss of so much free-standing sculpture of the fifth and fourth centuries leads modern viewers to miss the force of the Polykleitan athletic body and see uncontaminated sentimentality in what is a more quizzical relationship, nevertheless it is the form of the sculpture that makes modern viewers feel themselves put on the spot.

While we know nothing of ancient reactions to the Hermes and Dionysos group, on which Pausanias passes no judgement, we are plentifully informed about ancient reactions to Praxiteles' Aphrodite of Knidos [**140, 141**], although the statue itself survives only in copies. Pliny tells that Praxiteles made two statues of Aphrodite, one clothed and one naked, that the people of Kos chosed the clothed version, the people of Knidos the naked, thereby attracting a lively tourist trade and even an offer from a Hellenistic potentate to wipe out their national debt in return for the statue (they refused). Uniquely, the work attracted also erotic anecdotes: so, according to Pliny, 'They say that one man, seized with love, when he had hidden himself in the night, grasped the statue, and that a spot marks his desire', and a text of

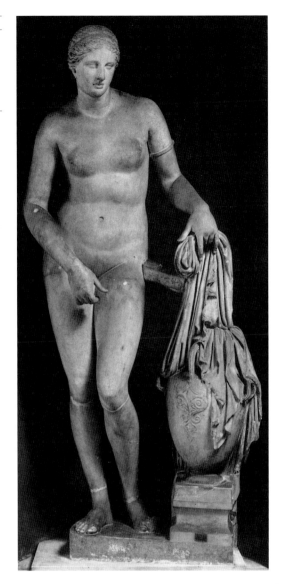

The Aphrodite of Knidos inspired a whole series of other naked or half-naked Aphrodites in Hellenistic art—the 'Capitoline Aphrodite', 'Aphrodite of Melos', 'Crouching Aphrodite', and so on. In these Aphrodite makes more or less strenuous gestures to cover herself, implying that the visitor is more or less expected, but few offer the same choice of narrative positions to the viewer as is offered by Praxiteles' work.

perhaps the third century AD makes a visit to the statue the subject of an imaginary dialogue (see p. 232).

Is it just the nudity of the Aphrodite which excites these accounts? It is certainly true that in representing Aphrodite naked Praxiteles was breaking with conventional practice. But it is also true that earlier sculptors had shown drapery clinging so close to female bodies as to leave little to the imagination (compare **113** and **114**), and discarding clothing might be held to be but a minor development.

Arguably what sets the Aphrodite apart from earlier displays of female erotic charm is the way in which it sets the viewer up. I have suggested earlier (p. 186) that the Nike balustrade exploited the possibility of arousing desire in viewers who were condemned to remain

voyeurs, viewers who could only watch as the desirable body paraded itself before their senses, but for whom even the fiction of a direct relationship with the sculpted figure was ruled out. But the Aphrodite of Knidos is different. Viewers who approach the statue along a line perpendicular to the front of the base [**140**] find themselves voyeurs of a drama which Aphrodite's rather inscrutable expression leaves them to reconstruct: they see a naked goddess, about to bathe or having taken a bath which was filled from the urn over which her clothes remain draped, looking up and to her left and instinctively moving her hand to conceal her private parts. Are they seeing the goddess interrupted, as she prepares to bathe or finishes bathing, by an unexpected third party away to their right? Or was the goddess bathing in anticipation of a desired visitor who now arrives? What is special about this statue is that viewers can change their position of viewing,

Ancient viewers' reactions to Praxiteles' Aphrodite

When we had enjoyed the plants to our fill we entered the temple. The goddess is sited in the middle, a most beautiful artistic work of Parian marble, smiling a little sublimely with her lips parted in a laugh. Her whole beauty is uncovered, she has no clothing cloaking her, and is naked except in as far as with one hand she nonchalantly conceals her crotch. The craftsman's art has been so great as to suit the opposite and unyielding nature of the stone to each of the limbs. Kharikles, indeed, shouted out in a mad and deranged way, 'Happiest of all gods was Ares who was bound for this goddess', and with that he ran up and stretching his neck as far as he could kissed it on its shining lips. But Kallikratidas stood silently, his mind numbed with amazement.

The temple has doors at both ends too, for those who want to see the goddess in detail from the back, in order that no part of her may not be wondered at. So it is easy for men entering at the other door to examine the beautiful form behind. So we decided to see the whole of the goddess and went around to the back of the shrine. Then, when the door was opened by the keeper of the keys, sudden wonder gripped us at the beauty of the woman entrusted to us. Well, the Athenian, when he had looked on quietly for a little, caught sight of the love parts of the goddess, and immediately cried out much more madly than Kharikles, 'Herakles! What a fine rhythm to her back! Great flanks! What a handful to embrace! Look at the way the flesh of the buttocks, beautifully outlined, is arched, not meanly drawn in too close to the bones but not allowed to spread out in excessive fat. No one could express the sweet smile of the shape impressed upon the hips. How precise the rhythm of thigh and calf all the way down to the foot! Such a Ganymede pours nectar sweetly for Zeus in heaven! For I would have received no drink if Hebe had been serving.' As Kallikratidas made this inspired cry, Kharikles was virtually transfixed with amazement, his eyes growing damp with a watering complaint.

Pseudo-Lucian, *Amores* 13–14. This text, preserved among the writings of the second century AD writer Lucian of Samosata, although deliberately 'over the top', indicates the way in which Greek viewers used mythology (Aphrodite's adulterous affair with Ares; the pretty boy Ganymede snatched up by Zeus to serve him on Olympos) as a way of expressing their own feelings. It also shows how this statue could elicit homoerotic as well as heteroerotic passion.

and with it their place in the narrative. They can move to their right to meet the goddess's gaze [**141**], and uncover her genitals, become the unexpected guest or the goddess' desired lover. They can indeed move all round the statue (see p. 232, the Knidians are specifically said to have set it in a round temple), and allow themselves to be tempted into yet other narratives, viewing others being seen by the goddess, or themselves embracing the goddess unseen from behind. Ancient stories of viewers' reactions to the Knidian Aphrodite reveal that this is precisely what they did.

The breakdown of the barrier between the world of the viewer and the world of the statue, which the body language of such mid-fourth-century pieces as the Antikythera bronze enacts, is here given a particular charge by opening up possibilities of an erotic and not merely a discursive relationship. If the Antikythera bronze puts

relationships involving aggression, and the Hermes and Dionysos those involving nurturing under scrutiny, the Knidian Aphrodite similarly prompts examination of the viewer's sexual relationships.

The sensational artist

The Knidian Aphrodite did not only excite fantasies about the behaviour of those who viewed it, it also led to stories about how Praxiteles came to sculpt it. Several epigrams have Aphrodite musing about when it can have been that Praxiteles saw her naked (seeing goddesses naked frequently has disastrous consequences in myth), and other stories claim that Praxiteles took for Aphrodite a real model, his mistress Phryne—part of a cluster of stories maintaining that Praxiteles' works mirror his own experience.

With Praxiteles and his lover the artist ceases to be a wonder-worker possessed of almost miraculous technical skill, and becomes instead the sensational artist of the modern world. Stories about earlier sculptors and painters concentrate on their technical skill or their abilities to imitate the forms of life. Now the artist enters into a relationship with his work, the artist's life and his work become conjoined. Not by chance is it only in the third century BC that the story of Pygmalion, the king who falls in love with a statue, was first told. Nor is it by chance that this viewer-lover becomes, in the hands of Ovid, a sculptor who falls in love with his own creation. It is precisely because statues and live humans now potentially inhabit the same world that it becomes possible for the viewer to form a relationship

Pliny on the achievements of Lysippos

Among Lysippos' works is a statue of a man scraping himself down [the Apoxyomenos] which Marcus Agrippa dedicated in front of his Baths and which the Emperor Tiberius found enormously pleasing. Although Tiberius generally behaved in an orderly fashion at the beginning of his Principate, he was unable to control himself over that statue and had it transferred to his bedroom and another statue substituted in its place. When the stubborn outcry of the Roman populace was so great that there were shouts at the theatre demanding that the Apoxyomenos be replaced, the Emperor, despite his passion for it, put it back.... His [Lysippos'] greatest contribution to the art of sculpture is said to have been the way he carved hair, the reduction in size of the head compared to earlier sculpture, the more graceful and 'drier' bodies, as a result of which his statues seemed taller. Latin has no term for the canon of measurements that he carefully observed, altering the old 'square' statues with a new and previously untried system; he commonly maintained that by other sculptors men were made as they were, by him as they seemed to be. Lysippos' especial skill seems to have lain in the animation of his work, observed in the smallest details.

Pliny, *Natural History* 34.62, 65. In this passage Pliny picks out two features of Lysippos' work that have been central to the argument of this chapter: the way viewers get passionately involved with his statues, and his affirmation that the representation imitates representation not reality.

with a statue and impossible that the statue was not itself the product of some relationship on the part of the sculptor.

The importance of the development described in this chapter cannot be overestimated: we are dealing with nothing less than the invention of the artist. The artist's life has entered into the interpretation of the artist's works, as the works themselves have entered into the viewer's life. Issues of artistic deceit are superseded, for deceit depends on there being a fundamental gulf between an object and its representation such that it is a 'mistake' to treat the representation as one would treat the object represented. The relationship which the viewer forms with Praxiteles' Aphrodite is not a relationship based on mistaking the representation for the represented, it is a relationship with the representation itself.

It is appropriate that this volume should end at this point, for this is the end of the story of an art without artists. As sculptures embrace the space of the viewer, and viewers are inspired to embrace sculptures, analogies between art and language which have been fundamental to the story told here begin to break down. The work of art has ceased to be a text and become a drama, a drama in which the artist too is an important actor.

Looking.
Backwards

The works of art discussed in this book did not merely reflect the world in which they were produced, they did much to create that world. Just as conventional conversational strategies shape our immediate socializing, and literary or cinematic genres both limit and enable expression, so the forms and means of artistic expression developed by painters and sculptors in the Greek world purveyed, and continue to purvey, an intense vision that was and is both enriching and constraining.

The agenda of revolution

The art investigated here explored a limited range of myths that concentrated either on the fight against monsters—sometimes literal monsters, like those fought by such culture heroes as Herakles, sometimes monstrously transgressive humans or humanoids, like the Amazons or Centaurs—or else on the fight against men, where the two parties were, as in the Trojan War, to all intents and purposes identical. We might see these two classes of myth as those on offer in the *Odyssey* and in comedy and satyr plays on the one hand, and in the *Iliad* and in tragedy on the other. Of these two models for understanding how to survive in the world, one suggested that there was no question as to which side a Greek should be fighting on, while the other suggested that there was so little to choose between the parties that, whichever was successful, the basic model of civic life was never under threat. Annihilation was staring you in the face in the first case, loss of honour in the other.

In the archaic Greek world the day-to-day threats came either from other cities or from the gods. Public poetry, whether the martial exhortations of a poet like Tyrtaios writing in Sparta in the seventh century or the epigrams and longer commemorations of the dead composed by Simonides at the beginning of the fifth century, and private poetry, such as Sappho's lyrical explorations of close relationships, both alike played variations on the *Iliadic* mode. Much painted pottery in private use, including Geometric figure scenes, and privately commissioned sculpture explored the essentially alike, most strikingly so in the *kouros*. Temple sculpture and pots made as dedications or placed in or on

Roman copy of a portrait of
Sokrates, after a Greek original
of the first half of the fourth
century BC.

This portrait models the head
of Sokrates on the head of the
satyr Silenos, and so makes
Sokrates almost the type of
man alien to the citizen body;
variants on this type soften the
satyric features and produce
instead a wise citizen.

tombs, on the other hand, concentrated on the *Odysseyan* encounter with the radical otherness of the divine and the supernatural, which were portrayed with powers exceeding the human, powers to petrify or give birth from the head.

The classical Greek world was quite different. With the conquest of Ionia by Lydians and then Persians in the second half of the sixth century and then the Persian invasion of the Greek mainland in 490 and 480–479 BC, the Greek cities really did come face to face with an enemy that was other. The individual monsters, that had served so well to represent the unknowable alienness of the gods, fade out of art in favour of the monstrous hordes of Giants, Centaurs and Amazons. From the end of the sixth century, temple sculptures no longer show moments in which supernatural power is displayed, but show instead sustained clashes between bodies of similarly armed figures more or less radically differentiated from one another by their bodily form. Tragedy repeatedly tests the otherness of military opponents by turning the traditionally indistinguishable Trojans into barbarians, and to similar effect pots and sculpture both play with giving alien figures standard Greek weapons and explore the forms and methods of non-standard patterns of warfare within and outside Greece. The challenge to the viewer is of how to categorize these encounters: are we part of an *Iliad* or of an *Odyssey*?

This changing mode of presentation has distinct political implications. The viewer of archaic art is encouraged to contemplate the solidarity of humanity; the viewer of classical art to contemplate the solidarity of Greeks or even, as in the Parthenon frieze, the solidarity of a particular citizen body. The distinctions which archaic public art exploits are distinctions about which few would dispute: the gaps between man and beast or man and gods can only be breached by supernatural intervention. But the distinctions exploited in classical art, like those exposed on some private monuments of the archaic period, are distinctions always open to question, and depend on boundaries which are more or less arbitrarily drawn.

The development of an art that explores human identity, in the sense of the place of the individual human within a human community, and explores that on the premise that the individual must negotiate his (and to some extent also her) own position, marks out Greek art from much if not all earlier art from the Near East. The revolution which others have detected in the style of Greek art, and described in terms of the imitation of nature, is not a matter of a technical breakthrough in the ability to draw or sculpt but of the development of a new agenda for the artists, an agenda dominated by the negotiation of the position and identity of the individual vis-à-vis fellow citizens and fellow members of human communities. It is that agenda, as well as the artistic style, that has played a profound part in the subsequent history of western art.

ΣΩΚΡΑΤΗΣ

The power of the Greek image

If little western art since the Greeks has been innocent of their influence, classicizing has been consciously adopted in western art on a variety of occasions and for what might be thought of as very disparate purposes. Within the artistic tradition of Rome, the first emperor, Augustus, eager to reconcile a people to the loss of the powers that they had enjoyed under the Republic, promoted art imitative of classical Athens. A similar desire to promote an image of egalitarianism and freedom in the face of a practice that was far different is to be seen in fascist neo-classicism in the twentieth century. But the neo-classicism of the late eighteenth century was, in the hands of artists like David, equally an instrument of republican revolution.

We should not see either of these uses as an abuse. Although there are ways in which much of the art of the ancient Near East is hierarchical and authoritarian, and it is tempting to see classical Greek city states, and particularly democratic Athens, as by contrast producing an art that is egalitarian and liberal, this is too simple a picture. As we have seen, the art of classical Athens can be seen both to encourage a critical approach towards classificatory distinctions and to offer a self-image to the citizen body which promotes self-confident exclusion of others. Indeed the quizzical examination of where boundaries between self and other are drawn is itself founded on a fundamental conviction that self, that is the self of the adult male citizen, really is different, however problematic the operation of that distinction may be in individual cases. Quizzical examination can indeed be seen as a way to avoid radical questioning, and the execution of Sokrates, the man who stressed the problems and contradictions within the values assumed by Athenian democracy, was no more accidental than the exclusion of ugly faces, such as that of Sokrates himself [142], from the Parthenon frieze. Athenian democracy, Athenian imperialism, and Athenian use of slaves are not just linked by chance, and more recent re-use of the idiom of classical Athenian art in the interests of all three is an accurate reflection of this.

Art, like other forms of communication, is a tool. The attractions of a particular artistic idiom lie in what it enables the user to do. Tools designed for one purpose may turn out to be useful for a quite different purpose, and products never previously imagined may be achieved because new tools become available. Greek art, both archaic and classical, but particularly classical, offered tools that could be employed to a variety of ends and was widely imitated in as well as since antiquity. Sometimes, as with the pots imitating Greek ceramic shapes and decoration that were made in Italy from the eighth century onwards, adopting a Greek style was a matter of adopting a style that was commercially successful. Sometimes, and this has been true in more recent times as well as in antiquity, adopting the imagery and style of Greece

was part of a bid to live as a Greek, or at least as Greeks are imagined to have lived. Often Greek forms have been other peoples' exotica, marking out those who have access to them as people of power and influence, in touch with the foreigner and able to communicate, or at least give the impression of communicating, in the foreigner's artistic language.

Much of the attraction of Greek art in antiquity depended upon the commercial success and political power of the Greeks: not by chance is the use of Greek art in the Middle East rather limited before the conquests of Alexander the Great. Those conquests offered the forms of Greek art, particularly the Greek art of the fourth century, as a common standard, in much the same way as they spread the Greek language as a common language. And just as Roman literature shaped itself both in imitation of and in opposition to Greek literature, so in the visual arts oppositional styles developed alongside imitative styles. That imitation and that opposition were not simply a matter of paying artistic homage or forging an independent artistic identity, they involved taking a stand for or against a lifestyle. In further exploring both the imitation and the opposition, the volumes on *Hellenistic and Early Roman Art* and *Imperial Rome and Christian Triumph* in this series will offer an account not just of what artists did, but of what art did, of the ways in which the combat with and over the tradition of the Greeks shaped Roman and then Christian identity.

It is still the Greek tradition over which the visual arts continue to fight. Just as in literature epics (Joyce's *Ulysses*, Walcot's *Homeros*) measure themselves up against the *Iliad* and the *Odyssey* rather than against *Gilgamesh*, so in figurative art phases of Egyptianizing are rare and passing, while the battle with the Greek heritage is constant. The Greek athlete sells men's underwear, the Aphrodite of Knidos sells tabloid newspapers, Achilles and Aias exchange their dice for cards in the work of Cézanne. And this continuing fight with Greek art is not simply a matter of artists struggling with the anxiety of influence. When feminists argue about the pornography of the image and the debasement of women through their representation, the fight is still against Greek art.

The importance of the on-going struggle over Greek art lies not in the continuities of imagery but in the continuities of issue. Greek art is important not for what it represents, but for the way it represents it. This book has tried to show both what was at issue in that representing, what the questions were to which the more or less familiar styles and forms of archaic and classical Greek art were responding, and how the response of figurative art itself enabled or promoted certain attitudes, both political and moral. The story that I have told has been a story which always looked forward, as I endeavoured to understand what was done in the light of what was to come. But I end here looking

backwards, because the study of Greek art is no mere antiquarian matter: understanding the artistic legacy we enjoy from archaic and classical Greece is a prerequisite if we are to understand what is at issue in art today, and indeed tomorrow. If we are to look, if we are to look forward, we need to learn to look backwards.

List of Illustrations

The publishers would like to thank the following individuals and institutions who have kindly given permission to reproduce the illustrations listed below.

1. A life class in the Cast Gallery, Ashmolean Museum, Oxford, 1994. Copyright the Ashmolean Museum, Oxford/photo Dr Donna Kurtz, Beazley Archive.
2. Athenian monument to the war dead of 394/393 BC. National Museum, Athens. (2744)/photo TAP.
3. Grave monument for Dexileos, 394/393 BC. H. (including base) 1.75 m. Kerameikos, Athens (P1130)/photo Hirmer Verlag GmbH, Munich.
4. Red figure cup, attributed to Douris c.500 BC. H. 11.4 cm, diameter 30.8 cm. Vatican Museum/photo Monumenti Musei e Gallerie Pontificie, Vatican City, Rome.
5. Attic red-figure cup, attributed to Epeleios Painter, c.510 BC. Interior. Staatliche Antikensammlungen Und Glyptothek, Munich (2619A)/photo Studio Koppermann.
6. and **7.** Attic red-figure cup, attributed to Epeleios Painter, c.510 BC. Exterior. Staatliche Antikensammlungen Und Glyptothek, Munich (2619A)/photo Studio Koppermann.
8. Argive mare and foal, Olympia, c. 750 BC. Bronze. H. 11.1 cm. National Museum, Athens (6199)/photo Deutsches Archäologisches Institut, Athens.
9. Corinthian stallion, probably from Peloponnese, c.730 BC. Bronze. H. 16 cm. Staatliches Museen, Berlin (31317)/photo © Bildarchiv Preussischer Kulturbesitz, Berlin, 1997.
10. Man fighting a centaur of Lakonian manufacture, c.740 BC. Bronze. H. 11 cm. Metropolitan Museum of Art, New York (17.190.2072).
11. Statuette of a seated figure holding something to his lips, Sanctuary of Artemis Orthia, Sparta, c.700 BC. Bronze. H. 7 cm. Sparta Museum (2155)/photo TAP.

12. Euboian Late Geometric Ovoid *krater*, by Cesnola Painter, Kourion, Cyprus, c.750 BC. H. 115 cm. Metropolitan Museum of Art, New York (74.51.965).
13. Attic Late Geometric I *krater*, by Hirschfeld Painter or his workshop, Athens, c.750 BC. H. 122 cm. Metropolitan Museum of Art, New York (14.130.14).
14. Attic Late Geometric II *oinochoe*, Athens, c.725–710 BC. H. 21.5 cm. Staatliche Antikensammlungen Und Glyptothek, Munich (8696)/photo Studio Koppermann.
15. Late Geometric IIb neck-handled amphora, by the Painter of Athens, c.720–700 BC. H. 48 cm. Department of Classical and Near Eastern Antiquities, Copenhagen National Museum (7029).
16. Athenian Late Geometric gold diadem, Kerameikos, Athens, third quarter of eighth century BC. L. 36 cm. National Museum, Athens (15309)/photo TAP.
17. Attic Late Geometric II *oinochoe*, Kerameikos, Athens, c.725–710 BC. H. 23.4 cm. Department of Classical and Near Eastern Antiquities, Copenhagen National Museum (1628).
18. Cast griffin-head attachment from a bronze tripod-cauldron, Kameiros, Rhodes, c.700–675 BC. H. 32 cm. Copyright © British Museum, London (70.3–1516).
19. Cast griffin-head attachment from a bronze tripod-cauldron, Kameiros, Rhodes, c.700–675 BC. Head-on view. H. 32 cm. Copyright © British Museum, London (70.3–1516).
20. Pointed Aryballos, Protocorinthian perfume jar attributed to the Boston Painter, c.675–650 BC. H. 6.8 cm, diameter 3.8 cm. Courtesy Catharine Page Perkins Fund, Museum of Fine Arts, Boston (95.10).
21. Statuette of Egyptian goddess Mut, Heraion, Samos, c.700 BC. Bronze. H. 17.4 cm. Photo Deutsches Archäologisches Institut, Athens.
22. Statuette of Hera, Heraion, Samos, c.640

BC. Wood. H. 28.7 cm. Photo Deutsches
Archäologisches Institut, Athens.

23. Electrum pendant, Kameiros, Rhodes,
second half of seventh century BC. H. 8 cm
(5.8 cm without pendants). Musée du Louvre,
Paris/photo Réunion des Musées Nationaux.

24. Ivory sphinx, Corinthian sanctuary of
Hera, Perachora, c.650 BC. H. 8 cm. National
Museum, Athens (16519)/photo TAP.

25. Monumental *pithos* found in a funerary
context, Mykonos, c.675 BC. H. 1.34 m.
Mykonos Museum/photo TAP.

26. Amphora from cemetery, Eleusis, Attica,
attributed to the Polyphemos Painter, second
quarter of seventh century BC. H. 1.42 m.
Eleusis Museum, Hellenic Republic, Ministry
of Culture, Athens/photo TAP.

27. Cycladic wide-mouthed vessel (mixing
bowl), Melos, last quarter of seventh century
BC. H. 98 cm National Museum, Athens (911)/
photo TAP.

28. Attic black-figure neck amphora, Dipylon
Cemetery, Athens, name vase of the Nessos
Painter, last quarter of seventh century BC.
H. 1.22 m. National Museum, Athens (1002)/
photo TAP.

29. Reconstruction of the entablature of the
Temple of Apollo, Thermon. After *Antike
Denkmäler* 2, plate 49.2.

30. Fragment of metope, temple of Apollo,
Thermon, c.630 BC. Painted terracotta. H. of
fragment, 44 cm; total H. of metope, 85 cm.
National Museum, Athens (13,410)/photo
TAP.

31. The Gorgon Medusa and her children,
pediment of temple of Artemis, Corcyra
(Corfu), c.600–575 BC. Limestone. H. 3.15 m;
full L. 22.16 m. Corfu Museum/ Photo
German Archaeological Institute, Athens.

32. Figures of Apollo, Artemis, and Leto,
temple of Apollo, Dreros, Crete, c.700 BC.
Beaten bronze. H. (Apollo) 80 cm; H.
(Artemis and Leto) 40 cm. Heraklion
Museum (2445–7)/photo © École Française
d'Athénes.

33. Nikandre's *kore*, Delos, c.650–625 BC. Life-
size, H. 1.75 m. National Museum, Athens
(1)/photo TAP.

34. *Kouros* of naked man, Attica, c.600–575 BC.
Marble. H. 1.84 cm. Metropolitan Museum
of Art, New York, Fletcher Fund 1932 (32.11.1).

35. Statue of Mentuemhet, prince of Egyptian
Thebes, Karnak, early sixth century BC.
Granite. H. 1.34 m. Cairo Museum.

36. Anavyssos *kouros*, Attica, c.530 BC. Marble.
H. 1.94 m. National Museum, Athens
(3851)/photo TAP.

37. Peplos *kore*, Athenian Acropolis, c.530 BC.
Marble. H. 1.17 m. Akropolis Museum,

Athens (679)/ Photo Deutsches
Archäologisches Institut, Athens.

38. *Kore*, Athenian Akropolis, c.525 BC.
Marble. H. 1.23 m. Akropolis Museum,
Athens (594)/photo TAP.

39. *Kore*, cemetery at Merenda, Attica, c.550
BC. Marble. H. 1.76 m. National Museum,
Athens (4889)/photo TAP.

40. *Moskhophoros* (Calf-bearer), Athenian
Acropolis, c.560 BC. Marble. H. 1.65 m.
Akropolis Museum, Athens (624)/photo TAP.

41. Attic black-figure *dinos* and stand by
Sophilos, Athens, c.580–570 BC. H. 71 cm.
Copyright British Museum, London (1971
11–1.1).

42. and **43.** Attic black-figure volute *krater*
('François vase'), signed by Kleitias as painter
and Ergotimos as potter, Athens, c.570 BC. H.
66 cm. Museo Archeologico, Florence (4209).

44. Tyrrhenian amphora attributed to the
Timiades Painter, Athens, c.570 BC. H. 40 cm.
Staatliche Antikensammlungen Und
Glyptothek, Munich (1426)/photo Studio
Koppermann.

45. Attic black-figure band cup attributed to
the Oakeshott Painter, Athens, c.550 BC. H.
16.4 cm, diameter 28.4 cm. Metropolitan
Museum of Art, New York, Rogers Fund, 1917
(17.230.5) photo © 1997 The Metropolitan
Museum of Art.

46. Lakonian cup, name vase of the Arkesilas
Painter, c.560 BC. Interior. Diameter (with
handles) 38 cm. Bibliothèque Nationale, Paris
(4899, 2707)/photo Hirmer Verlag GmbH,
Munich.

47. and **48.** Attic black-figure type B amphora
by the Amasis Painter, Athens, c.550–540 BC.
H. 30.1 cm without alien lid, 35 cm with lid.
Musée du Louvre, Paris (F26)/photo Réunion
des Musées Nationaux.

49. Attic black-figure neck amphora, signed
by the potter Amasis, Athens, c.540 BC. H. 32.5
cm. Cabinet des Medailles, Bibliothèque
Nationale, Paris (222) /photo Hirmer Verlag
GmbH, Munich.

50. Attic black-figure neck amphora, signed
by the potter Exekias, Athens, c.540–530 BC.
H.41.3 cm. Copyright © British Museum,
London (B210).

51. Attic black-figure type A amphora, signed
by the potter Exekias, Athens, c.540–530 BC.
H. 61 cm. Vatican Museum (344)/photo
Hirmer Verlag GmbH, Munich.

52. Belly amphora, attributed to the Swing
Painter, Athens, third quarter of sixth century
BC. H. 49.5 cm. Cincinnati Art Museum
(1959.1).

53. *Hydria*, attributed to the Leagros Group,
Athens, last quarter of sixth century BC. H. 51.8

cm. Copyright © British Museum, London (B323).

54. *Hydria*, Caere, Etruria, *c.*530 BC. H. 43 cm. Musée du Louvre, Paris (E701)/photo Réunion des Musées Nationaux.

55. and **56.** 'Chalkidian' amphora, southern Italy, *c.*530 BC. H. 48 cm. Copyright © British Museum, London (B155).

57. Early 'owl' tetradrachm minted in Athens, last quarter of sixth century BC. Silver coin. Weight 16.5 gm. Copyright © British Museum, London (BMC 26).

58. Metope from Temple Y, Selinous, third quarter of sixth century BC. Marble. H. 0.84 m. Museo Nazionale Archeologico, Palermo/photo Hirmer Verlag GmbH, Munich.

59. Metope from Temple C, Selinous, last quarter of sixth century BC. Marble. H. 1.47 m. Museo Nazionale Archeologico, Palermo/photo Hirmer Verlag GmbH, Munich.

60. Siphnian Treasury, Delphi, built *c.*525 BC. Reconstruction drawing after *Fouilles de Delphes*, 2, 16: 225 fig 133 (École Française d'Athénes).

61. Combat of Mamnon and Achilles, east frieze of Siphnian treasury, *c.*525 BC. Marble. H. 0.64 m. Delphi Museum/photo © École Française d'Athénes.

62. East end of north frieze, Siphnian treasury, *c.*525 BC. Marble. H. 0.64 m. Delphi Museum/photo © École Française d'Athénes.

63. Archer, west pediment, temple of Aphaia, Aigina, *c.*490 BC. Marble. H. 1.04 m. Staatliche Antikensammlungen und Glyptothek, Munich/photo Studio Koppermann.

64. Herakles, east pediment, temple of Aphaia, Aigina, *c.*480 BC. H. 0.79 m. Staatliche Antikensammlungen und Glyptothek, Munich/photo Studio Koppermann.

65. Herakles and stag metope, Athenian treasury, Delphi, *c.*490 BC. Marble. H. 0.67 m. Delphi Museum/photo Hirmer Verlag GmbH, Munich.

66. Funerary *stele* of old man and dog, Orkhomenos, Boiotia, *c.*490 BC. Marble. H. 1.97 m. National Museum, Athens (39)/photo TAP.

67. Base of *kouros* recovered from Themistoklean wall, Athens, *c.*500 BC. Marble. H. 0.32 m. National Museum, Athens (3476)/photo TAP.

68. and **69.** Attic black figure eye-cup ('Bomford cup'), *c.*520–510 BC. Exterior and Interior. H. 0.13 m. Copyright the Ashmolean Museum, Oxford.

70. and **71.** Attic red figure amphora, attributed to the Andokides Painter, Vulci, *c.*520 BC. H. 0.58 m. Staatliches Museen, Berlin (F2159).

72. Attic red-figure *stamnos*, signed by the painter Smikros, Athens, *c.*510 BC. Detail. H. of pot 0.39 m. Musées Royaux d'Art et D'Histoire, Brussels (A 717).

73. Attic red-figure calyx *krater*, attributed to Euphronios, Athens, *c.*510–500 BC. H. 35 cm, diameter at mouth 44.5 cm. Staatliche Museen, Berlin (2180).

74. Attic red-figure calyx *krater* , signed by the painter Euphronios, Athens, *c.*500 BC. Detail. H. of detail 0.18 m. Shelby White and Leon Levy Collection, New York/photo Bruce White.

75. and **76.** Attic red-figure *hydria*, attributed to the Kleophrades Painter, Nola, *c.*480 BC. H. 0.42 m, H. of picture 0.17 m. Museo Nazionale, Naples (24422)/photo Hirmer Verlag GmbH, Munich.

77. Attic red-figure plate, signed by the painter Epiktetos, Vulci, *c.*500 BC. Diameter 0.19 m. Copyright British Museum, London (E137).

78. and **79.** Attic red-figure bell *krater*, attributed to the Berlin Painter, Etruria, *c.*480 BC. H. 33 cm. Musée du Louvre, Paris (G175)/photo Réunion des Musées Nationaux.

80. and **81.** Attic red-figure cup, signed by the potter Hieron and attributed to the painter Makron, Vulci, *c.* 490 BC. Interior and Exterior. H. 12 cm, diameter 33 cm. Staatliche Museen, Berlin (2290).

82. and **83.** Attic red-figure bell *krater*, attributed to the Pan Painter, Cumae, *c.*470 BC. H. 0.37 m, diameter 0.42 m. James Fund and by Special Contribution, Courtesy Museum of Fine Arts, Boston (10.185).

84. 'Kritian Boy' statue, Athenian Akropolis, *c.*480 BC. Marble. H. 1.17 m. Akropolis Museum, Athens (698)/photo Dr Jeffrey M. Hurwit, University of Oregon.

85. Motya charioteer, Motya, western Sicily, *c.*470 BC. Marble. H. 1.81 m. Whitaker Museum, Motya/photo Dr Brian Sparkes.

86. 'Warrior A' statue, Riace, *c.*450 BC. Bronze. H. 1.98 m. Museo Nazionale, Reggio/photo Hirmer Verlag GmbH, Munich.

87. 'Warrior B' statue, Riace, *c.*450 BC. Bronze . H. 1.97 m. Museo Nazionale, Reggio/photo Hirmer Verlag GmbH, Munich.

88. Polykleitos' Doryphoros, Pompeii, original *c.* 440 BC. Marble copy. H. 2.12 m. Museo Nazionale Archaeologico, Naples (6146)/photo Alinari, Florence.

89. Attic red-figure *psykter*, signed by the painter Douris, Athens, *c.*490 BC. H. 29 cm. Copyright © British Museum, London (E768).

90. and **91.** Attic red-figure calyx *krater*, name vase of the Niobid Painter, Athens, *c.*450 BC.

H. 54 cm. Musée du Louvre, Paris (G341)/ photo Réunion des Musées Nationaux.

92. Tomb of the Diver, Paestum, *c*.470 BC. Muzeo Nazionale, Paestum/photo Scala, Florence.

93. Attic red-figure *pelike*, attributed to the Lykaon Painter, Athens, *c*.440 BC. H. 47 cm, diameter 34 cm. William Amory Gardner Fund, Courtesy Museum of Fine Arts, Boston (34.79).

94. Plan of the temple of Zeus at Olympia and the location of sculpture. After original drawing by Candace Smith in Stewart, *Greek Sculpture*, fig. 262.

95. Reconstruction of the original composition of the east pediment of the temple of Zeus at Olympia. After original drawing by Candace Smith in Stewart, *Greek Sculpture*, fig. 263.

96. Reconstruction of the original composition of the west pediment of the temple of Zeus at Olympia. After original drawing by Candace Smith in Stewart, *Greek Sculpture*, fig. 263.

97. Seer from east pediment, temple of Zeus, Olympia, *c*.460 BC. Marble. H. 1.38 m. Photo Hirmer Verlag GmbH, Munich.

98. Apollo from west pediment, temple of Zeus, Olympia, *c*.460 BC. Marble. H. 3.1 m. Olympia Museum/photo Hirmer Verlag GmbH, Munich.

99. Lapith and centaur from west pediment, temple of Zeus, Olympia, *c*.460 BC. Marble. 2.05 m. Olympia Museum/photo Hirmer Verlag GmbH, Munich.

100. Lapith woman from west pediment, temple of Zeus, Olympia, *c*.460 BC. Marble. Olympia Museum/photo The Ancient Art & Architecture Collection Ltd, Pinner.

101. Metope 10, temple of Zeus, Olympia, *c*.460 BC. H. 1.6 m. Olympia Museum/photo Hirmer Verlag GmbH, Munich.

102. Plan of Athenian Parthenon and location of sculpture. After original drawing by Candace Smith in Stewart, *Greek Sculpture*, fig. 318.

103. Metope (N.25), north side of Parthenon, 445–440 BC. Marble. H. 1.2 m (excluding fillet at top). Akropolis Museum, Athens/photo Deutsches Archäologisches Institut, Athens.

104. Metope (N.24), north side of Parthenon, 445–440 BC. Marble. H. 1.2 m (excluding fillet at top). Akropolis Museum, Athens/photo Deutsches Archäologisches Institut, Athens.

105. Metope (S.27), south side of Parthenon, 445–440 BC. Marble. H. 1.2 m (excluding fillet at top). Copyright © British Museum, London/ photo Hirmer Verlag GmbH, Munich.

106. Metope (S.30), south side of Parthenon, 445–440 BC. Marble. H. 1.2 m (excluding fillet at top). Copyright © British Museum, London.

107. Metope (S.31), south side of Parthenon, 445–440 BC. Marble. H. 1.2 m (excluding fillet at top). Copyright © British Museum, London.

108. North frieze (xlii. 130–134), Parthenon, *c*.440 BC. Marble. H. 1.06 m. Copyright © British Museum, London.

109. North frieze (xxxviii), Parthenon, *c*.440 BC. Marble. H. 1.06 m. Copyright © British Museum, London.

110. East frieze (vi. 38–42), Parthenon, *c*.440 BC. Marble. H. 1.06 m. Copyright © British Museum, London/photo Ancient Art & Architecture Collection Ltd, Pinner.

111. East frieze (v.28–37), Parthenon, *c*.440 BC. Marble. H. 1.06 m. Copyright © British Museum, London.

112. East pediment figures A to G, Parthenon, *c*.438 BC. Marble. H. of G, 1.73 m. Copyright © British Museum, London.

113. East pediment figures K to L, Parthenon, *c*.438 BC. Marble. H. of K, 1.3 m. Copyright © British Museum, London.

114. Figure 12, south balustrade, temple of Athena Nike, *c*.415 BC. Marble. H. 1.01 m. Akropolis Museum, Athens (12)/photo TAP.

115. Attic white-ground *lekythos*, attributed to the Sabouroff Painter, *c*.450 BC. H. 29 cm. Staatliche Museen, Berlin (3262).

116. Attic black-figure *lekythos*, name vase of the Beldam Painter, Eretria, second quarter of fifth century BC. H. 31.7 cm. National Museum, Athens (1129)/photo TAP.

117. Attic white-ground *lekythos*, attributed to the Achilles Painter, Eretria, *c*.440 BC. H. 42.5 cm. National Museum, Athens (1818)/photo TAP.

118. Attic white-ground *lekythos*, attributed to Group R, Eretria, *c*.410 BC. H. 48 cm. National Museum, Athens (1816)/photo TAP.

119. Funerary *stele* of Hegeso, *c*.400 BC. Marble. H. 1.49 m. National Museum Athens (3624)/photo TAP.

120. Funerary *stele* of Lykeas and Khairedemos, *c*.400 BC. Marble. H. 1.81 m. Peiraieus Museum (385)/photo Hirmer Verlag GmbH, Munich.

121. Funerary *stele* from the River Ilissos, *c*.330 BC. Marble. H. 1.68 m. National Museum, Athens (869)/photo TAP.

122. Pluto and Persephone from Tomb II, Vergina, Macedonia, 350–325 BC. Wall painting. 3.5 × 1.01 m. Photo Archive of the Vergina Excavations, Aristotle University, Athens.

123. Temple of Apollo Epikourios, Bassai, Arcadia. Photo Robin Osborne.

124. Plan of temple of Apollo Epikourios, Bassai, Arcadia. After original drawing by Candace Smith in Stewart, *Greek Sculpture*, fig. 448.

125. Part of the Centauromachy from frieze, temple of Apollo Epikourios, Bassai, 410–390 BC. Marble. H. 64 cm. Copyright © British Museum, London (524).

126. Part of the Amazonomachy from frieze, temple of Apollo Epikourios, Bassai, 410–390 BC. Marble. H. 64 cm. Copyright © British Museum, London (535).

127. Votive relief, Amphiaraon, Oropos, *c*.380 BC. Marble. H. 49 cm. National Museum, Athens (3369)/photo TAP.

128. Amazon, west pediment of temple of Asklepios, Epidauros, *c*.380–360 BC. Marble. National Museum, Athens (137.142)/photo TAP.

129. Head of giant, pediment of temple at Mazi, *c*.390 BC. Marble. H. 26 cm. Olympia Museum/photo TAP.

130. Head of Telephos, west pediment of temple of Athena Alea, Tegea, *c*.340 BC. Marble. H. 31.4 cm. Tegea Museum (60)/photo TAP.

131. Head from 'Tomb of Philip', Vergina, third quarter of fourth century BC. Ivory. H. 3.5 cm. Photo Archive of the Vergina Excavations, Aristotle University, Athens

132. Panel from south frieze, Mausoleion, Halikarnassos, *c*.350 BC. Marble. H. 89 cm. Copyright © British Museum, London (1006)/photo Hirmer Verlag GmbH, Munich.

133. Frieze of hunt from exterior of 'Tomb of Philip', Vergina, 350–325 BC. L. of frieze 5.6 m.

Photo Archive of the Vergina Excavations, Aristotle University, Athens.

134. *Stater* of Metapontion, 330–300 BC. Silver coin, obverse. Weight 7.84 gm. Photo Hirmer Verlag GmbH, Munich.

135. Portrait Head of a bearded man signed by Dexamenos, *c*.400 BC. Jasper gem. L. 21 cm. Francis Bartlett Donation of 1912, Courtesy Museum of Fine Arts, Boston (23.580).

136. Tetradrachm of Ptolemy I of Egypt (323–305 BC). Silver coin, obverse. Weight 16.97 gm. Photo Hirmer Verlag GmbH, Munich.

137. Tetradrachm of Lysimakhos of Thrace and Asia Minor (305–281 BC), minted at Pergamon. Silver coin, obverse. Weight 17.22 gm. Copyright British Museum, London/ photo Hirmer Verlag GmbH, Munich.

138. Statue of youth, Antikythera, *c*.340 BC. Bronze. H. 1.94 m. National Museum, Athens (13396)/photo TAP.

139. Hermes and Dionysos, ascribed to Praxiteles, sanctuary of Zeus, Olympia, mid-fourth or third century BC. H. 2.15 m. Olympia Museum/photo Hirmer Verlag GmbH, Munich.

140. and 141. Aphrodite of Knidos, Roman copy after original by Praxiteles of mid-fourth century BC. H. 2.04m. Vatican Museum/ photo Deutsches Archäologisches Institut, Rome.

142. Bust of Sokrates, first half of fourth century BC. Vatican Museum (314)/photo Scala, Florence.

The publisher and author apologize for any errors or omissions in the above list. If contacted they will be pleased to rectify these at the earliest opportunity.

Bibliographic Essay

There are many excellent general accounts of Greek art, ranging from the two large volumes by C. M. Robertson, *A History of Greek Art* (Cambridge, 1975), through the same author's *A Shorter History of Greek Art* (Cambridge, 1981), to J. Boardman, *Greek Art*, 3rd edn (London, 1986) with excellent illustrations, and R. M. Cook's provocative *Greek Art* (Harmondsworth, 1972). B. A. Sparkes, *Greek Art*, from *Greece and Rome New Surveys in the Classics No. 22* (Oxford, 1991) is a good and up-to-date commentary on the scholarly bibliography. The best of all picture books are, for sculpture, R. Lullies and M. Hirmer, *Greek Sculpture* (London, 1957) and, for pottery, P. Arias, M. Hirmer, and B. Shefton, *A History of Greek Vase Painting* (London, 1962), which also has excellent detailed notes on the works illustrated.

Among general treatments limited to a particular art form, on sculpture, R. Carpenter, *Greek Sculpture: A Critical Review*, 2nd edn (Chicago, 1971) displays a compelling fervour; B. Ashmole, *Architect and Sculptor in Classical Greece* (London, 1972) is remarkable both for its insistence on the practical background to building and carving and for the acuity of its stylistic observations; A. F. Stewart, *Greek Sculpture* (2 vols, Yale, 1990) gives a full, traditional coverage, placing much emphasis on ancient literary traditions, and providing a useful introduction to recent scholarship; N. Spivey, *Understanding Greek Sculpture* (London, 1996) is a racier book which is more concerned with context and the material conditions of production than with artists; on pottery J. D. Beazley, *The Development of Athenian Black-Figure*, 2nd edn (Berkeley, 1986) is a classic artist-centred account; B. A. Sparkes, *The Red and the Black: Studies in Greek Pottery* (London, 1996) provides a history of the study of pottery and an introduction to techniques and imagery which is not centred on individual artists.

Among books which attempt to put the visual arts into a wider context two stand out:

J. Hurwit, *The Art and Culture of Early Greece* (Ithaca, NY, 1985) for the period down to the Persian Wars, and J. J. Pollitt, *Art and Experience in Classical Greece* (Cambridge, 1972) for the period from the Persian Wars to the death of Alexander.

These are all works from which the reader will learn much on many of the topics discussed in this book, and in general I do not further mention them when indicating relevant bibliography on particular topics below.

Chapter 1. A History of Art Without Artists

The parallelism between the history of Greek art and the history of art in the Renaissance is well seen in E. Gombrich, *Art and Illusion*, 3rd edn (London, 1977), ch. 4 of which is devoted to Greek art 'The Greek Revolution' (see further chs 7–9 below). It is equally to the fore in Kenneth Clark, *The Nude: A Study of Ideal Art* (London, 1956) whose model of 'ideal art' is one that has prevailed in the study of classical sculpture in particular. The baggage that such assumptions carry is well brought out by discussions of the representation of women: see L. Nead, *The Female Nude: Art, Obscenity and Sexuality* (London, 1992).

What Greek and Roman writers say about Greek art is usefully collected by J. J. Pollitt, *The Art of Ancient Greece: Sources and Documents* (Cambridge, 1990), and for sculpture by A. F. Stewart, *Greek Sculpture* (2 vols, Yale, 1990) Part III (both arranged by artist). Note also J. J. Pollitt, *The Ancient View of Greek Art* (New Haven, 1974) which is concerned to explicate the technical terms used, and, for one particular source, J. Isager, *Pliny on Art and Society: The Elder Pliny's Chapters on the History of Art* (London, 1991).

For copies and the growing realization of the problems which they present see M. Bieber, *Ancient Copies, Contributions to the History of Greek and Roman Art* (New York, 1977); B. S. Ridgway, *Roman Copies of Greek Sculpture, the Problem of the Originals* (Ann

Arbor, 1984); C. C. Vermeule, *Greek Sculpture and Roman Taste* (Ann Arbor, 1977); and M. Marvin in A. Hughes and E. Ranfft (eds), *Sculpture and its Reproductions* (London, 1997).

Among previous attempts to locate Greek art in the context of a broader cultural history J. J. Hurwit, *Art and Culture in Early Greece* (Cornell, 1985); J. J. Pollitt, *Art and Experience in Classical Greece* (Cambridge, 1972); and J. Onians, *Art and Thought in the Hellenistic Age* (London, 1979) stand out, but they tend to look to political rather than social history, to landmarks in literature and philosophy rather than the humdrum nature of daily life. C. Bérard (ed.), *A City of Images: Iconography and Society in Ancient Greece* (Princeton, 1989) is extremely successful in relating vase iconography to the lives of ordinary Athenians, but does so at the expense of consideration of the particular contribution of the artist; see on this issue my review 'Whose Image and Superscription Is This?', *Arion* 3rd series 1 (1990–91), 255–75. For an admirable examination of vase iconography which is sensitive to change over time see Alain Schnapp, *Le Chasseur et la Cité. Chasse et Érotique dans la Grèce ancienne* (Paris, 1996).

Dexileos' monument is discussed as a text by M. N. Tod, *Greek Historical Inscriptions* vol. 2, *From 403 to 323 BC* (Oxford, 1948), no. 105. The monument to the cavalry is no. 104 in Tod; the monument to all the war dead of the year is *Inscriptiones Graecae II* Part III. 2, 2nd edn (Berlin, 1940), no. 5221. All three monuments are discussed by T. Hölscher, *Griechische Historienbilder des 5. und 4. Jahrhunderts* (Würzberg, 1973), 103–8. For decree reliefs see C. Lawton, *Attic Document Reliefs* (Oxford, 1995). The most detailed discussion of the monument is S. Ensoli, *L'heróon di Dexileos nel Ceramico di Atene* (Rome, 1987). For Athenian attitudes to cavalry in the years of Dexileos' service and death see I. Spence, *The Cavalry of Classical Greece* (Oxford, 1993), 216–24, and G. Bugh, *The Horsemen of Athens* (Princeton, 1988), 138–9. Classical grave reliefs are further discussed in ch. 10.

The artistic exploration of the *symposion* in painted pottery is brilliantly explicated by F. Lissarrague, *The Aesthetics of the Greek Banquet* (Princeton, 1990). For other aspects of the *symposion* see O. Murray (ed.), *Sympotica: A Symposium on the Symposion* (Oxford, 1990), and W. J. Slater (ed.), *Dining in a Classical Context* (Michigan, 1991). On satyrs see C. Bérard and C. Bron, 'Satyric revels' in C. Bérard (ed.), *A City of Images* (Princeton, 1989), 131–50, and F. Lissarrague, 'The sexual life of satyrs' in D. Halperin, J. Winkler, and F. Zeitlin (eds), *Before Sexuality: The Construction of Erotic Experience in the Ancient Greek World* (Princeton, 1990), 53–81. The pioneering study of Greek homosexuality was K. Dover, *Greek Homosexuality* (London, 1978); M. Foucault, *The Uses of Pleasure: The History of Sexuality* vol. 2 (London, 1987) is extremely enlightening about the construction of homoerotic relationships in Greece, but makes little use of visual representations. Representations of Peleus and Thetis, as of all other mythological characters, are collected and commented on in, *Lexicon Iconographicum Mythologiae Classicae* (Zurich, 1981–). See also, more briefly, T. H. Carpenter, *Art and Myth in Ancient Greece* (London, 1991), 195–6. For another instance from this same period in which Peleus wrestling with Thetis is juxtaposed to scenes of both homerotic and heteroerotic courtship see the Peithinos cup, *ARV* 115. 2, J. Boardman, *Athenian Red-Figure Vases: The Archaic Period* (London, 1975), fig. 214.

Chapter 2. From Praying to Playing

On the arts in Bronze Age Greece the standard works are Reynold Higgins, *Minoan and Mycenaean Art* (London, 1967), and Sinclair Hood, *The Arts in Prehistoric Greece* (Harmondsworth, 1978); neither is strongly art-historical. On Dark Age Greece (1200–700BC) see R. G. Osborne, *Greece in the Making 1200–479 BC* (London, 1996), chs 3 and 4; A. M. Snodgrass, *The Dark Age of Greece* (Edinburgh, 1971); and V. Desborough, *The Greek Dark Ages* (London, 1972).

The best introduction to Greek art in the Dark Age and the Archaic Period is J. Boardman, *Preclassical* (London, 1967). R. Hampe and E. Simon, *The Birth of Greek Art, from the Mycenaean to the Archaic Period* (London, 1981) offers splendid pictures. B. Schweitzer, *Greek Geometric Art* is an excellently illustrated art-historical account of sculpture and painted pottery from 1000 to 700 BC, but it is not entirely reliable in its descriptions, dating, and attribution to regional schools.

For sculpture the most important work has been done by those studying the finds from Olympia, particularly W. -D. Heilmeyer, *Frühe olympische Bronzefiguren* (Berlin, 1979). On horses J. -L. Zimmermann, *Les chevaux de bronze dans l'art géométrique grec* (Mainz, 1989) is fundamental.

The basic framework of protogeometric pottery was set out by Vincent Desborough, *Protogeometric Pottery* (Oxford, 1952), and that

for Geometric pottery by J. N. Coldstream, *Greek Geometric Pottery* (London, 1968). The connection between decorative motifs and pot use is explored in detail by J. Whitley, *Style and Society in Dark Age Greece* (Cambridge, 1991). The case for considering the Cesnola crater Euboian was made by J. N. Coldstream, 'The Cesnola Painter, a change of address', *Bulletin of the Institute of Classical Studies* 18 (1971), 1–15. Scenes of the laying out of the corpse are collected by G. Ahlberg, *Prothesis and Ekphora in Greek Geometric Art* (Göteborg, 1971) and burial practices more generally discussed by D. Kurtz and J. Boardman, *Greek Burial Customs* (London, 1972) and, for eighth-century Athens in particular, by I. Morris, *Burial and Ancient Society: The Rise of the Greek City-State* (Cambridge, 1987).

The issue of what geometric figure scenes show has been much discussed, both in general and with reference to particular scenes. Important general treatments include J. N. Coldstream, 'The geometric style: birth of the picture' in T. Rasmussen and N. Spivey (eds), *Looking at Greek Vases* (Cambridge, 1991), 37–56; A. M. Snodgrass, 'Towards an interpretation of the geometric figure scenes', *Athenische Mitteilungen* 95 (1980), 51–8; J. Boardman, 'Symbol and story in geometric art' in W. G. Moon (ed.), *Ancient Greek Art and Iconography* (1983), 15–36; A. M. Snodgrass, *An Archaeology of Greece* (Berkeley, 1987), ch. 5, 'The first figure scenes in Greek art', 132–69; and J. Carter, 'The beginning of narrative art in the Greek Geometric period', *Annual of the British School at Athens* 67 (1972), 25–58. On the particular issue of illustration of Homer see A. M. Snodgrass, 'Homer and Greek Art' in I. Morris and B. Powell (eds), *A New Companion to Homer* (Leiden, 1997).

On the earliest Athenian graffito see L. H. Jeffery, *The Local Scripts of Archaic Greece*, revised with supplement by A. W. Johnston (Oxford, 1990). On 'Nestor's cup' see R. Meiggs and D. M. Lewis, *A Selection of Greek Historical Inscriptions to the End of the Fifth Century BC* (rev. edn, Oxford, 1988) no. 1; D. Ridgway, *The First Western Greeks* (Cambridge, 1992), 55–7; O. Murray, 'Nestor's cup and the origins of the symposion', *Apoikia: scritti in onore de Giorgio Buchner, Annali del'Istituto Orientale di Napoli* n. s. 1 (1994), 47–54; and C. Faraone, 'Taking "Nestor's Cup Inscription" Seriously: Erotic Magic and Conditional Curses in Earliest Greek Inscribed Hexameters', *Classical Antiquity* 15 (1996), 77–112. The links between the sea and the *symposion* are explored by W. J. Slater, 'Symposium at Sea', *Harvard Studies in Classical Philology* 80 (1976), 161–70, and M. Davies, 'Sailing, Rowing and Sporting in one's Cups on the Wine-Dark Sea' in, *Athens Comes of Age: From Solon to Salamis* (Princeton, 1978), 72–90.

On Attic gold bands see D. Ohly, *Griechische Goldbleche des 8 Jahrhunderts v. Chr* (Berlin, 1953). On jewellery more generally see R. Higgins, 'Early Greek Jewellery', *Annual of the British School at Athens* 64 (1969), 143–53, and B. Deppert-Lip, *Griechischer Goldschmuck* (Mainz, 1985). Scenes of fighting at sea are collected by G. Ahlberg, *Fighting on Land and Sea in Greek Geometric Art* (Stockholm, 1971).

Chapter 3. Reflections in an Eastern Mirror

The best general introduction to orientalizing remains J. Boardman, *Preclassical* (Harmondsworth, 1967). I discuss the Greek world of the seventh century more generally in, *Greece in the Making, 1200–479 BC* (London, 1996), ch. 6. The material evidence for contact between Greece and the east is well summarized by S. Morris, *Daidalos and the Origins of Greek Art* (Princeton, 1992), ch. 5. For a more tendentious view of the nature of the contact see W. Burkert, *The Orientalizing Revolution. Near Eastern Influence on Greek Culture in the Early Archaic Age* (Cambridge, Mass. , 1992). I discuss both Morris and Burkert in 'À la grecque', *Journal of Mediterranean Archaeology* 6 (1993), 231–7.

The fundamental work on Corinthian pottery was done by Humfry Payne in the 1930s in *Necrocorinthia* (Oxford, 1931) and, *Protocorinthische Vasenmalerei* (Berlin, 1933). More recent finds are collected in D. A. Amyx, *Corinthian Vase-Painting in the Archaic Period* (3 vols. Berkeley, 1988) (with C. W. Neeft, *Addenda and Corrigenda to D. A. Amyx, Corinthian Vase-Painting in the Archaic Period* (Amsterdam, 1991)), and in J. L. Benson, *Earlier Corinthian Workshops* (Amsterdam, 1989). For a general introduction see T. Rasmussen, 'Corinth and the Orientalizing phenomenon', in T. Rasmussen and N. Spivey (eds), *Looking at Greek Vases* (Cambridge, 1991), 57–78.

The finds from the Samian Heraion are conveniently introduced by H. Kyrieleis, 'The Heraion at Samos', in N. Marinatos and R. Hägg (eds), *Greek Sanctuaries: New Approaches* (London, 1993). Oriental bronzes from the Heraion at Samos are discussed by U. Jantzen, *Samos. Band VIII. Ägyptische und orientalische Bronzen aus dem Heraion von Samos* (Bonn, 1972), and by H. Kyrieleis, 'Babylonische Bronzen im Heraion von

Samos', *Jahrbuch des deutsches archäologisches Instituts* 94 (1979), 32–48. The distribution of foreign objects at a number of different sanctuaries, including the Samian Heraion, is discussed by I. Kilian-Dirlmeier, 'Fremde Weihungen in griechischen Heiligtümern vom 8. bis zum Beginn des 7. Jahrhunderts v. Chr. ', *Jahrbuch des Römisch-Germanischen Zentralmuseums Mainz* 32 (1985), 215–54.

The orientalizing jewellery from Kameiros is discussed by R. Laffineur, *L'orfèvrerie rhodienne orientalisante* (Paris, 1978). On Daedalic art see R. Jenkins, *Dedalica: a Study of Dorian Plastic Art in the Seventh Century* (Cambridge, 1936), and S. Morris, *Daidalos and the Origins of Greek Art* (Princeton, 1992), ch. 9. The finds from Perachora are published in H. Payne, *Perachora* vol. 1 (Oxford, 1940), and T. Dunbabin, *Perachora* vol. 2 (Oxford, 1962).

Chapter 4. Myth as Measure

Representations of myth in early Greek art are collected by G. Ahlberg-Cornell, *Myth and Epos in Early Greek Art: Representation and Interpretation* (Jonsered, 1992), and by K. Schefold, *Myth and Legend in Early Greek Art* (London, 1966). The massive *Lexicon Iconographicum Mythologiae Classicae* (Zurich 1981–) covers Greek and Roman art from the seventh century onwards. T. H. Carpenter, *Art and Myth in Ancient Greece* (London, 1991) includes seventh-century as well as later material. The general issues surrounding how myths are identified and read on pots are discussed by J. Henle, *Greek Myths: A Vase Painter's Handbook* (Bloomington, Ill., 1973), ch. 1; A. M. Snodgrass, *Narration and Allusion in Archaic Greek Art* (Oxford, 1982); and S. Goldhill and R. Osborne, 'Introduction: programmatics and polemics' in S. Goldhill and R. Osborne (eds) *Art and Text in Ancient Greek Culture* (Cambridge, 1994).

The Mykonos *pithos* was first published by M. Ervin, 'A relief pithos from Mykonos', *Arkhaiologikon Deltion* 18/1 (1963), 37–75, with a further fragment published by J. Christiansen, 'Et Skår fra Mykonos', *Meddelelser fra Ny Glyptotek* 31 (1974), 7–21. M. Ervin (= M. Caskey) discusses relief *pithoi* more generally in 'Notes on Relief Pithoi of the Tenian-Boiotian Group', *American Journal of Archaeology* 80 (1976), 19–41.

The Polyphemos amphora was first published by G. Mylonas, 'Ο Πρωτοαττικὸ ς ᾽Αμφορεὺς της᾽Ελευσῖνος (Athens, 1957). For the context in which it was found see further G. Mylonas, *Τὸ Δυτικὸν Νεκροταφεῖον της᾽Ελευσῖνος*, 3 vols

(Athens, 1975). The classic discussion of protoattic pottery is J. M. Cook, 'Protoattic pottery', *Annual of the British School at Athens* 35 (1935), 165–219. The suggestion that middle protoattic pottery may have been made on the island of Aegina comes from S. Morris, *The Black and White Style* (Yale, 1984). For recent debate about how to read the scenes on the amphora see R. Osborne, 'Death revisited, death revised: the death of the artist in Archaic and Classical Greece', *Art History* 11 (1988), 1–16, and J. Whitley, 'Protoattic pottery: a contextual approach' in I. Morris (ed.), *Classical Greece: Ancient Histories and Modern Archaeologies* (Cambridge, 1994). I have tried to put the developments in protoattic pottery into the context of other changes in the archaeology of seventh-century Attica in 'A crisis in archaeological history? The seventh century BC in Attica', *Annual of the British School at Athens* 84 (1989), 297–322.

The Melian 'amphora' is most fully published by A. Conze, *Die Melischen Thongefässe* (18). Cycladic workshops are discussed by F. Salviat and N. Weill, 'Un plat du VIIe siècle à Thasos: Bellérophon et la chimère', *Bulletin de Correspondance Hellénique* 84 (1960), 347–86, and by F. Blondé and J. Y. Perreault, 'Un atelier de potier archaïque à Phari (Thasos)' in F. Blondé and J. Y. Perreault (eds), *Les ateliers de potiers dans le monde grec aux époques géométrique, archaïque et classique* BCH Supplément xxiii (Paris, 1992).

The Nessos Painter's amphora stands at the head of the development of Athenian black-figure pottery: see J. D. Beazley, *The Development of Attic Black-figure* (1951, rev. edn, Berkeley, 1986), 13–16.

Chapter 5. Life Enlarged

The best introductions to Greek religion are provided by J. Gould, 'On making sense of Greek religion' in P. Easterling and J. Muir (eds), *Greek Religion and Society* (Cambridge, 1985), and by A. M. Bowie 'Greek sacrifice: Forms and functions' and E. Kearns, 'Order, Interaction, Authority: Ways of looking at Greek religion' in A. Powell (ed.), *The Greek World* (London, 1995), 463–82 and 511–29. W. Burkert, *Greek Religion* (Oxford, 1984) remains basic as a reference work.

The standard works on Greek architecture are A. W. Lawrence, *Greek Architecture*, 5th edn revised by R. Tomlinson (Newhaven, 1996) and W. B. Dinsmoor, *The Architecture of Ancient Greece* (London, 1950). For how Greek architects worked J. J. Coulton, *Greek Architects at Work* (London, 1977) is fundamental.

On the Thermon metopes see H. Koch, 'Zu den Metopen von Thermon', *Athenische Mitteilungen* 39 (1914), 237–55, and H. Payne, 'On the Thermon metopes', *Annual of the British School at Athens* 27 (1925/6), 124–32. The Corfu pediment is discussed by J. L. Benson, 'The central group of the Corfu pediment' in *Gestalt und Geschichte: Festschrift Karl Schefold. Antike Kunst* Beiheft 4 (Bern, 1967), 48–60. The temple at Dreros and its sculptures are most thoroughly discussed by I. Beyer, *Die Tempel von Dreros und Prinias und die Chronologie des kretischen Kunst des 8. und 7. Jhs v. Chr.* (Freiburg, 1976).

M. Lazzarini collects all archaic dedicatory inscriptions in, *Le formule delle dediche votive nella Grecia arcaica* (Rome, 1976).

The classic studies of *kouroi* and *korai* were made by G. M. A. Richter, *Korai: Archaic Greek Maidens* (London, 1968) and, *Kouroi: Archaic Greek Youths* (3rd edn, London, 1970) who discerns separate regional traditions and assigns dates largely on the basis of representation of anatomical features. On the development of archaic sculpture in general see also B. S. Ridgway, *The Archaic Style of Greek Sculpture* (Princeton, 1977), and J. Boardman, *Greek Sculpture: The Archaic Period* (London, 1978). The question of the proportions of *kouroi* and *korai* and their relationship to Egyptian sculpture has been thoroughly investigated by E. Guralnick, 'Proportions of kouroi', *American Journal of Archaeology* 82 (1978), 461–72, and 'Proportions of korai', *American Journal of Archaeology* 85 (1981), 269–80. The issue of the significance of beardlessness is discussed by C. Sourvinou-Inwood, *'Reading' Greek Death to the End of the Classical Period* (Oxford, 1995), 252–70. On funerary use of *kouroi* and *korai* in Attica see also A. M. D'Onofrio, 'Korai et kouroi funerari attici', *Annali Istituto Orientale di Napoli. Archeologia e Storia Antica* 4 (1982), 135–70. On the scale of *kouros* production in the sixth century provocative remarks are made by A. M. Snodgrass, 'Heavy freight in archaic Greece', in P. Garnsey, K. Hopkins, and C. R. Whittaker (eds), *Trade in the Ancient Economy* (London, 1983), 16–26.

The *korai* from the Athenian Acropolis are well discussed and illustrated by H. Payne and G. Mackworth Young, *Archaic Marble Sculpture from the Acropolis* (London, 1936). Other important local concentrations of archaic sculpture include the Ptoön sanctuary of Apollo in Boiotia, on which see J. Ducat, *Les Kouroi de Ptoion* (Paris, 1971), and the sanctuary of Hera on Samos, on which see

H. Kyrieleis, *Der grosse Kuros vom Samos* (Bonn, 1996). For clothed *kouroi* see Payne and Young, plate 102 (Acropolis 633), J. Sweeney *et al.*, *The Human Figure in Greek Art* (Athens, 1988) no. 54 and B. Barletta 'The Draped Kouros Type and the Workshop of the Syracuse Youth', *American Journal of Archaeology* 91 (1987), 233–46. An example of an obviously youthful clothed figure is Dionysermos from Ionia (Louvre, MA 3600), on which see P. Devambez, 'Une nouvelle statue archaïque au Louvre. I. La statue', *Revue Archéologique* (1966), 195–215.

Sculptors' workshops in archaic Attica are investigated by D. Viviers, *Recherches sur les ateliers de sculpteurs et la Cité d'Athènes à l'époque archaïque* (Brussels, 1992). The iconography of Attic archaic sculpture is helpfully discussed by A. M. d'Onofrio, 'Soggetti sociali e tipi iconografici nella scultura attica archaica', in A. Verbanck-Piérard and D. Viviers (eds), *Culture et Cité: L'avènement d'Athènes à l'époque archaïque* (Brussels, 1995), 185–209. On Phrasikleia see E. Mastrokostas, 'Myrrhinous: la Kore Phrasikleia, oeuvre d'Aristion de Paros et un kouros en marbre', *Athens Annals of Archaeology* 5 (1972) 298–324. J. Svenbro uses Phrasikleia's inscription as the jumping-off point for a wider consideration of the role of writing in archaic Greece in *Phrasikleia: An Anthropology of Reading in Ancient Greece* (Ithaka, NY, 1993).

Chapter 6. Marketing an Image

The classic account of Athenian black-figure pottery is J. D. Beazley, *The Development of Attic Black-Figure* (rev. edn Berkeley, 1986). J. Boardman, *Athenian Black Figure Vases: A Handbook* (London, 1974) fully illustrates the range of black-figure pottery. Excellent discussions of individual pots are to be found in P. Arias, M. Hirmer, and B. Shefton, *A History of Greek Vase Painting* (London, 1962). On trade in pottery see my 'Pots and trade in archaic Greece', *Antiquity* 70 (1996), 31–44, with further references. The changing iconography of Attic pottery between 600 and 530 is discussed by H. A. Shapiro, 'Old and New Heroes: narrative, composition and subject in Attic Black-Figure', *Classical Antiquity* 9 (1990), 114–48. See also the general works on representation of mythology mentioned above in ch. 4.

The work of Sophilos is collected and studied in G. Bakir, *Sophilos: Ein Beitrag zu seinem Stil* (Mainz, 1981). The fullest discussion of the 'Erskine *Dinos*' is by

D. Williams, 'Sophilos in the British Museum', *Greek Vases in the J. Paul Getty Museum* 1 (1983), 9–34.

For the attempt to link the François vase to the poetry of Stesichoros see A. F. Stewart, 'Stesichoros and the François vase' in W. G. Moon (ed.), *Ancient Greek Art and Iconography* (Madison, 1983), 53–74. The imagery of Dionysos is discussed by T. H. Carpenter, *Dionysian Imagery in Archaic Greek Art* (Oxford, 1986). On the role of the frontal face, much in evidence in this and the next chapter, see F. Frontisi-Ducroux, *Du masque au visage: Aspects de l'identité en Grèce ancienne* (Paris, 1995), esp. chs. 6–10.

On the date and provenance of Tyrrhenian amphorae see T. H. Carpenter, 'On the dating of the Tyrrhenian Group' and 'The Tyrrhenian Group: problems of provenance', *Oxford Journal of Archaeology* 2 (1983), 279–93, and 3 (1984), 45–56, with N. Spivey 'Greek vases in Etruria' in T. Rasmussen and N. Spivey (eds), *Looking at Greek Vases* (Cambridge, 1991), 131–50 and 141–2. On the marketing aspect of pot painting, including Tyrrhenian amphorae, compare J. Henderson, '*Timeo Danaos* Amazons in early Greek art and pottery' in S. Goldhill and R. Osborne (eds), *Art and Text in Ancient Greek Culture* (Cambridge, 1994), 85–137.

On Lakonian vases see C. M. Stibbe, *Lakonische Vasenmaler der sechsten Jahrshunderts v. Chr.* (Amsterdam, 1972); C. M. Stibbe, *Lakonian Mixing Bowls: a History of the 'krater lakonikos' from the Seventh to the Fifth Century* BC, (Amsterdam, 1989); I. Margreiter, *Frühe lakonische Keramik der geometrischen bis archaischen Zeit (10. bis 6. Jahrhundert v. Chr.)* (Waldsassen-Bayern, 1988), and M. Pipili, *Lakonian Iconography of the Sixth Century* (Oxford, 1987).

On the Amasis Painter see D. von Bothmer, *The Amasis Painter and his World* (Malibu, New York, and London, 1985) and M. True (ed.), *Papers on the Amasis Painter and his World* (Malibu, 1987). Scenes of hunting and their erotic connections are explored by A. Schnapp, 'Eros the Hunter', in C. Bérard *et al.*, *A city of images: Iconography and Society in ancient Greece* (Princeton, 1989), 71–88, and in *Le Chasseur et la Cité: Chasse et Érotique dans la Grèce ancienne* (Paris, 1997). For the *symposion* see above ch. 1.

On Exekias see W. Technau, *Exekias* (Leipzig, 1936); J. Boardman, 'Exekias', *American Journal of Archaeology* 82 (1978), 11–24; and M. B. Moore, 'Exekias and Telamonian Aias', *American Journal of*

Archaeology 84 (1980), 417–21. Representations of Amazons are collected by D. von Bothmer, *Amazons in Greek Art* (Oxford, 1957).

On scenes of a warrior carrying a body see S. Woodford and M. Loudon, 'Two Trojan themes: the iconography of Ajax carrying the body of Achilles and Aeneas carrying Anchises in Black Figure vase painting', *American Journal of Archaeology* 84 (1980), 25–40. For the carrying off of a woman's body see J. Henderson, '*Timeo Danaos* Amazons in early Greek art and pottery' in S. Goldhill and R. Osborne (eds), *Art and Text in Ancient Greek Culture* (Cambridge, 1994), 85–137 at 113–30.

Caeretan *hydriai* are discussed by J. M. Hemelrijk, *Caeretan Hydriai* (Mainz, 1984). The classic publication of Chalkidian vases is A. Rumpf, *Chalkidische Vasen* (Leipzig, 1927).

Chapter 7. Enter Politics

I further discuss the development of city identity in the sixth century, including the development of coinage, in *Greece in the Making 1200–479 BC* (London, 1996), 243–91. The standard account of early coinage remains C. M. Kraay, *Archaic and Classical Greek Coins* (London, 1976), but see C. Howgego, *Ancient History from Coins* (London, 1995), 1–18, for convenient updating. The best pictures of Greek coinage are in C. M. Kraay, and M. Hirmer, *Greek Coins* (London, 1966).

Various attempts have been made to see more specific political issues in vase painting than I suggest here. Note in particular the various articles in which John Boardman has suggested that the tyrant Peisistratos at Athens identified with Herakles and encouraged the painting of Herakles scenes on pots, of which the most important are J. Boardman, 'Herakles, Peisistratos and sons', *Revue Archéologique* (1972), 57–72; J. Boardman, 'Image and politics in sixth century Athens', in H. A. G. Brijder (ed.), *Ancient Greek and Related Pottery* (Amsterdam, 1984), 239–47; and compare H. A. Shapiro, *Art and Cult under the tyrants in Athens* (Mainz, 1989). For critiques see my 'The myth of propaganda and the propaganda of myth', *Hephaistos* 5/6 (1983–4), 61–70; R. M. Cook, 'Pots and Pisistratan propaganda', *Journal of Hellenic Studies* 107 (1987), 167–9; and J. Blok, 'Patronage and the Peisistratidae', *Bulletin Antieke Beschavung* 65 (1990), 17–28.

On the Selinous sculptures see L. Giuliani, *Die archaischen Metopen von Selinunt* (Mainz, 1979). On the Siphnian treasury frieze see chapters by B. Holtzman, M. B. Moore, and

F. Croissant in, *Études Delphiques* BCH
Supplement 4 (1977), 295–304, 305–35,
and 337–63; L. V. Watrous, 'The Sculptural
Program of the Siphnian Treasury at Delphi',
American Journal of Archaeology 86 (1982),
159–72; and V. Brinkman, 'Die aufgemalten
Namenbeischriften an Nord- und Ostfries
des Siphnierschatzhauses', *Bulletin de
Correspondence Hellenique* 109 (1985), 77–130.

The Aigina sculptures are most thoroughly
published by A. Furtwängler, *Aegina: Das
Heiligtum der Aphaia* (Munich, 1906) and
D. Ohly, *Die Aigineten. 1 Die Ostgiebelgruppe*
(Munich, 1976). On the possible political
significance of the sculptures of the Athenian
treasury at Delphi see J. Boardman, 'Herakles,
Theseus and Amazons' in D. Kurtz and
B. Sparkes (eds), *The Eye of Greece: Studies in
the Art of Athens: Essays Dedicated to Martin
Robertson* (Cambridge, 1982), 1–28 at 3–16.

The most thorough discussion of archaic
funerary monuments is C. Sourvinou-
Inwood, *'Reading' Greek Death to the End of
the Classical Period* (Oxford, 1995), 140–297.
Attic monuments are collected by G. M. A.
Richter, *The Archaic Gravestones of Attica*
(London, 1961). On schools of sculptors
at work in Athens in the later sixth century
see D. Viviers, *Recherches sur les ateliers de
sculpteurs et la Cité d'Athènes à l'époque
archaïque* (Brussels, 1992).

Chapter 8. Gay Abandon
On the Bomford cup see J. Boardman,
'A curious eye cup', *Archäologischer Anzeiger*
(1976), 282–90.

On the advantages and weaknesses
of analyses of artforms that are medium-
essentialist (of which M. Robertson, *The
Art of Vase-Painting in Classical Athens*
(Cambridge, 1992), 7, provides a good
example), see N. Carroll, *Theorizing the
Moving Image* (Cambridge, 1996), 49–55.

The background to the invention of
the red-figure technique is discussed by
D. Williams, 'The invention of the red-
figure technique and the race between vase-
painting and free painting' in T. Rasmussen
and N. Spivey (eds), *Looking at Greek Vases*
(Cambridge, 1991), 103–118. The relationship
between pots and metal vessels has been made
subject of debate by M. Vickers, 'Artful crafts:
the influence of metalwork on Athenian
painted pottery', *Journal of Hellenic Studies* 105
(1985), 108–28, and M Vickers and D. Gill,
*Artful Crafts: Ancient Greek Silverware and
Pottery* (Oxford, 1994). For a sceptical view see
R. M. Cook, 'Artful crafts: a commentary'
Journal of Hellenic Studies 107 (1987), 169–71.

The most comprehensive account of
red-figure pottery is M. Robertson, *The Art of
Vase-Painting in Classical Athens* (Cambridge,
1992). J. Boardman, *Athenian Red Figure
Vases: The Archaic Period* (London, 1975)
covers the period discussed in this chapter,
with numerous illustrations.

On the way early red-figure artists put
themselves into scenes see J. Frel, 'Euphronios
and his fellows', in W. G. Moon (ed.), *Ancient
Greek Art and Iconography* (Madison, 1983),
147–58. Euphronios' work is best approached
via the exhibition catalogue, *Euphronios,
peintre à Athènes au VIe siècle avant J. -C.* (Paris,
1990). R. Neer valuably demonstrates the
inadequacy of considerations of naturalism
for explaining Euphronios' draughtsmanship:
'The Lion's Eye: imitation and uncertainty
in Attic Red-figure', *Representations* 51 (1995),
118–53. The drawing of human figures in early
red-figure is discussed by D. Williams, 'The
drawing of the human figure on early red-
figure vases', in D. Buitron-Oliver (ed.), *New
Perspectives in Early Greek Art* (Washington,
1991).

On the Kleophrades Painter see J. Beazley,
'Kleophrades', *Journal of Hellenic Studies* 30
(1910), 38–68, and J. Beazley, *Der Kleophrades-
maler* (Berlin, 1933; English version Mainz,
1974). The changing portrayal of Ajax and
Kassandra is discussed by J. Connelly,
'Narrative and image in Attic vase painting'
in P. Holliday (ed.), *Narrative and Event in
Ancient Art* (Cambridge, 1993), 88–129.

On Epiktetos' other British Museum
cup see F. Lissarrague, '*Epiktetos egraphsen*:
the writing on the cup', in S. Goldhill and
R. Osborne (eds), *Art and Text in Ancient
Greek Culture* (Cambridge, 1994), 12–27.

The classic discussion of the Berlin Painter's
amphora in Berlin is in the article in which
J. D. Beazley first established a corpus of vases
to be attributed to the hand of this artist of
unknown name: 'The master of the Berlin
Amphora', *Journal of Hellenic Studies* 31 (1911),
276–95. Beazley later devoted to the artist
a further article, 'Citharoedus', *Journal of
Hellenic Studies* 42 (1922), 70–98, and a mono-
graph: *Der Berlin-maler* (Berlin, 1930; English
edn, Mainz, 1974). The way in which Beazley
worked to uncover this artist has been fully
discussed by D. C. Kurtz , *The Berlin Painter*
(Oxford, 1983).

I have collected and discussed scenes of
satyrs and sleeping maenads in 'Desiring
women on Athenian pottery', in N. Kampen
(ed.), *Sexuality in Ancient Art* (Cambridge,
1995), 65–80, and have discussed the relation-
ship between images of maenads and the

actual worship of Dionysos in 'The ecstasy and the tragedy: Varieties of Religious Experience in Art, Drama, and Society', in C. B. R. Pelling (ed.), *Greek Tragedy and the Historian* (Oxford, 1996), 187–211. On scenes of rites involving a mask of Dionysos F. Frontisi-Ducroux, *Le dieu masque: une figure du Dionysos d'Athènes* (Paris, 1991) is fundamental. Note also more generally C. Bérard *et al.*, *A City of Images: Iconography and Society in Ancient Greece* (Princeton, 1989).

The fundamental work on the Pan Painter was J. D. Beazley, *Der Pan-maler* (Berlin, 1931, English edn, Mainz, 1974). See also B. -A. Follmann, *Der Pan-maler* (Bonn, 1968). On the god Pan himself see Ph. Borgeaud, *The Cult of Pan in Ancient Greece* (Baltimore, 1988).

Chapter 9. Cult, Politics, and Imperialism

For introductions to the history of fifth- and fourth-century Greece see J. K. Davies, *Democracy and Classical Greece* (2nd edn, London, 1993) and S. Hornblower, *The Greek World 479–323 BC* (rev. edn, London, 1991).

The transition from archaic to classical art has been much discussed. The most detailed study of the formal changes in sculpture is B. S. Ridgway, *The Severe Style in Greek Sculpture* (Princeton, 1970). The terms of the theoretical debate have been most influenced in recent years by E. H. Gombrich, 'The Greek Revolution' in his *Art and Illusion* (3rd edn, London, 1977). The debate is well reviewed by C. H. Hallett, 'The origins of the classical style in sculpture', *Journal of Hellenic Studies* 106 (1996), 71–84.

On the Kritian Boy see J. M. Hurwit, 'The Kritios Boy: Discovery, Reconstruction,and Date', *American Journal of Archaeology* 93 (1989), 41–80. On the Motya youth see V. Tusa 'Il Giovane di Mozia', in H. Kyrieleis (ed.), *Archaische und klassische griechische Plastik* vol. 2 (Berlin, 1986). The fullest discussion of the Riace bronzes is in L. V. Borelli and P. Pelagatti (eds), *Due Bronzi di Riace: Bolletino d'Arte Serie Speciale 3* (Rome, 1984). For their distinct early classical context see E. Harrison, 'Early Classical Sculpture: the bold style', in C. G. Boulter (ed.), *Greek Art, Archaic into Classical* (Leiden, 1985), 40–65. Oliver Taplin reports and illustrates modern viewers' reactions in *Greek Fire* (London, 1989), 87–9. I discuss the changing agenda of masculinity further in 'Sculpted men of Athens: masculinity and power in the field of vision', in L. Foxhall and J. Salmon (eds), *Thinking Men: Masculinity and its Self-Representation in the Classical Tradition*

(London, forthcoming). On Polykleitos see A. Borbein, 'Polykleitos' in O. Palagia and J. J. Pollitt (eds), *Personal Styles in Greek Sculpture* (Cambridge, 1996); H. Beck, P. Bol, and M. Bückling, *Polyklet: der Bildhauer der griechischen Klassik* (Mainz, 1990); and D. Kreikenbom, *Bildwerke nach Polyklet* (Berlin, 1990).

The oeuvre of Douris is studied by D. Buitron-Oliver, *Douris: a Master-Painter of Athenian Red-figure Vases* (Mainz, 1995). On the ligaturing of the penis see P. Zanker, *The Mask of Socrates* (Berkeley, 1995), 28–9, and my discussion in 'Men without clothes. Heroic Nakedness and Greek Art', in M. Wyke (ed.), *Gender and the Body in Mediterranean Antiquity: Gender and History 9/3* (1997), 504–28.

The best discussion of issues of mimesis in classical painted pottery is R. T. Neer, 'The Lion's Eye: imitation and uncertainty in Attic Red-figure', *Representations* 51 (1995), 118–53, discussing the *pelike* by the Lykaon Painter at 134–46. The Niobid Painter's name vase has been extensively discussed. The most important contribution has been J. Barron, 'New light on old walls: the murals of the Theseion', *Journal of Hellenic Studies* 92 (1972), 20–45. On wall-painting see A. Rouveret, *Histoire et imaginaire de la peinture ancienne* (Paris, 1989).

Both the building and the decoration of the temple of Zeus at Olympia are illuminatingly discussed by B. Ashmole, *Architect and Sculptor in Classical Greece* (London, 1972); see also B. Ashmole, N. Yalouris, and A. Frantz, *Olympia: The Sculptures of the Temple of Zeus* (London, 1967). I have discussed the Olympia Centauromachy along with the Centauromachies of the Parthenon and the temple of Apollo at Bassai in 'Framing the centaur: reading fifth-century architectural sculpture', in S. Goldhill and R. Osborne (eds), *Art and Text in Ancient Greek Culture* (Cambridge, 1994).

On the architecture of the Parthenon see M. Korres, *From Pentelikon to Parthenon* (Athens, 1994) and particularly J. J. Coulton, 'The Parthenon and Periklean Doric', in E. Berger (ed.), *Parthenon-Kongress Basel* (Mainz, 1984), 40–4. For a recent general discussion of building on the Acropolis see R. Rhodes, *Architecture and Meaning on the Athenian Acropolis* (Cambridge, 1995). The sculptures of the Parthenon have been well photographed and discussed on many occasions: note particularly F. Brommer, *The Sculptures of the Parthenon* (London, 1979) and J. Boardman and D. Finn, *The Parthenon and its Sculptures* (London, 1985). But the metopes,

frieze, and pediments are normally discussed separately and not as a single programme; I try to do the latter in my 'Democracy and Imperialism in the Panathenaic Procession: the Parthenon Frieze in its Context', in W. Coulson *et al.* (eds), *The Archaeology of Athens and Attica under Democracy* (Oxford, 1994), 143–50. For the frieze and its interpretation see M. Robertson and A. Frantz, *The Parthenon Frieze* (London, 1975) and I. Jenkins, *The Parthenon Frieze* (London, 1994). The suggestion that the east frieze represents the sacrifice of the daughters of Erekhtheus comes from Joan Connelly, 'Parthenon and Parthenoi: a Mythological Interpretation of the Parthenon Frieze', in *American Journal of Archaeology* 100 (1996), 53–80. I have stressed the importance of the viewer's procession in 'The Viewing and Obscuring of the Parthenon Frieze', *Journal of Hellenic Studies* 107 (1987), 98–105.

On the temple of Athena Nike see I. Mark, *The Sanctuary of Athena Nike in Athens: Architectural Stages and Chronology* (Princeton, 1993). The basic publication on the balustrade is R. Carpenter, *The Sculpture of the Nike Temple Parapet* (Cambridge, Mass., 1929). The sacrificial issues surrounding the balustrade of the temple of Athena Nike are brought out by M. H. Jameson, 'The ritual of the Athena Nike parapet' in R. Osborne and S. Hornblower (eds), *Ritual, Finance, Politics: Athenian Democratic Accounts Presented to David Lewis* (Oxford, 1994), 307–24. Against the traditional view that the balustrade reliefs are a sculptural *tour de force* that is merely escapist, see my 'Looking on—Greek style: Does the sculpted girl speak to women too?', in I. Morris, (ed.), *Classical Greece: Ancient Histories and Modern Archaeologies* (Cambridge, 1994), 81–96 and 85–6, where I also discuss the Athena Parthenos and Pandora.

Chapter 10. The Claims of the Dead

Athenian black-figure *lekythoi* were collected by E. Haspels, *Attic Black-Figured Lekythoi* (Paris, 1936). For black-figure *lekythoi* with scenes of dancing round a mask of Dionysos see F. Frontisi-Ducroux, *Le Dieu-masque, une figure de Dionysos à Athènes* (Paris, 1991), and for the name vase of the Beldam Painter see F. Frontisi-Ducroux, *Du masque au visage: Aspects de l'identité en Grèce ancienne* (Paris, 1995), 110.

On Athenian white-ground *lekythoi* see J. D. Beazley, *Attic White Lekythoi* (Oxford, 1938), repr. in D. C. Kurtz (ed.), *Greek Vases: Lectures by J. D. Beazley* (Oxford, 1989);

D. C. Kurtz, *Athenian White Lekythoi: Patterns and Painters* (Oxford, 1975); and I. Wehgartner, *Attische weißgründige Keramik* (Berlin, 1983). Images of Charon are discussed by C. Sourvinou-Inwood, *'Reading' Greek Death to the End of the Classical Period* (Oxford, 1995), 321–53.

On burial in classical Athens see D. Kurtz and J. Boardman, *Greek Burial Customs* (London, 1972); I. Morris, *Death-ritual and social structure in classical antiquity* (Cambridge, 1992), chs. 4–5, and I. Morris, 'Everyman's grave', in A. Boegehold and A. Scafuro (eds), *Athenian Identity and Civic Ideology* (Baltimore, 1993), 67–101.

I discuss the relationship between funerary imagery and Perikles' Citizenship Law in 'Law, the Democratic Citizen and the Representation of Women in Classical Athens', *Past and Present* 155 (1997), 3–33, and see more generally M. Beard, 'Adopting an approach II', in T. Rasmussen and N. Spivey (eds), *Looking at Greek Vases* (Cambridge, 1991), 12–35. For a major white-ground painter not discussed here see J. Oakley, *The Phiale Painter* (Mainz, 1990).

On Athenian funerary stelai see C. Clairmont, *Classical Attic Tombstones* (6 vols, Kilchberg, 1993); K. Friis Johansen, *The Attic Grave Reliefs of the Classical Period* (Copenhagen, 1951); B. Schmaltz, *Griechische Grabreliefs* (Darmstadt, 1983); and K. Stears, 'Dead women's society: constructing female gender in Classical Athenian funerary sculpture' in N. Spencer (ed.), *Time, Tradition and Society in Greek Archaeology: Bridging the 'Great Divide'* (London, 1995), 109–31. The Ilissos stele and other work attributable to the same sculptor are discussed by Stewart, *Greek Sculpture*, 92–4.

The three cups by the Sotades Painter have been much discussed in recent years. See L. Burn, 'Honey-pots: three white-ground cups by the Sotades Painter', *Antike Kunst* 28 (1985), 93–105; A. Griffiths, ' "What leaf-fringed legend?" A cup by the Sotades painter in London', *Journal of Hellenic Studies* 106 (1986), 58–70; R. Osborne, 'Death revisited; death revised. The death of the artist in archaic and classical Greece', *Art History* 11 (1988), 1–16 and 9–13; and H. Hoffmann, 'Aletheia: the iconography of death/rebirth in three cups by the Sotades Painter', *Res* 17/18 (1989), 67–88.

On the Vergina tombs and their wall-paintings see M. Andronikos, *Vergina: The Royal Tombs and the Ancient City* (Athens, 1984). On the various cults offering an after-life see R. C. T. Parker, 'Early Orphism', in A. Powell (ed.), *The Greek World* (London,

1995), 483–510; G. Zuntz, *Persephone* (Oxford, 1971); and A. Laks and G. Most (eds), *Studies on the Derveni Papyrus* (Oxford, 1997).

Chapter 11. Individuals Within and Without the City

For a general survey of Greek sculpture in the period covered by this and the next chapter see J. Boardman, *Greek Sculpture: The Late Classical Period* (London, 1995). J. Onians, *Art and Thought in the Hellenistic Age: The Greek World View 350–50 BC* (London, 1979) has some stimulating things to say about the fourth century in chapter 1. On the sculptures of the temple of Apollo at Bassai see B. Madigan, *The Temple of Apollo Bassitas* vol. 2, *The Sculpture* (Princeton, 1992).

For works on Greek religion see above under ch. 5. On the sanctuary of Amphiaraos at Oropos see B. Petrakos, Ὁ Ὠρωπὸς καὶ τὸ ἱερὸν τοῦ Ἀμφιαράου (Athens, 1968) and A. Petropoulou, 'Pausanias 1.34.5: Incubation on a ram skin', in G. Argoud and P. Roesch (eds), *La Béotie antique* (Paris, 1985), 169–77.

On the sanctuary of Asklepios at Epidauros in general see R. A. Tomlinson, *Epidauros* (London, 1983); on the sculptures of the temple see N. Yalouris, 'Die Skulpturen des Asklepiostempels von Epidauros', in H. Kyrieleis (ed.), *Archaische und klassische griechische Plastik*, vol. 2, 175–84 and on those of the temple at Mazi see I. Trianti in the same vol., 155–68. On Skopas see A. Stewart, *Skopas of Paros* (Park Ridge, 1977). On the ivory heads from Vergina see M. Andronikos, *Vergina: The Royal Tombs and the Ancient City* (Athens, 1984), 123–6.

The Mausoleion and its sculptures are well discussed by B. Ashmole, *Architect and Sculptor in Classical Greece* (London, 1972). Note also G. Waywell, *The Freestanding Sculptures of the Mausoleum at Halicarnassus in the British Museum: a catalogue* (London, 1978). On Mausolos more generally see S. Hornblower, *Mausolus* (Oxford, 1982).

The information about Macedonians sitting and reclining comes from Athenaios, *Deipnosophistai* 18a. On initiatory rites in Macedonia see M. B. Hatzopoulos, *Cultes et rites en Macedoine* (Athens, 1994), who discusses the frieze from the tomb of Philip, 92–102. For full photographic coverage of the frieze see M. Andronikos, *Vergina: The Royal Tombs and the Ancient City* (Athens, 1984), 100–19. For the way in which Alexander lived out myth see R. Lane Fox, *Alexander the Great* (London, 1973), and for his image see A. Stewart, *Faces of Power: Alexander's*

Image and Hellenistic Politics (Berkeley, 1993) and R. R. R. Smith, *Hellenistic Royal Portraits* (Oxford, 1988).

On Greek gems see J. Boardman, *Greek Gems and Finger Rings: Early Bronze Age to Late Classical* (London, 1970).

On Greek portraits see L. Giuliani, *Bildnis und Botschaft* (Frankfurt, 1986) and D. Metzler, *Porträt und Gesellschaft* (Münster, 1971). Greek portraits are collected by G. M. A. Richter, *The Portraits of the Greeks* (3 vols. London, 1965; rev. 1-vol. edn ed. by R. R. R. Smith (Oxford, 1984). On portraits of Sokrates see P. Zanker, *The Mask of Socrates: The Image of the Intellectual in Antiquity* (Berkeley, 1996) and J. Henderson, 'Seeing through Socrates: Portrait of the philosopher in sculpture culture', *Art History* 19 (1996), 327–52.

Chapter 12. The Sensation of Art

On the Antikythera youth see P. C. Bol, *Die Sculpturen des Schiffsfundes von Antikythera* (Berlin, 1972). On Lysippos see C. M. Edwards, 'Lysippos', in O. Palagia and J. J. Pollitt (eds), *Personal Styles in Greek Sculpture* (Cambridge, 1996), 130–53, and F. Johnson, *Lysippos* (Durham, 1927, repr. New York, 1968). On Praxiteles see A. Ajootian, 'Praxiteles', in Palagia and Pollitt, 91–129. On the Hermes at Olympia and its date see S. Adam, *The Technique of Greek Sculpture* (London, 1966), 124–8, and K. D. Morrow, *Greek Footwear and the Dating of Sculpture* (Madison, 1985), 83–4. On the Knidian Aphrodite see C. M. Havelock, *The Aphrodite of Knidos and her Successors: a Historical Review of the Female Nude in Greek Art* (Ann Arbor, 1995).

Chapter 13. Looking. Backwards

Stimulating remarks on the contrasts between archaic and classical Greece will be found in R. Seaford, *Reciprocity and Ritual: Homer and Tragedy in the Developing City-State* (Oxford, 1994). I explore other aspects of the contrast in my Epilogue to *Greece in the Making 1200–479 BC* (London, 1996) and in 'The polis and its culture', in C. C. W. Taylor (ed.), *From the Beginning to Plato: Routledge History of Philosophy* vol. 1 (London, 1997).

The various ways in which the Greeks have been used in more recent times are discussed in O. Taplin, *Greek Fire* (London, 1991). The adoption of Greek motifs by non-Greek peoples in antiquity is the subject of J. Boardman, *The Diffusion of Greek Art in Antiquity* (London, 1994).

850 BC 800 BC 750 BC

Political/military

● *c.*760 Greeks begin to settle abroad

● *c.*740–720 Spartan conquest of Messenia

Cultural

● 776 First Olympic Games

● *c.*750 Earliest Greek alphabetic writing
● *c.*750–690 Number of bronze dedications at sanctuaries markedly increases

Visual arts

● *c.*850–750 Middle Geometric pottery style prevails

● *c.*750–700 Late Geometric pottery style prevails
● *c.*720 Protocorinthian pottery style developed at Corinth

● 669 Argos defeats Sparta at battle of Hysiai

● c.650–500 'Age of Tyrants'
● c.630 Greek settlement in Libya
● c.620 Drako makes laws at Athens

● 594–593 Solon archon and legislator at Athens

● 545 Peisistratos establishes tyranny at Athens
● 540–520 Polykrates tyrant in Samos
● 508–507 Kleisthenes establishes democratic constitution at Athens

● 700 Poet Hesiod active
● c.670 *Iliad* and *Odyssey* reach their final form

● c.650 Earliest Greek lyric poets, Archilokhos, Tyrtaios, Semonides, active
● c.610–575 Sappho and Alkaios flourish on Lesbos

● 585 Thales predicts eclipse
● 581 Isthmian Games established
● c.575–550 Earliest electrum coinage in Ionia
● 573 Nemean Games established
● c.570–550 Birth of Pythagoras
● 556 Panathenaic festival established at Athens

● 535 First dramatic festival at Dionysia at Athens

● c.700 Protoattic pottery developed in Attica
– Dreros cult statues
● c.670–620 'Daidalic' sculptural style prevails
● 660 First stone temple of Apollo at Corinth

● c.625 First tiled roofs to Greek temples
– Early Corinthian pottery style developed
● c.620 Earliest black-figure pottery at Athens

● c.580 Temple of Artemis, Corcyra
● c.570 François vase

● c.525 Siphnian treasury at Delphi built
– Red-figure technique pioneered in Athens
● c.510–480 Technique of making hollow-cast bronze statues perfected

500 BC · **450 BC** · **400 BC**

Political/military

- 499–494 Revolt of Ionian cities from Persia
- 490 Athenians and Plataians defeat Persian naval invasion at Battle of Marathon
- 487 Ostracism first used at Athens
- 480–479 Persian invasion of Greece defeated
- 478 Delian League of Greek cities continuing the offensive against Persia established under Athenian leadership
- c.465 Athenians and allies defeat Persians at Battle of Eurymedon
- – Helot revolt
- 463 Democracy established at Syracuse
- 460–446 'First Peloponnesian War'

- 449 Athens makes peace treaty with Persia
- 431–404 Peloponnesian War between Athens and Sparta
- 430 Plague at Athens
- 427–424 Athenian campaign against Sicily
- 421 Peace of Nikias
- 415–413 Athenian campaign against Syracuse
- 411 Oligarchic coup of 400 at Athens
- 409–405 Carthaginian campaigns in Sicily
- 404 Peace between Sparta and Athens
- – Oligarchic coup of 30 Tyrants at Athens

- 400 Agesilaos becomes king at Sparta
- 395–386 Corinth, Thebes, and Athens at war with Sparta
- 386 Peace in Greece sponsored by Persian king
- 377 Second Athenian Confederacy founded
- 371 Thebans defeat Spartans at Leuktra
- 370–69 Messenia liberated from Sparta
- 360 Accession of Philip II of Macedon
- 356 Birth of Alexander the Great, c.20 July

Cultural

- 500–446 Pindar active
- 485 Comedy added to dramatic festival at Athens
- 484 Aeschylus' first victory at Dionysia
- 472 Aeschylus' *Persians*
- 469 Birth of Sokrates
- 460 Birth of Demokritos and Hippokrates
- c.460 Birth of Herodotus
- 458 Aeschylus' *Oresteia*
- 455 Birth of Thucydides

- 438 Euripides *Alkestis*
- c.430 Sophokles' *Oidipous Tyrannos*
- 427 Plato born
- 425 Aristophanes' *Akharnians*
- 415 Euripides' *Trojan Women*
- 405 Aristophanes' *Frogs*

- 399 Execution of Sokrates
- c.387 Foundation of Plato's Academy
- 384 Birth of Aristotle
- c.360 Xenophon's *Hellenika*

Visual arts

- 500–490 Temple of Aphaia, Aigina, built
- c.480 Kritian boy
- c.470–450 Polygnotos active
- 460s Temple of Zeus at Olympia built

- 447 Parthenon begun
- c.435 Pheidias' cult statue of Zeus at Olympia
- c.430 Funerary reliefs begin again at Athens
- c.420–400 Zeuxis and Parrhasios active
- – Temple of Athena Nike built
- c.410–390 Temple of Apollo at Bassai
- 409–406 Erekhtheion completed at Athens

- 394 Gravestone of Dexileos
- c.380–360 Temple of Asklepios, Epidauros
- c.360–330 Theatre built at Epidauros
- 352–351 Mausoleion at Halikarnassos

● 346 Peace of Philokrates
between Philip and Athens
● 337 Athens and Thebes
defeated by Philip at Battle of
Khaironeia
● 336 Philip assassinated
● 334 Alexander embarks on
Persian invasion and wins Battle
of Granikos
● 333 Alexander defeats
Persians at Battle of Issos
● 331 Alexander defeats
Persians at Battle of Gaugamela
● 327 Alexander invades India
● 323 Death of Alexander

● 347 Death of Plato
● *c.*335 Aristotle founds
Lyceum
● 331 Foundation of Alexandria
in Egypt by Alexander
● 322 Death of Aristotle

● *c.*350 Praxiteles' Aphrodite of
Knidos
● *c.*345–330 Temple of Athena
Alea, Tegea
● *c.*330–320 Lysippos achieves
his greatest fame

Index

red-figure pottery 16–21, 88, 114–15, 135–55, 164–9, 189–90
 invention and advantages of technique 20, 135–7, 139–41, 145, 167
 see also drawing
Reed Painter 194
regionalism 24–9, 90, 98, 117
reliefs 13–16, 38, 53–4, 128–30, 184–6, 195–201, 210–12
 see also metopes; frieze
religious activity 63, 69, 149–52, 200–11, 225
 see also dedication; sacrifice
revelling 18–*19*, 95, 145–7, 164–5
Rhamnous 199
Rhegion 12
Rhodes 34, 37, 48–9, 90
Riace Marina, bronzes from 160–3, 171, 186
Rome 202
 art of 240–1
 conquest of Greece by 225
rusticity, image of 152–4

sacrifice:
 of animals 69, 84–5, 180–1, 186, 210–11
 of humans 108–9, 147, 180–2
Salamis 45, 157, 199
Samos 46–9, 75, 79, 98
sanctuaries *see* temples; dedications
Sappho 237
Sarpedon 141
satyr plays 17, 150, 169
Satyros 218
satyrs 97, 100, 106, 133–4, 147, 149–51, 164–5, 186
 on cups 17–19
 on *lekythoi* 189–91
sculpture, architectural *see* frieze; metopes; pediments
Scylla 202
seduction, heterosexual 18–19
seer, at Olympia 170–2, 213, 215, 221
Selinous 119–20, 127–8
Severe Style 174
sexual relations 12, 17–20, 118, 133–5, 149
 see also desire
shields, in geometric art 34, 39–40
ships, on geometric pottery 30, 35–6, 39–40
shipwreck 35–7
Sicily 66, 119–20, 128, 159–61, 175, 186, 189
Sikyon 202
Sikyonian treasury 121–2
Silenos 238
 see also satyrs
silver:
 for coinage 118
 for details of bronze statues 163
Simonides 237
singing, at *symposion* 17, 133–5, 139–40

Siphnian Treasury, Delphi 121–3, 139, 136, 138, 143, 170
Skillous (Mazi) 213, 218
Skopas 215–16, 218, 223
slaves 133–5, 196, 200
slipper 133–5
Smikros 139–40
snakes *36*, 43, 45, 49, 60, 73, 211
social status, and art 27, 32, 38, 45, 65, 128–30, 139–41, 193, 195–9, 220
Sokrates 11, 158, 222, 238–40
soldiers *see* cavalry; hoplites; warriors
Solon 130
Sophilos 88–91, 94, 100, 112, 130
Sophokles 222
Sotades Painter 201
space:
 in painting 166–7, 169, 190, 219
 in sculpture 196
Sparta 15, 28–9, 41, 118, 152, 157–8, 184, 186, 217, 237
 pottery from 98–9
sphinx 49–51, 192
sphyrelaton 74–5
stamnos 115, 189
Stesichoros 93, 94
stone, use of for temples and sculpture 69–70, 73–85, 117–31, 158–63, 169–87, 197–200, 205–23, 228–35
 see also bronze; marble
studios, attracting visitors 10–11
Styx 190
suicide, of Aias 107
Swing Painter 108–9
symbol, god as 63
symbols, figures as 27, 29, 30–4, 38, 63
symmetria 194
symposion 12, 17–19, 36–7, 39–41, 90, 96–9, 108, 113, 133–5, 137, 147, 151–2, 154, 159, 164–5, 167, 190
Syracuse 177, 186

Tegea 213–18, 223
Telamon 125
Telekles, sculptor 79
Telephos 213–17
temples:
 architecture of 69–75
 see also architecture
 sculpture of 11–12, 60, 117–28, 169–87, 205–10, 212–18, 237–8
terracotta:
 Mycenaean and Dark Age use of 24
 used for temple sculpture 75
theatre, at Epidauros 212
Thebes, and Aigina 124–5
Themis 122–3
Themistokles 157
Theodoros, sculptor 79

Theokritos 153
theology, art and 27, 66–7, 131, 151–4, 172–3, 182–3, 207, 211, 228–35
Thera 75
Thermon 70–2
Theseus 93, 118, 127, 144
Thessaly 201
Thetis 88–93
Thucydides 184, 187, 217
thyrsos 149–51
 see also maenads
Tiberius, Emperor 234
Timiades Painter 96
Timotheos 218
tombs, monumental 218–21
 see also grave monuments
torture 189, *191*
trade:
 in eighth century 40, 66
 in pottery 17, 87, 95–9, 189
 in sculpture 24, 129
tragedy 17–18, 104–8, 145, 238
 see also Aeschylus; Euripides; Sophokles
tripod cauldrons 24, 43–5, 60, 65
Troilos 93, 95–6
Trojan Horse 53–7, 144
Trojan War 88, 91, 122, 237
trophies, to victory in war 186
Troy 32, 215, 238
 sack of 57, 125–6, 142–5, 176–7, 184, 212
tyrants 15, 118, 130, 158, 218
Tyrrhenian amphorae 95–6, 99, 105, 166
Tyrtaios 237

underworld 201
 see also Hades; Persephone

Vergina 202–3, 216–18, 220, 223
Victory 107, 202
 temple of Athena Nike 183–7, 197
viewing, context of 17, 19, 33–7, 55–7, 60, 133–4, 140–1, 182, 207–10, 219, 226–35
violence on Tyrrhenian amphoras 95
 see also war
voting, scenes of 108
votive reliefs 210–12
 see also dedications
Vulci 16, 99, 137, 145, 151

wall-painting 10, 69–70, 167, 202–3, 220–1
war 13, 14–16, 39–40, 53–7, 59, 61–4, 81, 103, 105–9, 118, 126, 184–7, 210, 237
 see also Troy
warriors 28, 45, 53–7, 61–3, 100, 107, 143–5, 210, 218–19, 225
 on grave reliefs 128–9, 195, 197–9
 on *lekythoi* 190, 192–3
 see also cavalry; hoplites
Wealth, personification of 230
wealthy, lifestyle of 13–17, 128–35, 139–41, 190, 196–9
 see also symposion
weaving 33, 72, 100, 107, 135–6, 182
western art, influence of Greek art on 1, 9, 241–2
white-ground pot-painting 136, 189–95
wine 17–20, 29, 230
 see also Dionysos; *symposion*; women
wings 101
women 61, 72, 75, 83–4, 117, 170–1, 196–7, 219
 and death 84, 190, 195–9
 on geometric pottery 32, 40
 on *lekythoi* 190, 193–5, 197–9
 and religion 63, 151–2, 207–9
 and war 53–7, 103, 105–6, 143–5, 207–10, 212
 wildness of 72, 105, 151–2
 and wine 17, 151–2, 230
 see also clothing; Gorgon; *korai*; marriage; nudity
wood 46, 47–8, 75
workshops 9, 88, 137, 161
wrestling 100, 138
 see also athletes
writing 71–2, 95–6, 105, 113
 incomprehensible 95, 99
 on pots 19–20, 91–4, 98–9, 100–1, 105
 on sculpted frieze 122, 124, 136
 see also inscriptions

Xenophon 15, 213
 Memorabilia 3.10.1–4 11
 Symposion 17

Zeus 91, 122, 147–8, 172, 216, 229, 232
 as rapist 119–20
 sanctuary of at Olympia 24, 108, 169–75, 210, 221
Zeuxis 194, 209

Oxford History of Art

Titles in the Oxford History of Art series are up-to-date, fully illustrated introductions to a wide variety of subjects written by leading experts in their field. They will appear regularly, building into an interlocking and comprehensive series. In the list below, published titles appear in bold.

WESTERN ART

Archaic and Classical Greek Art
Robin Osborne

Classical Art From Greece to Rome
Mary Beard & John Henderson

Imperial Rome and Christian Triumph
Jas Elsner

Early Medieval Art
Lawrence Nees

Medieval Art
Veronica Sekules

Art in Renaissance Italy
Evelyn Welch

Northern European Art
Susie Nash

Early Modern Art
Nigel Llewellyn

Art in Europe 1700–1830
Matthew Craske

Modern Art 1851–1929
Richard Brettell

After Modern Art 1945–2000
David Hopkins

Contemporary Art

WESTERN ARCHITECTURE

Greek Architecture
David Small

Roman Architecture
Janet Delaine

Early Medieval Architecture
Roger Stalley

Medieval Architecture
Nicola Coldstream

Renaissance Architecture
Christy Anderson

Baroque and Rococo Architecture
Hilary Ballon

European Architecture 1750–1890
Barry Bergdoll

Modern Architecture
Alan Colquhoun

Contemporary Architecture
Anthony Vidler

Architecture in the United States
Dell Upton

WORLD ART

Aegean Art and Architecture
Donald Preziosi & Louise Hitchcock

Early Art and Architecture of Africa
Peter Garlake

African Art
John Picton

Contemporary African Art
Olu Oguibe

African-American Art
Sharon F. Patton

Nineteenth-Century American Art
Barbara Groseclose

Twentieth-Century American Art
Erika Doss

Australian Art
Andrew Sayers

Byzantine Art
Robin Cormack

Art in China
Craig Clunas

East European Art
Jeremy Howard

Ancient Egyptian Art
Marianne Eaton-Krauss

Indian Art
Partha Mitter

Islamic Art
Irene Bierman

Japanese Art
Karen Brock

Melanesian Art
Michael O'Hanlon

Mesoamerican Art
Cecelia Klein

Native North American Art
Janet Berlo & Ruth Phillips

Polynesian and Micronesian Art
Adrienne Kaeppler

South-East Asian Art
John Guy

Latin American Art

WESTERN DESIGN

Twentieth-Century Design
Jonathan Woodham

American Design
Jeffrey Meikle

Nineteenth-Century Design
Gillian Naylor

Fashion
Christopher Breward

PHOTOGRAPHY

The Photograph
Graham Clarke

American Photography
Miles Orvell

Contemporary Photography

WESTERN SCULPTURE

Sculpture 1900–1945
Penelope Curtis

Sculpture Since 1945
Andrew Causey

THEMES AND GENRES

Landscape and Western Art
Malcolm Andrews

Portraiture
Shearer West

Eroticism and Art
Alyce Mahon

Beauty and Art
Elizabeth Prettejohn

Women in Art

REFERENCE BOOKS

The Art of Art History: A Critical Anthology
Donald Preziosi (ed.)